D1177333

Jean Laur

Architect, former curator of the Conservation d'Angkor

Angkor

An Illustrated Guide to the Monuments

VINCI

Flammarion

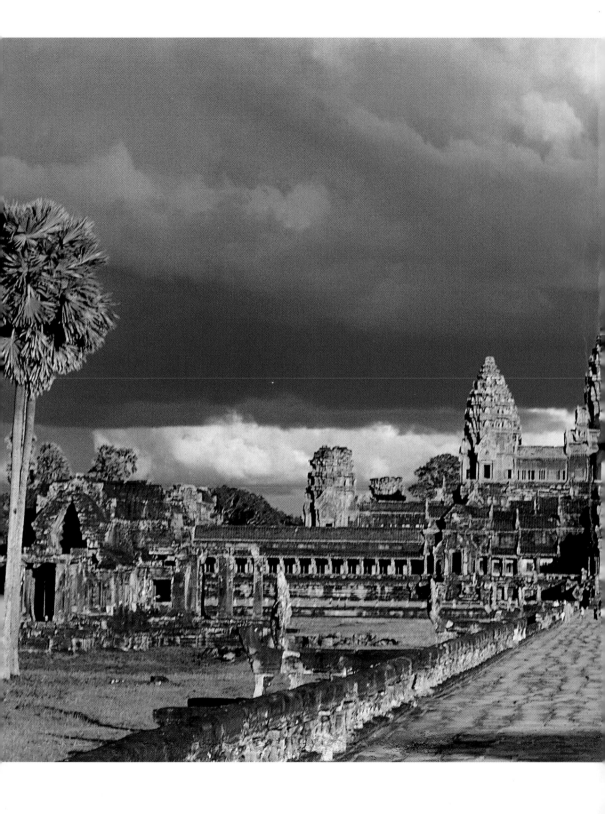

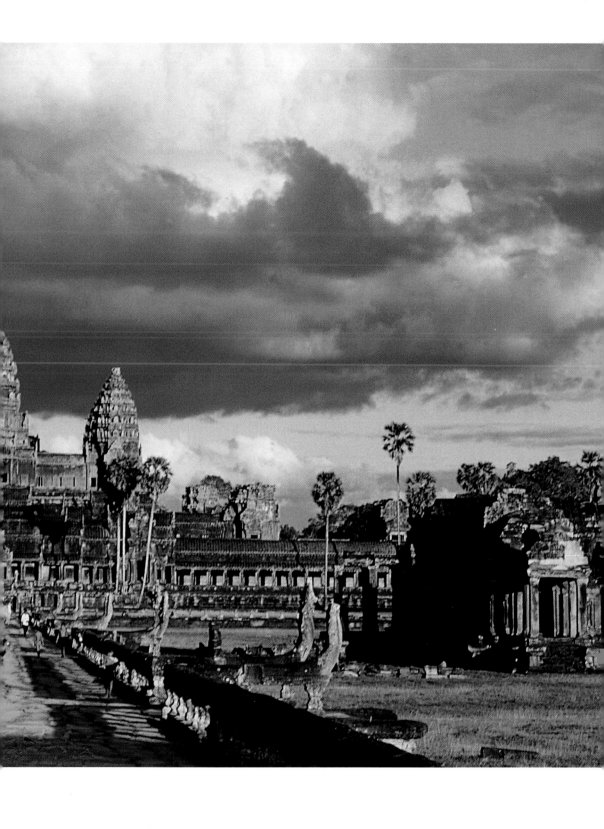

The author would like to thank:
Jérôme Tolot
Patric Buffet
Antoine Tchekhoff
M.-L. Philibert

Translated from the French by Diana Pollin
Edited for the English–language edition by Bernard Wooding
Page design and typesetting by Thierry Renard

Originally published as *Angkor: Temples et monuments*
© Arthaud, 2002
English-language edition
© Flammarion, 2002

ISBN : 2-0801-0723-2

Printed in Italy

Contents

• *Map showing the monuments of the Angkor group and the temples of the Roluos group appears at the end of the book.*

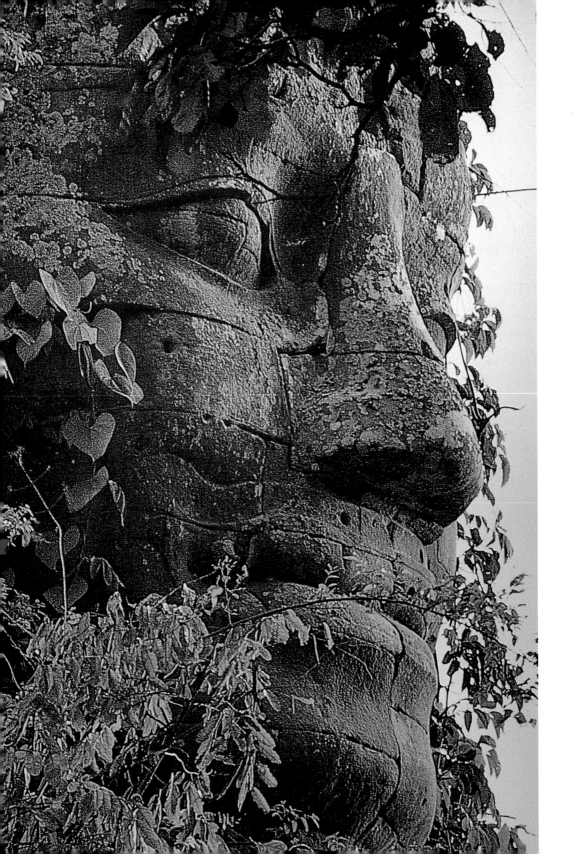

Foreword

In 1944, Maurice Glaize, curator of Angkor, published a seminal guidebook to the site. The most recent edition of Glaize's work, the guide of 1993, preceded the reopening of the monuments that a tragic state of belligerency had closed to the public. In the years following that period, visitors have been coming in ever-increasing numbers to see the marvels of Angkor. As an admirer and successor of Maurice Glaize, I felt that the guide I was writing should be in keeping with his love of the monuments and the clarity and precision marking their description.

This new guide is the fruit of my six year experience as curator of the Conservation d'Angkor and the result of studies and research that I have carried out, backed up by a series of visits since 1995.

Through this guide, I wish to address both visitors with limited time and those planning an extended stay. The users of this guide will find that the descriptions and succinct explanations for each monument in the main section have been included to provide a maximum amount of information. Historical, cultural and geographical data appear in the introductory chapters. The appendices contain information about some of the minor monuments, descriptions of the major bas-reliefs and more detailed discussion of certain aspects of Khmer civilization and religious beliefs.

Pages 2-3: Angkor Wat under monsoon clouds from the west causeway.

Left: face on the west gate tower, Banteay Kdei.

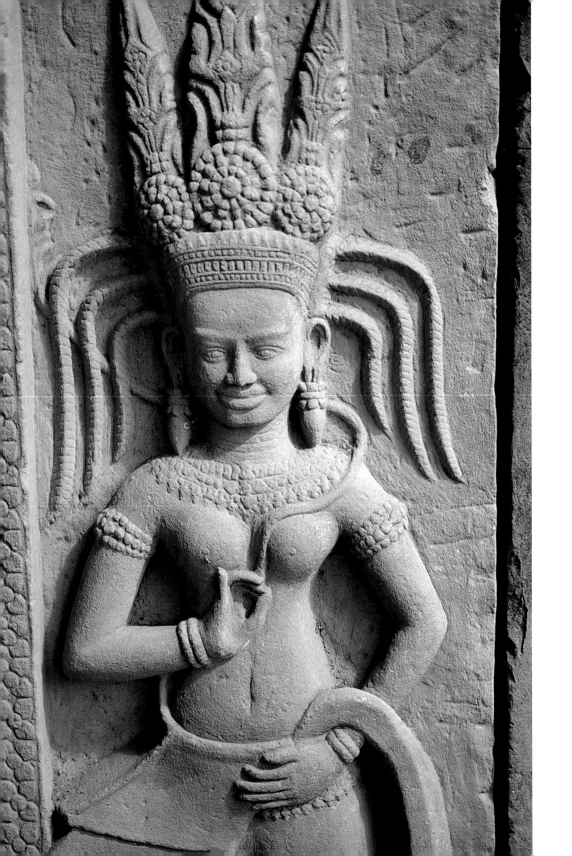

Practical Information

If possible, avoid going to Angkor in March and April, the hottest months, and during the rainy season from May to October.

Always take a lightweight, foldable rain poncho or jacket.

Pack a sturdy pair of walking shoes, since you will be doing a lot of walking and temple steps are often high and slippery.

Take light clothes that breathe as much as possible.

Have a compass with you. Although there are paths leading to the temples, in places like Ta Prohm, for example, it is easy to get lost. A pocket flashlight is also useful for looking at decorative details in dark areas.

Take a bottle of mineral water, a sun hat and sun screen.

Day or week passes can be purchased at the tourist office near the Grand Hotel in Siem Reap or at the entrances to the main archeological sites.

From Siem Reap, the temples can be reached by chauffeured motorbikes, available at hotels for individual visits or day rentals, or by chauffered car (usually air-conditioned) that can be reserved at the tourist office or at hotels. The tourist office will provide a local guide on request, but be sure to specify English-speaking and do not expect the explanations to be too accurate!

Left: *apsara* on a pilaster at Angkor Wat.

Page 11: *makara* disgorging a dancing figure amid swirls of foliage, lime-based mortar, Preah Ko.

Pages 12-13: the causeway leading to the south gate at Angkor Thom, flanked by good and evil genies pulling on a *naga*.

Suggested Tour Programs

The following itineraries are arranged according to length of stay.

One-Day Visits

Morning. South gate of Angkor Thom > Bayon > Terrace of the Elephants and Terrace of the Leper King > Neak Pean > East Mebon > Pre Rup.
Afternoon. Ta Prohm > Banteay Kdei > Srah Srang > Angkor Wat

Two-Day Visits

• **1st Day** • **Morning.** Prasat Kravan > Pre Rup > East Mebon > Preah Khan > Terrace of the Elephants and Terrace of the Leper King.
Afternoon. Ta Prohm > Banteay Kdei > Srah Srang
• **2nd Day** • **Morning.** South gate of Angkor Thom > Bayon > Royal Palace. **Afternoon.** Baksei Chamkrong > Phnom Bakheng > Angkor Wat

Three-Day Visits

• **1st Day** • **Morning.** Prasat Kravan > Pre Rup > East Mebon > Neak Pean > Preah Khan.
Afternoon. The Khleangs > Prasat Suor Prat > Gate of Victory > Thommanon > Chau Say Tevoda > Ta Keo
• **2nd Day** • **Morning.** Banteay Samre > Banteay Srei. **Afternoon.** Banteay Kdei > Ta Prohm > Srah Srang
• **3rd Day** • **Morning.** Baksei Chamkrong > Bayon > Royal Palace > Phimeanakas > Terrace of the Elephants and Terrace of the Leper King > Tep Pranam > Preah Palilay.
Afternoon. Phnom Bakheng > Angkor Wat

Four-Day Visits

• **1st Day** • **Morning.** Roluos group > Preah Ko > Bakong > Lolei. **Afternoon.** South gate of Angkor Thom > Terrace of the Elephants and Terrace

of the Leper King > Royal Palace > Phimeanakas > Tep Pranam > Preah Palilay
• **2nd Day** • **Morning.** Prasat Kravan > Pre Rup > East Mebon > Neak Pean > Preah Kahn.
Afternoon. Siem Reap River > Phnom Krom > West Mebon > Ak Yom
• **3rd Day** • **Morning.** Banteay Samre > Banteay Srei. **Afternoon.** Angkor Thom > Gate of Victory > Thommanon > Chau Say Tevoda > Ta Keo > Ta Prohm > Banteay Kdei > Srah Srang
• **4th Day** • **Morning.** Baksei Chamkrong > Bayon > The Khleangs > Prasat Suor Prah > Preah Pitu.
Afternoon. Phnom Bakheng > Angkor Wat

Five-Day Visits

• **1st Day** • **Morning.** Roluos group > Preah Ko > Bakong > Lolei. **Afternoon.** Terrace of the Elephants and Terrace of the Leper King > Royal Palace > Phimeanakas > Tep Pranam > Preah Palilay > Preah Pitu
• **2nd Day** • **Morning.** Prasat Kravan > Pre Rup > East Mebon > Ta Som > Neak Pean. **Afternoon.** Preah Khan > Prasat Prei > Banteay Prei > Krol Damrei
• **3rd Day** • **Morning.** Banteay Samre > Banteay Srei. **Afternoon.** Ta Keo > Ta Prohm > Banteay Kdei > Srah Srang
• **4th Day** • **Morning.** Courtyard of the Royal Palace > the Khleangs > Prasat Suor > Prat > Gate of Victory > Thommanon > Chau Say Tevoda.
Afternoon. Siem Reap River > Phnom Krom > West Baray > West Mebon > Ak Yom
• **5th Day** • **Morning.** Baksei Chamkrong > South gate of Angkor Thom > Bayon.
Afternoon. Angkor Wat > Phnom Bakheng

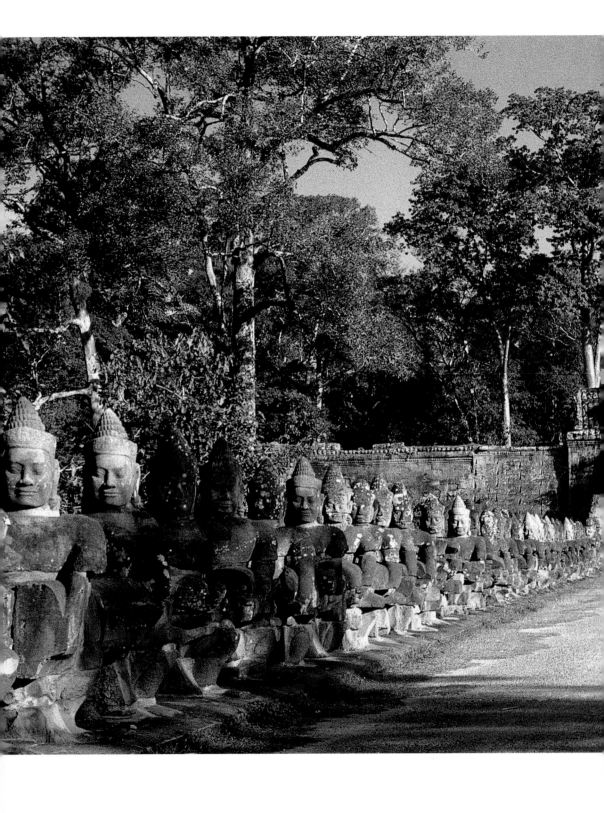

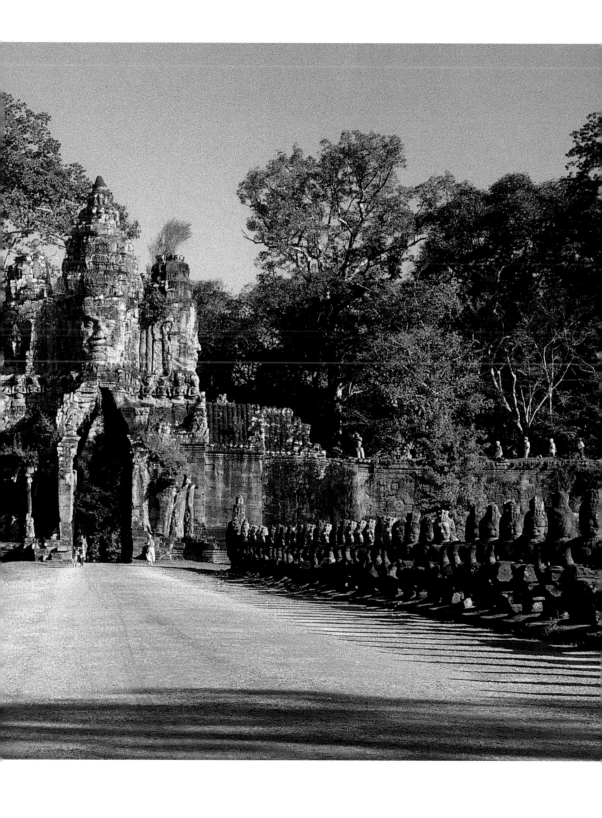

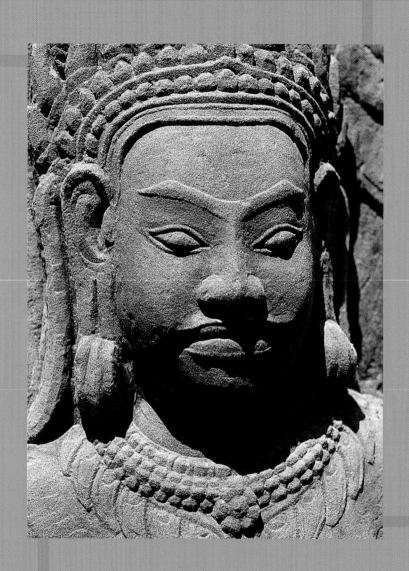

Cambodia
and Khmer Art

Geography, Climate and Flora

Cambodia is located in Southeast Asia, between 102° and 103° E and 10° and 15° N, approximately on the same parallel as Senegal. It is bordered by Thailand to the north and west, Laos to the north and Vietnam to the east. Cambodia covers an area of 181,000 km² and is roughly the size of the state of Washington.

Natural Environment

Two-thirds of the country are covered by a vast plain 450 km long and 200 km wide, stretching from the north to the northwest and from the south to the southeast. Originally a gulf, it was gradually transformed by the waters of the Mekong River flowing from their source high in the Himalayas. As it passed through the mountains, the river carried huge amounts of sediment and deposited them in the southern region of the Indochinese peninsula. This sediment created the river's delta and the gulf is being slowly filled even to this day.

To the north, the plain is surrounded by the Dangrek mountain range reaching nearly 500 m at its highest point and continuing eastward to the border of Vietnam in a series of plateaus.

The Cardamom and the Elephant mountains, peaking at 1,813 m and 1,000 m respectively, border the southern part of the plain. The southern foot of these mountains plunges into the Gulf of Thailand.

Some 40 km northeast of Angkor lies the sandstone massif of Kulen, averaging 490 m in altitude. Its open quarries supplied most of the stone blocks for the temples of Angkor.

Previous double page: Servant (detail), interior corridor, Terrace of the Leper King.

One of the "towers of the tightrope dancers," Prasat Suor Prat.

Water

Water, in the form of the Mekong River, the Great Lake (Tonle Sap) or the precipitation of the rainy season has always played a major role in Khmer life. The Mekong, a powerful river 4,200 km long, starts in the snowy Himalayas and flows through the northeast region of Cambodia to the South China Sea. In its course, it determines the level of the waters of the Great Lake, which varies depending on the time of year.

The Great Lake basin probably owes its existence to the collapse of ground in that particular area during a recent geological era. The guitar-shaped lake communicates with the Mekong and forms the real "lung" of the region, as it swells and retracts in harmony with the seasons. During the dry season from October to June, the lakes cover an area of 3,000 km^2. During the rainy season from August to September, the Mekong, following its course, swollen by the melted Himalayan snows and monsoon rains, floods the Tonle Sap River which fills the Great Lake tripling its surface area to 9,000 km^2. The limits of the flood zone partly determined the location for Angkor. The vagaries of the Great Lake have had a profound influence on the life of the Khmer people.

The smaller rivers of Cambodia spring from the Dangrek and Cardamom mountains and flow into the Great Lake, which they surround like the spokes of a wheel.

Climate

Like all Southeast Asian countries, Cambodia has a tropical climate with monsoons. There is a dry season from November to May and a rainy season from May to October, September being the wettest month. Cambodia has no typhoons.

On the plain, the average yearly temperature is 27°C; in Siem Reap, the town nearest Angkor, it is 26.6°C. The north and northeast winds in November generally cool the start of the dry season for two or three months. The temperature

Srah Srang seen from the landing stage, where the king used to bathe.

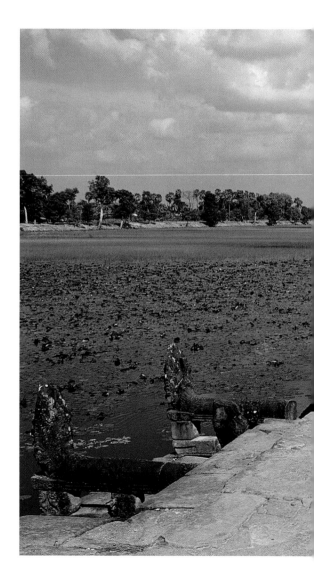

hovers around 23°C, making it the most pleasant season of the year. The hot months begin in February; the weather is humid and the skies threaten to break into electrical storms. In April, the temperature may reach 55°C in the sun. The first rains arrive in May, usually occurring during the afternoon. They continue for around two hours, relieving the heavy, unpleasant atmosphere of the hot season.

Flora

Cambodia has always had a great variety of forests ranging from the dense, tropical type to the clear forest that encircles the Great Lake. During the period of flooding from August to September, when the high waters spill over onto the land, the clear forest becomes a mangrove, filled with plankton and all kinds of fish. At that time, the waters of the Great Lake are among the richest in the world.

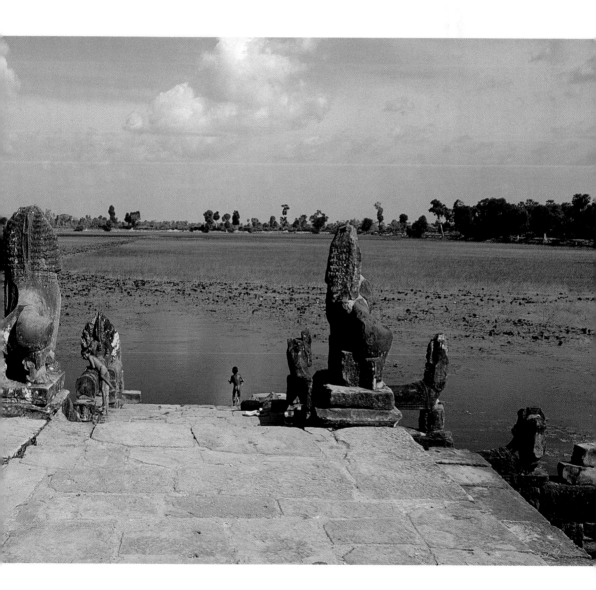

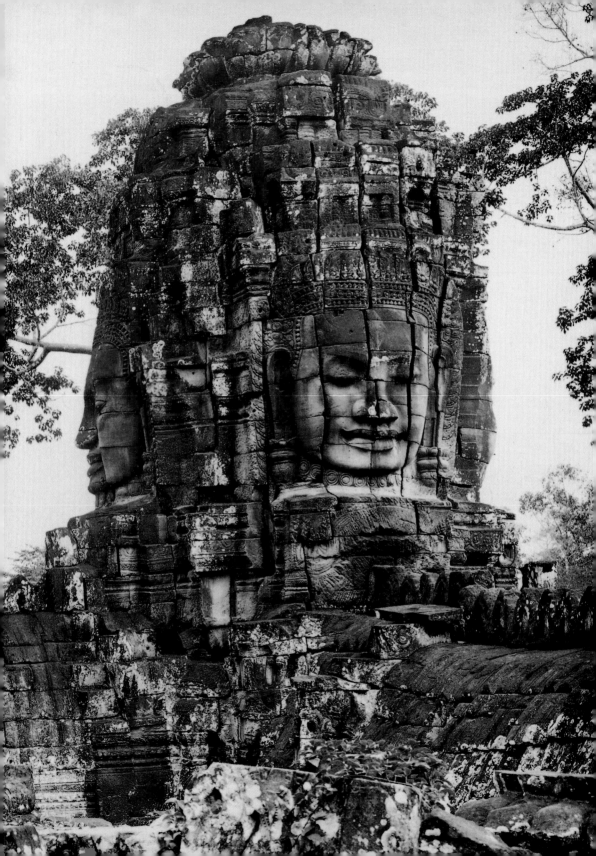

History of Ancient Cambodia

The earliest information about ancient Cambodia comes from China and dates to long before the foundation of Angkor, to around the 3rd century A.D., at the time of the kingdom of Funan. The arrival of Chinese ambassadors in that kingdom enabled some of its members to report for the first time on the lifestyle and customs of its inhabitants. Two hundred years later, in the 5th century,

One of the Bayon's fifty-four towers. The god-king contemplates the four cardinal directions of the empire.

Chinese chroniclers again portrayed life in Funan. At the close of the 6th century, a Chinese text mentions Chenla (or Zhenla), the state that replaced Funan, calling it Kambuja.

Zhou Daguan's description composed in the 13th century authenticates and completes what is known about the subject. Inscriptions on stelae and doorjambs provide other data about the king and the court, referring in particular to the founding of sanctuaries and gifts of land. Although written in Sanskrit, they were often repeated and transcribed into the vernacular of ancient Cambodia so that the literate could subsequently inform the people. A priceless source of information, these texts enable the visitor to gain a more profound understanding of the history, the political and social organization, and the beliefs and practices of the people of that era.

The Indochinese Peninsula
in Prehistoric Times

It is thought that human life first appeared in east Africa, in what is now Kenya, less than three million years ago and then spread in branches to the Middle East, Europe and Asia. Each branch evolved according to the specific climatic and living conditions of each region, eventually leading to the emergence of different races.

Almost nothing is known about the prehistory of the Indochinese peninsula in general and that of Cambodia in particular. Since the earliest times, however, the whole area extending from the Gulf of Bengal on the west to the South China Sea on the east has been subjected to patterns of monsoons, a phenomenon that could have been responsible for shaping a primitive common culture. The migrating populations followed the rivers, mountains and valleys in a hostile natural environment until they founded the first settlements in certain favorable areas.

Historians believe that the industry of stone carving in the region developed during the Quaternary era and continued for about two million years, apparently unaided by outside human contributions. The oldest traces of this practice have been sighted in Burma (Myanmar), Thailand and Laos. The human remains found there resemble Peking man (*Sinanthropus pekinensis*) and were thought to date back five hundred thousand years before the present. At that time, people subsisted by hunting and gathering.

The harshness of the natural environment obliged the people to seek refuge in caves and limestone rock shelters in the area currently part of northern Vietnam, notably near the cities of Hoa Binh and Bac Son, which are also the sites of Paleolithic graves. The implements that have been unearthed are, for the most part, rocks chiseled on one side and stones fragmented on both sides and polished on one side. There are scarcely any traces of pottery and farming does not seem to have been practiced at that time. The first inhabitants of the Indochinese peninsula were apparently not very ingenious and advances in their primitive civilization must be imputed to external influences.

During the Neolithic era, 6000 to 7000 B.C., a first wave of migrants, perhaps of the Mongoloid race, came down from the north and gradually spread throughout Southeast Asia. At the same time, a second wave arrived from China—Austronesians—who mated with the population to create a mixed civilization.

The Neolithic era saw the invention of stone polishing, ceramics, agriculture and husbandry. The populations of that epoch did not, in general, seek refuge in caves or rock shelters. There are very few archeological sites from this period in Indochina, the most important being in southern Vietnam, at Oc Eo, and Cambodia, at Mlu Prei, Anlong Pdau and Samrong Sen. The last is situated at the entrance to the Great Lake and is a rich depository of important and varied implements. Metalworking in the region (first copper, then bronze and finally iron) began in around 3000 B.C.

The erecting of megalithic monuments, consisting of huge stone blocks placed upright or horizontally, began during the Bronze Age and continued up to the beginning of the Iron Age.

Prehistoric and historic sites in southern Indochina.

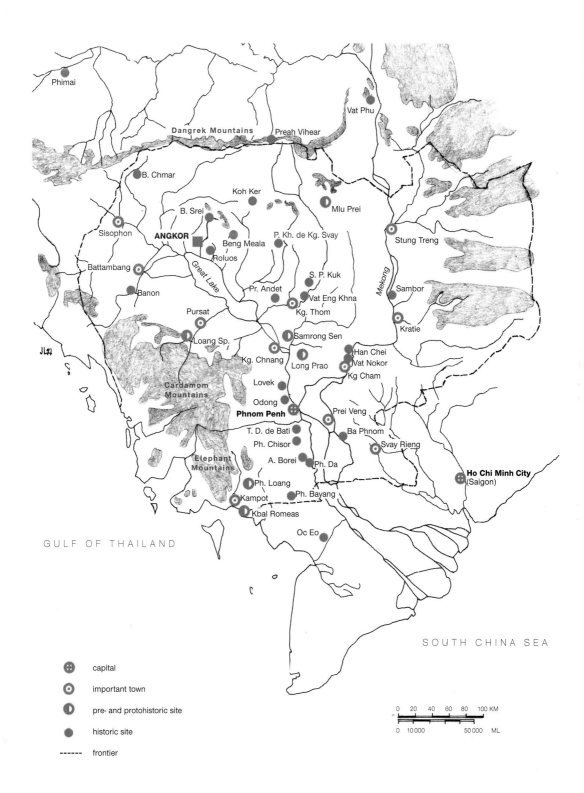

Phimai

Dangrek Mountains

Vat Phu

Preah Vihear

B. Chmar

Koh Ker

Mlu Prei

B. Srei

Sisophon

ANGKOR

Beng Meala

P. Kh. de Kg. Svay

Stung Treng

Roluos

Battambang

Great Lake

Pr. Andet

S. P. Kuk

Sambor

Banon

Vat Eng Khna

Pursat

Kg. Thom

Kratie

Loang Sp.

Samrong Sen

Mekong

Kg. Chnang

Long Prao

Han Chei

Vat Nokor

Lovek

Kg. Cham

Cardamom
Mountains

Odong

Phnom Penh

Prei Veng

T. D. de Bati

Ba Phnom

Ph. Chisor

Svay Rieng

Elephant
Mountains

A. Borei

Ph. Da

Ph. Loang

Ho Chi Minh City
(Saigon)

Kampot

Ph. Bayang

Kbal Romeas

Oc Eo

GULF OF THAILAND

SOUTH CHINA SEA

⊕ capital

◎ important town

◐ pre- and protohistoric site

● historic site

------ frontier

0 20 40 60 80 100 KM

0 10 000 50 000 ML

The northeastern part of Laos is particularly rich in groupings of large stone urns planted in the earth and containing cremated human remains. The huge circular constructions of raised earth found mainly in southern Indochina are also thought to be from the Neolithic period and may possibly have served for defensive purposes.

Indian Expansion and Its Influence

Contacts between India and Southeast Asia date back to prehistoric times, when maritime relations were established between both regions. The discovery of glass shards of Hindu origin in certain Neolithic graves of the Indochinese peninsula affirms that trade took place at that time.

Directly following the start of the Christian era, the imperial Rome of Caligula and Nero grew hungry for power and riches, gold, precious stones, spices and perfumes. Indian merchants, eager to establish lucrative trade relations with the imperial city, turned to the Orient in search of the highly sought-after products, thereby strengthening existing relations with Southeast Asia using land and sea routes.

The start of the Indianization of Southeast Asia coincided with the dawning of the Christian era

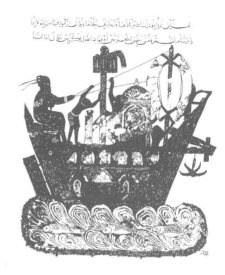

A ship sailing in the Persian Gulf, 13th century (Bibliothèque Nationale, Paris).

Facing page, top: Ravana, king of the demons, dance mask (National Museum, Phnom Penh).

Facing page, bottom: a demon (*rakshasa*), dance mask (National Museum, Phnom Penh).

The Saka Era

At the beginning of the 2nd century B.C., nomadic hordes unfurled their armies across Central Asia. They included the Scythians, or Sakas, who were already known to the Iranians in the 8th century B.C. The migrations of this population led them to the Indus River basin, where they established a base for their future conquests. Although belligerent invaders, the Sakas mingled with the local and strongly Hellenized populations, from whom they acquired knowledge, methods and techniques. This mixing enabled the Kushan dynasty to gain control of the Gandhara region (present-day northwestern Pakistan). The accession to the throne of the famous Kushan king Kanishka seems to coincide with the start of a calendar system that is attested by more than one hundred fifty inscriptions in India. The beginning of that era remains obscure, but it has been estimated that it began in A.D. 78. Thus, 900 in the Saka era corresponds with 978 of the Julian calendar.

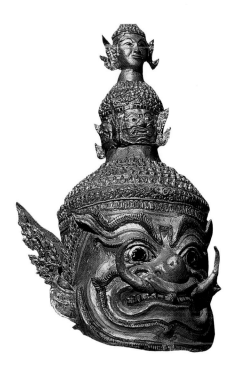

and took the form of contacts with the inhabitants of the Lower Mekong River basin. The newcomers were not total strangers to the continent. Indeed, in that part of Asia, a similar pattern of monsoons created a certain cultural unity both in spiritual and material terms.

The ease and rapidity with which the Indian civilization was accepted and assimilated by local populations, and particularly by their leaders, was due to the fact that the new arrivals were there to engage in trade and not in military conquest. The Indian expansion was based principally on commercial relations and remained essentially peaceful.

The Indian merchants "set up shop" along the coastlines in small trading posts that rapidly became centers of attraction, disseminating a culture superior to that of the host country. They were the points of transit for merchandise, traders, learned men, priests (both Buddhist and Hindu) and scientists, who were the transmitters of new ideas, as well as arts and techniques unknown in Southeast Asia.

The settlers knew how to blend into their host country's society; some even brought their own families from India, while others wed local women and put down roots in their adopted land. They respected local customs but continued to worship their own gods, who were gradually adopted by the indigenous peoples and were considered more powerful and more effective than the local deities.

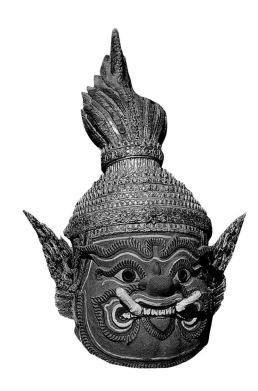

These merchants introduced the use of the Indian alphabet and the Saka calendar. They even initiated the use of the honorary title "Varman," meaning armor in the sense of divine protection, which would become part of the names of Cambodian sovereigns for the following ten centuries. Curiously enough, India has kept no record of these people who settled in Southeast Asia and who at times contributed to the founding of true empires.

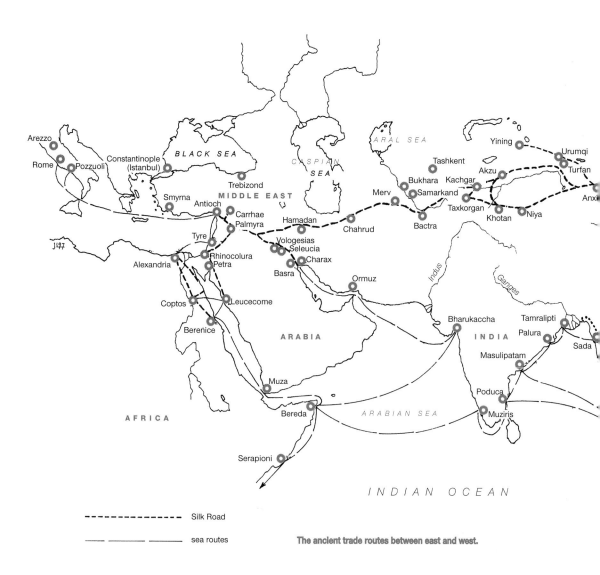

The ancient trade routes between east and west.

The Pre-Angkor Period

Funan

Ancient Chinese documents are the only source of information about the existence of a kingdom located in the south of the Indochinese peninsula in the Mekong delta. These chronicles, which date from the start of the 1st century A.D., reveal that the kingdom was called Funan, probably a deformation of the Khmer word *bnam* ("mountain"), which is today pronounced "phnom." An early example of

the growing influence of Indian culture is revealed by the legend of an Indian Brahman named Kaundinya, who set sail and arrived in Funan, where he met Princess Soma, the daughter of the *naga* king. They married and founded a dynasty that reigned over most of southern Indochina. All the Khmer rulers up until the 9th century claimed to be the descendants of this mythical couple.

Chinese historians of the 2nd century report that Funan was governed by Fan Man, a warlord who

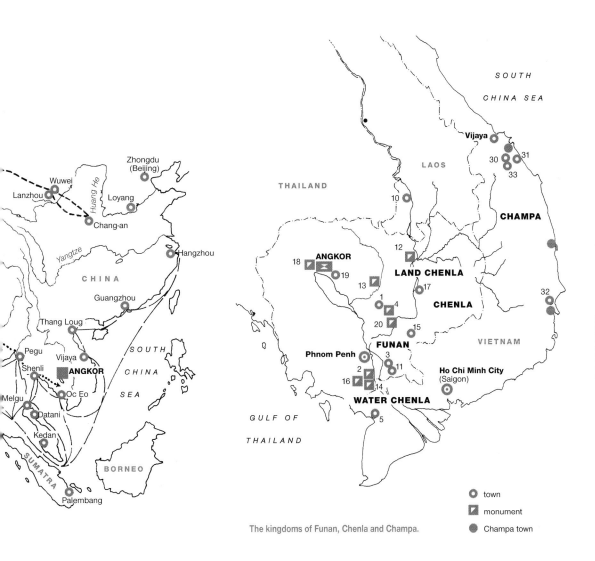

The kingdoms of Funan, Chenla and Champa.

town
monument
Champa town

assumed the title of maharaja ("great king"). He adopted an Indian form of administration for his kingdom, which he expanded eastward to the China Sea and westward to the southern tip of the Malaysian peninsula up to the land of Mon in lower Burma, where he died. Fan Chan, his successor, was principally concerned with commercial matters and established relations with India and China.

Between 245 and 250, a usurper mounted the throne and this new turn of events presented the

Funan (c. 220-500)
1. Samrong Sen
2. Angkor Borei
3. Ba Phnom
4. Sophas
5. Oc Eo

Chenla (c. 550-700)

Land Chenla (c. 700)

Water Chenla (c. 700)
10. Vat Phu
11. Adhyapura
12. P. Baran
13. S. Prei Kuk

14. Bayang
15. B. P. Nokor
16. A. M. Rosei
17. Sambhupura
18. P. Khmeng
19. Hariharalaya
20. Hanchey

Champa (until 8th c.)
30. Mi Son
31. Tra Kieu
32. Po Nagar
33. Dong Duong

Chinese chroniclers with good opportunities to write fascinating descriptions of the physical appearance, lifestyle and customs of the country's inhabitants. For a long while, nothing further was written about Funan. Then, at the beginning of the 5th century, Chinese historians mention the arrival of a second Kaundinya, testifying to the growing influence of the Indian civilization throughout Southeast Asia.

The accession of the first Jayavarman to the throne around 480 was the prelude to a glorious reign and a dazzling civilization. This ruler built his capital near the Ba Phnom site, southeast of present-day Phnom Penh. Chinese documents provide descriptions of life in Funan at that time.

An inscription in Sanskrit discovered in the Mekong delta indicates that swamp-draining techniques were employed. During this period, different religious practices were observed, including one honoring the Hindu deity Shiva in the form of the *linga,* a phallic symbol erected on the top of a mountain where the sky seemed to meet the earth. The cult of Vishnu also gained recognition and the existence of Buddhism—both the Lesser (Hinayana) and the Great Vehicle (Mahayana)—is mentioned in inscriptions of the period.

At the death of Jayavarman in 514, his son Rudravarman took power, but was forced to abandon Ba Phnom following an attack from the north. He transferred the capital to the right bank of the Mekong, to a site called Angkor Borei south of present-day Phnom Penh. Angkor Borei was the last known capital of Funan.

During the 7th century, the land was conquered and absorbed by its northern neighbor, Chenla. The kingdom of Funan, which had dominated the Indochinese peninsula for five centuries, disappeared.

Chenla

Chenla, an inland kingdom of the Mon-Khmer ethnic group, was mentioned as a kingdom for the first time in a Chinese text of the Sui dynasty (581-620). The Chinese always used the name Chenla when referring to the land of the Kambuja, the Khmer country.

Initially, the center of this kingdom might have been situated in the Great Lake region. Following in the footsteps of the Funan monarchs, the Kambuja rulers claimed to have been the fruit of the union of Kambu, a mythical ancestor, and the goddess Mera, from whom the name "Khmer" seems to have been derived. Chenla, the successor of Funan in the Indochinese peninsula, can be considered the true cradle of historical Cambodia.

Srutavarman was said to be the first king of Chenla. His son and heir to the throne, Sreshthavarman, started a brilliant dynasty. He built his capital on the middle reaches of the Mekong around the Wat Phu hill, now in southern Laos.

King Bhavavarman came to power in the 6th century at a time when Chenla was a vassal of Funan. Pushing north, he expanded his kingdom along the Mekong at the expense of his neighbor, the kingdom of Champa that occupied a strip of territory between the Annamese Cordillera and the sea. When Rudravarman, the last king of Funan, died around 539, Bhavavarman, citing birthrights inherited from his mother, staked a claim to the throne. He was probably unsuccessful, because he attacked the kingdom and subjugated it, nevertheless granting it a certain measure of autonomy.

Bhavavarman died in 598 and was succeeded by his brother, Mahendravarman, whose reign was very short. His son, Isanavarman I, took power; his twenty-four-year reign, from 611 to 635, was a period of territorial conquest. Perhaps judging the old capital Wat Phu no longer to be the geographic center of his new realm, he established another city in Cambodia, to the north of Kompong Thom, at Isanapura on the present-day archeological site of Sambor Prei Kuk. Under the reign of Isanavarman, Chenla reached the height of

its glory. His successor, Bhavavarman, left hardly any traces. Around 659, Jayavarman I mounted the throne to reign peacefully for forty years.

When Isanavarman I came to power at the beginning of the 7th century troubles began, leading to the weakening and the dislocation of the kingdom. Chinese sources tell us that enemies of Jayavarman I, taking advantage of the situation, divided the country into two parts. The northern part was Land Chenla, a country of plains and mountains; the southern part was Water Chenla, which was by the sea. Both Chenlas were further split into smaller states, the one in the Angkor region being governed by a woman.

A Chinese text composed during the reign of Isanavarman I describes the lifestyles and the customs of the court at that time; inscriptions engraved in Sanskrit and in ancient Khmer give an insight into the religious life of the kingdom.

At the end of the 7th century, Chenla, together with the rest of the Indochinese peninsula, had to face attacks on its coastlines from two newly powerful Indonesian kingdoms, Java and Sumatra, throwing Southeast Asia into turmoil. Chenla itself was probably subjugated by Java. This troubled era of partition, warfare and fragmentation into several smaller states, together with the Indonesian military incursions and domination of Chenla, created a one-hundred-year break in the chronology of the Khmer kings.

The first act of the founding king of the Angkor monarchy was to organize a ceremony in which he was consecrated the sole ruler of Chenla, which he proclaimed independent from Indonesia. On his return from Java, where he had been living for reasons that are still unclear, this sovereign, the future Jayavarman II, undertook the reunification of Cambodia.

The Angkor Period

Perhaps because he considered the old capital Isanapura to be inadequate, Jayavarman II established another city that he called Hariharalaya (present-day Roluos). He then settled in another pre-Angor site, on Mount Mahendraparvata (today Phnom Kulen), where he was crowned King Jayavarman II. He obtained freedom from Java through ceremonies of appeasement and conciliation. His reign of forty-eight years heralded the Angkor period, a new era during which several monarchs engaged in reuniting the country.

In 850 Jayavarman III, his son, came to power and reigned for twenty-seven years at Hariharalaya. Indravarman I, inheriting the throne in 877, built the brick temple of Preah Ko and the temple-mountain of Bakong, where he erected the royal *linga*, the phallic emblem of Shiva. To the north of this site he created a *baray*, the Indratataka, to provide water during the dry season.

The son of Indravarman I, Yasovarman I, took power in 889 and remained a few years at Hariharalaya. In the middle of Indratataka, he built the four brick towers of the temple of Lolei, which was dedicated to the memory of his parents. After this display of filial piety, he decided to build his own capital, Yasodharapura, not far from Hariharalaya, on the site of the present-day Angkor. He erected a temple on the top of Bakheng hill, around which he built his new capital, creating a four-sided moat, possibly for defense purposes. As his father had done at Hariharalaya, he created a vast *baray* 2 km wide and 7 km long (the East Baray) to the east of his city. The waters of the river coming down from Phnom Kulen gathered in the enormous reservoir, replenishing the city; Yasovarman I also built several monasteries south of the reservoir.

Following double page: ladies of the court gossiping, bas-relief, southwest corner pavilion, Angkor Wat.

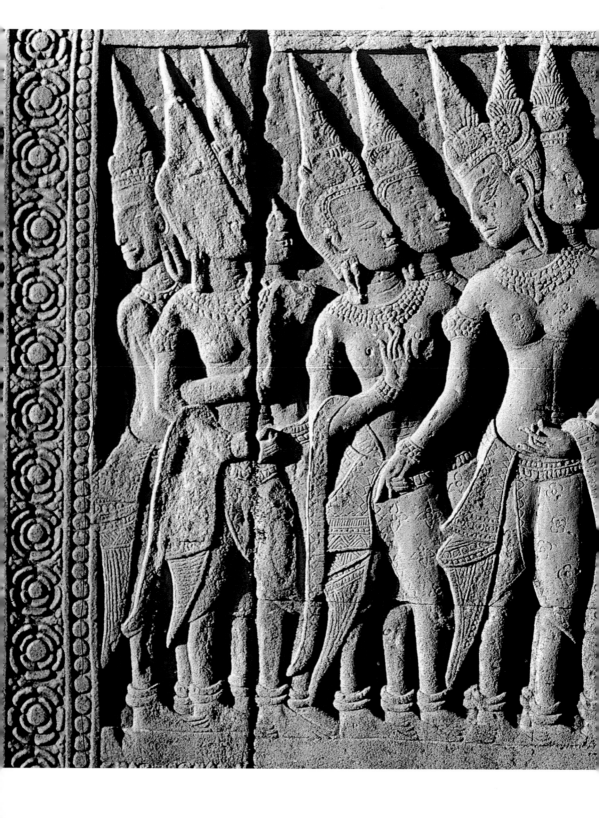

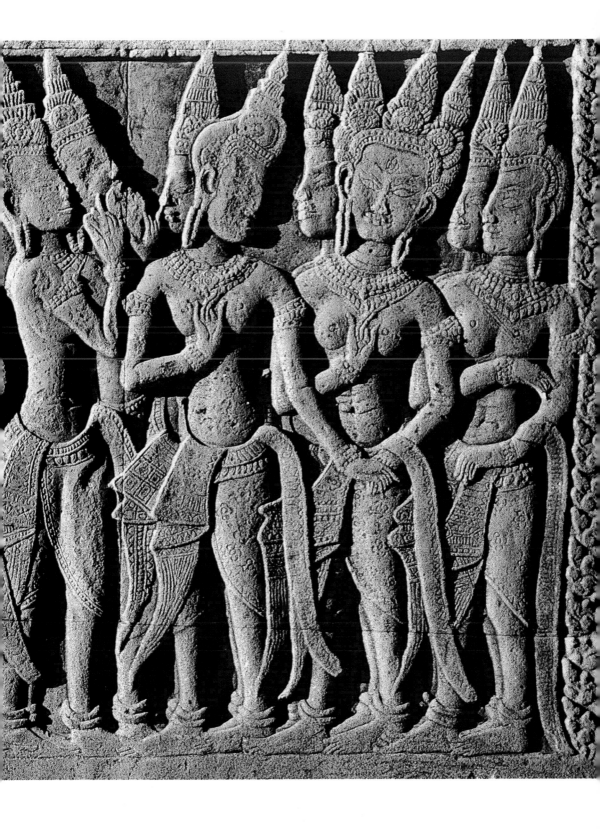

Yasovarman I only reigned for approximately twenty years, but exerted such a deep influence that no other king who came after him dared to modify the symbolical structure of his capital, Angkor. We have little information about his two sons, Harshavarman I and Isanavarman II, who assumed power successively from 910 to 928.

In 921, an uncle of the royal princes took power, perhaps as a regent until they came of age. He founded a new capital far removed, to the northeast of Angkor at Chok Gargyar (present-day Koh Ker), and was crowned king as Jayavarman IV. He undertook important constructions like the Prang, a great pyramid rising 35 m and forming the base of the royal *linga*, and he had a great reservoir, called the Rahal, dug out of the rocks.

Jayavarman IV died at Koh Ker around 940, leaving power to his son Harshavarman II, who reigned only for a short time and was succeeded in 944 by Rajendravarman, a relative of Jayavarman IV. Rajendravarman moved the capital back to Yasodharapura, thereby reverting to the tradition established fifty years earlier by Yasovarman I.

One of the first accomplishments of Rajendravarman II on arriving at Angkor in 952 was to build the five brick towers of Mebon in the middle of the East Baray to honor his ancestors. To the south of this *baray* he built the temple-mountain of Pre Rup, his state temple, which he dedicated to the royal *linga*. The country was administered by the king and assisted by persons of high rank who also wished to display their piety. One of the king's nobles had the lake Srah Srang built; another one built the pink sandstone temple Banteay Srei in 967, a marvel of decorative art and certainly one of the most beautiful archeological sites of Angkor.

Rajendravarman II died in 968; his son, still a young boy at the time, followed him under the name of Jayavarman V. The dignitary responsible for the Banteay Srei temple, Yajnavaraha who was also the king's guru, became regent while Jayavarman was an adolescent.

Jayavarman V, after having lived at Yasodharapura, founded his own capital outside the city limits. The pyramid of Ta Keo may have indicated the center of the new city. The construction of the temple started at the end of the 10th century but it was interrupted by the death of the king in 1001; it would remain unfinished.

His nephew Udayaditiavarman I came to the throne, but ruled for only a year; his death in 1002 was the beginning of a ten-year battle for succession that was to cease only with the establishment of a new dynasty. Udayaditiavarman's accession to the throne was contested during his lifetime by two pretenders. Little is known about the first, Jayaviravarman, other than that he resided at Angkor from 1003 to 1006 and attempted to rally the courtiers of the dead king to his cause. The second, Prince Suryavarman, was rumored to be of Malaysian extraction and was a descendant of King Indravarman I. As he lived at a distance from the capital Angkor, he concentrated his efforts on the kingdom's provinces.

Between 1006 and 1010, for reasons that remain unclear, Jayaviravarman disappeared from the Cambodian scene. Suryavarman I was thus free to settle at Yasodharapura, where he assumed the crown as Suryavarman I. He secured the allegiance of the important people of his kingdom, some of whom had served his enemy. In the course of his lengthy fifty-year reign, he pacified the kingdom that was torn by internecine struggles and spread Khmer civilization up to the Menam basin and Thailand.

The tower of the central shrine and the southern tower, Banteay Srei.

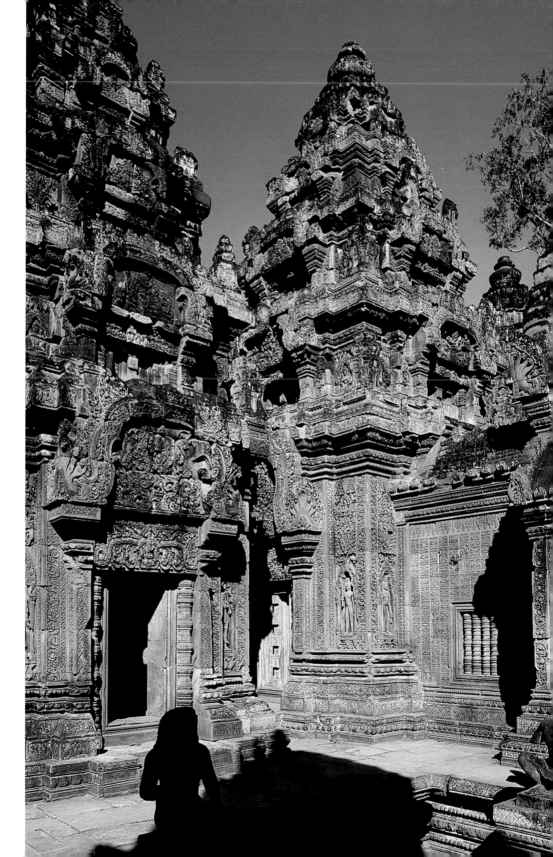

While Suryavarman I did not undertake great works at Angkor itself, he built the great temple of Preah Vihear 140 km northeast of Yasodharapura. Perched on the edge of a cliff of the Dangrek mountain chain, at an altitude of over 400 m, this temple dominates the Cambodian plain. This king was also responsible for the great remote site of Preah Khan in Kompong Svay east of Angkor and the temple erected on Phnom Chisor south of Phnom Penh. It is possible that Suryavarman I also initiated the construction of the West Baray situated west of Angkor. Even grander than the East Baray, it measures 2.2 km in width and 8 km in length.

Suryavarman I, one of the great kings in Cambodian history, died in 1049 leaving his throne to his young nephew, Udayadiavarman II. He ruled for only sixteen years over a land fraught with revolts that left considerable destruction in their wake. Despite this disruption, he built the beautiful and majestic pyramid of Baphuon, the "Golden Mountain" of inscriptions that would awe the Chinese diplomat Zhou Daguan two hundred years later during his stay at the court of Angkor. It would seem that Udayadiavarman II completed the construction of the West Baray, which was nearly identical to the East Baray except that it was 1 km longer; however, the West Mebon at the center of the West Baray differed from its partner to the east.

At Udayadiavarman II's death in 1066, his brother Harshavarman III came to the throne and launched a campaign to restore all the ruins of the preceding reign. However, he had to repel two attacks from the Champa armies during his reign. The dynasty of Suryavarman I ended with his death in 1080.

At the end of the 11th century, the land of the Khmers was once more divided. The appearance of a new king, Jayavarman VI, who seems not to have issued from a previous royal bloodline, was an odd historical phenomenon and one that must have created turmoil and fighting when he assumed the reins of power. Jayavarman IV ruled

for twenty-seven years but left no significant traces. At his death in 1107, his elder brother seized power but soon was deposed by one of his adolescent nephews who, despite his young age, showed great cunning and ambition and was able to crown himself king as Suryavarman II

An ambitious and aggressive ruler, the new king spent many years waging war on his neighbors and consequently extended his empire to Champa beyond the Annamese Cordillera up to the borders of the kingdom of Burma. He renewed diplomatic ties with China, which granted him recognition as the "Great Overlord of

Below: King Suryavarman II during an audience, southeast section of the third gallery, Angkor Wat.

Facing page: a devout Buddhist, Jayavarman VII would often say that the "plight of the people is the plight of the king."

the Song Empire." The Khmer civilization flourished during his forty-year reign. He established many religious foundations throughout the country and he was also responsible for the start of the Thommanon and Chau Say Tevoda temples at Angkor, as well as the Beng Meala temple in the east, at the foot of the Kulen mountain range. However, his crowning achievement and masterpiece remains Angkor Wat, his temple and tomb, the most prestigious of all Khmer edifices. A magnificent architectural composition, Angkor Wat sends its five "stone arrows" soaring to the sky as if it wishes the viewer to become aware that he is in the everlasting presence of a great king.

The death of Suryavarman II around 1150 triggered a period of turmoil in the country as a legitimate ruler was sought. The kingdom finally fell into the hands of Yasovarman II, whose origins and accomplishments during the fifteen years of his reign remain unclear. We know that after his return from a campaign in Thailand, he fell victim to a seditious courtier, who was anointed King Tribhuvanadityavarman; he held power for a

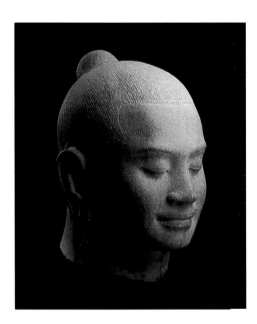

dozen years but bequeathed no definite architectural trace or activity to posterity.

Northeast of the Khmer kingdom, between the China Sea and the Annamese Cordillera, was Champa, the kingdom of the Chams. Like Funan, Champa was strongly influenced by India, but this did nothing to alter the state of latent war that persisted between the neighboring kingdoms, characterized by periodical border skirmishes.

Irked at the continual Khmer incursions into his territory, King Cham Jayaviravarman IV led a punitive military campaign against Angkor in 1177. He was accompanied in this undertaking by several liege Cambodian princes who opposed the usurper Tribhuvanadityavarman and by another Khmer prince, the future King Jayavaraman VII, pretender to the Khmer throne. The strategy was to send two armies marching on Angkor; the first mounted on chariots tried unsuccessfully to cross the Annamese Cordillera; the second, sailing up the Mekong River and the Great Lake, arrived at Angkor. Surprised by the attack, the city offered little resistance as it had no real defense system. In the course of these battles, King Tribhuvanadityavarman was killed and the city was taken by the Chams, who pillaged it but did not destroy it. They settled in the city for four years midst the hostility of the Khmers, who never forgave them their plundering or their occupation.

A few years before this event, Jayavarman VII, an aged ruler and descendant of the most ancient dynasties of Cambodia, came onto the scene. For reasons that are unclear, he had spent his youth in Champa, where he was residing when he learned of the overthrow of Yasovarman II. Since he had inherited from his mother the rights to the vacant throne, he hurried back to Cambodia but arrived to find the usurper Tribhuvanadityavarman at the head of the empire, leaving him to retreat to his dominions to await a more favorable opportunity to recover his throne. The occasion presented itself with the invasion of Angkor and the death of the

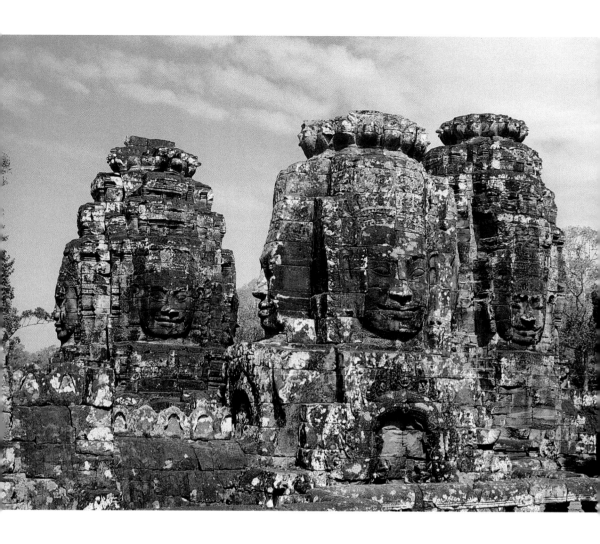

Sentinel-like face towers at the Bayon.

usurper. He seized it and for the next four years deployed his energies in repulsing the Chams and dominating the other Khmer pretenders. He was successful in both endeavors and acceded to the throne in 1181, taking the name of Jayavarman VII.

In 1190, he had an opportunity to take revenge when he invaded Champa territory, seized the capital and annexed the country, which remained a Khmer province until 1220. The new king, Jayavarman VII, ruled over a vast empire, possibly the biggest in the history of Cambodia, extending from the China Sea to the Gulf of Bengal to the west.

The king had a new capital built, Angkor Thom, and secured it against attack. In the center of the city, he erected the great temple of Bayon. With its towers decorated with faces, this is perhaps the most amazing of all Khmer structures. Throughout his reign, which lasted for approximately forty years, the king was driven by a passion for building. Inscriptions emphasize the fervent Buddhism of the monarch, who adapted the cult of the god-king to the Mahayana Buddhist sect to which he belonged. In spite of this fact, the Brahmanic elite that revolved around the seat of power continued to act as a network of court advisers.

Jayavarman may have still been king in 1218; the date of his death cannot be precisely determined. His successor, Indravarman II, remains a mystery except for the probable date of his death in 1243. He was replaced by Jayavarman VIII, who had to confront the first onslaught of the Thais in 1285. Also, a Mongol horde coming from Champa attempted to invade Khmer territory. Although the attempt was apparently unsuccessful, Jayavarman VIII cautiously chose to pay tribute to the great Mongol khan, Kubilay.

Certain Khmer kings in the course of their reigns, notably Suryavarman II and Jayavarman VII, embarked on a program of territorial conquest that resulted in large empires that were hard to control. In the 13th century, Cambodia began to suffer the consequences of this situation, compounded by the growing fatigue of the people obliged to carry out harsh tasks, notably the construction of the temples in conditions tantamount to slavery.

During this period, throughout Southeast Asia in general and Indochina in particular, there was a shift away from the imported Indian civilization. This civilization, which had been adopted by an increasing number of Khmers during the preceding centuries, was gradually modified by the indigenous culture, to such an extent that the local elite, who had been heavily impregnated with Indian culture, began to disappear. This cultural weakening of Southeast Asia was exacerbated by the appearance of a new form of Buddhism, mainly in Cambodia. Until that time, the country had been under the sway of Mahayana Buddhism (Great Vehicle) in the form of the cult of the *devaraja* (god-king), which existed alongside a powerful current of Hinduism. Both religions, however, remained out of the intellectual reach of the common people. In the 13th century, Hinayana (Lesser Vehicle) Buddhism from Sri Lanka began to acquire a following among the leaders of society. Simple in its expression and practice, it was subsequently adopted by the people. The teaching and practice of the *arhat*, which encouraged the renunciation of all desires, was not the best way to boost nationalistic fervor in the face of the ever-growing threats faced by the kingdom. During the same period, an anti-Buddhist reaction from the believers in Brahmanism led to the mutilation of most of the artworks in the temples erected by this king.

In 1295, Jayavarman VIII, under pressure from his son-in-law, abdicated in his favor. The son-in-law took the name of Srindravarman and was deposed in 1307. Other sovereigns subsequently ruled the empire, but we know nothing about them, as there are no records of their actions and exploits.

The Abandonment of Angkor and Its Discovery by the West

The *Royal Chronicles*, written anonymously in the 19th century in Cambodia, are practically the only elements we have for studying the history of the country after the 14th century. As the American researcher Michael Vickery has observed, the *Royal Chronicles* contain legends presented as historical fact, so should be read with great caution. These documents report that Angkor was conquered in 1431 and occupied by the Thai army, which forced the Khmer kings to abandon it and take refuge in what is now Phnom Penh. However, according to a 16th-century inscription, we know

that the Khmer throne was returned to Angkor and that the royalty actually lived there. At that time, Angkor Wat enjoyed prestige even beyond the borders of Cambodia and was also a place of pilgrimage. In any event, the temple remained of major importance for all the Khmer people.

The first European visitors to the Khmer ruins were the Spanish and Portuguese in the 16th century. In the 19th century, Angkor was "rediscovered" by French missionaries promoting Christianity in Thailand. Over the following years, Cambodia and the Angkor region in particular were explored by the French and, at the start of the 20th century, archeologists began taking an interest in the ruins. Working in a hostile natural environment, they first strove to save the overgrown temples and then courageously attempted over the years to penetrate the secrets of the forgotten Khmer civilization.

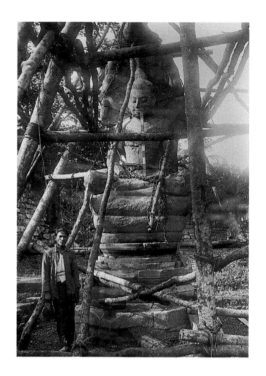

The Conservation d'Angkor and the Ecole Française d'Extrême-Orient

By the end of 1860, France was already a political presence in the south of Indochina. In 1863, the Khmer king Norodom recognized his land as a French protectorate. Although Angkor may have been almost completely unknown in the West, it enjoyed great prestige in the Far East.

An officer of the French navy, who represented France at the Cambodian court and who had participated in several expeditions mostly in the Angkor region, gathered notes for what would become the first archeological manual about Cambodia. These observations aroused such interest that in 1891 an archeological mission was organized in Indochina. In 1901, this became the Ecole Française d'Extrême-Orient.

The Franco-Siamese treaty of 1907, thanks to which several provinces were returned to Cambodia, notably Siem Reap, the site of the Angkor temples, paved the way for the creation of the Conservation des Monuments, which worked

with local craftsmen and laborers to clear the forests and rebuild the temples.

It would be impossible to cite the names of all the scientists, researchers and experts who, despite limited means and hardship, contributed in their own separate ways to our knowledge of Khmer art and civilization. Work on the site is a gigantic undertaking demanding skill, intelligence, astuteness, patience and abnegation from all the members of the EFEO, some of whom gave their lives to the cause. The tragic events that began unfolding in Cambodia in 1970 interrupted the EFEO's work. In the 1980s, France was no longer in sole charge of the restoration of the monuments and now Cambodia bears responsibility for their conservation. However, as the site has been placed by UNESCO on the World Heritage list, Angkor receives contributions from other nations, such as India, Indonesia, the U.S. and Japan. In the future, other countries may join this group of benefactors of Cambodia and Khmer culture.

Anastylosis

For more than thirty years, work carried out by the Conservation d'Angkor (the Angkor Conservation Office) involved for the most part preservation: bush-clearing, the reinforcing of walls, colonettes and lintels, the consolidation of ruined temples that were in danger of collapsing.

Given the scale of the task, certain priorities had to be established. The most urgent cases received immediate attention. Due to a lack of resources

Facing page, top: the great statue of Buddha discovered in the central well of the Bayon by Georges Trouvé in 1933.

Facing page, bottom: curator Henri Marchal in front of Banteay Srei, the temple that he reconstructed in 1931.

Following double page: tree roots "strangling" a gallery at Ta Prohm.

and knowledge, only limited efforts could be made to consolidate the most unstable elements.

In 1929, the Director of the Archeological Services of the Dutch Indies on a visit to Angkor expressed his astonishment at the methods being used. Although effective in preserving the constructions at least temporarily, they did nothing to solve the true problems of restoring the monuments.

For several years, teams of Dutch archeologists working in Java, then a colony, had successfully adopted an extremely simple method of restoring the monuments. Called anastylosis, the method entailed placing on the ground and arranging according to order all the different elements and noting their exact position in the monument. Then new foundations were built and the pieces were put back into position, like a jigsaw puzzle, using a system of hooks where necessary. Missing blocks were replaced with others, appropriately marked so that there would be no confusion.

Henri Marchal, the curator of Angkor at that time, went to Java to study the method developed by his Dutch colleagues. When he returned, he initiated the successful restoration of the small temple of Banteay Srei, using the new method. Over the following years, other monuments, notably Neak Pean, Banteay Samre, Bakong, three doors of Angkor Thom, the central part of Bayon and several shrines of Preah Khan were saved from ruin.

Thanks to the acquisition of a vast quantity of construction material left behind by the French army following its withdrawal from Indochina in 1954, it was possible to use the technique more extensively. Furthermore, the method inspired the invention of new procedures, including the main technique employed in the restoration of colonettes and broken lintels. As well as being easy to carry out, the new technique perfectly respected the spirit in which the monument was constructed and its basic materials. In 1960, the technique was unfortunately abandoned.

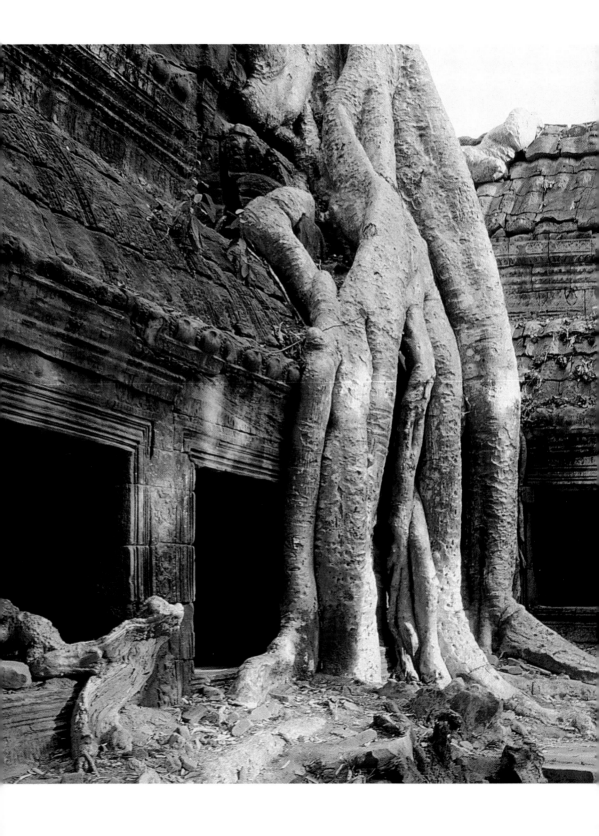

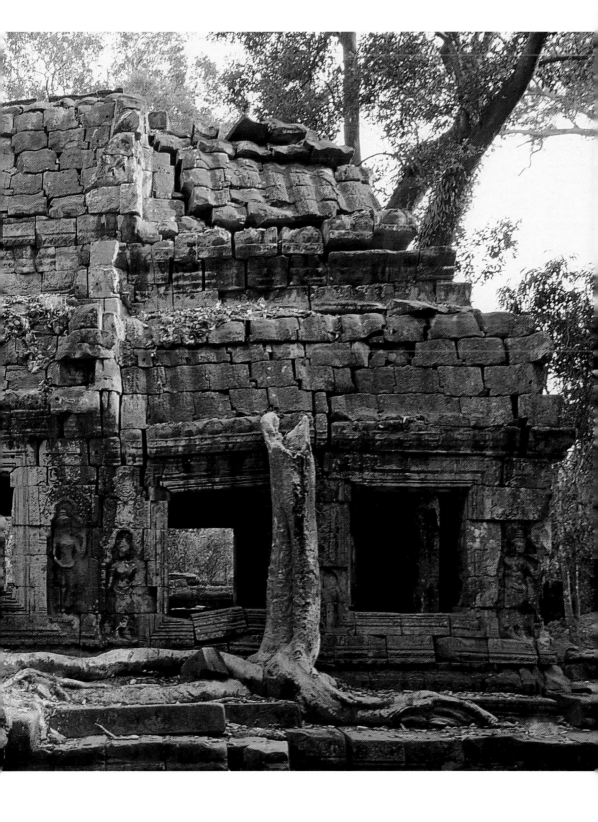

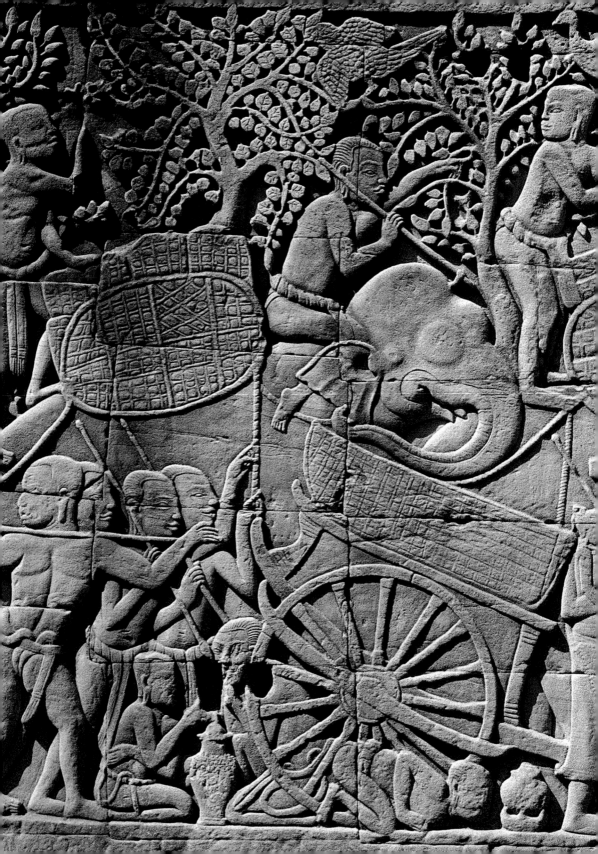

The People
of Cambodia

The land of the Khmers has been populated since the dawn of humanity. The Khmer language belongs to the Mon-Khmer language family; Mon, a close cousin to Khmer, was spoken in Lower Burma (now Myanmar) and in the mountain territory of Upper Laos. Khmer was once used over a much larger territory than present-day Cambodia. It was spoken throughout the Mekong delta, in Thailand, on the Korat plateau and in part of Menam.

Religion and Ritual

The Khmers have always been pious, frequently incorporating superstition into their beliefs. The first religious practice in Indochina was nature worship. The ancient Khmers attributed souls to animals, plants and objects, creating diverse cults of genies whose duties were to guard over their lives and those of their clans. A few vestiges of this animism persist in the countryside today, notably in the form of the *neak ta* (literally, "ancestor

person"), an earth genie. The role of the *neak ta* is to watch over the upkeep and prosperity of the territory that it is assigned to protect. Modern Cambodians revere and summon the *neak ta* in the form of a simple stone, a tree root or a part of an ancient statue generally placed in a small raised wooden hut, although the *neak ta* may also be lodged in a tree hollow.

The first Cambodian religions derived from India. Vedism was the earliest religion in India. It gradually evolved into Brahmanism, which was succeeded by classical Hinduism. The Vedic corpus of texts was contained in four collections called *Vedas*, sacred books dedicated to the gods, who were worshiped and invoked for their benevolence. They were the gods of the earth, the intermediate space or the sky, and could be friendly or dangerous, or, in a few cases, both at the same time. Vedism was primarily a religion of sacrifice, with offerings made to the gods during the fire ceremony. The highest-ranking Vedic god was Indra, whose feats of valor are widely reported in the texts. Then came Shiva, the strangest one; creator of the "primeval waters," he was also, thanks to the *linga*, or phallus, the pro-creator. He represented both the preserver and the destroyer, and was identified with death and the passage of time. Other divinities were Agni, the fire

Stopping by the side of the road, bas-relief,

east side of the third gallery, Bayon.

god, Varuna, who reigned over the sky and the balance of the earth, and Soma, the deity who guarded the liquor of immortality.

The Hindu religion is a patchwork of different elements, a mixture of Vedic and Brahmanic gods that inspired new divinities. Three gods, the Trimurti, theoretically of equal importance, coexist at the head of this pantheon. Brahma, the creative element, is represented with four faces; he is often mounted on a swan or sacred goose, the *hamsa*. Vishnu, the four-armed protector of the world, floats over the primeval ocean shielded by the hoods of the serpent *naga*; he is represented as meditating at the start of a new cosmic period. He rides the shoulders of the mythical bird Garuda. Whenever the world is in danger, Vishnu descends to fight evil, assuming different avatars (incarnations). Shiva is at different times the destroyer and the benefactor; he grants favors to those who worship him in the form of the *linga*, the powerful and creative phallus of the god. Sometimes he possesses five superposed heads and ten arms, and he performs a dance for the cosmic powers. He is usually mounted on the white bull Nandi.

Hindus believe that a creative energy streams from a god and that this energy assumes a feminine form called *shakti*. Vishnu transfers his force to his *shakti*, Laksmi, the goddess of beauty and fortune. Shiva transmits his force to Parvati, who becomes, depending on circumstances, Uma, the intellectual and transcendental enlightenment, the black Kali, who dances on a corpse, or the violent Candi. She is often also known as Durga, the ferocious female warrior who combats demons and giants. The universe also swarms with numerous fantastic beings. Hindu gods are powerful creatures, but like humans they are subject to the transmigration of souls (*samsara*).

Hinduism was the source for several religions that became dominant forms of worship at Angkor. The earliest of these was Shivaism, which held sway in the 9th and 10th centuries. It was supplanted in the 11th century by Vishnuism. The *devaraja* (meaning "the king of the gods" in Sanskrit) was another cult that developed during the Angkor period.

Angkor was a temple to Vishnu (as well as being a tomb for Suryavarman II) and its layout was determined by the Hindu cosmological system. During the period of construction, however, Buddhism had been growing in ascendancy in Indochina and several later Khmer rulers were won over by it. Buddhism began in India as a reform movement in reaction to Vedism and Hinduism. Buddhism, unlike Hinduism, centered on a historical figure, Siddhartha Gautama, who was born in Kapilavastu in northern India, in the middle of the 6th century B.C. Several important events in the historical life of the Buddha, from childhood through his enlightenment, provided themes for artists and are depicted in bas-reliefs at Angkor. By the early centuries of the Christian era, two major schools of Buddhism had emerged: Mahayana (Great Vehicle) and Hinayana (Lesser Vehicle). They both spread to Cambodia, but at different times. It is the former that is of most relevance to the art and architecture of Angkor, as Hinayana Buddhism was not introduced until the 13th century, by which time all the major monuments had been built. The principal religious ideal of Mahayana Buddhism is a *bodhisattva* (enlightened being), one who has entered nirvana, but renounces attainment of enlightenment to return to earth and help relieve the sufferings of humanity. *Bodhisattva* images appear extensively in Khmer art, especially during the late Angkor period. The one most frequently represented in reliefs is the Avalokiteshvara.

Indra riding his three-headed elephant, detail of the east pediment, *mandapa*, Banteay Srei.

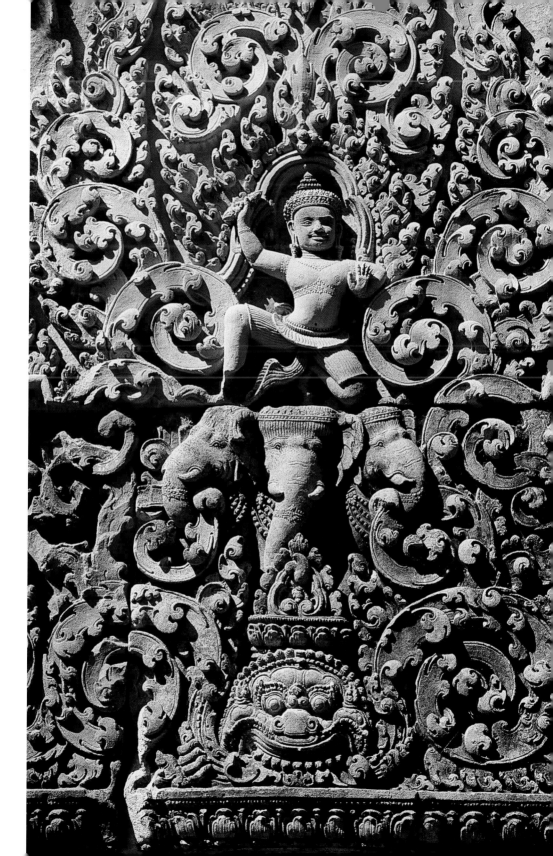

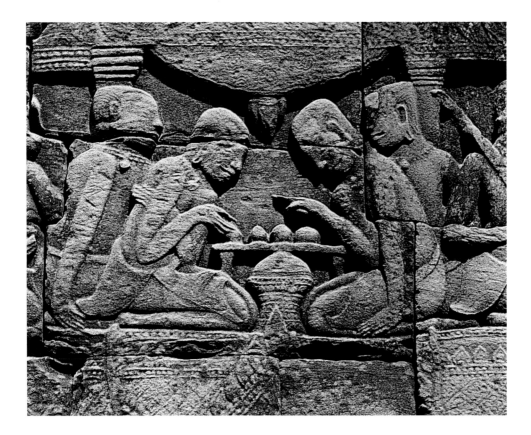

Houses

As certain bas-reliefs reveal, the homes of Khmer peasants at the time when Angkor was built were not very different from those of today. Houses traditionally face east and for the most part stand apart from each other, surrounded by orchards. They consist of wooden structures supported on stilts. Walls consist of panels of braided coconut tree leaves. The frame is covered on two or three sides by strips of bound thatch. Beneath the living quarters there is a small area that doubles as a tool shed and a night shelter for cattle and fowl. A crude ladder, always with an odd number of rungs to ward off evil spirits, gives access to the upper story. It is removed at night to insure safety. The bamboo floor is not very robust and can only support lightweight furniture. There are no tables, chairs, or beds—only

Game of checkers, bas-relief, south façade of the third gallery, Bayon.

Following double page: family walking behind a cart, bas-relief, east façade, third gallery, Bayon.

mats. Clothing and precious items are stowed in a chest. The upper story contains only one room that is sometimes partitioned by means of a lightweight screen or curtain; the doors and windows are covered by moveable panels made of palm leaves. There is no kitchen; meals are prepared outside or under the house on a simple stove.

The roofs of the houses of wealthy people are tiled and the walls are clad with wooden boards. A pediment of carved wood sometimes crowns the front veranda.

Living Conditions at the Royal Court

The king lived in a palace built of wood
and light materials; but, as a god, he resided
in a temple of stone.
GEORGE CŒDÈS,
Pour mieux comprendre Angkor, 1951.

Both the houses of the common people and the estates of the princes have disappeared at Angkor. Even the wooden structures of the Royal Palace have since long succumbed to the rigors of the tropical climate. Nevertheless, we can get an idea of what the royal palace was like from the inscriptions in the temples and from the bas-reliefs of such monuments as Bayon. The sculptures depict pavilions that could very well have been sited within the walls of the Royal Palace. There is also a report written at the end of the 13th century by Zhou Daguan, a member of the Chinese embassy delegation who noted down what he heard and saw in the land of the Khmers. He found Angkor a flourishing city despite the major difficulties besetting the kingdom; he explains: "The palace, the official residences and the estates of the nobles are all oriented eastward . . . the houses of the princes and the important officials have different structures and dimensions from those of the commoners. The common areas and the outbuildings are covered by thatch; only the family's temple

and private quarters may be covered by tiles. Each person's station in life determines the dimensions of his abode."

Although the Chinese envoy was evidently denied access to the private lodging of the king ("I have heard tell of many wondrous places within the Palace but they are thickly guarded and it is impossible to gain entry"), he received accounts of the descriptions of marvelous buildings, spacious verandas and winding covered passages. Judging by the few representations that we have, the palace consisted of a long structure one or two stories in height with porches. The roof was supported by a series of sturdy columns. It had upswept eaves and was covered with round, varnished, colored tiles. The main bays were surmounted by a decorated pediment. Drapes were hung between the veranda columns to keep the air inside cool; they were raised in the evening when temperatures had dropped. These royal residences also included private apartments surrounded by plantations and several public buildings.

Daily Life in the Angkor Period

As Zhou Daguan noted, Khmer society was sharply divided along class lines. There was a gulf between the royal family, the clergy, and the leaders of society and the commoners, who were important but subordinate and "liable to be taxed and worked till death." The slave class represented the bottom rung of the social ladder and was scorned and cursed with names like "dog," "foul-smelling" and "hateful."

Daily Life in the Countryside

Most people lived off the land, working in the fields. Their lives were regulated by the different agricultural tasks and by the events of village and family life.

The men tilled the earth by means of plow and harrow and irrigated the rice fields and gardens. They ventured into the forest to hunt and gather

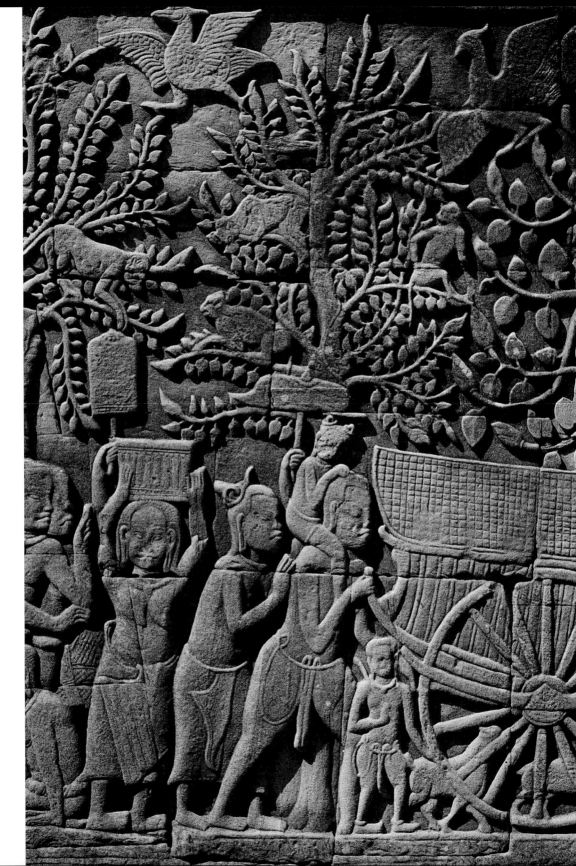

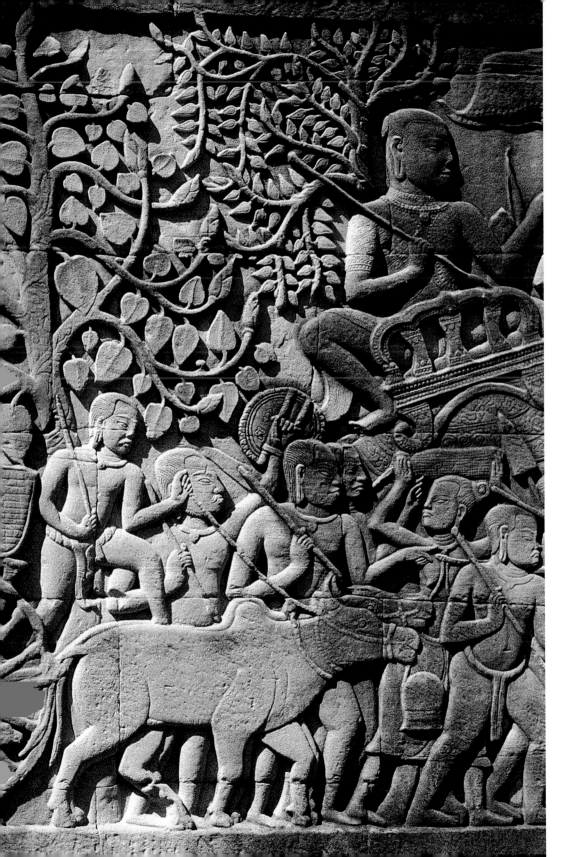

Excerpts from *The Customs of Cambodia* by Zhou Daguan

The young mother who has just given birth cooks some rice, rolls it in salt and applies it to her genitals. After one night and one day, she removes it. This insures that her pregnancy will have no harmful consequences and that she will keep her youthful appearance . . . In the family where I was staying, a young woman had delivered a child and I was able to witness what happened. The next day, she gathered the baby in her arms and went to the river to wash. It was really extraordinary.

They have no coffins to place their dead, only a type of mat. They cover the deceased with a sheet. The funeral processions include flags, banners, and musical instruments. As the procession passes, the mourners sow two "pans" of grilled rice. Once outside the city, they find some remote and uninhabited area; they abandon the body there. They wait for the vultures and the wild dogs to come and devour it. If the whole process is quickly accomplished, they say that the deceased relative was deserving of this favor. If the animals do not come to eat the corpse or consume it only partially, the people say that the dead family member had committed some fault. At the present time, there are people, of Chinese origin, who are starting to cremate the dead. At the death of the parents, the children do not go into mourning but the sons shave their heads and the daughters cut their hair right up to their foreheads so whatever remains is about the size of a sapeque. That is their way of showing filial piety. The king is buried in a tower but I do not know whether his body is buried or only his bones.

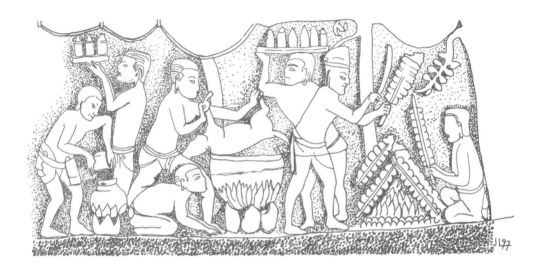

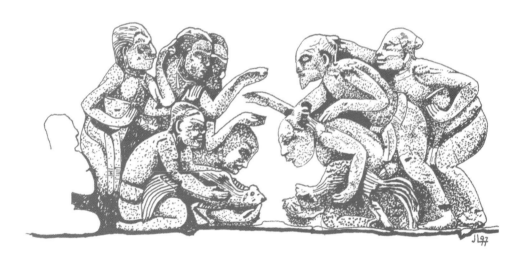

Facing page: birth scene, bas-relief, south side of the third gallery, Bayon.

Top: preparation of a feast, bas-relief, south side of the third gallery, Bayon.

Bottom: cockfight, bas-relief, south side of the third gallery, Bayon.

wild berries. They fished with lines, nets and bow-nets and raised farm animals. The women worked in the house, pounded the rice they had helped plant, prepared the meals, wove garments, and raised the children.

The young, freely raised, often enjoyed a relaxed code of conduct. The parents of a marriageable young woman would voice the following prayer: "May you be desirable to men! May a hundred and a thousand men ask for your hand in marriage!"

On the subject of marriage, Ma Touan Lin, a Chinese contemporary of Zhou Daguan who had also spent time in Cambodia, relates, "The hopeful suitor first sends presents to the young woman of his desires; then the girl's family chooses a favorable day to deliver her under the protection of a marriage-broker to her husband's house. After the wedding ceremony, the husband receives a portion of her parents' wealth and departs to live in his own house." Nevertheless, many men married the girls they had taken earlier as mistresses, a practice that meant neither disapproval nor dishonor for the couple.

The children were born soon after the marriage and Zhou Daguan records his amazement at how short the "lying in" period was for the mother.

Daily life revolved around the family. Meals involved sitting on mats and eating from dishes of baked clay. Forks and chopsticks being unknown, people ate with their fingers, using their right hand in keeping with the Hindu tradition, according to which the left hand is impure. Directly after the meal, "They jiggle their toothpicks made of poplar wood and recite prayers." The Chinese envoy was bewildered and concerned at how frequently people washed before meals. "People are often ill because of their excessively frequent baths and the ceaseless washing of their heads." Yet, aside from those illnesses imputed to extreme cleanliness, other very real diseases existed. Leprosy, dysentery and cholera took a heavy toll upon the population.

The markets offered numerous remedies said to kill all sorts of pains, but they often proved ineffective when applied, even after the intervention of the healer, and the outcome was death.

At the market, roots, leaves, powders, and medicinal potions were strewn about on mats beside vegetables, fruits, meat and fish, fabrics, dishes, earthenware jars and other utensils. Some stalls served soups and fish or bananas grilled on skewers, while others offered jewels and charms to insure good fortune. Noises and shouts enveloped the entire marketplace, with men loudly placing bets at cock or pig fights, fortune tellers plying their trade and men, drunk on palm tree wine, exchanging the very scenes that appear on the bas–reliefs of Bayon.

Zhou Daguan, like all the Chinese chroniclers who visited Cambodia, reported with amazement the practices surrounding death, "When in mourning, the custom is to require the nearest of kin to shave their heads and beards." Funeral ceremonies took different forms. Sometimes the corpse would be devoured by dogs, wild beasts or birds of prey; sometimes it would be buried in a ditch, cremated on a funeral pyre or thrown into a river to drift with the current. Other types of ceremony included the presentation of offerings to the gods and many devotions around the temples. Certain agrarian festivities set the stage for grandiose commemorations, such as the celebration of the "storing of the rice paddy mounds" or "the burning of the paddies."[*] Particularly important occasions would be graced by the presence of the sovereign.

Daily Life at the Royal Court

The life of the king within his private chambers remains largely a mystery. Zhou Daguan tells us, "Whenever I entered the palace, I beheld the King emerge with his first wife and sit at the golden window belonging to the private apartments. The palace folk formed lines beneath the window on both sides of the veranda and took turns gazing." The sovereign, the royal family and the nobility

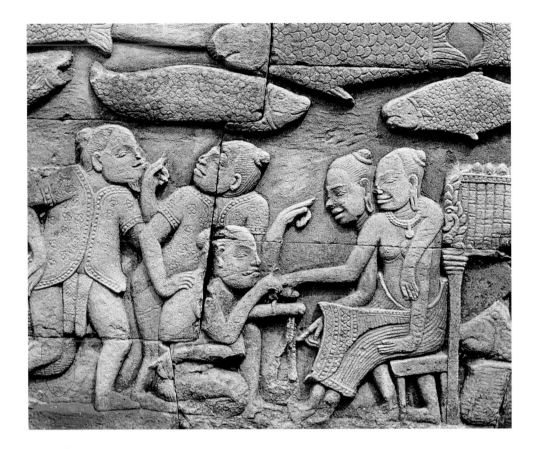

Fortune-telling scene, bas-relief,
south façade of the third gallery, Bayon.

Page 55: Laksmana beside the repentant demon Vibhisana,
Battle of Lanka (detail), north façade of the third gallery,
Angkor Wat.

probably played out their lives within the palace walls. Subjects who wished to approach their king to request a favor were permitted to appear at a daily audience held in the ornately decorated Council Chamber. On such occasions, he and his retainers would arrive in great pomp to the sound of conches, the signal for all to bow down.

Occasionally, the king would hold council on the Royal Terrace with his ministers. He would sit on a high throne behind numerous parasols, while his servants waved fans and fly swatters above his head. The sovereign would be lightly dressed in precious fabrics, with numerous jewels about his neck, arms and ankles; a gold diadem would encircle his head. He would dictate his orders to a scribe under the attentive gaze of his advisers

kneeling at his feet, their right hands placed on their hearts as a sign of admiration and respect.

For short journeys from his palace, the king traveled supine within a golden palanquin born by the women servants of the palace. All those who caught sight of it bowed down with their brows touching the earth. Whenever he emerged for the celebration of a solemn occasion, a lavish procession announced his coming. At its head was the cavalry, midst banners and flags, followed by a marching band in a flourish of flutes, trumpets, conches and drums. Crashes on a gong marked the tempo. The young ladies of the palace, variously attired, followed in great numbers. Then came carriages drawn by horses decked in gold followed by the princes and ministers surrounded by hosts of red parasols and mounted on elephants. Then the wives and the concubines of the king, in many different sorts of vehicles and finally, behind them, in a richly adorned *howdah** atop his elephant, the king himself, ringed by white and gold parasols, his officers beside him for his protection.

The Khmers, who were frequently at war with their neighbors, had a large and powerful army. The sovereign's private guard must have been an impressive sight. A Chinese historian living during the Sui dynasty reports: "More than a thousand guards clad in breastplates and armed with spears stand in formation at the steps of the throne, in the rooms of the palace, at the gates and at the peristyles." When he went off to war, the king was mounted on an elephant. He wore virtually the same clothes as his soldiers: a simple brief shirt and a loincloth. Judging by the images of the bas-reliefs, the battles were bloody.

We know little about the king's funeral, other than that his body received different treatment from that of other men. Was he cremated, perhaps on the Terrace of the Leper King? Or was he buried inside a temple?

Daily Life in the Temples and Monasteries

We have very limited information about life in the monasteries. Our knowledge is based principally on documents registering land gifts to the sanctuaries and others indicating the numbers of persons (several tens of thousand) living in the monasteries and their functions. We know that the officiating priests devoted themselves to worship, while the others attended to religious services; the performers of sacred dances and the musicians and singers, all women, wore ornaments to the ceremonies. A large staff of servants looked after the temple that was, in itself, a small city that included tailors, shepherds, plantation overseers and peasant-slaves who cultivated the rice fields. Texts engraved on certain stelae disclose the situation of the religious people, the discipline they had to observe, their instruction as well as the attitude they were compelled to adopt in their dealings with laymen. The temple was also a haven for the wretched and the ill.

The monastery during a restricted space of time, was open to worthy postulants, "Those solely intent on good conduct and study, freed from the duties of a master of a household and who are able to keep in check the demands of their senses."

The discipline that the monks observed was extremely harsh: they had to go to bed and get up early; they had only one meal a day; they adhered to a strict timetable for prayers and work; and they followed a strict dress code. While in the monastery, they were forbidden to have relations with women, even their wives.

Besides the rituals and religious practices, the monastery played a pedagogical role. It enabled students to acquire the fundamentals of reading, writing and grammar and also taught them the different philosophical doctrines pertaining to religious beliefs.

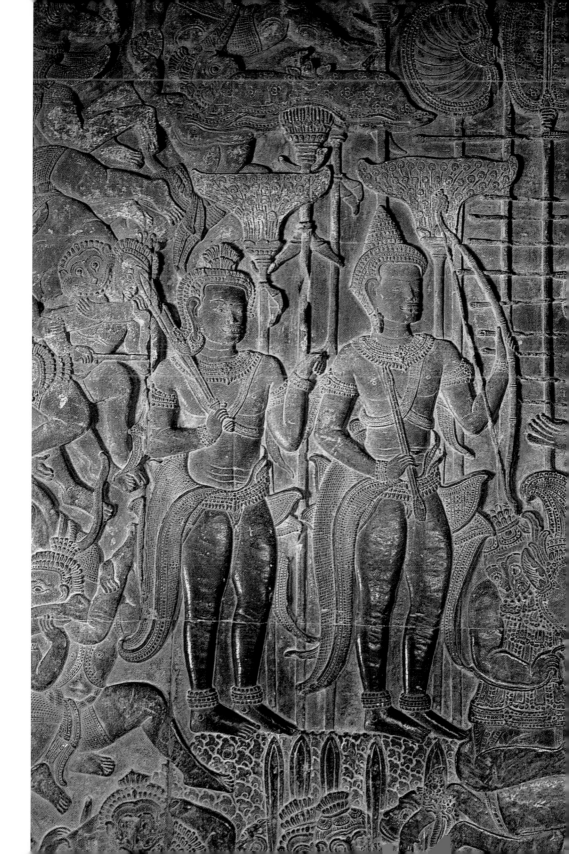

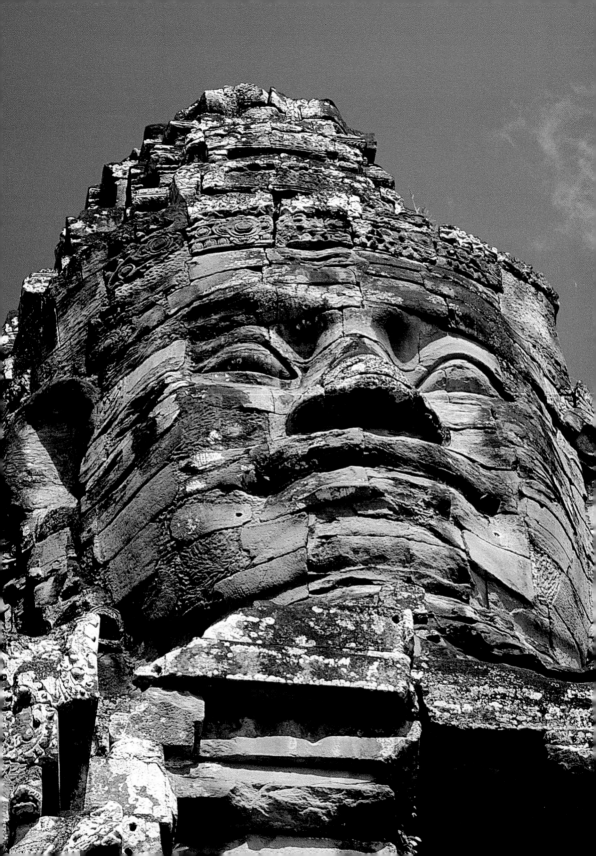

Khmer Monuments

General Considerations

The Khmers created original structures inspired by typically Hindu themes. In terms of execution, their skill lay more in decoration and sculpture than in masonry, which to them amounted to little more than the science of piling one rock on another, although some of their structures compare favorably with the great works of ancient China, Egypt and Mexico.

One of the most important aspects of Khmer monuments is their cosmological character. For the Khmers, the temple was a reflection of the universe as conceived in the Brahmanic-Hindu scheme of things.

The Khmers preferred to construct their temples on slopes or hills, but even those built on flat land functioned as hallowed areas where the human could communicate with the divine. As the highest member of the state, the king embodied all the spiritual and material forces of the land, and represented the sole link between his subjects and the gods. He was in effect God on earth.

The Khmers adopted two different types of structure for their sanctuaries. The first is the flat temple, which consists of a raised terrace supporting a series of towers for the most part dedicated to past sovereigns and the family of the ruling monarch. Preah Ko of the Roluos group is a perfect example of this type of construction. The second is the representation of the Hindu cosmos in the form of the temple-mountain, consisting of a truncated, stepped pyramid like those at Bakong or Angkor Wat. A key characteristic of the temple-mountain is its harmonious symmetry, as exemplified by Angkor Wat with its two cruciform axes centered on a single tower. The overall structure here is almost perfectly balanced in relation to its longitudinal axis.

Gazing into eternity: a face on one of the towers of the Bayon.

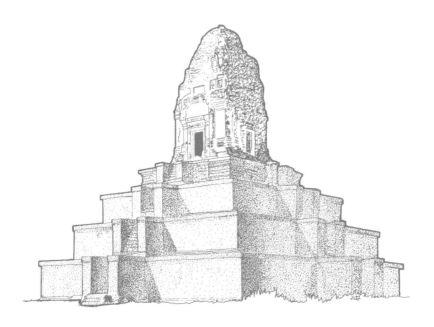

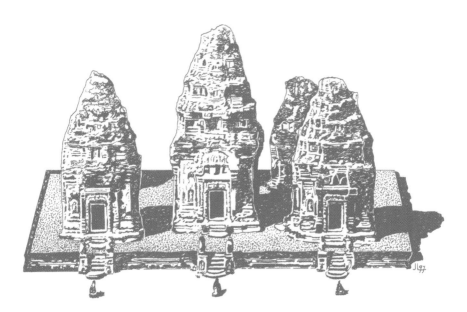

Top: the temple-mountain of Baksei Chamkrong. As in the tall religious structures of other civilizations, the aim of the Khmer temple was to get closer to heaven and the gods who dwelt there.

Bottom: the flat temple of Preah Ko. Unlike the mountain-temple, which was built for communicating with the gods, the flat temple was built to honor and deify humans: kings, princesses, ancestors of the reigning sovereign.

Indian Influence

Hindu religious ideas and architectural concepts inspired by the Brahmanic cults were introduced into Southeast Asia when India established contacts with that region. These cultural borrowings rapidly received different interpretations that, in the case of Khmer architecture, diverged radically from their Hindu sources.

Meaning

The flat temples with their high towers house representations of certain god figures created to glorify past kings and the deceased relations of the ruling sovereign. The images were placed there to supplicate the gods so that they would look favorably on the founder of the temple.

The meaning of the temple-mountain and its surroundings is slightly obscurer, the aim being to represent the cosmos as it appears in Hinduism. The mountaintop marks the center of both the universe and the royal city, and is the seat of the sovereign who, thanks to his exalted and sanctified status, can enter into contact with the supernatural situated in the upper reaches of the temple. The stepped pyramid was the privileged location for divine and earthly communication benefiting the king, his court, the kingdom and the people.

Symbolism

The Indian and Chinese civilizations, which had a major impact on the history of Southeast Asia, were influenced by ancient political and religious ideas from the Middle East, where sages envisaged a magical relationship between the micro- and macrocosms. In India, the notion of a universal cosmic order appeared with the dawn of civilization; the world was seen as a harmoniously arranged reflection of everything human and animal. The pattern of this world was the mirror image of the one the gods moved in, with its mountains and its plains, its seas and its rivers,

and its palaces and cities, which were inhabited by a population structured according to a strict hierarchy with an absolute sovereign at its head. This notion, which applied to individuals as well as to the entire social fabric, was intended to achieve balance. The kingdom, the city, the palace and the temple all replicated the higher edifice of the universe. This assimilation of the human and divine realms of existence enabled men to exert an influence on the gods. It was thus important to align earthly achievements with those of the cosmos.

Architecture, which is concerned with structure and volume, became a means to accomplish the divine cosmic objectives on earth. God or the gods have always been regarded as celestial beings and in order to approach the divine, to obtain the protection of the divinities and receive their favors, men have erected soaring monuments like the pyramids of Egypt, the ziggurats of Mesopotamia, the Temple of the Sky in China, the temple-mountains in Southeast Asia, the stepped pyramids in Central America and the cathedrals of Europe.

Many monumental creations in Southeast Asia, and particularly in Cambodia, are small-scale reproductions of the universe as conceived in Brahmanic Hinduism. In the middle of the central continent rises the cosmic mountain Mount Meru, surrounded by the stars and by six other continents arranged in concentric circles. This mountain is bordered by seven oceans, the seventh being confined by a barrier of rocks. Brahma, the creator, sits atop Mount Meru in the world of the gods, protected by the guardians at each cardinal and sub-cardinal point.

The Khmers conceived Mount Meru as a stepped pyramid symbolizing the dwelling, the celestial palace and the summit inhabited by the gods. The height of the pyramid is emphasized by it crowning towers placed in a quincunx pattern on the uppermost tier.

Surprisingly, although Mount Meru is derived from Indian religious ideas, no similar structure is to be found in India. With the temple-mountain, Khmer architects created a form that in symbolic terms corresponded exactly to Mount Meru, the axis of the universe.

Purpose

Art historians and experts in Khmer art have long debated the purpose of the temple-mountains. Were they solely places of worship or were they tombs as well? It has now been established that they served both purposes.

As temples, they were the main shrines that received the sovereign himself or the great priest acting vicariously for him. The king prayed to the god or the gods for favors for himself and his kingdom. Nevertheless, these shrines do not fit Western definitions of centers of prayer, because they were first and foremost the abodes of a god, one of the creators of the universe who, when addressed by the powerful forces of the kingdom, assured the essential prosperity of the realm and its leaders. Pleasing a particular divinity meant reciting prayers to his idol, serving him and maintaining his existence in his sculpted appearance, as if he were an authentic monarch. He was woken in the morning, given ablutions three times a day, carefully fed and, in the evening, ceremonially put to rest. During the day, the statue was entertained by musicians. He was the proprietor of his own estates, with his own rice fields that his serfs cultivated for his profit. The temple was the domain of the god, who would treat, kindly or harshly, those who maintained order.

The Khmer temples were also tombs containing the burial sites of deceased kings, who chose to identify themselves with a certain divinity. As we have very limited knowledge of the funeral rites of the ancient Khmers, we must refer to Zhou Daguan, as well as to those practices still observed in Thai and Cambodian royal courts.

All the funeral vats found in Cambodia, a dozen in all, were empty at the time of their discovery. They were relatively small, perhaps indicating that the body was placed soon after death inside an urn in the fetal position, symbolizing the possibility of a new birth.

The hole in the base of the vat was designed to gather the dead person's serums; the opening at the top of the lid evacuated the gases rising from the decomposing corpses and also served

as an aperture through which a cord passed, symbolically linking the deceased to the world of the living. When the corpse was completely dry, on the day determined by the astrologers as favorable for the cremation ceremony, it was burned and the ashes gathered and placed in an urn kept in the temple. The depositing of the mortal remains of the kingdom's leaders in the heart of the temple proves that the temple also functioned as a tomb.

The Bayon from the northeast.

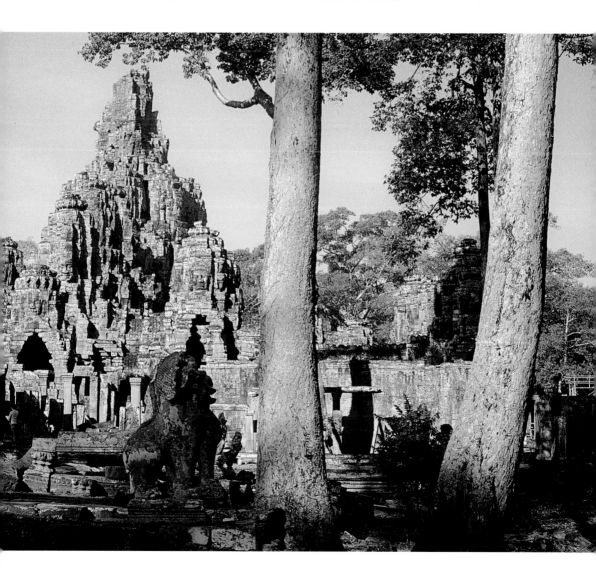

Orientation

In ancient Cambodia, astronomy was essentially of Hindu origin, as was astrology, an occult science that gave rise to other kinds of magical practices and was used to determine the orientation and location of temples.

The architect, who was most probably a priest selected for this special assignment, carefully examined the chosen area, studied the planetary conjunctions of the moment, and then proceeded to determine the exact position that the sacred area was to occupy. The main axis for the entire future temple was precisely east-west, although it occasionally deviated from this because of topographical imperatives or for particular astrological reasons. A north-south line was drawn perpendicular to this first axis. The main entrance to the temple was almost always facing east, the theater of the morning sunrise. The importance of the cult of the sun in ancient civilizations is well known. The king of the stars, the sun, rising to dispel the darkness and the anguish of the night, restores warmth to the earth. It travels along the great curve of the firmament from east to west before surrendering the world to obscurity and cold. The *prasavya* funeral rite that consists in circling the

Creating the illusion of height, Baksei Chamkrong (*top*) and creating the illusion of length, Banteay Srei (*bottom*).

Facing page: Bakong from the east.

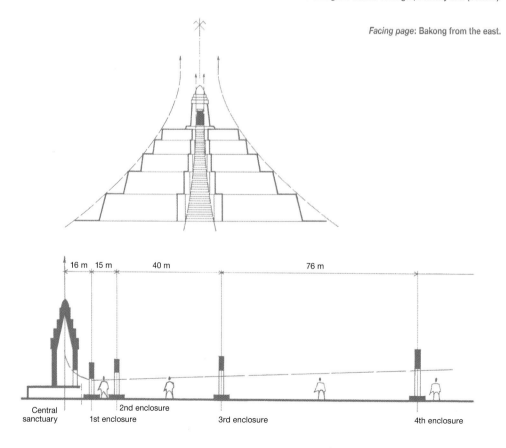

16 m 15 m 40 m 76 m

Central sanctuary — 1st enclosure — 2nd enclosure — 3rd enclosure — 4th enclosure

temple from right to left or from east to west, with the temple on the left side of the mourners, may be a symbolic reenactment of the sun's trajectory.

Angkor Wat is one of the rare temples to open on the west. Its unusual orientation may have its origin in its link to the cult of the dead. Several other monuments in the Angkor region exhibit the same orientation, a fact that may not be entirely fortuitous.

Proportions and Optical Illusions

Ancient Cambodian architecture is characterized by its soaring elevations. Originally, the technique of building corbeled vaults over the shrines was used to give the appearance of great height. However, in the 12th century, this optical effect was accentuated by the construction of a series of recessed terraces on top of the towers.

The same technique was used to create the illusion of grandeur in the temple-mountain, in which a massive square base supports a tower made up of tiers that become smaller as they rise to the highest level, where the shrine is located. The four

stairways leading up to the shrine followed the same pattern and the stone lions guarding either side of the first steps of the successive flights shortened with the ascending levels. All these elements created the illusion that the temple—in reality not very high—was a tall structure.

The Banteay Srei temple uses another optical trick that involves lengthening the perspective. As you walk from the east to the central shrine, the entry pavilions (*gopuras*) grow shorter as you advance; the doors in the passages diminish gradually in height until the last door leading to the shrine is only 1 m 8 cm high and is wide enough to admit only one person at a time. The widespread use of this technique of reduction with regard to apertures and the dimensions of the different temple areas creates the illusion of distance and great size.

Both of these relatively simple techniques—the recessed terraces and progressive reduction in size—served the same purpose, namely to make the monuments appear larger and higher.

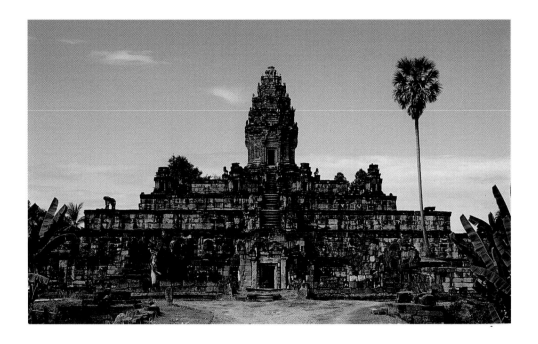

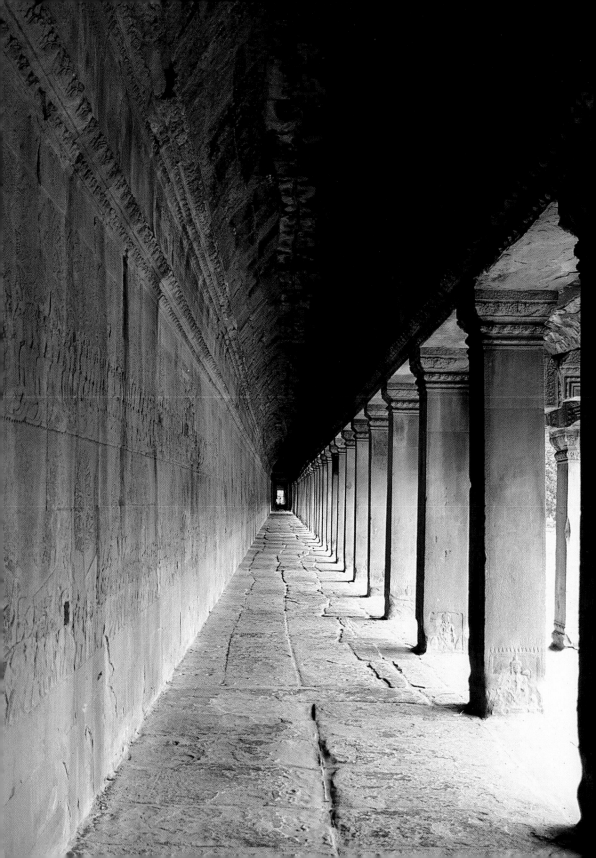

Khmer Architecture

Layout

The ground plans of the earliest Khmer temples, as at Preah Ko and Bakong, were relatively simple. Over time, they became more refined and sophisticated, culminating in the perfection of the temple-mountain Angkor Wat and the flat temple of Banteay Samre. The desire to improve these constructions led to complicated, excessively baroque edifices like the Bayon and Preah Khan and decadence ensued. This progression from simplicity to degeneration is one that many artistic movements follow.

Pre-Angkor temples built between the 7th and the 9th centuries also generally have simple layouts, consisting of a single shrine surrounded by a square or rectangular moat. The access to the temple is through an east-west oriented causeway situated on the axis of the monument. In several temples, however, an enclosure wall separates the main structure from the moat in order to enhance the importance of the sacred area. As the central Sambor Prei Kuk group of monuments illustrates, even at this time there was a desire to create larger structures.

At the end of the 9th century and the beginning of the 10th, there was a tendency to create odd-numbered groups of shrines placed on a single low base. The groups were dominated by a central shrine, such as the one at Prasat Kravan. This type of construction evolved into the practice of placing the shrines in two rows, as at Preah Ko (flat temple), and finally, arranging them into the quincunx pattern that typifies the temple-mountain.

Wall with bas-reliefs, southwest wing of the third gallery, Angkor Wat.

At the beginning of the 9th century, during the Angkor period, more ambitious plans based on increasingly sophisticated compositions were developed, drawing on the knowledge acquired during preceding architectural projects. Two types of plan in particular stand out, both symmetrical. The first is essentially square, the second is symmetrical only about the longitudinal axis. In the square plan the east-west and north-south axes intersect at right angles. Only the pyramids attached to a few temples, like those at the Bakong and the Bakheng, follow this type of plan. To highlight the main entrance to the temple, generally located on the east façade, huge causeways, annexes and galleries were built, resulting in the elongation of the plan. This second ground plan was used for both temple-mountains (Pre Rup, Angkor Wat) and flat temples (Banteay Samre, Ta Prohm).

Moats, Basins and Reservoirs

In the symbolical vision of the Khmer temple as a microcosm, moats represent the oceans that in Hindu thought bordered the world. The edges of the moats are formed by blocks of laterite carved into steps and are curbed by great slabs of sandstone. At Angkor Wat alone, those curbs measure nearly 6,700 m in length.

Digging of the moats such as the one at Angkor Wat, which is 200 m wide and on average 2 m deep, required thousands of laborers. Creating this body of water entailed transporting 1,700,000 m³ of earth—equivalent in volume to a square tower 100 m long and 170 m high. The earth removed may in part have been used in the construction of the various terraces of the monuments.

Basins and reservoirs served different purposes and can be divided into three main categories:

— The basins lining the main causeway are of modest dimensions (those at Angkor Wat measure only 53 m by 110 m). Like the moats, they formed part of the symbolical represention of the microcosm.

— The srah are situated for the most part on the east side of a shrine. They begin at the main entrance and extend along the axis of the structure. Landing stages suggest that access to the shrine was possible by boat. Srah are medium-sized, the Srah Srang at Banteay Kdei, for example, measuring 300 m by 700 m.

— Barays are huge reservoirs. The first one constructed at Angkor, the Indratataka, is 800 m wide and 3,500 m long and lies to the north of the Roluos group of monuments.

King Yasovarman I built the East Baray soon after establishing his capital at Angkor at the close of the 9th century. The East Baray (1,800 m by 7,000 m) was part of the cosmic vision of the Khmer religion. It provided the city with its water supply and may have also served as an irrigation

system. Due to technical difficulties, the East Baray dried up forty-four years after it was built. Its successor, the West Baray (2,000 m by 8,000 m), was only completed at the beginning of the 11th century.

In the second half of the 12th century, King Jayavarman VII built a reservoir (900 m by 3,500 m) at the end of the axial road to the east of the temple of Preah Khan.

A distinguishing feature of most of the great reservoirs is the presence of an islet in their center containing a monument that may or may not be significant, like the East Mebon of the East Baray. The Preah Khan and the West Baray are exceptional because they surround islets which have monuments with basins—basins within basins.

Terraces

The terraces mark the start or end of an access and lead to the entry gateway of the temple, or the *gopura*. The development of the terraces began during the 10th century, continued during the 11th century and reached a peak during the 12th century with the Angkor Wat style that involved an increasingly complex cruciform architectural plan. The terrace was raised several levels and preceded by flights of stairs. The Bayon style at the end of the 12th century and beginning of the 13th added a new dimension to these levels, notably with the Royal Terrace—better known as the Terrace of the Elephants—and the Terrace of the Leper King. A particular variation on the terrace theme appeared during this era in the form of landing stage terraces, as found at Srah Srang.

Facing page, top: layout symmetrical along both axes (Bakheng).

Facing page, bottom: layout symmetrical along a single axis (Pre Rup).

The great inner west causeway from the east, Angkor Wat.

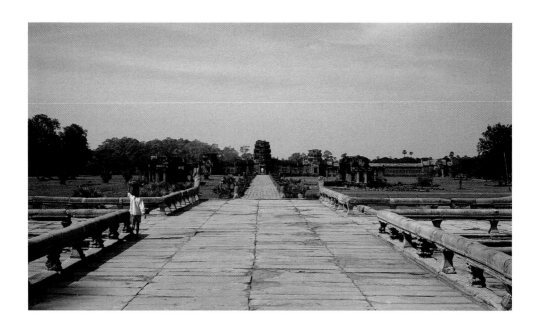

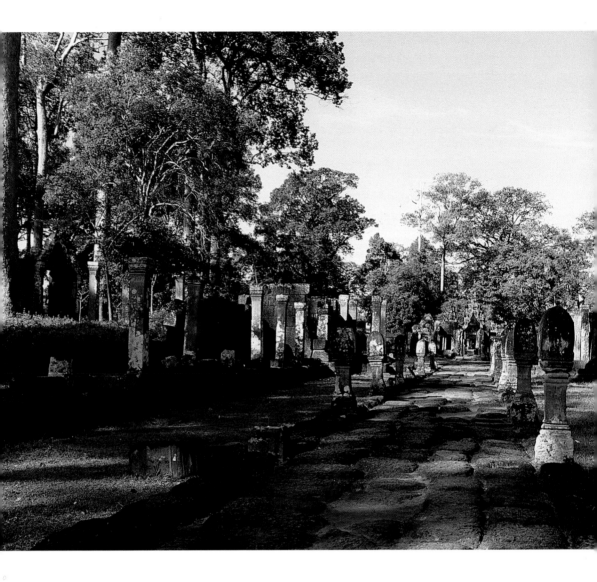

Causeways

These vary in length and indicate the east-west axis of the temples. They tend to be more elaborate on the east side of the temple. The earliest causeways were little more than simple paved roads; they soon evolved into raised structures allowing travelers to cross the moats. The Bakong was the first to have stone *nagas* lining the causeway in the form of a decorated balustrade; these large statues are placed on the ground. A later

development can be seen at the Baphuon, where the balustrade is raised above the ground and placed on dice-shaped supports. During the Angkor Wat and Bayon periods, the railings became works of art in themselves, with monumental many-headed cobras carved in stone.

The causeways over the moats do not link up with each other. Other causeways, such as the one leading to the east entry gate at the Baphuon, are made of sandstone blocks set on

Causeway lined with stone markers leading to the shrines, Banteay Srei.

small columns. Some experts have seen this type of road construction as an adaptation of the wooden bridges mounted on stilts that still span the Siem Reap River.

Enclosures

As we have mentioned above, the Khmer temples, inspired by Hindu cosmology, were microcosms of the universe. The moats symbolized the oceans, while the walls were the mountain chains that surrounded the world. Originally the temple walls were nothing but fences of tree trunks driven into the soil.

During the pre-Angkor period, the walls were freestanding and were made of brick. In the Angkor period, the walls were replaced by various enclosures and brick was gradually abandoned for laterite or, in rare cases, sandstone. The multiplication of enclosures served a practical as well as symbolic purpose, since they formed a screening system for the numerous worshippers who came to the temples. Only the holiest of the holy could gain entry into the sacred areas and the temple's mysterious aura was enhanced. In most instances, the enclosure had four points of entry located at the four cardinal points.

Galleries

From the very beginning, the Khmers intended to construct only simple enclosures but were obliged to convert them into covered passageways that were lined with pillars or openings. The gallery was protected by its wooden structure covered in tiles; later, brick and sandstone vaults were used. In the 12th century, the gallery was frequently doubled on one or both sides by a narrower passage covered by a half-vault.

What purpose did these galleries serve? In most cases, they permitted worshippers to gain access to the stations of prayer, but at some sites (the first enclosure wall at Ta Keo) they led nowhere, or else were too small to stand up in (Phimeanakas).

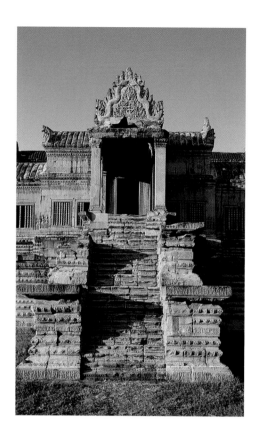

Stairway leading to the south *gopura*, second enclosure, Angkor Wat.

covered with tiles, then bricks and finally by sandstone blocks. Before the gallery, the *gopura* served as the model for the corbeled vault covering a small space.

Shrines

The typical Khmer shrine consists of a rectangular or square base topped by an elaborate cornice supporting a stepped tower of gradually diminishing dimensions.

Pre-Angkor sanctuaries or shrines did not appear until the 7th century. Usually small in size, its façades are ornamented by pilasters and its roof forms a series of small terraces of equal height.

A variation on this theme became the standard during the succeeding years and was adopted during the Angkor period. Its distinguishing feature was its roof, which had few terraces and was increasingly short. False doors appeared on three of the four façades of the building with lintels supported on pilasters and colonettes. These false doors and their surrounding ornamentation became the rule during the Angkor period. During this time, porches were built around each doorway, some quite substantial. In some cases, they were so large that they were combined with other rooms to make large structures in themselves.

Until the 11th century, Khmer shrines had only one opening, located on the east side. They subsequently became more complex, with additional doors, porches and eventually galleries,

Gopuras

Gopuras are the gateways in the wall of a city or a temple. The size of the *gopura* is determined in part by the importance of the temple, although the main access to the east tends to be larger. If the monument contains several enclosures, the outermost *gopura* is the largest. Construction of *gopuras* flourished during the 7th to the 13th centuries. They were initially smallish rooms with two doors, but they gradually became more complex, forming a cross. At an even more intricate stage, their sides were extended so that they joined the walls. As both these parts had become separate structures, they had their own doors and became secondary passageways. As the ground plan of the *gopura* grew in complexity, they became veritable shrines in themselves. The roof was

Aerial view of the Bayon revealing the outlines of an Indian *yantra*.

Following double page: east entrance of Preah Khan.

finally culminating in a flourish of *gopuras* at each cardinal point.

Most shrines as they appear to us today are unadorned, although a few have carved inner walls. The floor of the shrine is lower than the threshold.

Some temples include several shrines. In such cases, the main shrine is larger than the others, stands on a higher base and has bigger porches. The eerie and majestic towers of faces, characteristic of the Bayon period, rise above the *gopuras* and the secondary shrines.

Secondary Structures

Libraries

Although they are commonly referred to as "libraries," these buildings in fact offered scant protection from the weather, and were poorly lit and inadequately protected. The first libraries appeared during the 9th century and were generally square buildings with thick brick walls having only one door on the west side and several higher openings for ventilation. During the 10th century, the ground plan became rectangular and sandstone and laterite replaced brick as the building materials. They were built on sandstone bases and the main entrances had small porches, also of sandstone. The pyramid-shaped roof became a small story, ornamented by horizontal windows and balusters surmounted by vaults.

During a later era, the east and the west porches, which were reached by external stairways, were transformed into complex and intricate structures with additional pillars and profiled

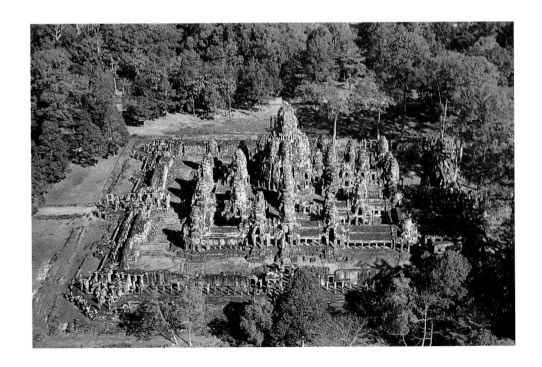

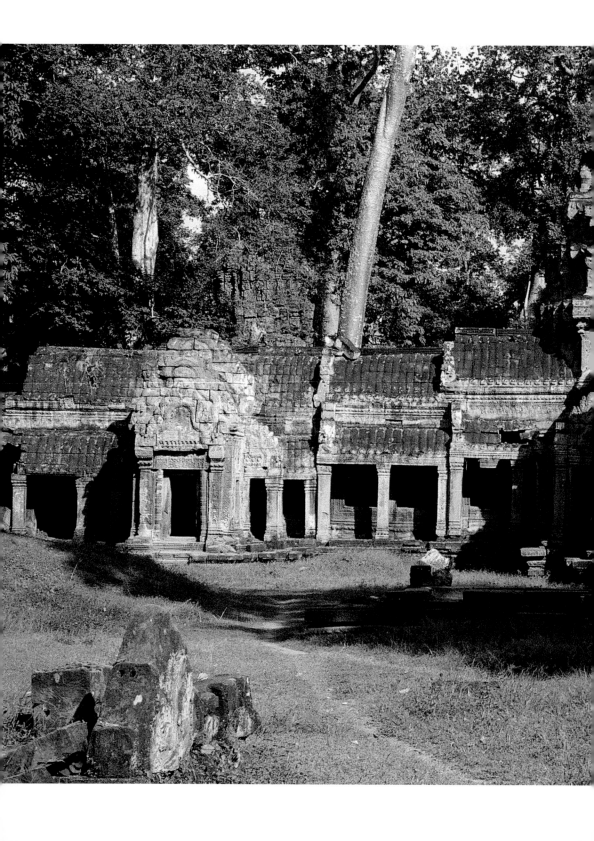

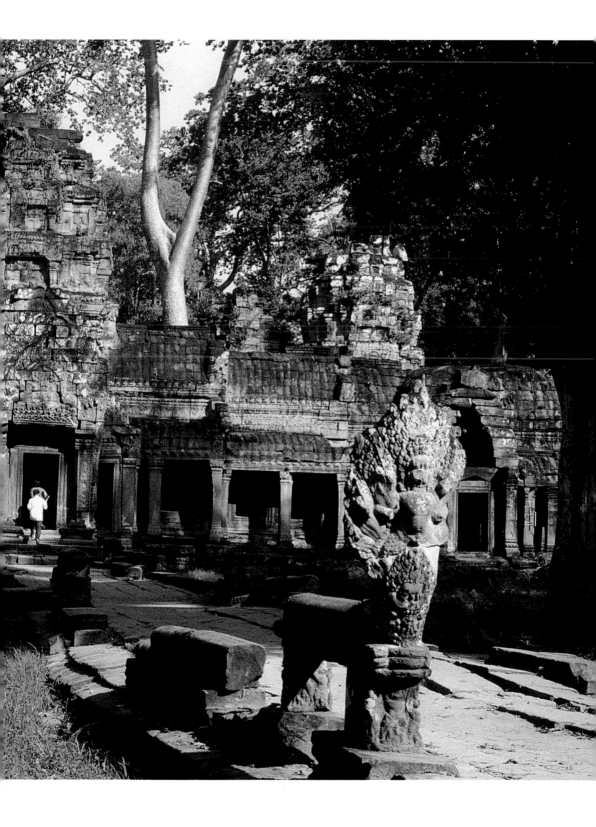

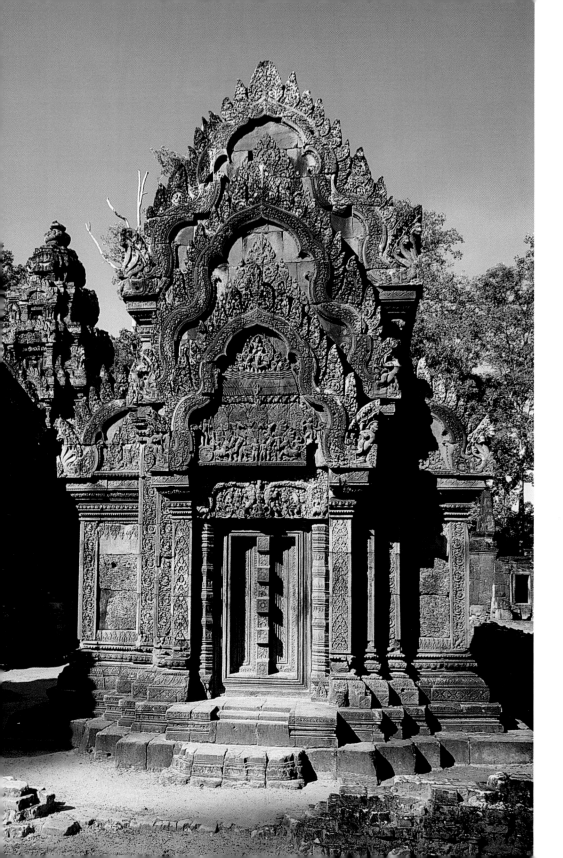

pediments. Doors were added to the north and south sides; bars protected the high windows, which had become larger. The raised interior story rested on a set of sturdy pillars.

In the major groups of monuments, the libraries are located outside the outermost enclosure on either side of the main access or else within the wall surrounding the main shrine. Angkor Wat has both. A modest-sized temple would normally have only one library, always situated on the south and with a single door on the west side.

Other Edifices

The temple groups include other buildings of various dimensions erected both inside (Pre Rup) and outside (Banteay Srei) the main walls. These secondary edifices include single rooms with porches, great chambers surrounded by vestibules and with fore-parts at their ends and elongated structures with two doors on one side. These buildings are built principally out of sandstone or laterite and it is thought that they were lit and ventilated by long windows placed on balusters on the upper reaches of the walls. They had wood and tile roofs or corbeled sandstone vaults.

In certain large groups of monuments, you sometimes find outside the temple area a network of chambers grouped around an inner courtyard. These are usually referred to as palaces, but it is not known why they were built.

The north library at Banteay Srei seen from the east.

On the pediment: Indra's rain.

In the 13th century, a new type of building appeared when King Jayavarman VII erected scores of hospitals. These were constructed out of lightweight materials and nothing remains except their sandstone chapels, whose walls bear engravings pertaining to the existence of small "rest huts" that kings, notably Jayavarman VII, erected for the benefit of travelers and pilgrims. Built along the same lines as the libraries, these shelters are quite different from Western hotels and contrast with the comfort of the straw huts, a type of construction that is more appropriate for the hot, humid climate.

In the northeast section of the enclosures around several of the great temples (Preah Khan), there is a strange rectangular stone edifice in the Bayon style. It has large windows and is placed on tall, sturdy, round columns. Since there is no stairway or other means to access this level, its presence remains a mystery.

Materials

Brick

Clay, the most ancient of all construction materials, is an exceptionally malleable material that makes it very suitable for the creation of images of gods and the construction of buildings. In Cambodia, from the 7th to the 13th centuries, brick was the preferred material for shrines. The type of brick used was generally of good quality and very resistant. Analyses indicate that the bricks were composed of a mixture of clay and sand. The sand, which was used to reinforce the clay, contained numerous quartz particles, together with plant material that was added to provide better consistency. This mixture was poured into wooden frames, kneaded like dough and the excess was removed. The brick was subsequently fired at temperatures that did not exceed 300°C. Dimensions vary from one monument to another, but on average the bricks are 26 cm long, 14 cm wide and 6 cm

deep. The Khmers did not use cement, but rather bonded the courses to each other by rubbing the bricks together and reinforcing them with a special adhesive of vegetal origin still employed in certain regions of Asia. The bricks were usually laid flat, but were not always overlapped, leading to many dangerous dislocations. Bricks were often used as facing for an inner wall that contained rubble.

Tiles and Finials

Thanks to fragments discovered during clearing operations, we know that the tiles used in the pre-Angkor period were flat, rectangular, heavy and quite large, measuring approximately 26 cm long, 15 cm wide and 3 cm thick. They were sometimes fixed to the laths by shoulders. Thinner, lighter tiles were also used, with grooves on their upper sides. These were held either by shoulders or a wire wound about a hole.

The tiles of the Angkor period were equally flat, but had raised edges on their upper sides. They were slightly trapezoidal and were of the same dimensions. The tiles were fixed to the laths in the ancient Roman way, their interlocking shoulders or tenons making them watertight; their upper sides were enameled in shades of blue or green.

Certain fragments of earthenware about 30 cm long resemble the sandstone finials and they may also have been used as finials.

Sandstone

Stone has always been present in Khmer temples, from pre-Angkor times to the end of the Angkor period. Sandstone was available in large quantities in the Khmer kingdom and became the most popular building material.

Sandstone is a mixture of minerals in a state of decomposition and natural cement. Different structural characteristics create the soft, medium and hard types of sandstone. All of the types are classified according to their origins. Sandstone is

also found in different colors: gray, which is the most widely used, green with blue nuances, pink, and red.

The temples of Angkor were built from the sandstone found in the quarries of the foothills southeast of the Kulen massif. The stone extracted lay near the surface; occasionally the Khmer builders would not even dig for the stones, which meant that the building materials had already been altered by the climatic conditions. The huge blocks were often detached by levers, wrenches or by fire, a technique that worsened their already deteriorated condition.

In the 9th century, at the end of the pre-Angkor period, sandstone became widely used, particularly for doorsteps, door frames, small columns, lintels and statues. During the Angkor period, sandstone was the standard material for all the monuments, although it was occasionally combined with laterite.

Once in place, the stone suffered the destructive effects of the atmosphere—the acid rains of

the rainy season, the erosion caused by water penetrating the rock, the swelling and the disintegration of the stone slabs. It was also attacked by lichen and algae. Down the centuries, the climate has favored the exuberant growth of the jungle vegetation within the confines of the temples; trees grow everywhere and it was feared that as their roots increased in size, they would dislocate the stone blocks. Studies have shown, surprisingly, that the damage caused by this excessive growth has not been that extensive.

Laterite

Laterite is a red stone that contains aluminum oxide and iron. In the region around Angkor, a layer 1 m deep of laterite can be extracted at about 4 m below ground. The laterite in its unrefined state is soft and easy to cut. Khmer builders transported it in blocks averaging 40 cm in height, although some measured up to 2 m. When left in the open air, laterite hardens as it dries and small cavities form, making it impossible to carve.

Facing page: the *mandapa* and main shrine at Banteay Srei.

Pages 78-79: the first enclosure seen from the southwest corner at Banteay Samre, citadel of the legendary Samre.

The Khmers used laterite in particular for the construction of the enclosures and as retaining walls for the bases. Several temple-mountains have terraces covered by laterite used conjointly with sandstone.

Wood

Wood has always been an important material in Cambodia and many of the stone elements of the temples were treated as if they were made of wood. During the pre-Angkor period, wood was used to build both royal palaces and humble peasant huts. In the temples, doors, false ceilings and even the filler blocks of lintels were made from wood. A few temples were even built of wood in anticipation of a more durable replacement. They have all disappeared now.

Metal

The bronze industry dates back to the beginning of the Khmer civilization. Traces have been found at several sites, of which the Neolithic site at Mlu Prei, in the northern region of the Great Lake, is the most important. Bronze and stone-cutting techniques evolved simultaneously. The Mlu Prei site has yielded axes, knives and sickles.

We do not know exactly when iron was introduced into Cambodia and our knowledge of Khmer metalworking techniques is patchy. Nevertheless, to the north of Kompong Thom there is a "mountain of iron" (Phnom Dek) that has, from ancient times, always yielded a ferric mineral lying on the ground that the Khmers gathered and processed. The iron implements, replicas of existing bronze tools, were made into different types of chisels for carpentry and for carving the bricks and the sandstone. Iron and, to a lesser extent, bronze were employed during the Angkor period in particular for dovetails or double T's to secure and stabilize the stone blocks. According to Zhou Daguan, certain temples were decorated in sheets of metal.

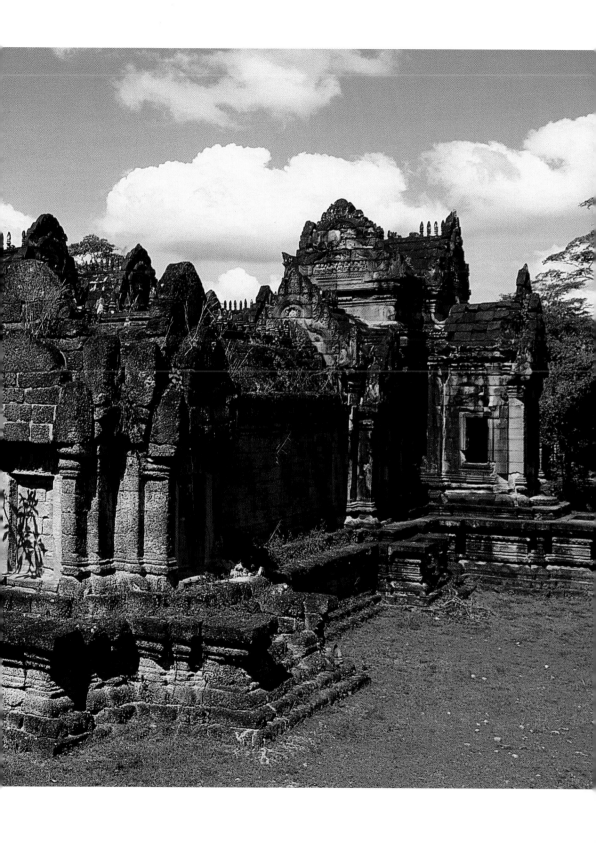

Architectural Elements

In the Angkor region, the soil is generally composed of sediments of ancient and recent deposits with a high proportion of sand. The older deposits containing a compact underlying base of clay are fairly impermeable, unlike the more recent sandy clay deposits on which most of the monuments are built and which are characterized by their vulnerability to water penetration. It is well known that hard-packed sand is an excellent foundation, but the Khmers did not use this technique. They simply created on the sand a rock bed of loose crushed stones on which they placed one or two uncemented foundations of laterite blocks of varying dimension. The thick foundation was designed to absorb and redistribute the enormous weight of the monument. However, the heavy rains of the rainy season infiltrated the superstructures and trickled down into the sand layer forming the base of the construction; little by little, the sand was washed away. Without adequate support, the laterite blocks began to part, causing the elements of the superstructure to shift.

Foundations, Bases and Platforms

Brick bases generally have foundations of sandstone slabs resting on laterite blocks. Sandstone bases, which are often lower, have the same type of foundations as brick bases. However, sandstone is a much heavier material than brick, so numerous cracks in the foundations are likely to appear.

The platforms of the temple-mountains present different problems. The principle of the foundations remains the same. The retaining wall, which can be quite high and dominates the bases, must resist strong shifts of the earth that threaten the stability of the monument. Different types of imported unpacked earth, each with its own angle of instability, fill the interiors of most temple-mountains. In general, the capacity of a base to withstand the movement of the dirt inside it depends on the height of the monument, the thickness of its walls, the resilience of the retaining wall, and the width of the foundations and their capacity for redistributing the weight of the entire monument. In most cases, the Khmer pyramids do not satisfy any of these conditions, and furthermore the walls of the platform beyond the first terrace rest on loose earth, which merely accentuates their weight and their instability.

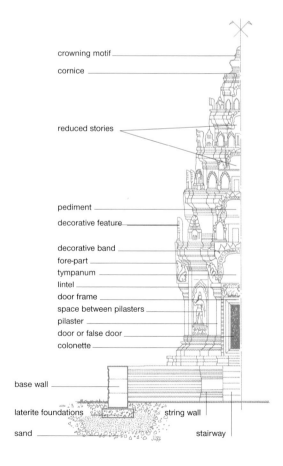

crowning motif
cornice
reduced stories
pediment
decorative feature
decorative band
fore-part
tympanum
lintel
door frame
space between pilasters
pilaster
door or false door
colonette
base wall
laterite foundations
sand
string wall
stairway

Walls

As we have seen, the walls of Khmer temples were not made solely from brick. Frequently, two brick facings enclosed various construction materials that were used as filling. The brick courses were more or less horizontal but the bricks within each row were unevenly placed. The overlapping of bricks on contiguous rows was largely a matter of chance. Such a haphazard arrangement was extremely sensitive to ground movement and bricks became dislocated despite their strong ties.

Facing page: the structural elements of a Khmer sanctuary.

Below: unfinished tower at Ta Keo.

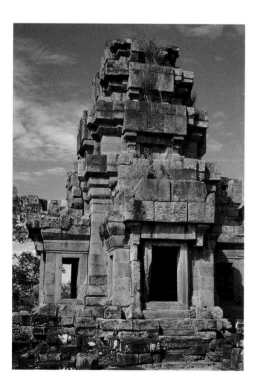

The sandstone blocks were dry when they were laid and they joined so perfectly that the joint is often hard to make out. To achieve this uniformity, the blocks had to be cut with extreme precision then smoothed before they were placed on the wall. The Khmers were unaware that blocks could be fixed together and consolidated by chain bonds and toothing stones, so they used bronze and iron anchors to insure stability. They also adapted certain woodwork techniques to stabilize the stone frames. When they first started to use sandstone, the horizontal joints of the walls were perfectly straight. In later years, as good stones became scarcer, the Khmers became less selective in their choice of elements, which they fastened not according to the joints but according to the shapes of the blocks, as at Bayon. This practice did nothing to prevent the dislocation of the walls when the foundations of an edifice proved to be weak.

Roofs and Vaults

Truss

Man's first instinct is to seek shelter for himself and his family from the hostile forces of nature. He turned to rock caves and to huts with sloping roofs of branches lashed together. Later, with the arrival of bronze and iron implements, he was able to cut down trees more easily and build from different elements.

Roof construction during the pre-Angkor and Angkor period relied on unsophisticated methods, as illustrated on certain bas-reliefs. Both lightweight and massive structures were erected in the same way. Trusses were constructed with bits of oversized wood with or without tie-beams; the principal rafters rested on ridge or eaves purlins; a series of common rafters was placed on the principal rafters, with or without the presence of intermediate pieces; lathing served as a fixing for the tiles. Slots and grooves carved in the stone for the insertion of these wooden elements are all that remain of these roofs.

Vaults

The traditional Khmer belief that a god actually inhabited a shrine led to constant concern about how to protect the god's dwelling. The Khmers employed imperishable building materials—first brick and later blocks of sandstone. Nevertheless, the system the Khmer builders adopted, the corbeled vault, limited the possibility of spanning great areas or constructing immense rooms—which in any case were not needed since the temples were not meant to provide shelter for large groups of worshippers. The vaults may have made it more difficult for Khmer architecture to assume its monumental role, though its very nature is basically solemn, serene and addressed to posterity.

The corbeled vault is created by superposing horizontal cantilevering brick or stone courses. This method produces no side thrust, but if one piece should fall, the whole vault collapses. The vault may have straight or curved sides depending on the projection of each course in relation to the others. In pre-Angkor shrines, small bricks were used, leading to vaults with pyramid-shaped intrados. In the Angkor period, sandstone blocks were placed mostly lengthwise, enabling builders to construct curved intrados. The carvings on the intrados and the extrados were different. The Bayon style, with its towers of faces, had no influence on the construction of vaults, because the faces are only carved to the thickness of the dressing.

In general, inside the towers, the upper section of the brick or sandstone vault ends in a narrow chimney connecting with a small flue running through the top of the monument.

From the earliest times, the barrel vault has been used in the Middle East, the Mediterranean and, to a lesser extent, India. It is strange that the builders of ancient Cambodia, despite their knowledge of India, remained ignorant of this basic type of vault that is relatively easy to build and can span spaces of various sizes. Their decision not to use it may have had religious ramifications.

Stairs

One of the important elements in the Khmer temple, and in particular the temple-mountain, is the stairway.

In the pre-Angkor period, most of the bases were low, so staircases were short and not very steep, with treads and risers of equal dimensions.

At the start of the 9th century, in the early Angkor period, the spread of the temple-mountain modified the proportions of the steps leading to the shrines. The risers became larger than the treads, with the result that certain stairways are at

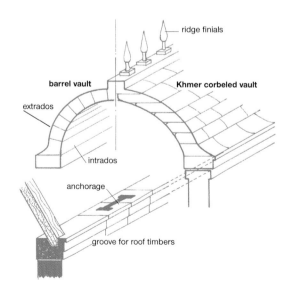

ridge finials

barrel vault Khmer corbeled vault

extrados

intrados

anchorage

groove for roof timbers

seventy degree angles. So steep are they that one wonders if they were actually intended to be climbed. Several stairways have landings, while others consist of a single flight leading up to the highest level. To create a lengthening effect, some stairways become smaller as they ascend.

The string walls are made of masonry and some have landings between two stories. In order to give the pyramid the desired effect of great height, the string walls become narrower as they rise. The steps are undecorated, except for the first step of each flight, which is shaped like the brace of a music score. A few are decorated with extremely intricate carved designs. The Baphuon has several profiled risers.

Doorways and Windows
Doors
Pre-Angkor shrines have doorways opening on the east side, with false doors on the other three façades. The typical doorway is about 1 m 10 cm wide and 2 m and 20 cm high. The outer frame generally consists of four sandstone blocks with metal ties at the corners carved to imitate woodwork. A few temple doorways are made out of two blocks, while others are simply quadrilateral openings carved in a single sandstone slab. In the pre-Angkor period, decoration on the frames was rare, although it became more common around the beginning of the 9th century. At this time, artists also began to carve inscriptions on the reveals of the stone doors.

On the outer side, two small stone columns on either side of the opening support the lintel, which is often carved. The columns are flanked by false columns of brick, which provide support for an entablature with a pediment.

The double doors were made of wood and opened on the east. The false doors on the

Doors

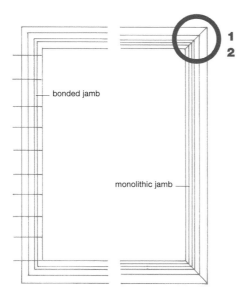

bonded jamb

monolithic jamb

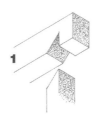

1
2

Detail 1: a housing joint.
Detail 2: a housing joint with mortise and tenon.

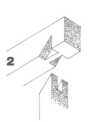

1

2

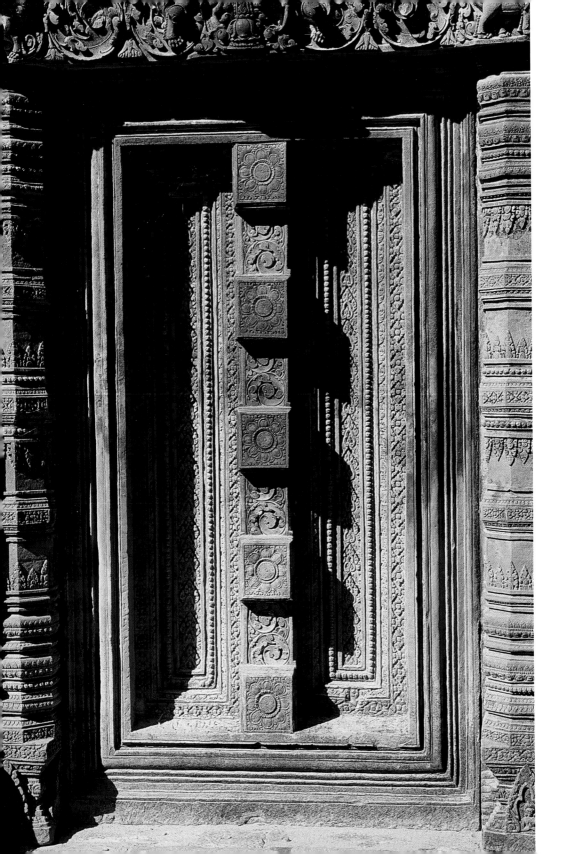

façades of certain monuments are made of brick and display rough paneling brushed with lime-based mortar on which the wooden decorations on the main door of the east side were reproduced.

During the Angkor period, the doors, false doors and their surrounding structures remained essentially unchanged, except that stone replaced brick. With the construction of Angkor Wat, the jambs were built by piling blocks of stone on top of each other.

The study of doors and their decoration was decisive for establishing the different stylistic categories in Khmer architecture.

Windows

With the exception of a shrine located south of Phnom Penh (Asram Maha Rosei), there is no known monument of the pre-Angkor period that has windows. It was not until the Angkor period that temples began to have windows.

The window frames were built on the same principle as the door frames. There are several types of window:

— Free windows that have neither locks nor bars. Surprisingly, in several monuments from the Angkor period, they are the only way into the inner galleries.

Low windows

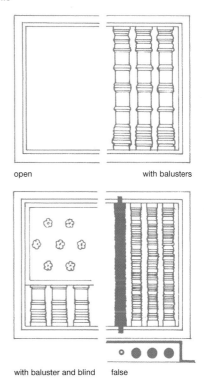

open with balusters

with baluster and blind false

High windows

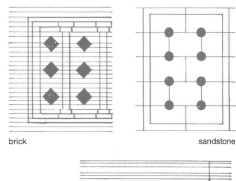

brick sandstone

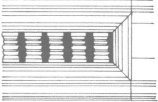

Facing page: false door on a secondary tower at Pre Rup. with balusters

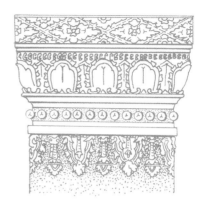

Capital, Banteay Srei.

Lantern pillar,

Ta Prohm.

Brick pilaster, Bakheng.

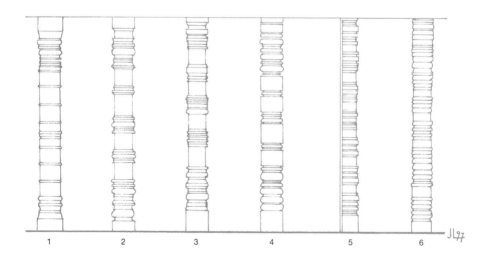

Colonettes

1. Prei Khmeng (8th century). 3. Banteay Srei (10th century). 5. Angkor Wat (12th century).
2. Preah Ko (9th century). 4. Bakheng (12th century). 6. Preah Khan (13th century).

— Windows with balusters. In reality, these are free windows with balusters replacing bars. The balusters have carved horizontal bands that vary in number; occasionally, a window might have two rows of balusters. The balusters are always in odd numbers (5, 7, 9) and have tenons at both ends.

— High windows already existed in certain brick edifices. For the most part, these openings were filled by a screen of square or lozenge–shaped slits. This style appeared later in sandstone, with the loophole type of window that was in some instances accompanied by balusters.

— False windows were created by means of recesses in the wall and had balusters. Some of these false windows had balusters on the lower half and a roller blind in the upper part.

Supports
Pilasters
Brick pilasters are typical of the Angkor period. They project slightly from the façade or corner and bear no weight. They play a more important role as frames for doors or false doors, because they support entablatures topped by pediments. During the 10th century, the pilasters were gradually abandoned. From this time up until the end of the Angkor period, the only columns were those that framed stone doorways and false doors and served as supports for the pediments.

Posts
Wooden posts were used outside the temples to serve as supports for porch roofs or as flagpoles. Post holes can be seen carved in the stone in front of several shrines.

Following double page: the great causeway of the western entrance to Angkor Wat and the moat.

Pillars
A rare element during the pre-Angkor period, the pillar of that era was cut from a single block of sandstone and was used to bear galleries with tile roofs.

During the 11th century, they were used as supports within the temples and were made by piling blocks of stones one on top of the other.

The pillar became a distinctive feature of the Angkor style, but it was not until the construction of Angkor Wat that they were used as supports for the sandstone vaults.

The carved capital and the base of the pillar are identical. The stone tenon of the base served either to fix a wooden piece or to reinforce a stone lintel. Round pillars were more rare and tended to be larger. Examples can be seen at Preah Khan; their purpose remains obscure.

During the Bayon period, the courtyards of several Buddhist temples were adorned with small square sandstone pillars placed on a large base (other examples of this style are at Preah Khan and Ta Prohm).

The presence of a sturdy tenon on top of the capitals could be evidence that they may have supported a lightweight structure or a large lantern; for lack of a better term, they are called the "lantern pillars."

Colonettes
During the Angkor period, small monolithic sandstone columns were built. Free or engaged, they served as supports for the stone lintels above doors or false doors. At first they were round, but during the Angkor period they became free and octagonal, a form obtained by eliminating the angles of the four sides of the square block they were made from.

Three-, four- and five-sided columns can also be found in door frames. With the construction of Angkor Wat, columns were made out of superposed blocks.

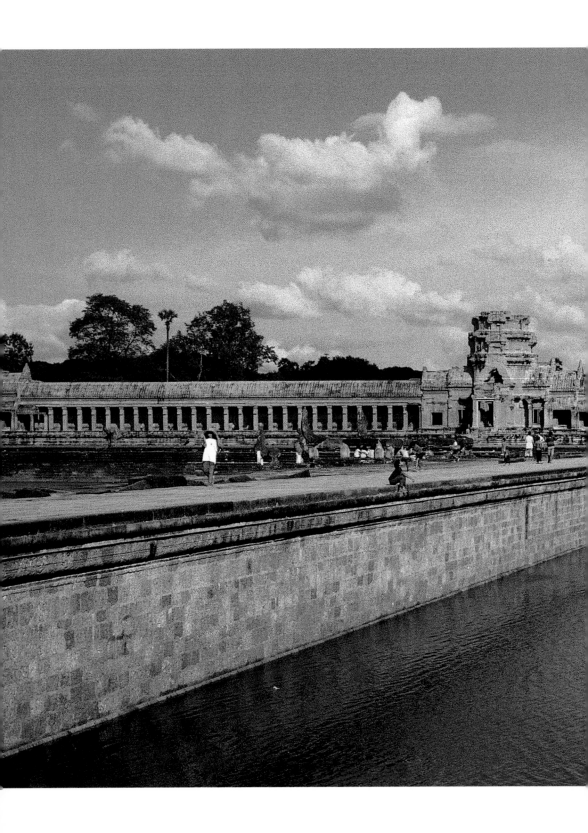

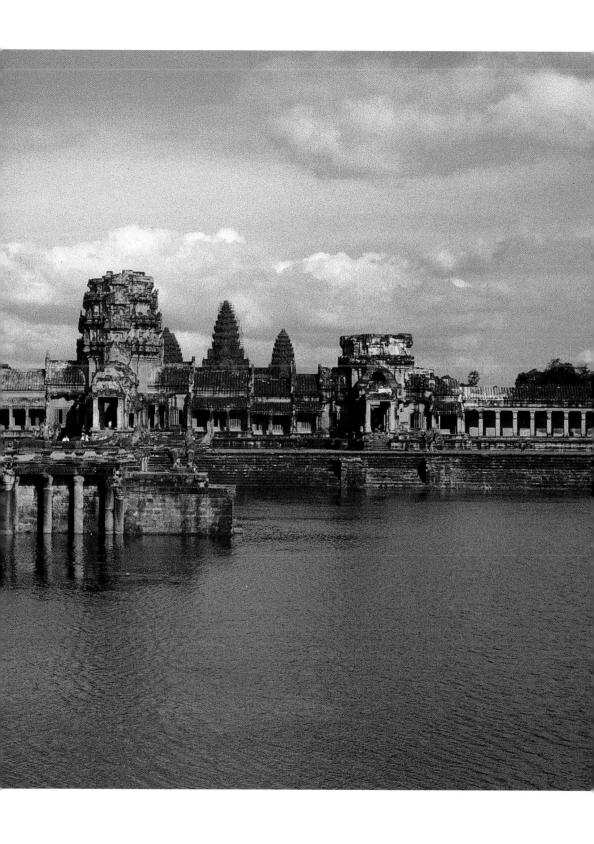

Construction Techniques and Tools

The construction of the monuments of Cambodia required many groups to work together as craftsmen and administrators. Construction projects of such huge scale could only be undertaken by a kingdom that was rich both in material and human capital, powerful, solidly established and capable of obliging its subjects to contribute to these colossal endeavors.

No less amazing was the attitude of the ancient Khmers, whom we might have supposed would be reluctant to undertake the construction of a mausoleum for a single individual, the god-king, a distant being far removed from the concerns of their everyday lives. Who were the tens of thousands of laborers who toiled to construct the temples? They were native Khmers—craftsmen and trained masons who may have received their initial schooling from Indian sculptors; common laborers who hauled the great blocks of stone; free peasants or slaves; prisoners brought back from the wars the Khmers waged; and men and women taken from occupied territories. No exact historical accounts exist concerning the identity of the workers, but it is likely that the Khmers treated them in the same way that neighboring lands treated theirs.

The treatment of the building materials is another matter. Brick-making presented few problems, since the clay required was found practically on the surface of the ground. Being lightweight and small, the bricks were easy to handle and to transport, unlike the huge sandstone blocks that weighed several tons.

The principal sandstone quarries are located on the southeast flank of Phnom Kulen, a great sandstone massif about 30 km from Angkor. The great blocks of sandstone, once freed and roughly squared, were transported probably by cart or pirogue to the construction sites. The exact roads and the waterways taken are not known; there are three possibilities:

— The stone blocks might have been loaded on to carts then carried by pirogues down the Siem Reap River to Angkor. However, the river is navigable only at certain times of the year. Furthermore, it is located a long way from the quarries, at the opposite end of the country (see Map). This method would have required a long and difficult journey.

— A shorter journey by land could have been made from the quarries to a supposed canal running north-south from the area southeast

Transportation of building materials.

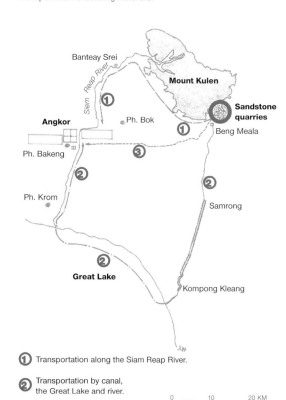

① Transportation along the Siem Reap River.

② Transportation by canal, the Great Lake and river.

③ Overland transportation.

of Kulen (now the village of Samrong), then a descent of this canal to Kompong Kleang, a village on the edge of the Great Lake. The boats could have taken this waterway and then gone up the Siem Reap River to Angkor. This theory does not take into account the low water levels during the dry periods of both the canal and the Great Lake.

— As a final possibility, land transportation of the stones might have started from the quarries, continued on the long raised dike running east-west, skirted Phnom Bok, and then finished at Angkor, not far from Banteay Kdei. This is the shortest route and could have been traveled at any moment of the year.

When the roughly hewn stone blocks were brought from the quarries, they had to be cut to fit a particular position. This system of positioning the blocks of stone started during the early Angkor period and became so widespread that it resulted in the highly irregular walls of the monuments of the Bayon era.

As we have seen, tight horizontal and vertical joints between blocks could have been created by repeatedly rubbing one piece with its mate, although it is unlikely that such a technique would have been feasible with stones positioned many meters above ground level.

The ancient Khmers built scaffolding using wood from the nearby forest. For the upper stories, in addition to scaffolding they also made ramps from bound tree trunks. The blocks could have been brought to the sites on small wooden rollers and raised by jungle vine cords tied to pegs, as indicated by the holes visible on numerous blocks.

Construction Time

How long did it take to build the monuments at Angkor? As there are no construction logs available (they may not have been kept or were perhaps destroyed), historians and researchers can only speculate about this. Estimations are extremely difficult when there is no information about numbers of laborers or key factors such as political events, wars and epidemics. A study of the construction of the great temple at Banteay Chmar (110 km northwest of Angkor), at present overgrown with jungle vegetation, suggests that it took fifty years to build. A study of the West Baray estimated that six thousand workers traveling 30 m a day while transporting 2 m^3 of earth would have taken three years to fill up the embankments of that vast body of water (14,000,000 m^3 of earth). Stylistic factors are sometimes of help. The style of the Angkor Wat temple, for example, indicates that it was built as King Suryavarman II's mausoleum. As each sovereign demanded his own temple when he came to power, it may be deduced that Angkor Wat was built during the thirty-year reign of Suryavarman II, from 1113 to 1145.

Although not directly relevant, it is interesting to note that the great pyramid of Kheops, with its square base 230 m long and 146 m high, demanded the labor of 100,000 men working over a period of thirty years.

Decoration

The Khmer artists seemed to detest emptiness; they filled every space with exquisitely carved decorations and even carved areas that could not be seen. Most motifs were adapted from Indian art. Khmer artists tended to avoid terrifying, morbid, and erotic themes, carving religious representations and images of animals or plants.

Religious Representations

These images were obviously carved on temple walls to encourage the devotion of worshippers come to pay homage to the gods. From a modern viewpoint, these bas-reliefs constitute a marvelous mural decor.

Images of the Brahman Divinities

The major divinities, the lesser masculine and feminine gods, and the figures that have gained divine status appear mostly on the lintels, pediments, and bas-reliefs.

Principle Gods

• Brahma

He is always sculpted with four heads and four arms. On the bas-reliefs, he features in various compositions, such as the friezes of the nine gods, where he rides the swan-goose Hamsa. He is placed on the tree sprouting from Vishnu's navel during the god's cosmic sleep. During the pre-Angkor period, Brahma appears on a few rare lintels as the principal god figure.

• Vishnu

He is frequently seen in an upright position, his four hands holding his sacred objects: a globe (the earth), a discus, a conch and a club. He may be placed on sandstone as well as brick. On the lintels in particular, he is commonly portrayed on the serpent that floats over the cosmic waters. Not all the avatars of Vishnu appear on the bas-reliefs. However, Krishna, the god's principal avatar, appears on the walls of Angkor Wat, where he plays a role in the *Mahabharata* epic. In other pictures, Vishnu is reincarnated as Rama struggling against the tyrannical powers of the demons that haunt the island of Lanka (present-day Sri Lanka). Standing on a tortoise, he holds Mount Mandara, the symbolical churn that Vishnu uses to whip the Ocean of Milk. In most of his images, Vishnu is riding on Garuda, the mythical bird.

Detail from the Heaven and Hell bas-relief, gallery of the third enclosure, Angkor Wat.

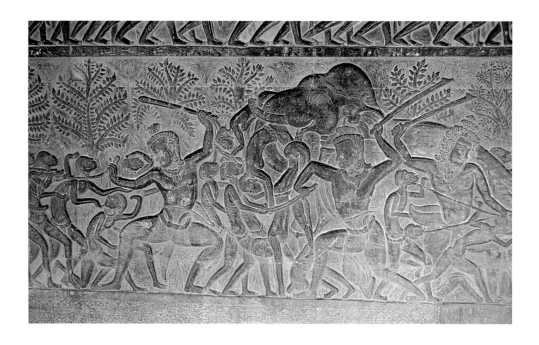

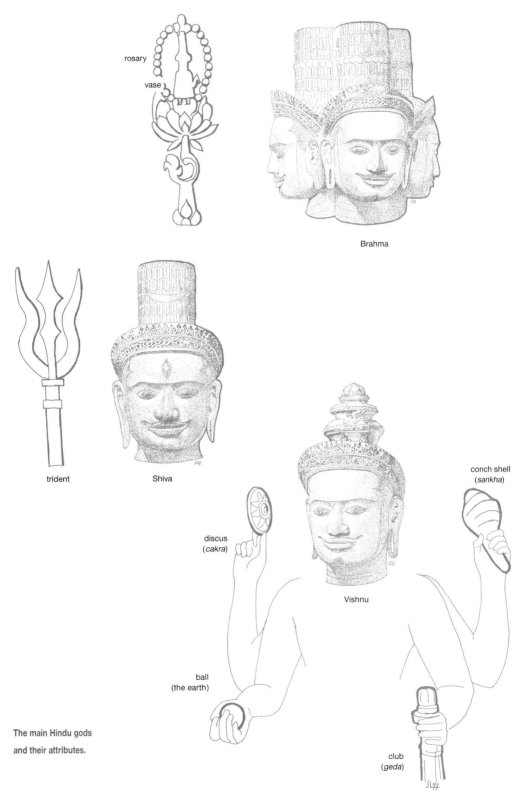

rosary

vase

Brahma

trident

Shiva

discus
(*cakra*)

conch shell
(*sankha*)

Vishnu

ball
(the earth)

The main Hindu gods
and their attributes.

club
(*geda*)

• Shiva

This god's human appearances are distinctly less numerous than those of Vishnu, the most typical representation being the *linga* (phallus). The bas-reliefs of the end of the 10th century show that his images became more frequent and diverse. He rides the sacred bull Nandin.

Minor Gods

The minor gods accompany the principle deities. Surya, the sun god, appears on a wall of Angkor Wat wearing a sun disk as a halo and riding a chariot drawn by a team of fiery steeds.

Skanda, the god of war, appears several times, always at Angkor Wat; he rides a peacock or, occasionally, a rhinoceros.

Indra, the god of storms and lightning, is represented as early as the pre-Angkor period on lintels. The image of the god astride a three-headed elephant also appears frequently on the east lintel of the Angkor shrines.

Goddesses

Devi and Sri, the feminine energies of Shiva and Vishnu, are the most common goddesses. Devi appears during the Angkor period mainly on the pediments of Banteay Srei and at the foot of pilasters.

Very few lintels of the pre-Angkor period display images of Sri whose other name is Laksmi. She became quite popular, however, during the Angkor period, particularly as the wife holding her husband Vishnu's legs during his sleep above the cosmic waters. Representations of these minor goddesses on bas-reliefs are rare.

Divine Figures or Deified Mortals

These god figures that are common to the Brahmanic and the Buddhist faiths play only a minor role, but they participate in the general symbolic vision.

The *dvarapalas* guard the gateways; they are carved on the pilasters on either side of the main entrances to the temples. The figure to the right of the gate holds a trident and seems benevolent, while his counterpart on the left has a frightening look and bears a club.

The *devatas* are goddesses that replace the *dvarapalas* in less important temples.

The *apsaras* are heavenly nymphs born when Vishnu churned the ocean; they appear in great numbers on the walls and the pillars of the Angkor style temples.

The union of the gods (*devas*) and the demons (*asuras*) recounted in the legend of Vishnu and the Ocean of Milk is reproduced on many bas-reliefs, notably on the large panel of Angkor Wat.

The *rishis* adorning the friezes, pilasters, pillars and small columns are bearded sages seated in lotus position with their hands locked in prayer.

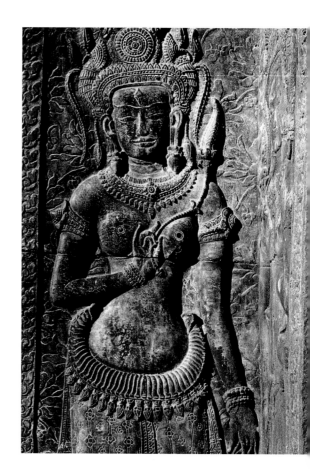

Buddhist Images

Images of Buddha began to appear on lintels relatively late, around the end of the 10th century. The Bayon style was the high point of Buddha portraits, with scenes of his life adorning the lintels, the pediments, and the decorations on the stelae and the historiated scrolls.

Among the *bodhisattvas* (enlightenment beings), Avalokiteshvara (known as Lokeshvara in Cambodia), the *bodhisattva* of compassion, is a popular figure in the Angkor Wat style, although it was particularly the Bayon era that gave him his many heads and arms.

Animal Imagery

Animals, sometimes in idealized or transposed interpretations, appear as statues in the round and on bas-reliefs. Aside from their symbolism, these are masterpieces of decorative art.

• *Naga*

The *naga* ("snake"), which is a water spirit, is an essential and permanent element of Khmer iconography. Its cylindrical body sprouts several raised heads, always in odd numbers, forming a corolla. The *naga* appears on the lintels as a support for the sleeping god Vishnu as he reposes on the cosmic waters. The *naga's* body was the cord Vishnu used to churn the oceans. Rendered as balustrades, *nagas* often stand guard over the causeways.

Nagas carried by statues of gods and demons line the causeways leading to Angkor Thom; this representation is a possible evocation of the rainbow, believed to be the link between Earth and Heaven. Two stone *nagas* are seen wrapped protectively around the shrine of Neak Pean.

The *naga* forms an interesting partnership with its arch rival, the mythical bird Garuda, whose image is carved on ramps from the Angkor period.

Finally, in Buddhist representations, it shelters the meditating god who is seated on its coils.

Left: *apsara* carved on a corner of the first enclosure gallery, Angkor Wat.

Right: *apsara*, inner courtyard of the second enclosure, Angkor Wat.

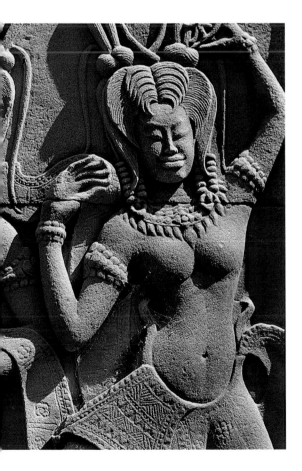

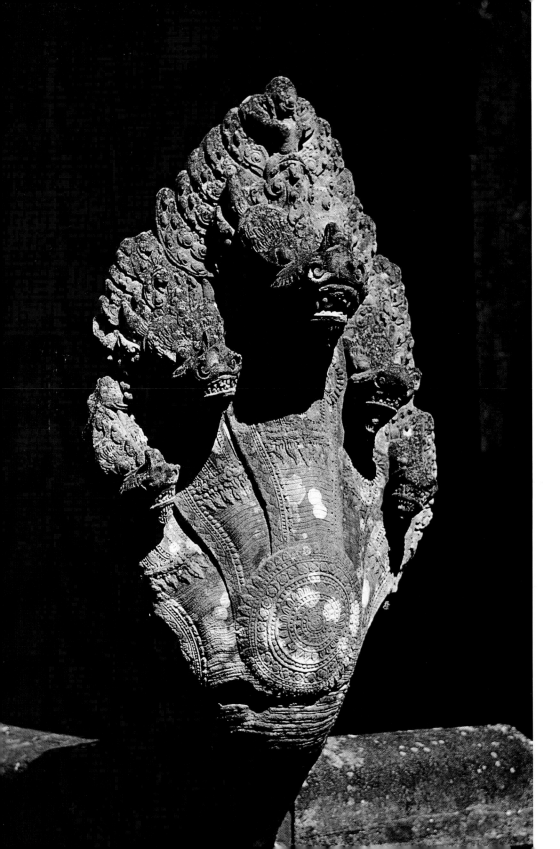

• Bull

The humped bull, originally from India, is carved on bas-reliefs, pedestals, lintels and pediments. The sacred bull Nandi, the animal dedicated to the god Shiva and the god's mount, lies in front of the entrances to the god's shrines.

• Elephant

The elephant appears, harnessed, in processions or battle scenes. In high-reliefs, it has three heads and carries the god Indra. It is also found on the corners of the gateways to Angkor Thom. In statues in the round, the elephant has cosmic status as the guard of the east; at the corners of certain temple-mountains, it watches over the four directions.

One of its representations is Ganesha who, as god of wisdom and the son of Shiva, levels the obstacles on the path of life. Ganesha has an elephant head, four human hands, and a round belly.

• Lion

In sculptures in the round, the lion is a strange, inhospitable animal. A mean-looking, goggle-eyed creature with flared nostrils and protruding fangs, it looks not unlike an angry poodle. As a high-relief on the walls of the Terrace of the Elephants, it stands on its hind legs. In the bas-reliefs, it carries the celestial palaces, but on lintels usually only its face is carved, likening it to the *kala's* mask.

Another version, the horned lion, is a starting point for foliated scroll carvings.

Facing page: end of a *naga* balustrade from the inner courtyard of the first enclosure at Banteay Samre (Conservation d'Angor).

Below: the Khmer army in marching formation, third gallery, east wing, Bayon.

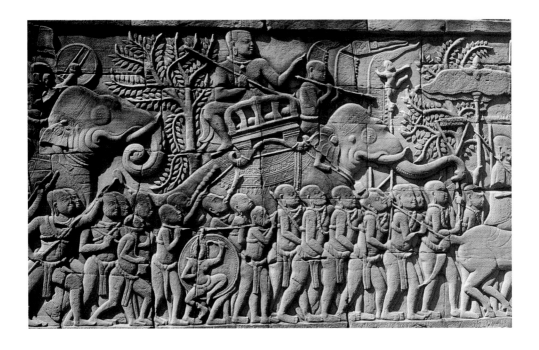

• Gander or Sacred Goose

This creature is named Hamsa when it is Brahma's mount. During the Angkor period, it was carved on pedestals, colonettes, and friezes. Lintels at Angkor display two ganders facing each other.

• Monkey

Endowed with a human shape, it was popular mostly in the *Ramayana* period, as several bas-reliefs at Angkor Wat testify.

• Tortoise

One of the avatars of the god Vishnu, it is found almost exclusively on bas-reliefs. The shell of the tortoise bears Mount Mandara, which supports the gods and the figures who churn the Ocean of Milk.

• Peacock

The vehicle of Skanda, the god of war, but it is relatively rare in Khmer art, although it does feature on several panels at Angkor Wat.

• Horse

The horse has various functions: it appears in many parades and battles, and it draws the chariot of the sun god Surya across the heavens. It may also be the future Avalokiteshvara rescuing the shipwrecked from the isle of the ogresses.

Mythical Subjects Inspired by Real-Life Forms

• Garuda

This mythical bird is part of Brahmanic and Buddhist iconography. It is the mount of the god Vishnu. The *garuda* is actually half-bird and half-human. It has a feathered bust and thighs, and the head of a bird of prey with a sharp, hooked beak, but its eyes are round and its ears are human. Standing on its hind legs, its raised arms reveal wings and its legs seem to have the paws of a wild beast ending in the claws of a bird of prey.

Garudas are sculpted on lintels, where they occupy a central position, as well as on friezes and bas-reliefs. Always in conflict with its legendary rival, the *naga*, it tries to trample the snake into submission.

Garudas and *nagas* often feature together on balustrades.

• Makara

Part-reptile part-pachyderm, the *makara* has a serpentine body ending in a coil and the head of an elephant with a strong set of teeth but no tusks. The *makara* plays an important decorative role in Khmer art. It appears as a kind of gargoyle and bears a striking but coincidental likeness to the head of Quetzalcóatl, a figure on the pre-Columbian temples of Mexico.

• Kala

The *kala* (also known as *rahu*) has protruding eyes emphasized by thick eyebrows, dilated nostrils, a strong jaw, and short arms. *Kalas* appear mainly in bas-reliefs on pilasters and lintels, shown swallowing a discus (the moon) that results in eclipses. Its mouth often drips with different sorts of plant life. It appears in profile on the end of pediments, where it regurgitates a lion or a *naga*. This motif can also be seen on lintels, except here it is clutching plant stems in its hands.

Plant Images

Representations of plants in the form of stems, croziers, and foliated scrolls tend to be highly stylized, so it is impossible to identify individual varieties. The one exception is the lotus, a recurring element in Khmer art.

The plant and flower images on bas-reliefs mingle in wild tangles and blend in with the portraits of real or imaginary animals. The hindquarters of a lion, for example, may form the beginning of a foliated scroll that will terminate as a *hamsa*. On a lintel, a sinuous stem may end as an upright *naga*.

Compositions can be very imaginative and complex, with series of inverted or upright foliated scrolls, undulating stalks or lozenges that frame a motif or that alternate with rose figures or leaves. Lotus flowers are combined with images of stylized beasts, and lotus petals adorn moldings.

Naga

Makara

Kala

Garuda

Mythical figures

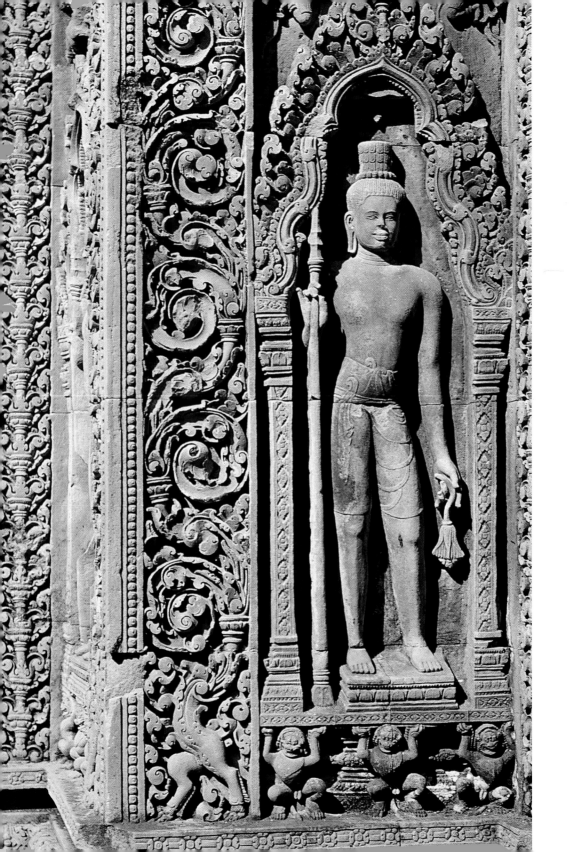

Decorative Elements

Pilaster

As only a few pre-Angkor pilasters have survived, our knowledge of this style is limited. They were influenced by post-Gupta Indian art of the 6th century. They are adorned with floral motifs inspired by blue and pink lotuses; these motifs are set within lozenges with pearly rims. There were also croziers and pendentives, foliated scrolls framed by vertical bands, round pearls, volutes and sinuous leafy or floral stalks.

The Angkor period retained and embellished these motifs, adding complex rings and vegetal stems that are sometimes entwined or free or enhanced by Vishnu cult figures like the dancing *apsara*.

On the pilasters of the Buddhist temples of Jayavarman VII, the floral croziers are entangled about images representing scenes of the life of Buddha.

Between Pilasters

Over the course of time, the decoration between false columns became increasingly ornate, reaching a peak in the Bayon period. In the pre-Angkor era, images were carved between pilasters and coated with lime-based mortar.

A *dvarapala* guarding the main shrine at Banteay Srei.

During the Angkor period, huge images of increasing complexity depicting the *dvarapala* or the *devata* were placed under arches.

Pillars

To begin with, pillars were decorated with a single frieze on the capital. Gradually lozenge patterns were added on the abacuses; moldings fraught with petal carvings embellish the abacuses. The decoration spread to the upper section of the pillar shaft in the form of teardrop motifs and garlands, although the base remained unadorned. Decoration of the pillar reached its apogee with the Angkor Wat style.

Doors, Colonettes, Lintels and Pediments

The decorations on doors, colonettes, lintels and pediments have been valuable aids in determining the evolution of Khmer art and creating stylistic categories.

• Doors

The plain door of the pre-Angkor period became more elaborate during the Angkor period with the addition of moldings. At the temples of Angkor Wat and Bayon, door reveals are adorned with tapestry-style decorations. The practice of engraving reveals with inscriptions began during the pre-Angkor era.

• Colonettes

The decoration of the small columns supporting ornamented lintels became more complex and intricate over time. The cylindrical colonettes in the pre-Angkor period resemble the Indian Gupta era model (4th to 5th century), featuring large bands decorated with images of plants around the middle. The shaft on either side of this band was eventually decorated with simple moldings.

The capitals, bases, and shafts of the octagonal columns of the 7th century were decorated in the same manner. Over time, however, the three sections disappeared beneath highly ornate moldings, occasionally subdivided into ten sections with alternating decorated or plain bands.

1. Pre-Angkorian

2. 10th century (Bakheng)

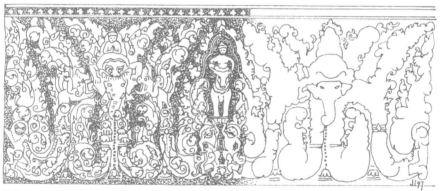

3. End 10th century (Banteay Srei)

• Decorative Lintel

The earliest shrines in Cambodia date back no further than the 7th century. Influenced by Indian architecture, the colonettes and lintels on these monuments are the only stone elements that are not sculpted.

The earliest lintel decorations were inspired by Indian models and enable us to determine to which style the monument belongs. From the beginning of the 7th century to the 13th century, thirteen styles have been established. The lintel decoration revolves around a central historiated

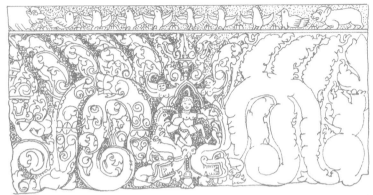

4. 11th century (Baphuon)

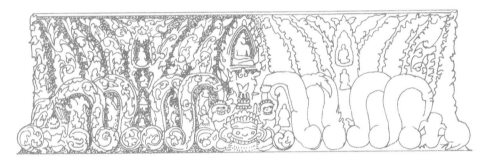

5. 12th century (Angkor Wat)

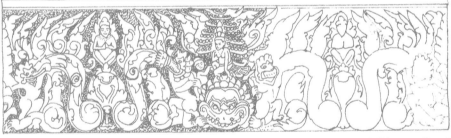

6. 13th century (Bayon)

Evolution of the Khmer lintel

medallion. This central figure is surrounded by two secondary medallions. Above the three medallions are small arches terminating in images of mythical beasts. The figurines "riding" the arches were later moved to the ends of the lintel, where they became larger and replaced

the mythical animals. The tear-shaped forms "dripping" over the arches are also occasionally replaced by human scenes or by images of Vishnu lying on the Cosmic Ocean. Around the 8th century, the three medallions and arches tended to be fused and, at a later date, this figure

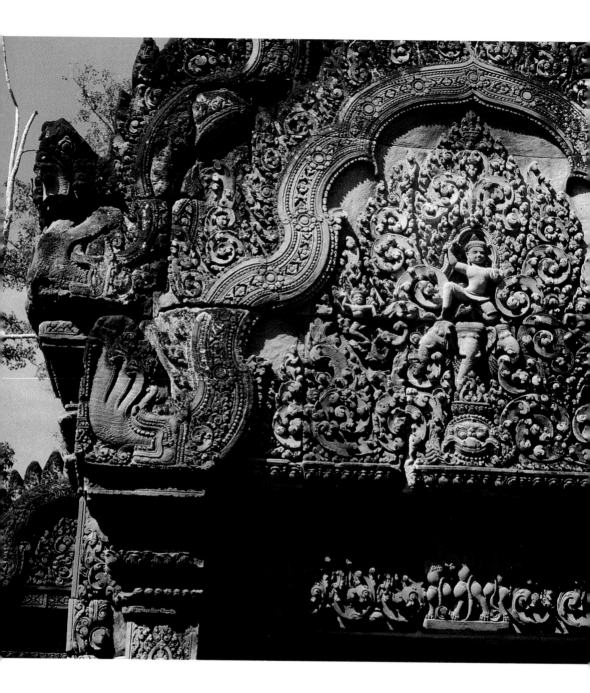

became a plant stem or cord. During the 10th century, the sculptors turned this motif element into volutes curling at the ends of the lintel, while a more important motif dominates the center.

The stems acquired a proliferation of leafy growths. During the Angkor Wat period, lintels were occasionally decorated with scenes featuring large numbers of figures arranged in tiers or

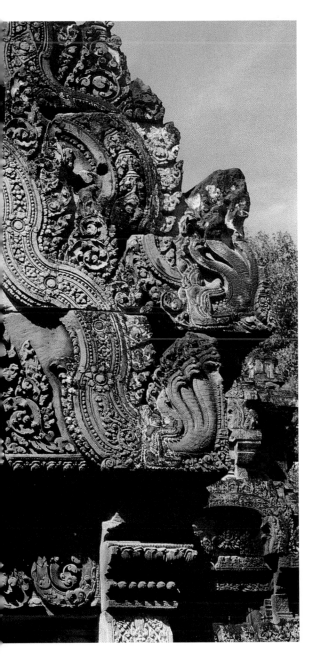

Indra riding his three-headed elephant,
east pediment of the mandapa, Banteay Srei.

with motifs of sinuous branches. The lintels at the Bayon reproduce the style of the preceding era, but add small subjects to the floral and plant motifs.

• Pediment

The few well-preserved pre-Angkor pediments are all made out of brick and curve into inverted U shapes at the ends on their capitals. The typical pre-Angkor pediment is neither very prominent nor highly decorated; it terminates with *makaras* facing the center. The tympanum occasionally has a small likeness of a palace in the center.

The typical Angkor pediment is marked by a three-cusped band that ends in an upright *naga* or a *makara* with a raised trunk. The sandstone pediment did not appear until the 9th century with the Bakhong style. It displays a central motif surrounded by secondary figures set within a floral decor and arches.

One pediment of Banteay Srei was to become the model for all the others. The rounded arch became an ogee shape, while the sides of the arch were carved with floral motifs. In later edifices, the floral decorations curled about the head of a monster.

With the Angkor Wat style, the curved bands became less distinct, the arch became flatter and the spandrels teem with subjects placed in bands, with the main subject (a god or a king) placed higher than the others. The Bayon era monuments kept and accentuated the same forms, greatly flattening and softening them.

Walls

In the pre-Angkor period, the brick walls between pilasters were decorated with great motifs that were carved or modeled and then fired. A favorite subject was "flying palaces." These motifs were then covered in layers of lime-based mortar that were chiseled as required. In the 10th century, unbroken, diagonal web-shaped motifs first appeared. This type of wall

decoration became more complex, with flowered branches and foliated scrolls that are encased in small square patterns. The Angkor Wat style, demonstrating the dislike of Khmer sculptors for empty spaces, proliferates in relief carvings that resemble lace or tapestry work. This type of carving was typical of the Bayon style and can even be found in places that are out of sight. In some monuments, the bas-reliefs have important scenes instead of the usual floral decorations, particularly where they appear on large wall panels.

Windows

Window frames are decorated with moldings of varying degrees of complexity. In the Angkor Wat and Bayon styles, tapestry motifs that are similar to the ones decorating doorways can be found. Windows with balusters are more common than free windows. The balusters, of which there are always an odd number, were chiseled in sandstone while hollow bands were added to their upper sections. In the Bayon style, the upper section was frequently covered with scattered flower motifs.

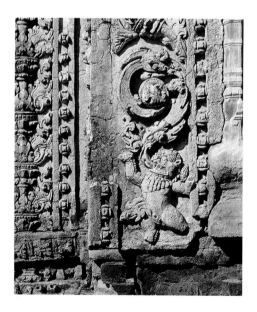

The Use of Lime Mortar

The thick white protective coating that was applied to the brick walls of monuments, particularly during the pre-Angkor era, consisted of a mixture of water, lime, sand, and remnants of paddy husks, whose fixing power was strengthened by the addition of a plant-based adhesive. The mortar was poured into holes bored in the walls or into the cavities of each brick. As soon as it had set, the stucco was initially modeled on the motifs carved into the bricks, then chiseled more precisely to enhance the theme. The foliated scrolls, stems, and croziers, as well as the human and mythical beast figurines, prefigure later stone sculptures.

Were the Khmer Monuments Painted?

The façades and interiors of buildings in ancient Egypt, Greece, and India were often painted, as were the portals of medieval cathedrals in Europe. Khmer builders, like their Indian masters, painted their temples. Preah Khan and Neak Pean have colored areas on a few sections of their monuments. At Angkor Wat, vestiges of red paint are still visible on and around certain subjects of the bas-relief known as the Battle of Lanka. The patinated, shiny surfaces of certain sections of the Heaven and Hell panels may also indicate that these were originally painted.

Left: lion spewing a flowery volute, lime-based mortar, Preah Ko.

Facing page: Vishnu on a *garuda*, interior sculpture on brick, Prasat Kravan.

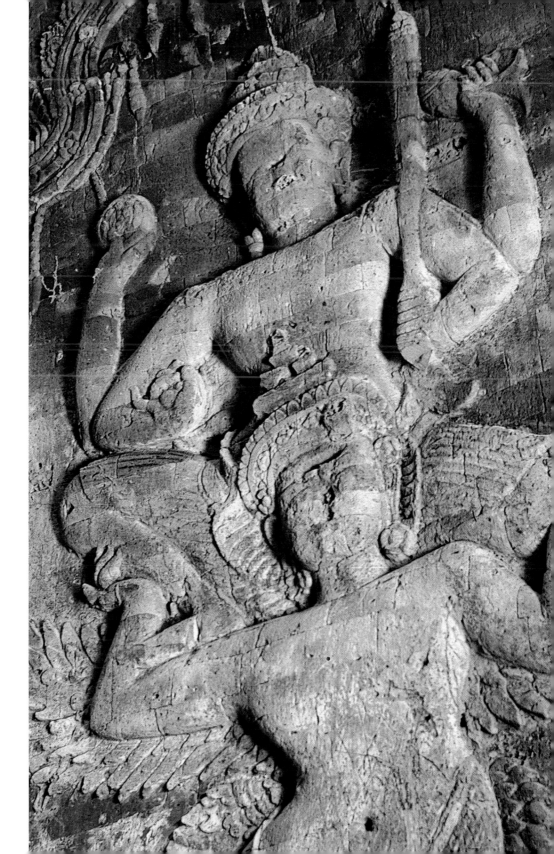

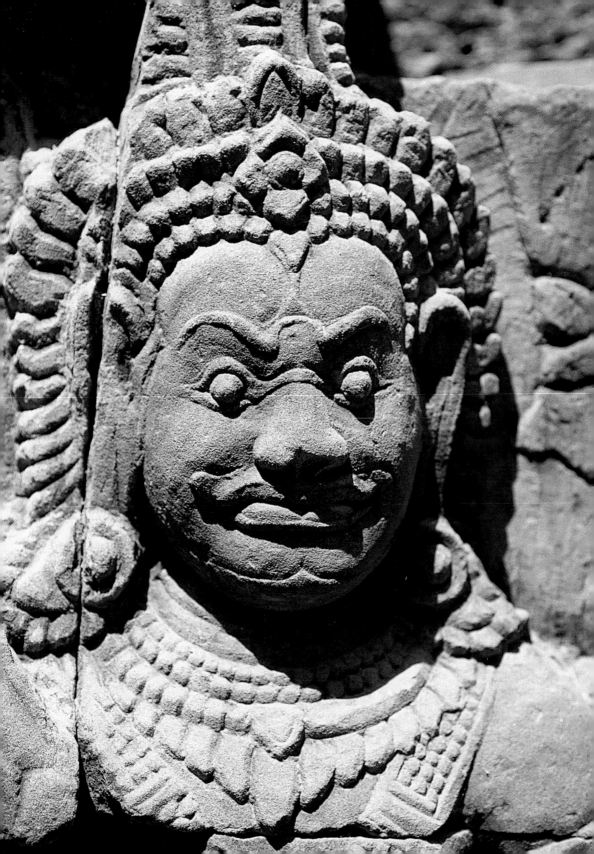

Statuary

Bas-Reliefs

A bas-relief is a sculpture that projects only slightly from a flat background. Khmer bas-reliefs ranged from decorations of geometric and floral motifs to vast scenes.

The oldest known Khmer bas-reliefs can be traced back to the 7th century; they are the brick medallion shapes on the enclosure wall of Sambor Prei Kuk, a group of monuments located 140 km southeast of Angkor. Stone lintels from the same period adorned with medallions with groups of figures or single figures, often astride imaginary beasts, may be precursors of bas-reliefs showing dramatic scenes. Between the 7th and 8th centuries, the Prei Khmeng style appeared with its grander figures placed on the brackets at the ends of lintels or occupying the entire surface of a spandrel. The carving of Vishnu's cosmic slumber is an example of the latter type.

Demon, interior corridor, The Terrace of the Leper King.

In the 9th century, bas-reliefs were coated in lime mortar, as on the outer walls of the Preah Ko temple of the Roluos group. From the same period, bas-reliefs depicting continuous scenes were sculpted on the southern façade of the fifth level of the Bakong pyramid (bas-reliefs of this kind are not found anywhere else).

Two of the five towers of Prasat Kravan, a temple dating from the early 10th century, contain exceptional brick sculptures. These elegant sculptures, which did not necessitate lime-based mortar coatings, re-create on a grand scale scenes from the life of Vishnu.

Around the middle of the 10th century, the art of the Khmer bas-relief reached its apogee. The finest examples adorned the lintels, pediments, and walls of the shrines.

With the Baphuon style of the 11th century, there was a revival in the practice of including people and animals in the bas-reliefs on lintels. Also, an ingenious method of superposing small tableaux on the walls of *gopuras* was developed, enabling artists to portray a variety of scenes and giving them freedom to interpret their subject matter.

Although the pediments, semi-pediments, and lintels at Angkor Wat are all very worthy of

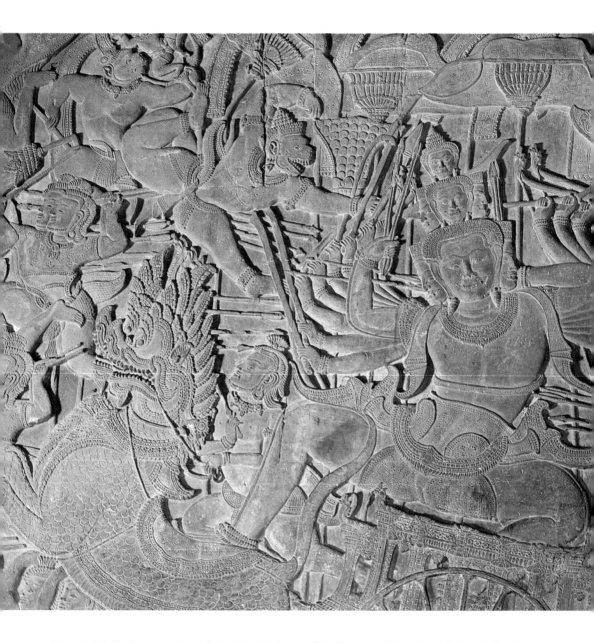

interest, it is the immense bas-reliefs of the third enclosure wall that interest us most. The Khmer artists' dislike of empty spaces on bas-reliefs is clearly evident in this part of the temple, which features scenes drawn from Brahmanic legends and evocations of royal celebrations treated in false perspective.

The Bayon and its outer galleries, dating from the early 13th century, offers us depictions of war, as well as scenes from the everyday life of the Khmer people. The huge bas-reliefs of the Terrace of the Elephants and of the Terrace of the Leper King present us with the pageantry of royal processions and the mysteries of Mount Meru.

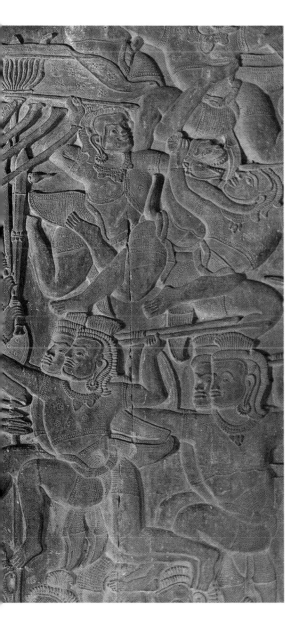

The multi-armed, multi-headed giant Ravana,
detail from the *Battle of Lanka* bas-relief, northwest wing,
gallery of the third enclosure, Angkor Wat.

Statuary

The Khmers followed the different cults that spread from India in the earliest centuries of our era. They sculpted stone images of the Indian gods, but gave them original interpretations inspired by native Khmer ideas. If the Indian gods in India were seemingly dark, brooding, macabre, erotic figures, their Khmer counterparts were graceful, chaste, and dignified. Their sole function was to illustrate sacred texts.

Brahmanic Statuary

With the exception of those created at the turn of the 12th century, under the reign of Jayavarman VII, Khmer statues are highly stylized and devoid of any individualization. Nevertheless, as George Cœdès writes, inscriptions indicate that like the Indians, "the Khmers believed that they could set within the stone the very essence of the persons they worshipped," and that "these images are principally those of the kings, the princes or the great dignitaries represented as gods who have absorbed or will absorb them at the end of their earthly existence."

Almost nothing is known about the sculpture produced in the most remote period of Khmer history. Excavations carried out in the south of Indochina, formerly Funan, have not been very revealing. However, Chinese texts written at the end of the 5th and beginning of the 6th century relate how the Khmers fashioned their bronze idols and how they carved wood. Nevertheless, in the course of the 6th and 7th centuries, with the decline of Funan and the rise of Chenla, statues in the round appeared. The production of this early period has been grouped together under the heading of the Phnom Da style after the pre-Angkor archeological site of the same name that is 65 km south of Phnom Penh.

At that early period, sculptors worked with schist or sandstone implements. Statues were held in position by means of a supporting arch.

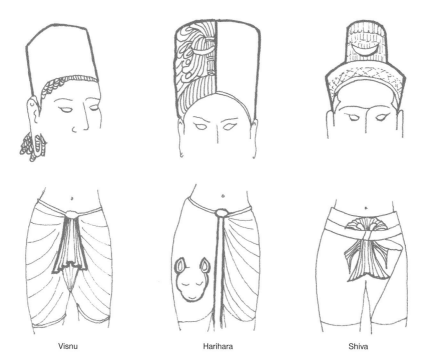

Visnu Harihara Shiva

The figures all exhibit an extremely ceremonial attitude, combined with a daring thrust of the hips; the faces are all long and slightly flat; their noses are aquiline and their hair is curled. Among the god figures, Vishnu wears a high cylindrical headdress and Shiva's locks are in a high bun held with two bands from which two handle-shaped locks fall. The clothing is a simple straight skirt (*sampot*). Gathered in front in a fixed central knot, the folds of free fabric flow between the two legs and are tied behind the figures' lower back at the waist.

A second method produced sandstone statues. The subjects wear the same hair adornments; the pleats of the *sampot* are replaced by an anchor-shaped or cup-shaped piece of fabric covering the thighs. The statues of this era exhibit a curious fusion of Vishnu and Shiva emblems on the *sampot* and on the headdresses, dividing the statue vertically down the middle, with the right side representing Shiva and the left Vishnu. This compound representation is known as a Harihara.

The influence of India is evident in both methods. Strangely, no feminine images of that period are known to us.

This first style gradually evolved into the Sambor Prei Kuk style (6th to 7th century), a continuation but with some innovations, most notably generously rounded statues of women. Greater attention is paid to anatomy in works of this period. The smooth *sampot* has a double anchor-shaped flare in front. As in sculptures of the preceding style, statues appeared to have been decked with removable jewels and a thin diadem combined with high buns and miters. The men's faces wore mustaches that were frequently curled.

The Prei Kmeng style that followed (6th to 7th century), is best known for its richly adorned robed and bejeweled figures on lintels. The men's cylindrical headdresses tend to become rounder and their elaborately curled locks frame graciously swelling cheeks.

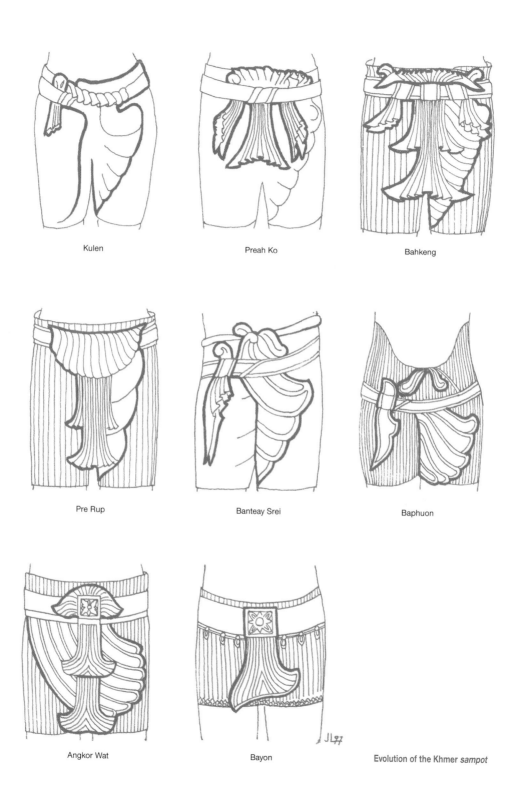

Kulen

Preah Ko

Bahkeng

Pre Rup

Banteay Srei

Baphuon

Angkor Wat

Bayon

Evolution of the Khmer *sampot*

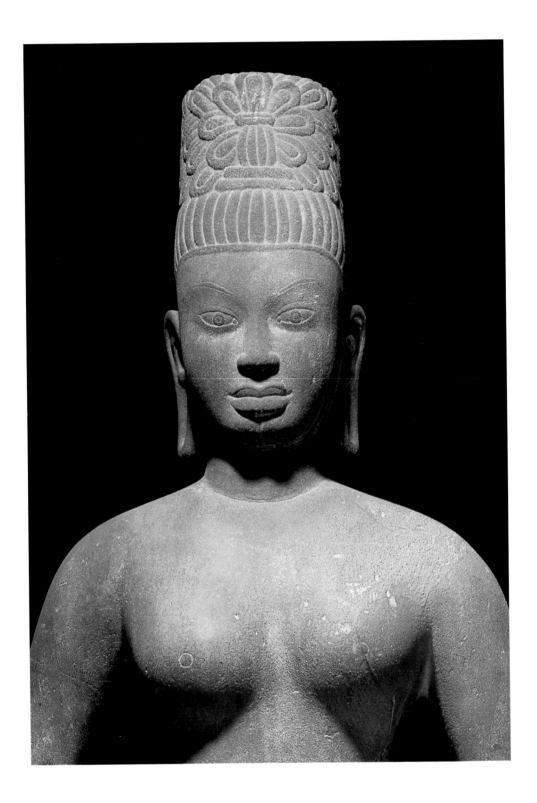

The Prasat Andet style (second half of the 8th century) prefigured its more decadent later version, the Kompong Preah style, characterized by statues in the round with fuller forms.

With the Kulen style (9th century), the body and occasionally the supporting arch disappear. The sway of the statues' hips becomes less marked and the forms thicken. The faces display highly arched eyebrows and the miter extends to the neck. Some figures also wear intricately chiseled diadems and miters that rise in tiers. The men's smooth *sampot* hugs the knees and its folds brim out over the left thigh. The upper part of the *sampot* is maintained by a cloth belt draped with the fabric. No feminine statue has ever been found.

In the Preah Ko style (9th century), supporting arches disappeared and the first group sculptures appeared. Sculptors attempted to add a sense of movement to freestanding statues and bas-reliefs. The tendency toward fuller forms in male statues becomes obesity, while female representations become lighter but more generous. There is hardly any pronounced hip movement. The men have added mustaches to close-cropped beards, but the masculine and feminine apparel remains largely unchanged. All the divinities, as well as the gateway guards (*dvarapala*), wear diadems at the base of high buns or miters.

The Bakheng style (9th to 10th century) emphasizes the ceremonial aspect. The masculine

statues display a slimmer waistline and a more developed pelvis. A type of skirt with regular vertical pleats replaces the smooth *sampot*, but the cup-shaped draped fold covering the left thigh is retained. The belt holds a short flap while the rest of the garment falls in regular flares. The *sarongs* for the women are similar, but have richly ornate pendants hanging from the belt.

Certain statues of the Koh Ker style (10th century) combine majesty and an almost palpable dynamic energy that testifies to a growing creativity on the part of the sculptors. This period saw a multiplicity of postures. The faces are benevolent and wear a smile that would become a distinctive feature of the Bayon era. The men's *sampot* loses its cup-shaped drape, but keeps the double anchor adornment of the previous style. The style is marked by greater intricacy and attention to detail, and a certain sartorial sophistication, demonstrated by the large round flap hanging from the belt that covers the anchor fold. Similarly, the top part of the women's *sarong* has a large flap, but there are no gems suspended from the belt. One of the most characteristic innovations of this style are the jewels that are chiseled in the stone. The diadem has become more ornamented and is occasionally combined with a layered conical bun.

The Pre Rup style (10th century) adds few original touches, although several bas-reliefs anticipate the Banteay Srei style.

The Banteay Srei style (10th to 11th century) developed simultaneously with the Pre Rup style. Two tendencies can be seen: the first is the continuation of the two preceding styles, and the second, which is more daring, owes its inspiration to past models that it tries to adapt to the tastes of the period. The statues are more naturalistic, the poses more relaxed, and the faces more cheerful, with full, sensual lips surmounted only by a finely chiseled line representing a mustache. The Kulen style *sampot* reappears for the men. The *sarong*

Upright *devi* (sandstone, 7th century, Musée National des Arts Asiatiques-Guimet).

mustaches; the eyes are sketchily carved and have hollow sockets. The hairstyles consist of finely braided tresses mounted in a round bun held at the base by a pearled band. The statues do not wear diadems. Although the *sampots* cover only half the thighs in small vertical folds, at the back they rise higher over the waist; the draped pieces in front, as in the Banteay Srei style, fan out across the left thigh; there is a butterfly-shaped knot placed at the back on the belt. The *sarong* of the female statues adopts basically the same form, except that the piece of fabric draped over the belt in front is noticeably longer. The women's belts may have small ropes or even short tear drop ornaments.

The Angkor Wat style of the following period improved and developed the innovations of the Baphuon era. The free sculptures of the Angkor Wat style mark a return to inert, heavy forms, unlike the bas-relief carvings that are character-ized by gracefulness and movement. The statues are generally small, except for the colossal gate-way guards (*dvarapala*) that are over 3 m in height. The statues' *sampots* retain the draped double anchor shape in front, but add a pleated flare extending from the right hip to the left thigh. The *sarong* of the female statues has the same form as the Baphuon style with its tiny folds, but

on the women's statues has central vertical pleats flaring below the belt and forming an S-shaped piece above; their wide and highly ornamented belt is hung with garlands and pendants imitating the precious jewels crafted by the goldsmiths. There seems to have been no notable change in hairstyle. The statues placed on the wall are small in order to harmonize with the reduced dimen-sions of the monuments.

The Kleang style (10th and 11th century) would appear to follow the preceding Banteay Srei style, but there is insufficient information about this period.

The Baphuon style (11th century) produced elegant statuary of smaller dimensions. The bod-ies of the statues are long, with a narrow pelvis and broad shoulders dominated by a large head. The faces are similar to those of the Banteay Srei style except that the chins, which are frequently cleaved, show only faint traces of beards and

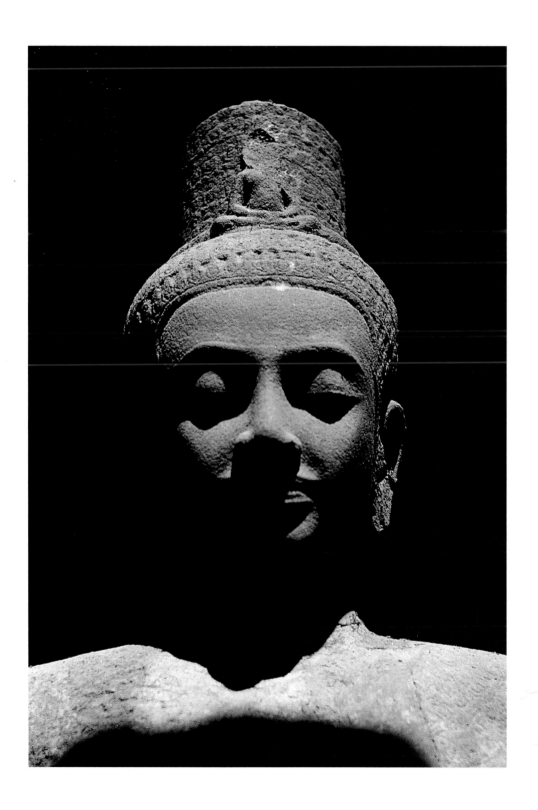

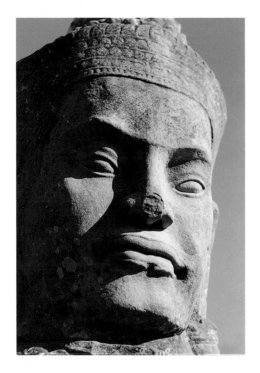

adds embroidery to the hem of its central flap in a fishtail shape. The images of the goddesses on the bas-reliefs display at once a considerable diversity of dress and a great harmony of composition. Their hairstyles might appear extravagant, but they are always very elegant.

The Bayon style (13th century) is celebrated for its renowned mystical smile, the best-known examples of which can be seen on the faces on the towers. The extraordinary technical mastery and perceptiveness of the sculptors is even more evident in certain statues in the round, notably of Buddhist inspiration. The difference between statues in the round and bas-relief work that appeared during the preceding period becomes more distinct in the Bayon style. As regards the clothing, the *sampot* shortens and abandons its flares, but retains the double anchor shape or the fishtail-shaped piece in back or in front. The women's *sarongs* are smooth now and embellished by designs of scattered flowers; an ornate braid appears on the edge of the flap and the lower part is slightly upturned.

Buddhist Statuary

We have no definite proof that Buddhism was brought into ancient Cambodia; the earliest signs of this religion in Funan go back no further than the 6th century, a time when works of stone and wood were made.

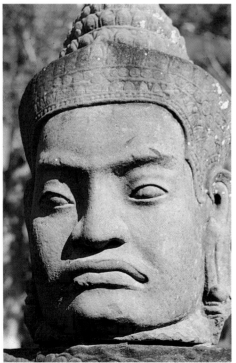

Heads of *devas* (*top* and *bottom*), south gate, Angkor Thom.

Facing page: bas-relief portrait of a warrior (detail), interior corridor, Terrace of the Elephants.

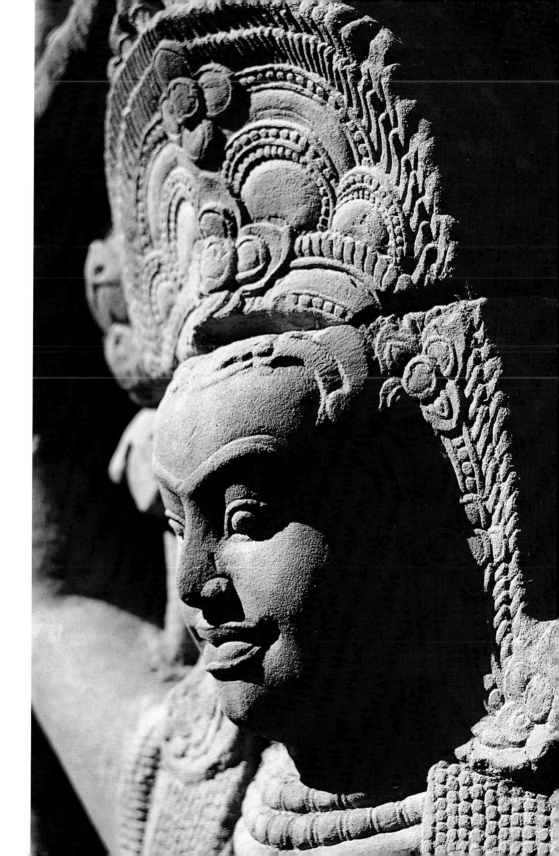

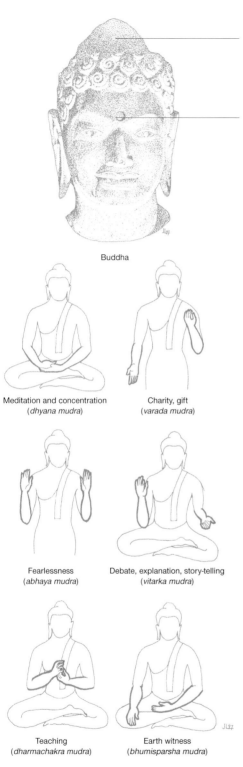

Buddha

Cranial protuberance
(*ushnisha*)

Third eye (*urna*),
absent from Khmer art

Buddha's hand gestures (*mudras*)

Meditation and concentration
(*dhyana mudra*)

Charity, gift
(*varada mudra*)

Fearlessness
(*abhaya mudra*)

Debate, explanation, story-telling
(*vitarka mudra*)

Teaching
(*dharmachakra mudra*)

Earth witness
(*bhumisparsha mudra*)

Images of Buddha were sculpted using the same techniques as those of contemporary Brahmanic sculptures. However, Buddha statues are harder to categorize. The influence of south India in all Buddha statues is evident in the posture, head, facial marks, hairstyles, and clothing.

The earliest pre-Angkor Buddha images show him in a standing position wearing a smooth robe wrapped around his body, but leaving his right shoulder bare. The garment falls behind the figure just below the knees, from where it rises to wrap itself under the left forearm, or else it is held in the figure's hand and descends to the ankles. The face is full; the ear lobes are elongated; the eyes may be either open or shut; and the hair is arranged in curls that are flat but worn close, emphasizing slightly a conical bump on the head.

Lost-Wax Process

The lost-wax, or cire-perdue, process is an ancient method of hollow metal casting.
The technique has evolved down the centuries, but essentially it involves the following steps:

- A model of clay, wood or plaster is executed.
- A clay or plaster mold is created from the model, made up of several pieces.
- The interior of the mold is coated with a layer of wax whose thickness will determine the desired thickness of the metal.
- The empty spaces of the mold are then covered by fire clay and holes are made in the mold.
- A first firing melts the wax, which leaves the mold through the holes (hence the term "lost-wax").
- The metal (generally bronze) is then poured through the vents in place of the wax.
- After a cooling period, the statue is lifted from the mold.
- Finally, the surface of the statue can be chiseled and refined as desired.

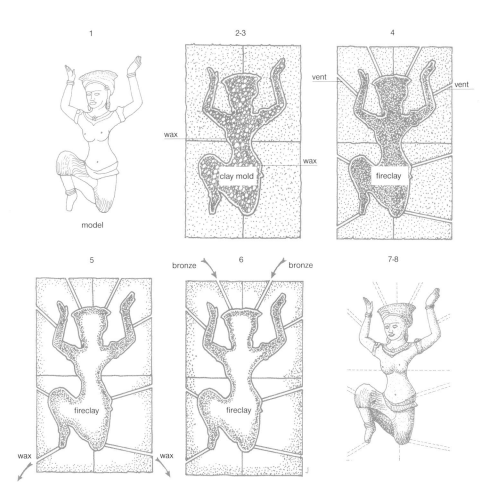

There is almost no trace of statues of Buddha from the Angkor period before the middle of the 10th century, a time when numerous representations were created. The statues were treated in the same manner as the Brahmanic images, with finely drawn mustaches, bare torsos, and hair arranged in squares and held by a band. Statues of Buddha seated on coiled *nagas* abound, but the outstanding representations of the Angkor Wat style are the Buddhas wearing a monk's garments and adorned with diadems, necklaces, bracelets, chiseled belts, and pendants. The faces of this style have open eyes and occasionally mustaches.

The Buddhist iconography of the Bayon style is a particularly clear expression of Mahayana Buddhism. The style saw the invention of new facial expressions. Particularly important are the *naga* Buddhas, which were seldom adorned. Other Buddhas wear precious jewels and finery: they are placed standing on high-reliefs, lean on stelae or meditate in the lotus position.

The statues of Buddha show the subject performing the hand gestures (*mudras*) that were part of the Brahmanic tradition.

Bronze Statues

Discoveries of the pre- and protohistorical sites of ancient Cambodia, particularly that of Oc Eo located in present-day southern Vietnam, provide evidence of a very old bronze-making industry. Numerous bronze objects have been found on this site—idols, jewels, pieces of ritual or domestic furniture—and form the basis of our knowledge of the ancient Khmer metalwork. The bronze pieces that have been identified as belonging to the pre-Angkor period demonstrate the skill and technical mastery of the craftsmen and founders. Most of the pieces, even the larger ones, were executed using the lost-wax process.

For large-scale works (recumbent Vishnu on the West Mebon), the statue's end joints (arms and hands) are sometimes reinforced with the addition of metallic pieces or strengthened with metal pegs.

The smaller statuettes are generally solid, while the larger ones contain a core formed by highly burned wax that assumed the appearance of coal. The monumental works are hollow. All the Khmer bronzes are of capital importance for iconographic studies. A large collection of them can be seen at the National Museum at Phnom Penh.

Shiva performing the *tandava*, his cosmic dance, bronze statuette (National Museum, Phnom Penh).

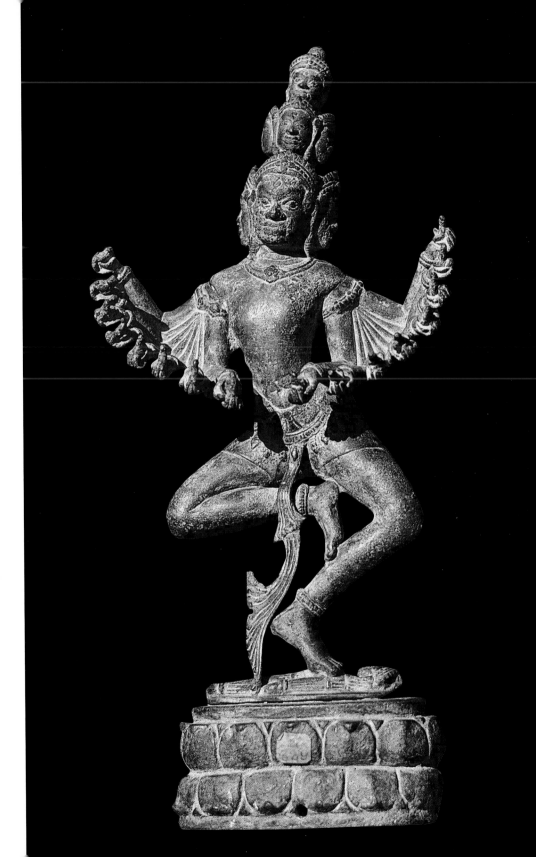

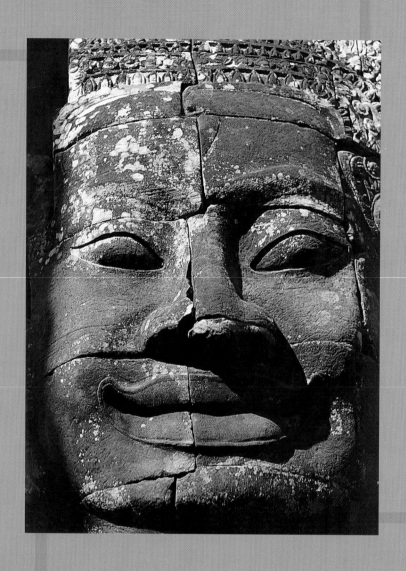

Guide to the
Monuments

How to Use
the Guide

Transcription of Khmer Names

The Indianization of Southeast Asia brought with it a specific vocabulary of architectural terms. Unfortunately, there is no documented text that can serve as a guide to the names of the monuments. Many of these names appear to have been created or recomposed—in many cases by non-native Khmer speakers—long after the temples were built and then evolved over time. The temples were sometimes named after the divinities inhabiting them, after their founders, or after the person to whom they were dedicated. Some were named after a great event and occasionally they were named after the place where they were built.

Interpreting the names of the monuments is a hazardous exercise and the translations given here should be treated with some caution.

Page 124: Face on a tower with the characteristic smile, Bayon.

Angkor Wat

អង្គរវត្ត

Meaning: the city-pagoda	Restoration: 1948, 1950,
Date: first half 12th c.	1954, 1961
Built by: Suryavarman II	Pron.: angko vouat
Religion: Brahmanic (dedicated	Map: N 24
to Vishnu)	Interest: **** archeo./art.
Cleared: 1908–11	Visit: am or end of pm

Each monument has its own section, at the beginning of which there is a table of facts, points of interest and tips. The specimen entry above explains how this table is presented.

The heading at the top is the transcription in Roman characters of the monument, in this case Angkor Wat.

Meaning: this is a translation of the Khmer name ("the city-pagoda").

The entries "Date," "Built by," "Religion," "Restoration" and "Cleared" are self-explanatory.

Pron.: the Khmer pronunciation of the name (angko vouat).

Map: the grid reference identifies the square on the map in which the monument can be found.

Interest: each monument is graded on a scale of one to four stars and a basic category of interest is given–"archeo." for archeological, "art." for artistic and "walk" for those that provide pleasant outings. Some monuments may belong in several categories.

Visit: the best time for visiting–morning (am) or afternoon (pm).

Access

For convenience, directions to the monuments are generally given in relation to the two routes devised by French archeologists, known as the Petit Circuit (approximately 17 km long) and the Grand Circuit (approximately 26 km long). Both of them start at the edge of the south moat of Angkor Wat. Depending on which monument you are visiting, you will either need to turn left or right when taking either of these routes.

Monument enclosure walls are numbered starting from the center of the monument.

Ak Yom (592)

 អក់ យំ

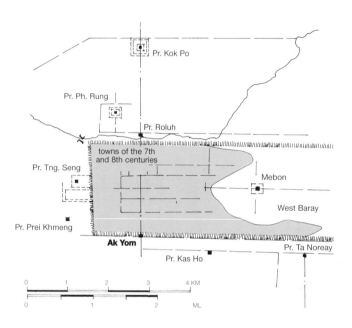

Meaning: the crying bird

Date: 7th–9th c.

Built by: unknown

Religion: Brahamic

Cleared: 1932–35

Map: K 3

Pron.: akyom

Interest: ** archeo.

Visit: am or pm

Left: location of Ak Yom.

Facing page: general plan.

Access

From the square in front of the Grand Hotel d'Angkor in the center of Siem Reap, take the Sisophon road heading west. After 7.5 km, take the road on the right to the West Baray. Once you have reached the south bank of the *baray*, follow the path going west. The monument will appear on the left, below the bank, 600 m southwest of the *baray*.

Characteristics

The Prasat Ak Yom was probably part of a group of small pre-Angkor monuments that bordered the west side of the West Baray. The clearing of Ak Yom did not take place until 1932 and was only partial, as most of the temple lay beneath the dike of the *baray*, which was needed to retain the waters of the reservoir. Ak Yom represents the prototype of the temple-mountain, which evolved considerably over the course of time.

Description

A precise description of this monument only became possible after it was cleared in 1935. The whole of the northern side of the temple has been buried by earth from the southern dike of the

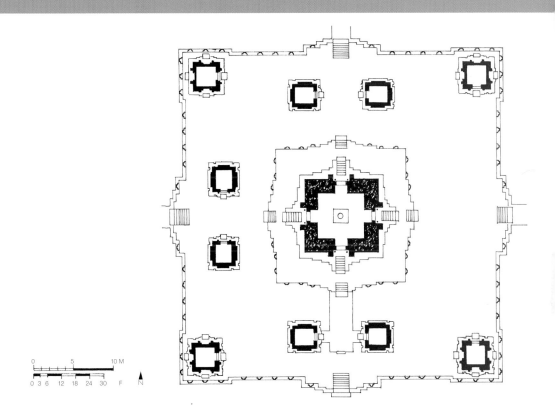

0 5 10 M

0 3 6 12 18 24 30 F N

baray (to the right of the monument) that has been carried there by the strong monsoon rains. Nevertheless, the foundations of the central sanctuary are recognizable; on the upper part lies a large grooved block of sandstone broken in two. The block, which is a perfect square, has a round central hole leading directly to a well below. On the north side, a highly sculpted lintel lies on the ground. There are a few remaining steps on the west side, and further south the traces of three brick towers are visible.

The monument is a three-tiered pyramid. The outer brick wall of the first level forms a vast square recipient filled with earth. The remains of four corner towers and six intermediate towers are still discernible. Above this first foundation, two other levels, paved with bricks, display projecting decorations.

A central square tower measuring over 9 m on each side crowns the highest terrace. The presence of slots for posts suggests that this tower and the corner towers, which are also in brick, may originally have been covered by a wooden roof. An additional brick wall was later added to the towers to permit the construction of a corbeled vault. The central tower is much higher than the other shrines.

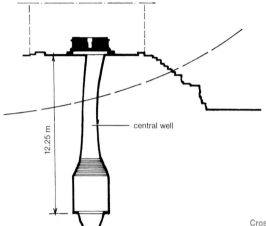

Cross-section of the underground chamber.

Inside the shrine, an imposing pedestal, now broken in two, once held a *linga*. From the floor of the cella, a central well (diameter 1.20 m, depth 12.25 m) leads to a square underground room (2.7 m by 2.7 m) with a brick vault. This chamber must originally have enclosed a sacred offering that has been pillaged. Two gold leaves engraved with elephant images were found here, although their original location has still to be precisely determined. The motifs on the temple walls are valuable elements in the study of the pre-Angkor decorative arts.

Several pieces made of sandstone come from a more ancient temple: a jamb from the door of the central *prasat* is inscribed with a text dated June 10, 674. The lintels are in a typical pre-Angkor style and their arches have medallions with hanging pendants, evidently taken from other places. On certain lintels, the animal images tend to become foliage. The small cylindrical columns are decorated with several bands of leaf and pearl motifs.

The false sandstone doors have particularly complex decorations, which include a central band adorned with spiral floral motifs alternating with raised stone "knobs" embossed with human images. The central section is surrounded by larger square bands with medallions of animals in the center and foliage around the edges. Images of female goddesses (*devatas*) appear sharply in relief on the brick walls between the pilasters; as in Indian representations, the goddesses' supple bodies have three curves. Several window frames and one of the *devata* friezes are inscribed with the dates of A.D. 600, 704, and 1001.

Angkor Thom

អង្គរធំ

Meaning: the great city	Restoration: doors in 1944, south	Map: DJ 19-25
Date: end 12th–early 13th c.	causeway in 1955 and 1960	Interest: *** archeo.
Built by: Jayavarman VII	Pron.: angko thom	Visit: am
Religion: Buddhist		

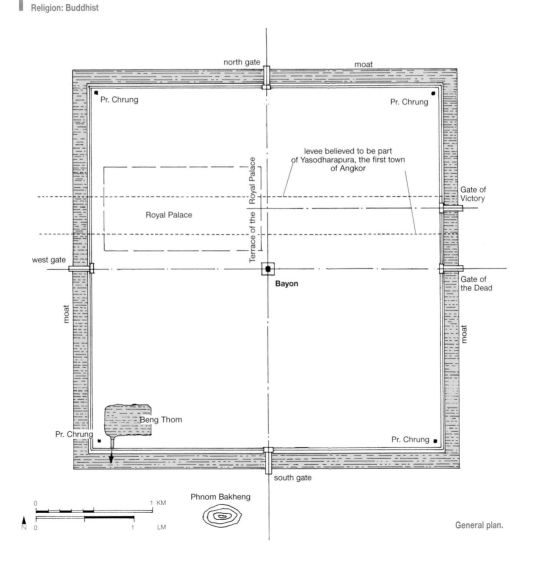

General plan.

Access

Follow the Petit Circuit on the left in front of the moat. The great enclosure wall of Angkor Thom is usually entered by the south gate situated 1,600 m north of the west causeway leading to Angkor Wat.

Characteristics

The wall which surrounds the last capital city of the Khmer empire forms a square with sides of 3 km enclosing an area of 900 hectares. This vast quadrilateral that covers the northern part of Yasodharapura, the first city of Angkor, is divided by two axes, north-south and east-west; each has a single gate except the east which has two. The axes intersect at the Bayon temple. The outer wall is faced in laterite and curbed with sandstone. It is surrounded by a moat 100 m wide and 5 to 6 m deep in places.

Description

In 1177, the invading Champa troops had no difficulty entering the city of Angkor, which was only protected by a wooden wall. When Jayavarman VII founded Angkor Thom, he may have surrounded it with a high wall to provide protection in the event of a new attack, but it is also possible that it was erected as a fourth enclosure for Bayon.

Outer Wall

The rampart is made of laterite blocks almost 1 m thick and approximately 8 m high with a projecting base. It is reinforced internally with earth that rises the full height of the wall, which is topped by a sandstone coping. The earth embankment, in fact, serves as a path along which Jayavarman VII built small temples called the Prasat Chrung at each of the four corners of the city (see below). As the wall had no fortifications such as machicolations, lookout turrets or embrasures, this defensive wall was strictly symbolic. The inhabitants doubtless entrusted their fate to the will of the gods.

Inside the wall, between the northeast and southwest corners, the earth embankment slopes down 3 m into the Beng Thom, or Great Pond, (400 m long by 250 m wide). The latter empties into the moat through five vaulted passages through the earth levee and the base of the wall. The inner city contains a complex but largely invisible network of drainpipes and canals.

Gates

Angkor Thom may be entered through five gates, four of which lie on the Bayon temple axis; they are the south gate, the north gate, the west gate and the east gate, known as the Gate of the Dead. The fifth entrance, the Gate of Victory, also on the east side, is situated in the center of the terrace of the royal palace. The five gateways are all built to the same architectural conception. The south gate is the most accessible and its causeway has recently been restored.

South gate, Angkor Thom.

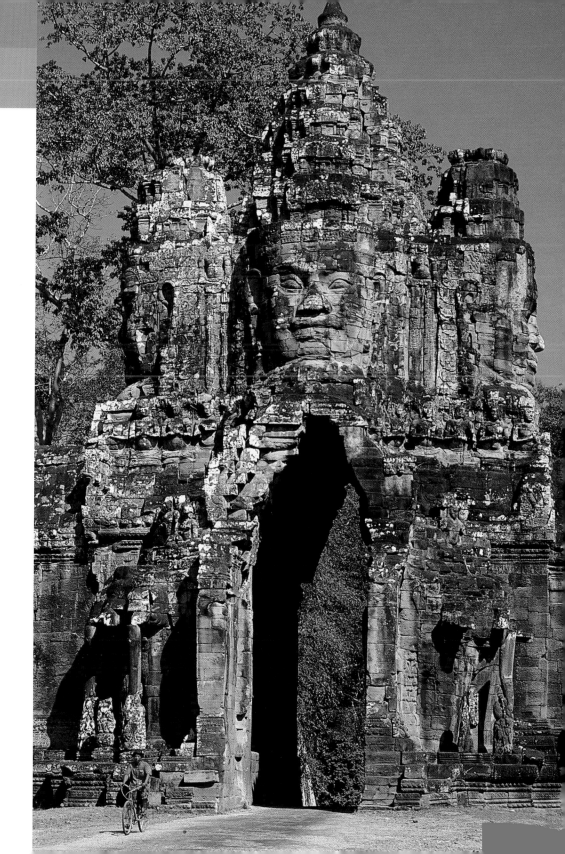

South Gate: Causeway

The gateway is entered by crossing the moat on a dike (16 m wide, 108 m long and up to 6 m high). The side walls are made of laterite and the causeway is an earth embankment. The causeways prevent the four sections of the moat from connecting with each other. The causeway walls are capped by a sandstone coping on which stand fifty-four stone giants on each side (as the Chinese envoy Zhou Daguan noted at the end of the 13th century). Each figure (2 m high) holds part of the body of a *naga*. At the entrance to the causeway, the *nagas* unfurl their hoods with their seven embedded heads (4 m high). At the other end, near the gate, two multi-headed stone colossi hold the *naga* tails. The giants on the right side of the causeway are demonic: they have harsh features, frowns, downturned mouths, round, protruding eyes and strange hairstyles in the form of bands of leaves falling behind their ears. The giants on the left side (walking north) have serene faces and foreheads circled by diadems beneath conical tiaras. Most of the heads have been replaced by copies.

The identity of these figures has long remained a subject of speculation. One of the first theories suggested that, in accordance with Indian mythology, the *naga* when held by the giants symbolized the rainbow that links the world of the humans—Angkor Thom, the royal city—to the universe of the gods. According to another theory, the serpent and the gateway giants are related to the *nagas*, the *asuras* and the *devas* in the myth of the Churning of the Ocean of Milk as they appear on the southeast bas-relief of the third enclosure of Angkor Wat. If this

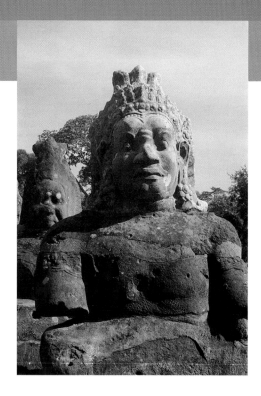

A demon (*asura*) pulling on the *naga*.

theory is true, then the waters of the moats would represent the ocean. A more advanced version of this second theory interprets the pivot of the churn (in the hands of Vishnu) as being the core of Bayon, whose round, central Mount Mandara would have made an excellent instrument to beat the milk from the waters of the ocean; the giant guardians of the gateways would have helped the process by pulling on the *naga* as a cable. Another recent theory envisages the *nagas* as the guardians of the wealth of the royal capital.

South Gate

The south gate is 30 m long and on average 5 m wide. It consists of three face-towers, the central

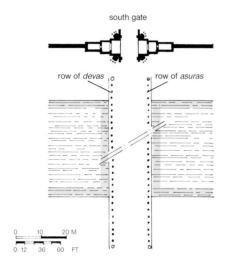

south gate

row of *devas* row of *asuras*

0 10 20 M

0 12 36 60 FT

and tallest one of which includes two wings link-ing with the sandstone enclosure and a cart track. Inside the building, there are two square platforms (3 m on each side) ending in short flights of stairs that lead to passageways terminating in oblong windowless chambers.

Each of the four corners of the central building has a magnificent statue in the round of a three-headed elephant gathering lotus flowers with its trunks; the statue (6 m high) rests on a pedestal. A god resembling Indra, the god of the air, sits on the elephant; in his right hand, he holds a *vajra*, the weapon that launches bolts of lightning across the sky. Celestial female dancers form a ring around him.

An ornamented cornice encircles the right and left wings of the building 7 m above the ground. At the four corners of the cornice where the roof begins, four upright *nagas* rear their heads. The left and right wings of the edifice are vaulted with

an extrados imitating rows of tiles; finials crown the roof. The central section of the building is cov-ered by the beginning of a vault dominated by a frieze of statues in the round (1 m tall) represent-ing seated praying figures. The middle tower (24 m tall) has two faces, one facing the cause-way, the other the Bayon. Each face has open eyes, ear lobes distended by heavy rings and long pearl-shaped pendants. The ornate, tiered, cone-shaped crown ends in a lotus flower bud. The other two sandstone structures each have only one face. There is about a 4 m difference in height between the middle tower and the flanking tow-ers, which have a similar decoration; their cone-shaped tops have only two tiers and terminate in a large lotus flower crown.

In the axis of the central block, two short pro-jecting walls formed the jambs of former pas-sageways that would originally have been 7 m high. Heavy wooden doors opening on both sides protected the city; these were mounted on pivots and reinforced by a system of bars that were inserted into holes (still visible) in the sand-stone walls.

Other Gates

The other four gates to the north, west and east (the Gate of the Dead and the Gate of the Victory) are similar to the south gate.

Other Monuments

Many other monuments, notably the Bayon, the royal palace, the Khleang and the Prasat Suor Prat, can be found within the outer wall, sur-rounded by forest (see the relevant sections).

Angkor Wat

> See descriptions of the
major bas-reliefs on pages
333-346.

Meaning: pagoda city

Date: first half 12th c.

Built by: Suryavarman II

Religion: Brahmanic (Vishnu)

Cleared: 1908–11

Restoration: 1948, 1950, 1954, 1961

Pron.: angko vouat

Map: N 24

Interest: **** archeo., art.

Visit: am or end pm

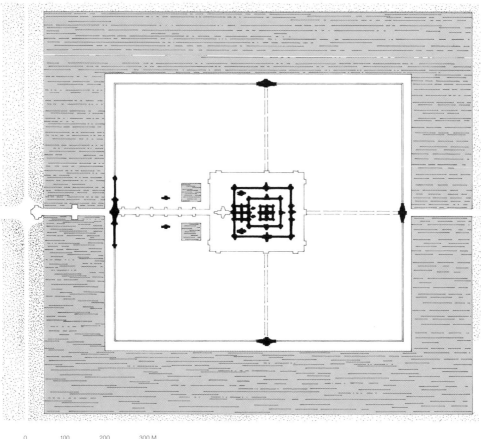

Access

Take the Petit Circuit on the left. Follow the dike until you reach the great west causeway.

Characteristics

Angkor is the masterpiece of Khmer temple architecture; the magnificence of its symmetry is equaled only by the harmonious beauty of its soaring towers. The extraordinarily rich decorations inside, notably the bas-reliefs, display an exceptional compositional sense and mastery. This collection of legends in stone is of unique archeological value and iconographic interest.

The presence of the monks in the Buddhist monasteries nearby helped protect the temple from the vegetation and insured that Angkor Wat would continue to be a popular place of pilgrimage for Cambodians even after it ceased to be the Khmer capital in 1431.

General plan.

Description

Angkor Wat is a tall three-tiered pyramid that forms the base for a central shrine and four towers arranged in a quincunx pattern; the whole temple complex is surrounded by an enclosure and a moat. Unlike most Khmer temples, where the main entrance is to the east, Angkor Wat is approached from the west. Taking into account the temple's funerary purpose and the frequent association of the god Vishnu with the west, some archeologists have attributed this unusual orientation to religious requirements, while others believe it may have been for topographical and town planning reasons.

With its outlying moats, Angkor Wat forms a rectangle of 1,470 m by 1,650 m and covers an area of more than 240 hectares. The temple, itself, located at the edge of the third gallery, measures only 187 m by 215 m. The monument is the largest architectural complex at Angkor.

Angkor Wat was both a temple and a tomb erected by the god-king Suryavarman II, who identified with Vishnu. When he died, his ashes were deposited in the tomb and he was deified and named posthumously the "king who left for the supreme abode of Vishnu" (Paramavishnuloka). In accordance with the Brahmanic custom, the funeral rite involved circumambulating the temple counterclockwise (prasavya).

The causeway on the east side, which is a simple levee of earth, is a possible although rarely used entrance. We shall begin our visit through the main entrance, from the west.

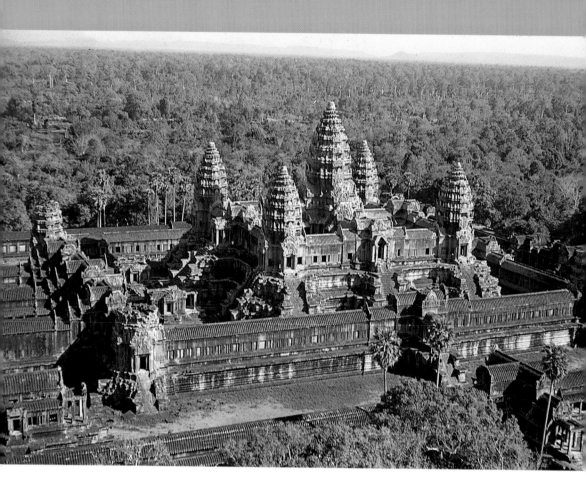

The second and third enclosures, Angkor Wat.

Outer West Causeway

After leaving the road and ascending a few steps, you will reach a cruciform terrace guarded by seated stone lions and upright *nagas*, unfortunately in a very poor condition. They marked the ends of a balustrade supported by dice-shaped stone blocks that have, for the most part, disappeared. You will see a paved causeway (12 m wide, 250 m long) with a landing stage on either side halfway along. A flight of steps, with string walls supporting stone lions, leads down to the level of the moats.

Moats

The two moats which enclose the fourth wall are magnificent expanses of water, separated by the east and west causeways. They are 200 m wide, cover a surface area of 96 hectares and, at the present time, average 2 m in depth. Their rugged banks are made of laterite steps with a wide sandstone coping.

On either side of the west bank, you will see the bottom section of two flights of steps that have also been restored, as well as two landing stages.

Fourth Enclosure

The west causeway terminates in the grand entrance pavilion (*gopura*), reached by ascending a few steps. The *gopura* marks one of the axes of the outermost wall, which is separated from the moats by an earth embankment 30 m wide. The wall is over 4 m in height and is made of laterite blocks placed on a profiled base; the upper part has a pronounced cornice surmounted by a sandstone coping. At the midpoint of each of the three sides is a smaller *gopura*.

West *Gopura* of the Fourth Enclosure

The *gopura* of the west façade (100 m long) is the most extensive and includes a central pavilion and two annexes or wings; but only the central pavilion gives access to the fourth enclosure from the outer west causeway.

The cruciform central pavilion is made of sandstone and contains two porches. It has a partly truncated pyramidal roof with graduated tiers. Both wings are connected to the main building by a short vaulted gallery with a wide opening on the side facing the moats.

The annexes are identical in structure to the central pavilion, but smaller. A raised gallery approximately 60 m long extends to the north and south of both annexes. Both pavilions are cul-de-sacs, leading to a false decorated sandstone door. Like the previous gallery, the wall is blind on the temple side but open on the moat side, with a row of columns. The gallery is covered by a corbeled vault. Beyond the false doors, a great covered porch extends from the outer bank to the vast interior esplanade. This is actually a cart track high and wide enough to be used even by elephants.

Inside the enclosure there are three other sandstone *gopuras*, measuring 38 m long and on average 26 m wide. Raised on several steps, each one of them encloses a central hall surrounded on either side by columned wings. Like the pavilions on the west façade, their annexes have vaults; a tiered pyramid covers the hall.

The darkness of the west *gopura* contrasts vividly with the wide open, sunny perspective of the long causeway. From this vantage point, the three visible towers of the temple resemble a giant hand reaching up to touch the blue sky or the golden mists of the setting sun.

Inner West Causeway

This causeway has sandstone paving and is 9.40 m wide and 350 m long. Stairways (twelve in all) placed at 50-m intervals on either side lead to the great interior esplanade 1.50 m lower down. The stairways have string walls. Both sides of the

causeway have *naga* balustrades. To the right of each stairway, on the highest string wall, the *nagas* raise their sinuous bodies to "sprout" their seven heads of stone. At the end of the causeway is a vast platform.

Platform

This vast platform (245 m wide, 360 m long) consisting of an earth-filled sandstone base is 1.40 m higher than the espalanade. There are three entrances to the platform: 1) the two stairways on the west façade; 2) the causeway; 3) the three

stairways located on each of the two other sides. The *naga* balustrade around the platform is interrupted only by the stairs and the causeway, which abuts a high cruciform terrace leading to the temple.

Libraries

The visitor who starts from the west *gopura* and reaches the fourth stairway on the causeway will see to the right and left a library and a pool. The libraries, which are in extremely poor condition, stand about 20 m from the causeway. They are

General view of Angkor Wat from the west.

elongated, gracefully proportioned, cruciform structures, 35 m wide and 55 m long, standing on high bases of carved sandstone. They are reached via stairs leading to columned porches. The interior consists of a central room and two wings with columns. Numerous barred windows provide light for the whole structure. The roofs start with a half-vault that abuts a high parapet wall supported on internal pillars. The other four sections of the *gopura* intersect at the center to form a groin vault. A few remnants of decoration are still visible inside the building, on the upper wall.

Basins

Returning to the causeway and heading toward the temple, you will see two rectangular basins (53 m wide, 110 m long) that are symmetrical to the axis of the monument. They were originally bordered by a sandstone curb, which is still in place round the north basin. This particular basin is usually kept filled with water covered by lotus flowers.

Our long walk has now led us to the great cruciform terrace that leads to the actual entrance to the temple.

NW CP

The Battle Between the *Asuras* and the *Devas*

The Battle of Lanka

NL 3

NL 2

cruciform terrace

WG 3

cruciform galleries

WG 2

SL 2

L: library
G: *gopura*
CP: corner pavilion
N: north
S: south
E: east
W: west

The Battle of Kurukshetra

SL 3

| 0 | 5 | 10 | | 20 | | 30 | | 40 M |
N | 0 | 10 | | 50 | | 100 | | 130 FT |

suggested itinerary —————

SW CP

The Historical Parade

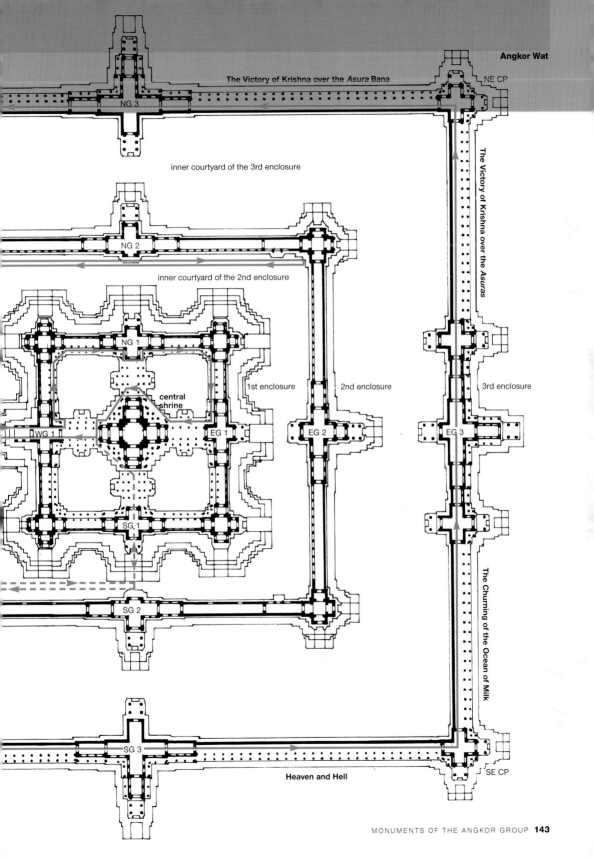

Angkor Wat

The Victory of Krishna over the *Asura* Bana

NE CP

NG 3

inner courtyard of the 3rd enclosure

The Victory of Krishna over the Asuras

NG 2

inner courtyard of the 2nd enclosure

NG 1

central shrine

1st enclosure

2nd enclosure

3rd enclosure

WG 1

EG 1

EG 2

EG 3

SG 1

The Churning of the Ocean of Milk

SG 2

SG 3

Heaven and Hell

SE CP

Cruciform Terrace

This structure 42 m wide and 50 m long has two tiers, the first 2.5 m high and the second rising 50 cm above this level and set back 50 cm from the edge of the lower tier. A profiled sandstone wall skirts the length of the terrace, providing a narrow open passage that was formerly enclosed by a *naga* balustrade. A row of fluted columns supports the wall. Three stairways flanked by lion sculptures lead to the upper terrace, which is surrounded by the remains of the emblematic *naga* balustrades. Sacred dances may have been performed here.

Advancing eastward, the visitor will come to the west *gopura* of the third enclosure wall.

Third Enclosure

The first terrace (2.50 m high) of the pyramid is maintained by a wall with sandstone facing adorned with thick moldings. This first terrace forms the base for a rectangular gallery (177 m by 212 m) with sandstone paving. The gallery itself, 4.5 m wide, is lined by a sandstone wall decorated with magnificent bas-reliefs. On the opposite side of the gallery, on the outside, there is an open wall with columns in double rows forming two passages, 2.40 m and 98 cm wide.

The gallery roof begins as a half-vault resting on the outer columns connecting with a full vault resting both on the inner row of columns and the wall decorated with the bas-reliefs. The vault of the inner row of gallery columns once had a decorated wooden ceiling supported by means of a cornice. Each of the four sides of the gallery has a *gopura* and a pavilion at its corner. The roofs of

the *gopuras* and the corner pavilions terminate abruptly in gables.

The west and east *gopuras* have identical architectural plans and dimensions; 60 m long, they are composed essentially of a central room with an extended porch; a passage surrounded by a wall with windows joins them to two other small cruciform wings that are identical in structure with the corner pavilions.

The north and south *gopuras* are exactly like the ones on the east and west sides but have smaller dimensions (only 33 m long) and the annex buildings were never constructed.

The cruciform corner pavilions are set within a square measuring 10 m on each side. The *gopuras* and corner pavilions have stairways connecting them with the outside ground level of the surrounding gallery of the third enclosure.

Gallery of Bas-Reliefs

This gallery defines the sacred space of the temple and would have been inaccessible to commoners, who could only watch the ceremonies from the esplanade or the platform surrounding the third enclosure. The width of the passages was not suited to the needs of great processions.

The bas-reliefs, 2 m in height, are carved in the sandstone. Combined, the panels cover a surface area of around 1 sq km. Pilgrims coming to venerate the temple over the centuries used to rub their hands against certain parts of the bas-reliefs, thus creating the smoothness that is noticeable to this day. The reliefs recount the legends of Vishnu and King Suryavarman II. The quality of the sculpture varies widely; the south and southeast sides

King Suryavarman II, builder of Angkor Wat, Gallery of the
Historical Parade.

and the walls of the west façade display the best
panels; the other images are coarse and crudely
sculpted. Several panels were executed in periods
following the reign of Suryavarman II.

To be able to "read" the bas-reliefs, the visitor
must be aware that the Khmer sculptors con-
ceived of perspective as the superimposition of
different registers within a scene. "Near" and "far"
in relation to the viewer mean being either in the
lower or the upper tier of the panel. Thus the
viewer needs to mentally tip the panel backward
to read the bas-relief.

A brief description is provided below, but more
precise details can be found in the appendix.

The visitor might want to respect the ancient
Khmer tradition of starting with the ritual *prasavya*,

which means turning right immediately after the
west *gopura* and keeping the shrine on his or her
left. Note the high thresholds in the doorways that
were intended to keep out the evil spirits that
moved about close to the ground.

West Gallery, South Wing:
The Battle of Kurukshetra

The panel of this bas-relief is 48 m long. It is struc-
tured so that the scene converges from either side
toward the center and the principal theme, the
Battle of Kurukshetra. This was an episode in the
conflict between the Kaurava and Pandava clans
and forms part of the great Indian epic, the
Mahabharata.

Southwest Corner Pavilion

This pavilion with its four axial side chambers, lin-
tels, doors and windows becomes a stone canvas
for themes inspired by the *Ramayana* and the life
of Vishnu.

South Gallery, West Wing, called The Gallery
of the Historical Parade

This bas-relief almost 90 m long is entirely dedi-
cated to King Suryavarman II, builder of Angkor
Wat. A procession of court figures parades on the
bottom left side of the panel; a group of armed
troops toward the top of the panel are shown
squatting, awaiting orders. The sovereign, who is
seated on a throne on the edge of a mountain, is
surrounded by court sages and dignitaries; then
the troops are shown descending from the moun-
tain to join the marching figures in a new proces-
sion of foot soldiers, knights and war elephants

ridden by the generals. Two-thirds of the way along the panel, the sculptures represent religious men led by a military marching band following a guard of bizarrely dressed mercenaries marching in a disorderly way. After the south *gopura*, the visitor enters a new gallery.

South Gallery, East Wing, called the Gallery of Heaven and Hell

The beginning of this panel 63 m long begins its story in three registers which end as two. The scene shows the dead receiving rewards or punishments according to the good or bad deeds committed during their lives. A third of the way along appears Yama, the god of death and the supreme judge, mounted on his bull and holding a club in his hand. He orders his henchmen to fling the evil-doers at the bottom of the panel into the thirty-two regions of hell, where they will suffer tortures and thousands of torments. At the top, the princes and

nobles enter the celestial palaces, where one of the thirty-seven paradises is waiting for them.

After passing the unadorned southeast corner pavilion, the visitor enters another ornamented gallery.

East Gallery, South Wing: The Churning of the Ocean of Milk

This bas-relief 47 m long represents the struggle between the envoys of good and evil. It is a symmetrical composition built around the central image of Vishnu directing the Churning of the Ocean. The benevolent gods (the *devas*) are at his right and pull on the *naga*, whose snake body

Fish, saurians and ocean monsters in the Churning of the Ocean of Milk.

becomes the cord to turn the churn while the evil gods, the fallen *asuras* pull in the opposite direction. At the foot of the panel, the fish and the strange animals inhabiting the waters are caught in the maelstrom created by the churn. The liquid that emerges is the *amrita,* the liquor of immortality which will also create many beings, like the celestial dancers, the *apsaras.*

Continuing the visit to the north, we arrive at the east *gopura;* there are no distinguishing characteristics except for an inscription on the left wall dating from the 18th century that relates the construction of the small funerary monument (*stupa*) whose remains are visible on the outside at the foot of the *gopura* base.

East Gallery, North Wing: The Victory of Vishnu over the *Asuras*

This panel 50 m long represents Vishnu mounted on the *garuda* driving off the many *asuras* (demons) who are attacking him from all sides. This piece was created during the 16th century, when Khmer art had lost the freshness of the early periods; the craftsmanship is distinctly inferior to that of the previous bas-relief.

The pavilion of the northeast corner has no significant mural decoration and is not worth a prolonged stop.

North Gallery, East Wing: The Victory of Krishna over the *Asura* Bana

This crudely carved bas-relief, also from the 16th century, narrates another episode from the epic of the god Vishnu appearing in his avatar, Krishna. A struggle between the god and the *asura* Bana, a

devotee of Shiva is depicted. A great image of Vishnu on a *garuda* occupies the center of the panel; it is a distinctly better work than the rest of the sculpture.

The north *gopura* has no significant decoration.

North Gallery, West Wing: The Battle between the *Devas* and the *Asuras*

This panel 95 m long is a variation on the theme of the battle between the friendly and the fallen gods. This image may also be seen as the eternal combat between the forces of good and evil that rule the world. To create this great cosmogonic battle scene, the artists introduced no less than twenty major divinities entering the tableau at the left of the panel; each is mounted on animal-drawn vehicles; the *asuras* enter from the right. The warriors encounter each other in a riot of interlaced bodies; the whole scene possesses an amazing energy.

We have now arrived at the northwest corner pavilion, which, unlike the other two pavilions described above, has great artistic and iconographic value.

Northwest Corner Pavilion

The bas-reliefs carved in this cruciform pavilion refer to various legends of Vishnu, with scenes from the *Ramayana*, including the slumber of the god above the waters of the Cosmic Ocean and the procession of the nine gods who supplicate Vishnu to incarnate himself on the earth. These sculptures cover wall panels, the upper doors and windows, the window frames and the typanum of the interior pediments.

West Gallery, North Wing: The Battle of Lanka

The Battle of Lanka is an episode from the *Ramayana*. The multi-headed giant Ravana, ruler of the island of Lanka (Sri Lanka), angered the gods with his evil deeds; the divinities ask Vishnu to intervene. Vishnu incarnates himself as Rama and forms an alliance with the king of the monkeys; then Vishnu-Rama prepares to do battle with Ravana, who has seized his wife and is holding her prisoner on his island.

Our visit has now reached the west *gopura*. One of the three stairways will lead us to a great rectangular courtyard 1.40 m higher.

Cruciform Galleries

The cruciform galleries occupy a courtyard measuring 47 m wide by 53 m long. The north, south and west sides of this courtyard have solid walls; the east side is formed by the west wall of the second enclosure. The cruciform galleries (8 m wide) divide the courtyard up into four smaller courtyards, each of which contains a small square basin (14 sq m) bordered by a molded sandstone wall (3 m high). The basins are reached by steps. The galleries have in all one hundred sixty pillars supporting vaults and half-vaults placed in double rows. The north and south sides of this court enclose small galleries (4 m wide), each separated from the outside by a wall whose single opening leads to the inner courtyard surrounding the second terrace of the pyramid. All the floors are paved in sandstone. The roof is a composition of half-vaults and full vaults that were once concealed by a decorated wooden ceiling. Friezes of *apsaras* appear on the molded entablature above the pillars, while scenes inspired by the Vishnu legends animate the interior pediments of the gallery abutments. Praying ascetics are portrayed on the bases of the columns. The gallery known as the Gallery of 1,000 Buddhas contains images sculpted many years after the construction of the monument; they have relatively minor importance, although they are still venerated by Cambodian visitors.

Inner Courtyard of the Third Enclosure and Libraries

The inner courtyard around the foot of the second terrace of the pyramid averages 30 m in width on the north, south and east sides and 45 m on the west side, which is the location for two other libraries. These two libraries, situated on the axis of the single doors of the north and south walls of the cruciform courtyard are similar to those of the fourth enclosure except that they are smaller (20 m wide by 35 m long) and have no antechambers or porches on the north and south sides. Their bases are approximately 6 m high and are accessed by four stairways. The visitor is advised to start his tour by the north library, where the stairways are easier to climb. There is a lovely view of the second enclosure and the courtyard; several admirable pediments still have their carved decorations. The corners of the library walls display well-preserved carvings of *apsaras*.

A series of false windows interrupts the incongruously austere walls surrounding the courtyard.

Returning to the cruciform enclosed space, we reach the building adjoining the second enclosure.

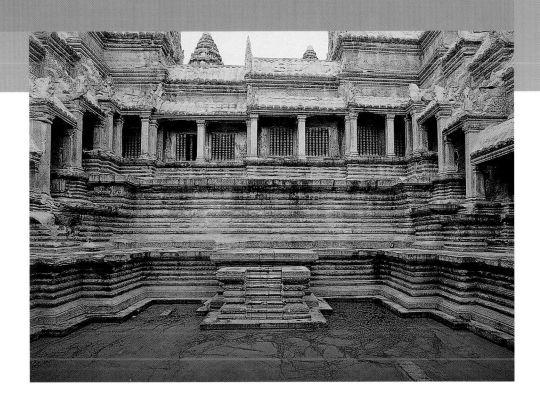

Pool and small courtyard, second enclosure, Angkor Wat.

Second Enclosure

The second enclosure consists of a highly pro-filed base 5 m high supporting a surrounding gallery. The upper section of the second terrace can be entered only from the inside on the west side by three stairways of three flights of steps; a recent wooden staircase has made the central flight more convenient. The stairways are covered with a series of corbeled vaults supported by pillars and walls. On the outside, the stone pediments create a billowy wave-upon-wave effect as they rise in succession.

The side gallery and the base composing the enclosure for this second level trace a rectangle with sides of 100 m by 118 m. It is 2.45 m wide and has, at its four corners, *gopuras* which are smaller versions of those of the third enclosure wall. These corner pavilions are massive cruci-form structures with no windows.

False windows with balustrades punctuate the solid walls bordering the gallery on the outside; however, the inner wall is open with small bays on the south side. There are many windows on the east and north sides; here the visitor will discover the celebrated *devata* images described in a fol-lowing section. The west wall, however, is blind.

Each *gopura* and corner pavilion is accessible by one or several particularly steep stairways.

Inner Courtyard of the Second Enclosure

Leaving the galleries by the central door of the west *gopura*, we arrive at a porch marking the start of the cruciform alleys, which each measure 2.50 m wide and are raised 1.20 m higher than

the interior courtyard level. They are lined with *naga* balustrades placed on a series of short stone columns and they lead to the large main stairway rising to the top platform of the temple and to two small libraries on either side of the main east-west axis; The libraries (7 m wide, 19 m long; base 1.20 m high) have the same structure as those of the inner courtyard of the third enclosure, but they contain only one room. They are partially ruined and missing their roofs.

The visitor will admire the images of the *devatas* on the north wall, whose grace and elegance are enhanced by their complex headdresses and attire. These lovely women move among tiny, intricately carved square frames. The floral motifs include miniature narrative scenes with human subjects. The most beautiful and admired *devatas* can be seen at the corners and on the north, east and west walls. Each door leading to the inner courtyard is topped by trefoiled pediments with a tympanum adorned by numerous small figures. A corbeled vault covers the entire gallery.

We have now arrived at the foot of the last and highest block of the temple, which supports the first enclosure and the central shrine.

First Enclosure

The base of the first enclosure (12.50 m high) is a sandstone block of highly molded steps diminishing in size as they rise. The visitor may reach the top by twelve stairways that lead either to the *gopura* or to the corner pavilions. Due to the steepness of the stairs (about seventy degrees), it is recommended to use the central stairway on the west despite its forty-five degree angle or a stairway with an iron ramp that has been placed over the central staircase on the south side; this recent addition has intermediate concrete steps of normal height.

The surrounding gallery of this enclosure forms a perfect square measuring 50 m on each side. Its exterior wall (2.50 m wide) has windows with balusters and its interior wall has a double row of sandstone pillars.

Four cruciform *gopuras* stand at the main axes; two cruciform pavilions on either side of the *gopuras* accentuate the corners. The four *gopuras* and four corner pavilions surrounding the main shrine are linked by covered galleries, also cruciform, that start at the *gopuras* and lead to the center where they converge at the main shrine. These galleries (7 m wide) are more spacious than the surrounding galleries and they enclose two porches.

The double row of pillars around the cross-shaped galleries and the surrounding gallery divide the area into four small courts, 1.60 m lower down, that might have been used as patios or pools where the worshippers cleansed themselves before entering the shrine; these courts are accessible by small stairways. Four vaults provide each *gopura* with a cruciform superstructure. Each corner pavilion is topped by an ogive-shaped five-tiered tower that is crowned by a lotus bud.

Wonderful *devatas* grace the *gopuras* and the corner pavilion walls.

The gallery offers exceptional views of the monument and the western causeway in particular.

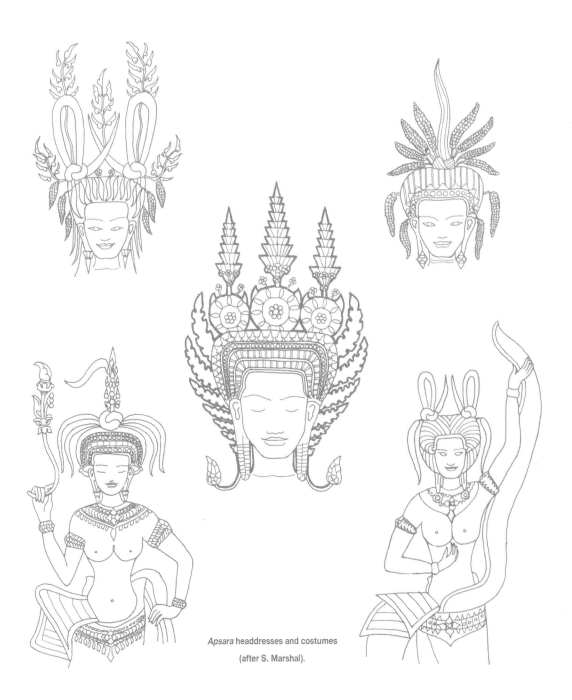

Apsara headdresses and costumes
(after S. Marshal).

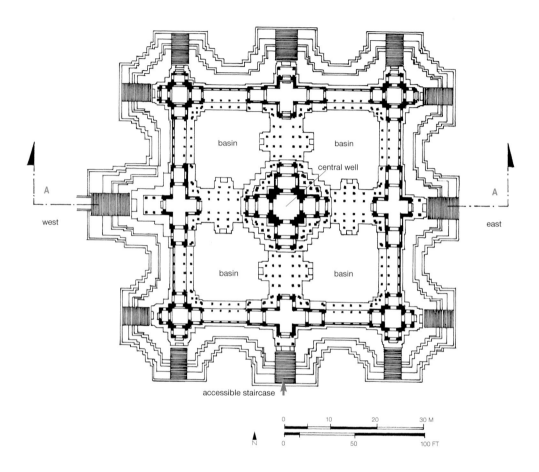

basin

basin

central well

A

A

west

east

basin

basin

accessible staircase

0 10 20 30 M

0 50 100 FT

N

Central Shrine

The cruciform shrine at the heart of the temple lies within a square cella measuring 5.50 m on each side. The cella is extended along each of its main axes by two open rooms of unequal dimensions adding nearly 18 m to the base. The sandstone block forming the side structure of the cella rises 16 m in successive tiers and forms an ogive identical to the corner pavilions but with a greater volume. The rooms adjoining the cella are covered by two-tiered vaults ending in pediments adorned with narrative scenes. The shrine tower rises more than 35 m above the floor of the gallery of the first enclosure and is 58 m higher than the esplanade surrounded by the moat.

The stone marks on certain sculptures and the traces of coating and paint suggest that the central tower, like the rest of the monument, may have been painted or gilded at one time. Originally, the cella opened onto the four façades and included

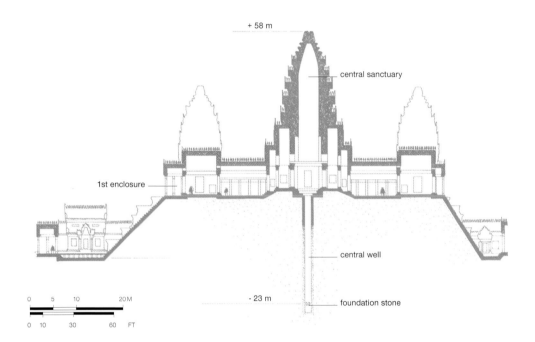

+ 58 m

central sanctuary

1st enclosure

central well

- 23 m

foundation stone

0 5 10 20 M

0 10 30 60 FT

Facing page: first enclosure and central shrine.

Above: cross-section.

a statue of the god-king, Vishnu-Suryavarman II. The occupation by the Buddhist monks several centuries ago brought changes to the layout. First, the image of Vishnu was removed, then several openings were closed and false doors became niches for the statues of standing Buddhas.

The main shrine of Angkor Wat has a deep well in the center, which is a feature of other Khmer temples. In 1935, the well was found to go 23 m below ground. Excavations under the temple's foundations revealed two superposed laterite blocks containing two hammered-gold leaves that had been placed in a circular compartment inserted into the upper block. These leaves, lying on crushed laterite, were separated by four other square gold leaves also covered by a very pure fine sand mixed with two white sapphires. Not surprisingly, the sacred treasure which was once stowed under the base of the god-king's statue was missing, the bounty of temple robbers.

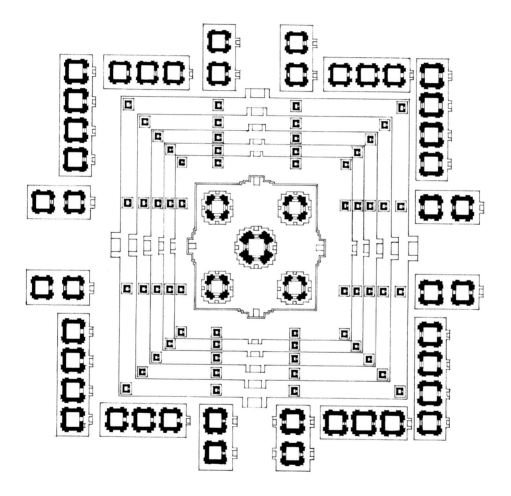

Plan.

Facing page: location of Phnom Bakheng.

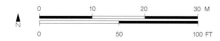

0 10 20 30 M

N

0 50 100 FT

Bakheng (Phnom Bakheng)

ភ្នំ បាខែង

Meaning: strong hill

Date: c. 907

Built by: Yasovarman I

Religion: Brahmanic
 (dedicated to Shiva)

Cleared: 1919–30

Restoration: 1931–34

Pron.: p'nom bakai-eng

Map: K21

Interest: *** archeo, art.

Visit: end pm before
 sunset

supposed course of the
causeway

Royal Palace

East Baray

West Baray

Bayon

Siem Reap River

Phnom
Bakheng

existing
border

Angkor Wat

0 1 2 3 KM

N

0 1 2 ML

Access

Take the Petit Circuit on the left: 1.3 km north of the west entrance to Angkor Wat and 300 m from the south gate of Angor Thom, a cleared area at the foot of the hill comes into view.

There are two ways of reaching the temple: by taking the very steep path with some steps leading directly to the platform of the temple, or by following—on foot or on elephant—the "path of the elephants," which is a less steep forest road.

Characteristics

According to an inscription found in the area, Phnom Bakheng was no ordinary hill but the center of the world, Mount Meru in Indian cosmology. The temple was planned as a harmonious reflection of the different periods of Indian astronomy adopted by the Khmers. The arrangement of its different buildings symbolized the arrangement of the universe.

Description

When Yasovarman I decided to build his new city at Angkor, he was free to choose among three hills to erect his temple and the royal *linga:* the Phnom Bok, the Phnom Krom and the Phnom Bakheng. He chose the third hill although he also built temples on the other two.

Like most of the other Khmer temples, the main orientations of Bakheng are on the east-west and north-south axes, although east was traditionally the favored orientation.

The Symbolism of Bakheng

Bakheng symbolizes the astronomic periods. It represents Mount Meru, the center of the world according to Indian cosmology. There are 109 towers in all, the central shrine representing the polar axis and the 108 buildings that surround it evoking the cosmic revolutions around this axis. One hundred and eight is the base number that corresponds to a "great year," a *yuga,* which means the stretch of time necessary for the appearance, the evolution and the disappearance of a world that numbers four million three hundred twenty thousand human years.

From the vantage point of each of its diagonals, Bakheng has only thirty-three towers, representing the same number of gods who according to Indian tradition live on Mount Meru, the center of the world with its five peaks. Nevertheless, only three towers corresponding to the three peaks that shelter the divine triad of Vishnu, Brahma and Shiva appear in this monument.

The Bakheng hill was originally an oval-shaped sandstone massif measuring 600 m long, over 300 m wide and nearly 70 m high. Yasovarman I ordered the summit to be leveled and terraces to be created so that a stepped pyramid could be built; on the last tier of the pyramid, he established a temple that became the center of his city, Yasodharapura, and his kingdom. An L-shaped double earth embankment flanks the west and south sides of the monument and ends at the river. The purpose of this odd construction is not known.

The visitor climbing the "rocky stairway" on the east side will see on both sides huge sitting stone lions 2 m high. With their gaping mouths and huge beady eyes, these "guards" stand watch at the first entrance to the hill. The 70 m ascent of the hill ends at the vast platform (120 m by 185 m) forming the monument's base. A laterite-paved alley 8 m wide starts precisely at the point where the hill was cut off and leads to the foot of the monument. The alley passes a great impression

of Buddha's foot carved in the rock, and then, on the right, a stela with a very indistinct inscription together with the remains of a building. A first laterite wall is followed by a second (2.20 m high), interrupted by the ruins of an east entry pavilion. The vestiges of the pavilion will lead us to two rectangular libraries (6 m by 7 m), one on the north and the other on the south, each with two doors, one opening to the east and the other, a later addition, to the west. The sandstone one-story structures are covered by a corbeled roof. The round holes in the walls of the libraries might have been a form of ventilation.

Base of the Pyramid

After the libraries, the visitor reaches the foot of the temple-pyramid, which is surrounded by square towers. These towers, of which there were originally forty-four, have thick brick walls and sides measuring 7 m long. They are arranged in groups of two, three or four and rest on common bases. The north, south and west sides of the

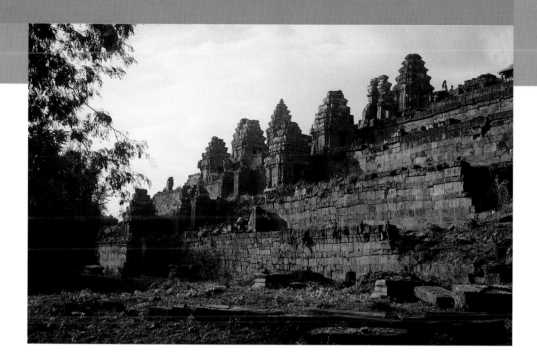

Phnom Bakheng.

towers have three false doors and a real opening to the east. The towers on the east side have two false openings and two real entrances on the east-west axis. Finally the two shrines standing in the center of four stairways can be entered either by a single door on the east or an entrance on the east and west. A series of small terraces once covered the shrines, but these have disappeared except for the ones of the west side.

On the east side, to the left of the stairway, stands a handsome and finely chiseled pedestal of hard sandstone (1.08 m high). Its upper section (1.47 sq m), exhibits a hole that served as a mortice to fit a tenon for the foot of a statue. In the same block, there is a honeycomb pattern made of eight smaller holes, which was probably used as a reliquary.

Pyramid

The inner filling of the pyramid is not the usual earth, but the stone extracted from the terraced hill. Carved into terraces and paved in sandstone, the stones were subsequently arranged in five shortening tiers, each representing a story. The whole structure reaches the relatively low height of 13 m. A square with sides of 76 m forms the base; the highest story measures 47 m on each side and carries a large sculpted base 1.46 m high and 31 m on its sides crowned with the five towers.

The four axial stairways lead to the last terrace and the tower-shrines. The size of the individual steps and the string walls with their lions shorten with each ascent to create the illusion of height. There are sixty small sandstone temples on the terraces parallel to the stairways, on each of their sides and at the four diagonals of the base. They are reduced versions of the shrines, with a main building, a roof of four false levels and a lotus bud decoration at the top. The narrowness of these

terraces makes their single easterly opening very difficult to negotiate. The small temples in general were left roughed out.

On the upper level, a great Buddha statue stands on a pedestal made by the bonzes with stones recovered from shrines at the Baphuon monument.

Five towers in quincunx formation were uncovered during the clearing of the ruined temple. The main shrine was truncated at the roof level. Only pieces of walls and scattered fragments of stone blocks of the other four towers remain in their present state.

Despite the disappearance of the superstructure of its principle shrine, Bakheng is still a valuable monument. The sanctuary is a square of 8 m on each side mounted on a small base 1.45 m high. The east-facing shrine doors are accessed by stairs with four steps. The highly molded areas around the windows are flanked by two octagonal colonettes with bulb-shaped bases and capitals; the shafts are decorated with bands interspersed with garlands. The sculptures which once adorned the lintels above the columns are gone, but the pilasters alongside the doors are still magnificently ornamented with the busts of tiny figures swathed in foliage. Also visible are the finely chiseled foliage scroll patterns placed at the corners bordering the great feminine images (*devatas*), above which *apsaras* are flying in the heavens under the tiny arches. The skirts of the *devatas* are unique. The capitals of the pilasters have retained their decoration, although some of the carvings on their pediments have disappeared; you can still see the outlines of a few motifs like

the *makara* heads whose raised trunks terminate the line of the pediment arches. An inscription on the east door jamb of the north gate added after the construction of the monument informs the visitor that it was built in the 10th century.

When the axial well was excavated, a stone vat with an evacuation hole at its bottom was discovered 2 m below the earth. After investigation, it was found to have a funerary connotation.

The four annex towers must have been the smaller versions of the central shrine. On the east a few remaining wall panels stand upright; a *linga* placed on a pedestal is at the center of each of the four shrines.

There are also holes dug into the sandstone paving stones east of the central shrine which must have been slots for flagpoles to hang banners to the glory of Shiva and the god-king.

Three Nandis (the sacred bull and mount of Shiva) sculptures were revealed when the base of the pyramid was cleared. Like all the shrines with four openings, Bakheng has these sacred bull statues opposite each temple access.

Finally, the visitor may stop to view two very beautiful lintels formerly belonging, undoubtedly, to the secondary towers and which are now lying on the ground on the northern side of the fifth terrace.

Regretfully, the upper terrace of Bakheng became an emplacement for artillery during the bloody conflict between government and Khmer Rouge forces. A large metallic pylon now stands against the central shrine. It is hoped that the occupation by the bonzes will not entail the construction of more straw huts.

Baksei Chamkrong

បក្សីចាំក្រុង

Meaning: the bird that watches
 over the capital
Date: 947
Built by: Rajendravarman
Religion: Brahmanic (dedicated to Shiva)
Cleared: 1919 and 1954
Pron.: bak-saay tcham-krong
Map: K 22
Interest: * archeo., art.
Visit: am

Access

Follow the Petit Circuit on the left. The temple site is 1.45 km north of the west road to Angkor and 250 m from the south gate of Angkor Thom. Baksei Chamkrong appears on the left side of the road surrounded by tall trees, which form a beautiful setting for the temple, with its russet brickwork.

General plan.

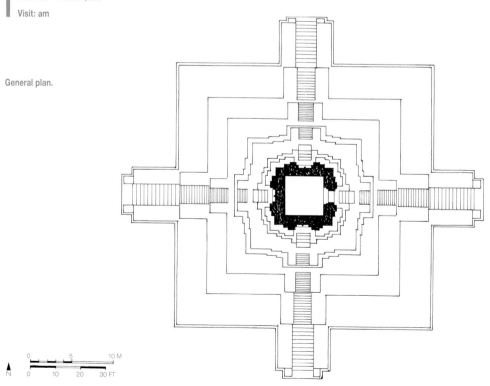

0 5 10 M

N 0 10 20 30 FT

Characteristics

The outstanding feature of Baksei Chamkrong, a small pyramid-temple, is its single tower. The texts, carved on its two east door jambs are valuable documents, giving the genealogy of all the monarchs of Cambodia until A.D. 947.

Description

The monument was originally surrounded by a wall, of which nothing remains, although the ruins of an entry pavilion (*gopura*) are still visible on the east side.

The pyramid-temple has a laterite interior. On the outside, its four terraces shorten as they ascend. The first terrace rests on a square base measuring 31.3 m, on each side and nearly 6 m in height. The first three terraces are built of calibrated laterite blocks about 42 cm in height. They are not carved but display a slightly profiled base and a wide string course in their upper area. Above the steps, an intricately molded base 2.5 m high supports the single tower.

Stairs on the east-west north-south axes lead to the central shrine. Baksei Chamkrong was the first temple at which the stairs ascend in a single flight. The bottom stairs are 2.3 m in width, but those nearing the shrine measure only 1.5 m wide. String courses and string walls made of laterite outline the upper sections of the flights. Baksei Chamkrong represents a vivid contrast with Bakheng in its use of the tricks of perspective to create the illusion of being bigger than it actually is.

Visitors who wish to climb to the central tower need to exercise care, as the edges of the stairs

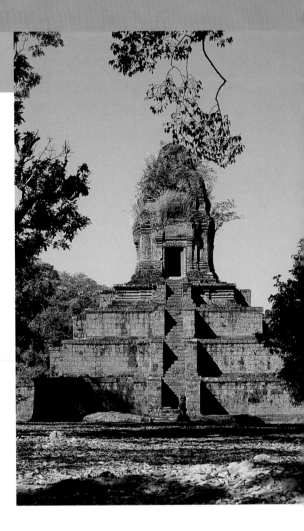

Baksei Chamkrong from the east.

have deteriorated and many steps are high and narrow. They also become slippery during the rainy season. The single tower-shrine is a brick construction with walls 1 m thick. The tower encloses the shrine, which has a square-shaped base of uneven outline in brick. Each side is 8 m long.

The four doors of the temple, three of which are false, are located on the main axes. The sandstone entrance structure with its complex moldings is framed by two small columns displaying octagonal bases and bulbous capitals. The shafts are decorated alternately with a triple band with pearl motifs in the center and a single band. The free space is carved with clusters of grapes hanging from a lush vine. The false doors are flanked by the same supports. The doors are arranged in such an ingenious manner that their stonework resembles wood. A large intricately chiseled stone band studded in different places with five stone ornamented knobs runs vertically down the middle of each door. Each knob is decorated with a lotus flower motif.

Two other bands bearing a leaf motif are placed in parallel positions between the central band and the door jambs. The same motifs appear on the side panels, where they blossom forth from corollas.

Only the north and east façades have lintels in decent condition. The carved image of Indra on a three-headed elephant dominates the entire east lintel, extending throughout the twining foliage and terminating in volutes. Ganesha, the elephant god, riding his own trunk, peeps out from the center of the volutes. A frieze of praying figures appears above the entire lintel. The north lintel is identical except that it has a figure placed on top of an open lotus flower. Its lower section is in poor condition.

On either side of the doors there are pilasters supporting the abutments of the pediments. Unfortunately, the sculptures on the tympanums have disappeared. Near each corner of the tower, figures of the *devatas* have been chiseled into the brickwork. Lime-based mortar coatings once covered the entire structure. The ground inside the temple is considerably lower than the doorstep and the inside walls are bare. A recent statue of a reclining Buddha has been placed at the back. The corbeled intrados and the various projecting supports of the small receding outer terraces are in brick.

Equally remarkable are the inscriptions on the door jambs of the east gate relating the temple's founding in 947 and the erection of a golden statue of Shiva. These texts, forty-two and fifty-four lines in length, are the finest extant examples of ancient Khmer writing engraved in stone. After a brief prayer to the gods, they evoke the illustrious and supposedly ancient family tree of the king and builder Rajendravarman.

According to one study, the basic form of Baksei Chamkrong resembles the stepped pyramids of India raised on the graves of certain followers of Shiva.

In 1954, the underground section of the pyramid was excavated to see if there was a crypt like the one at Ak Yom. However, instead of a crypt, the diggers unearthed a four-sided foundation stone with small holes in the upturned side. One of the holes yielded a very fine gold plate shaped as a banyan leaf; there was no writing on it.

Banteay Kdei

បន្ទាយក្តី

Meaning: the citadel
 of the monks' cells

Date: mid-12th–beginning 13th c.

Built by: Jayavarman VII

Religion: Buddhist

Cleared: 1920–1922

Pron.: bantee-ay k'dey

Map: J 30

Interest: ** archeo.

Visit: am or pm

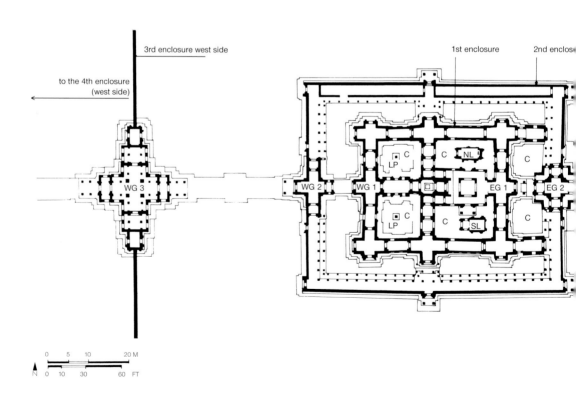

3rd enclosure west side

to the 4th enclosure
(west side)

1st enclosure

2nd enclos

WG 3

WG 2 WG 1 EG 1 EG 2

C
LP

C NL C

C
LP

C SL C

0 5 10 20 M

N 0 10 30 60 FT

Access

Follow the Petit Circuit on the right. About 4.5 km after Prasat Kravan, you will see Banteay Kdei opposite the Srah Srang reservoir. The visit to the monument will begin on the east side.

Banteay Kdei can be combined with a visit to Ta Prohm. After leaving the east *gopura* of the fourth enclosure of Ta Prohm, turn right and follow the wall until you come to the enclosure of Banteay Kdei. The visit will then start at the west *gopura* of the temple.

Description

Banteay Kdei remains an enigma for the moment: unlike other monuments, it does not have a stela that provides data about its construction. It might have been erected on the ruins of a Buddhist site. The monument was transformed several times during its history. It started as a small temple and eventually grew to become nearly as big as Ta Prohm and Preah Khan. Like these two monuments, the largest of its walls enclosed a city. Extending existing edifices was a typical practice

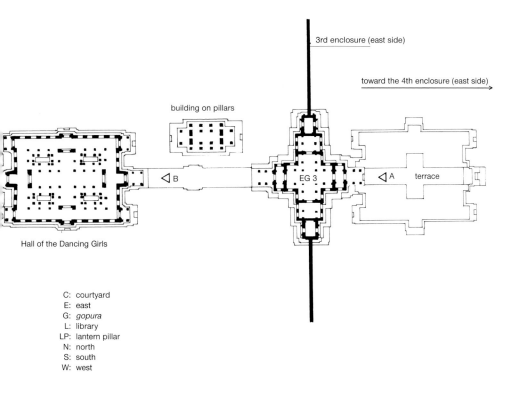

3rd enclosure (east side)

toward the 4th enclosure (east side)

building on pillars

◁ B EG 3 ◁ A terrace

Hall of the Dancing Girls

C: courtyard
E: east
G: *gopura*
L: library
LP: lantern pillar
N: north
S: south
W: west

of the Jayavarman VII era and Banteay Kdei was one of several temples to be altered. Like its companions, however, it is poorly constructed.

The landing stage and the great reservoir, Srah Srang, are eastward extensions of the monuments.

Fourth Enclosure, East Entrance

The 3 m-high laterite wall is surrounded by fallen masonry, but the remains of its highly molded coping still support its once proud sandstone ridge. The wall is a rectangle (500 m by 700 m), with four sandstone *gopuras* placed at its cardinal points. These identical cruciform *gopuras* have porches, a central hall and annexes. Four *garudas* guard the outer arms of the cross. At the corners of the annexes, sculptures of decorative female figures stand under arches. The wall sections are embellished by false windows each with three balusters and lowered shades. The sandstone base of the *gopuras* is rather high and heavily molded. A tower with four faces covers the central hall. Another sandstone ridge emphasizes the corbeled wings. After visiting the *gopuras*, follow the dirt road flanked by moats leading to the third enclosure. The ruins of two sandstone and laterite libraries stand 40 m from the enclosure on the north and south sides of the road. On the northern side there are fragments of imported pediments and an image of the Great Departure from Kapilavastu of the Future Buddha.

Third Enclosure

The laterite rectangular enclosure measures 2.5 m in height, 300 m in width and 320 m in length. Each façade has a *gopura* situated on the

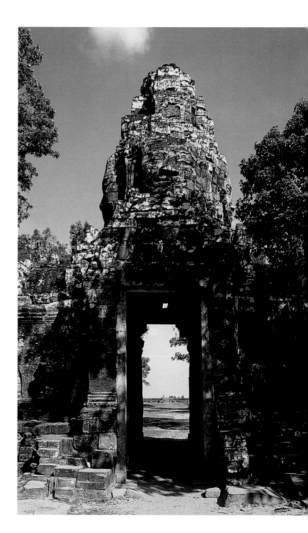

Above: inner façade of the east *gopura*, Banteay Kdei.

Facing page: doorway of the east *gopura*.

axis of the main shrine. The east *gopura*, which has a vast, elevated sandstone terrace in front of it, is reached by three flights of four steps guarded by the emblematic lions on their string walls. Equally emblematic are the *naga* balustrades at the edge of the terrace, which includes a second, slightly raised cruciform terrace that leads to the main entrance of the *gopura*.

The pavilion is a sandstone cruciform edifice with a main porch, two side entrances, a hall with pillars and extensions on all four sides. The main entrance rests on square sandstone pillars with decorated bases and capitals. The first two pillars support a sculpted trefoil pediment adorned with the image of a standing figure accompanied by a maidservant in a pavilion, while *apsaras* "fly" about them. The annex of the southern passage is

also dominated by a decorated pediment. The hall is covered by a groin vault interrupted in its span by pediments, while the main passages are covered by half-vaults topped by a succession of ridge finials. The interior is lit by square windows separated by panels bearing crude sculptures of goddesses under arches surrounded by scroll-work. A statue of Buddha sits supreme in the center of the *gopura*. The laterite enclosure joins the gable walls of the passageways.

Building on Pillars

After visiting the *gopura*, take the short stone road with the *naga* balustrades. Before entering the next building, you will notice on the right a sandstone edifice with square pillars, 0.50 m on each side and over 3 m high, resting on a stone

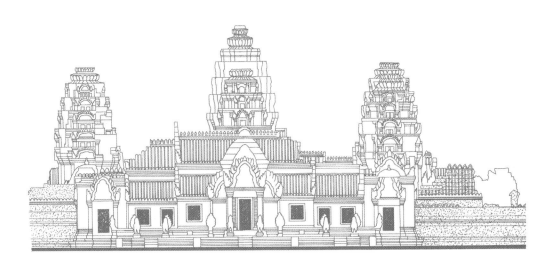

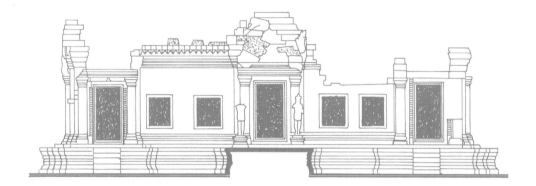

base about 1.5 m high. The pillars once sup-
ported a superstructure possibly of lightweight
materials, of which only a few sandstone lintels
remain. The same type of construction exists at
Ta Prohm and Preah Khan, where there is no indi-
cation of its purpose.

Above: east façade of the Hall of the Dancing Girls,
Banteay Kdei.

Facing page: view from the south
of the Hall of the Dancing Girls.

Hall of the Dancing Girls

The next building is enclosed by sandstone walls
over 4.5 m high, built on a highly molded base of
1.5 m, almost 22 m wide and 30 m long. The east
and the west sides of the walls have three-pillared
porches and four windows, while the north and
south sides have a central passageway framed by
four windows on each side. Inside, sixteen sturdy
pillars enhance the cruciform axial passages
(3.35 m wide). Less imposing pillars border an
aisle that is 2.5 m wide. The seventy-two pillars of
the room itself are arranged in four sections clus-
tered about a small inner court. The superstruc-
ture of the Hall of the Dancing Girls no longer
exists. Nevertheless, although the side passage-
ways may once have been covered with vaults
resting on the wall and the pillars, it is unlikely that
the axial passages had stone roofs. All the

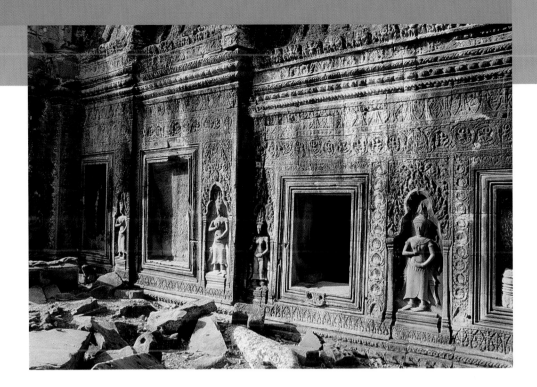

porches and central passageways have trefoil sculpted pediments. The mural decorations resemble those of the preceding temple section; female *devatas* are sculpted on the wall between the windows and there are high friezes of Buddha beneath arches (now gone). *Dvarapala* (guardians of the gate) adorn the pillars at the north and south exits. The Hall of the Dancing Girls derives its name from the *apsaras* dancing on lotus flowers sculpted on the sides of the axial pillars.

Leave by the door on the west axis and take the short alley leading to the entrance of the second enclosure.

Second Enclosure

The east *gopura*, a strange building, was conceived as two concentric Greek crosses with a side gallery skirting the inner cross; it seems to be duplicating the *gopuras* of Ta Prohm and Preah Khan. The *gopura* is enclosed in a square with sides measuring 11 m. Its entry door on the east has a porch with a missing pediment (possibly partially reconstructed on the ground); the pediment on the inside of the porch is still in place, although the roof has all but disappeared. The laterite enclosure wall rising 3 m with base and coping ends at the *gopura*; the wall, a four-sided figure 50 m wide over 63 m long, has four doors on its east and west sides; those near the east corner have porches with pillars; on the north side, a single door placed in the center looks out onto the porch. Thus, there are twelve openings to the interior side gallery (2.30 m wide), which is bounded on one side by the enclosure wall and on the other by pillars that stand parallel to smaller supports (no higher than 1.70 m) that mark the boundaries for the gallery. These two rows of pillars form a passage 1 m wide.

On the north side, the gallery pillars joined by a laterite wall may have been later additions. The roof of the gallery is a semi-circular vault, in contrast with the half-vault which covers the passage between the pillars.

First Enclosure

The first enclosure is in reality a gallery made of laterite and sandstone, forming a rectangle 30 m wide and 36 m long; it occupies most of the inner court area of the second enclosure. At its cardinal points, it has four cruciform *gopuras* and pavilions with adjoining rooms of various proportions. Thus, the whole structure forms a side gallery with openings for light on its north and south sides and doors on its east and west sides. The northeast and southeast corner pavilions are linked to the pillars of the second enclosure by two elongated rooms open on three sides.

Courtyards, Libraries and Central Shrine

The identically structured north and south *gopuras* of the first enclosure were built off-axis toward the west by 2 m. The east *gopura* looks out onto a central courtyard (7 m by 8 m) surrounding a square room (4 m on each side) with four large windows. Three small rooms link the small court on its west side to the central shrine. The west *gopura* connects with the shrine through an oblong chamber with windows and two side doors. This layout creates two courtyards (8 m by 11 m), in the middle of which are square sandstone pillars (1.78 m high) resting on a large two-tiered base and crowned by decorated capitals with strong stone tenons. They are known as the "lantern pillars" and their purpose remains a mystery. Each courtyard on the east side has a small library (4 m by 7 m), which includes a vestibule open on the west and a larger room with no bays.

Like the *gopuras*, the side gallery is covered by a semicircular vault; however, the corner pavilions support storied towers rising to a height of more than 14 m. The central shrine tower soaring above the complex (17.5 m high) displays a similar architectural conception.

The walls of the first enclosure are decorated in the usual manner with *devatas* in niches and friezes of Buddhas that are for the most part in poor condition; several of these images are still venerated by Cambodians today.

Baphuon

ប្រាសាទ

Date: c. 1060

Built by: Udayadityavarman II

Religion: Brahmanic (dedicated to Shiva)

Cleared: 1902–14

Restored: 1959, 1961, 1970,
 1994–present day

Protected: 1916–1919

Pron: bap-ou-an

Map: G 21

Interest: *** archeo., art.

Visit: am or pm

Visits to the Baphuon are temporarily suspended as the monument is currently being restored by the Ecole Française d'Extrême-Orient. It is scheduled to reopen in 2005.

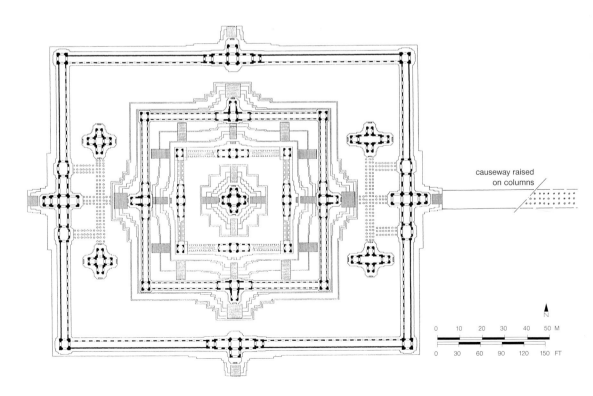

causeway raised
on columns

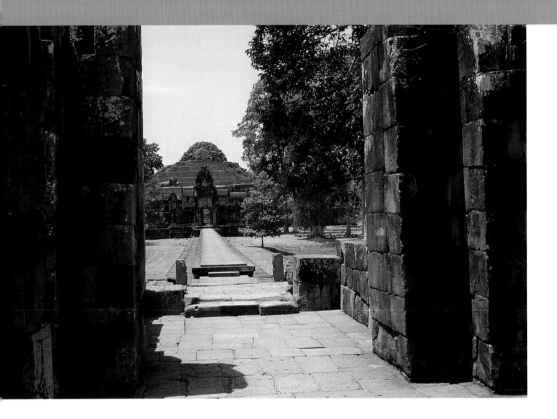

View from the east *gopura* of the raised causeway
and the temple, Baphuon.

The temple is a five-story, vast pyramidal struc-
ture. It is surmounted by three terraces and
flanked by galleries, with the highest platform
supporting the central shrine. The view from the
third enclosure reveals a nearly perfectly symmet-
rical temple. The opening on the east side is
slightly greater than its counterpart on the west.
The monumental entrance beside the royal

square consists of three cruciform *gopuras* joined
by three galleries. An unusual feature is the raised,
sandstone-paved causeway 200 m long, which is
supported by three rows of small columns. Two-
thirds of the way along there is a cruciform pavilion.

The monument is famous for its very delicate
carvings, inspired by episodes from the
Ramayana, on the four entrances to the second
enclosure. The Chinese diplomat and chronicler
Zhou Dauguan wrote admiringly of the Baphuon,
describing the temple-mountain as the "Tower of
Copper." An inscription unearthed at the foot of
the Baphuon mentions a "mountain of gold" that
the king built in the center of his city, Angkor, to
enclose the *linga*, the symbol of the god-king.

West Baray

or Baray Khang Litch

បារាយណ៍ខាងលិច

Meaning: the great flat body

 of water of the west

Date: eleventh century

Built by: (probably)

 Suryavarman I

Pron.: ba-ray-e kaong leetch

Map: G - K, 2-17

Interest: * archeo., walk

Visit: am or pm

Access

From the center of Siem Reap, travel west on the road to Sisophon. After 7.5 km, a road will appear on the right beside a small canal. Follow this road for about 2.5 km until you reach the south dike of the *baray*.

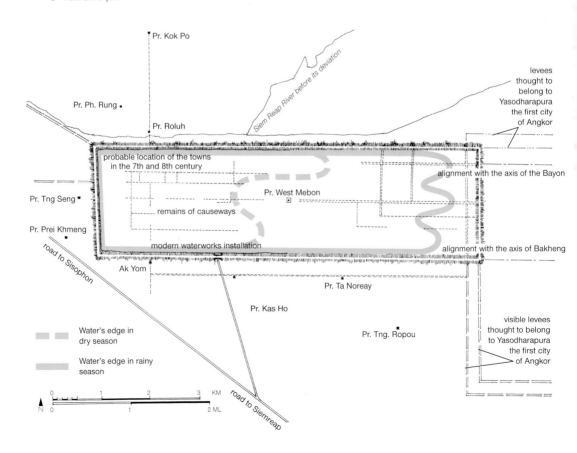

Characteristics

Until recently, at the western end of the *baray* there used to be a lovely beach of fine sand sloping gently down into the water, where depths could reach over 4 m. The beach was submerged after the erection of a dike. For those who wish to visit the Mebon ruins on the island in the center of the reservoir, there is a boat service.

Description

The West Baray is a vast rectangle 2 km wide and over 8 km long. Its waters are retained by earth banks; its eastern embankment may also have formed the side of the moat that used to encircle, possibly on the west, the center of the first city of Angkor, Phnom Bakheng. The remains of ancient causeways, buildings and other objects have been found on its west side, indicating that the area was once inhabited before it was deliberately flooded. Cities like Prei Khmeng, Kok Po and Prasat Phnom Run located in the vicinity of the Ak Yom temple, which was buried under the south bank, prove that the waters covered what used to be an urban area. At the center of this huge expanse of water stands the West Mebon monument (see p. 193). The *baray* is not entirely full.

The western section contains water year round, but its eastern section has silted up and is occupied by villages and rice fields.

What was the purpose of the West Baray and its counterpart on the east? Some experts argue that the *barays* were built to irrigate the rice fields during the dry season. Other specialists, while accepting this strictly pragmatic view of the *baray*, maintain that it also served a religious function as a sacred watering place.

There is also the question of how the reservoirs were filled. Several possibilities have been put forward: they may have been designed to collect rainwater; the water could have been deposited by the streams welling up through the deep layers of clay; or the water came from the Siem Reap River. All of these or a combination of several of them might have been true.

The *baray* has created its own mythological context. One story says that thanks to the irrigation system it provides, the Khmer farmers could harvest a rice crop three times a year; if that were true, they alone could feed a population of at least one million people! This is improbable since, according to geologists, the soil in the Angkor region is not well suited to the cultivation of rice.

East Baray

or Thnal Baray

ថ្នល់បារាយណ៍

Meaning: the great reservoir used
 as a nursery for rice
Date: end of 9th–beginning
 of 10th c.
Built by: Yasovarman I
Pron.: t'nal ba-ray-e
Map: D-H, 28-42
Interest: * archeo.
Visit: early am or late pm

Access

Take the Grand Circuit on the right. Continue past Pre Rup and head for the West Mebon in the direction of Ta Som. To arrive at the *baray*, you will have to pass the concealed north and south dikes of the *baray*.

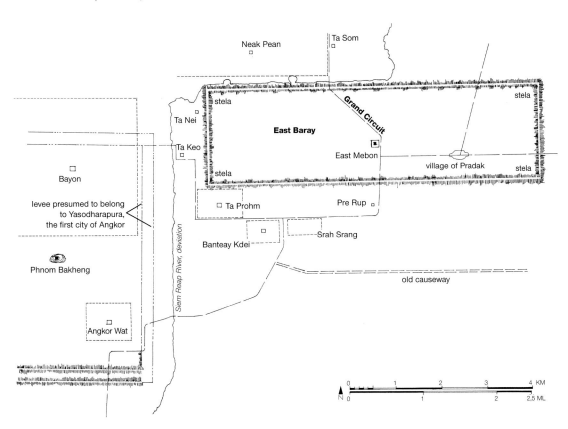

Characteristics

The reservoir, which has been dry for centuries, has no particularly distinctive features.

Description

This *baray*, which is 1.8 km wide and 7.1 km long, was the first large artificial lake and was built at the same time as the first city of Angkor, Yasodarapura. This is the "east lake" referred to in Zhou Daghuan's *The Customs of Cambodia*. It was built during the reign of Yasovarman I. The inscriptions on the stelae at its four corners mention that Thnal Baray, an artificial lake, was built in that area. The four stelae were placed in a shelter near the lake; subsequently a fifth stela with an inscription was discovered southeast of the *baray*, in a shelter identical to the one at Pre Rup. In section, the banks formed a trapezoid 10 m high with a base of 120 m and a top 20 m wide, which means they would have contained 12.5 million cubic meters of earth for the entire 17.8 km of embankment. Assuming the earth used to build the dikes was not brought from elsewhere, but rather was taken from the interior of the reservoir, then the Khmer builders would have had to remove a layer 1 m thick from the 12,780,000-sq-m-area covered of the *baray*. It has been estimated that it would have taken six thousand workers moving 2 m of earth a day six years to complete the task. At the center of the *baray* stands the East Mebon, which was accessible only by boat. Judging from the difference in levels between the bottom of the reservoir and the landing stage, it is clear that the depth of water would have been at most 2.50 m. The presence of the landing stages proves that the *baray* was still full when Rudravarman erected the East Mebon in 952. It is thought that when King Yasovarman I built the *baray* around 895, he deviated the course of the Siem Reap River to fill it, as well as to provide water for the new city he had just founded around Phnom Bakheng.

When Suryavarman I had the West Baray built, the East Baray must already have been empty. Different theories have been put forward to explain why it dried up, including some sort of breach in the banks. If, however, the reservoir depended on the river, it may simply be that through erosion the level of the river bed fell, and hence the level of the water also fell.

Like its western counterpart, the purpose of the East Baray is unclear. No mention of irrigation appears on any of the four stelae, whose texts refer to its religious role.

Bayon
 បាយ័ន

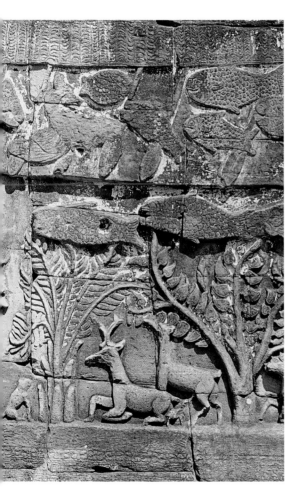

Detail of a bas-relief with animals, Bayon.

Date: end of 12th–beginning of 13th century

Built by: Jayavarman VII

Religion: Buddhist

Cleared: 1911–13

Restoration: 1933–39, 1946–96

Pron.: bayon

Map: G 22

Interest: **** archeo., art.

Visit: am

> See description of major bas-reliefs
on pages 347-358.

Access

Follow the Petit Circuit on the left. The monument represents the geometric center of Angkor Thom and is 1.5 km from the south gate of the city and 3.25 km from the west causeway leading to Angkor Wat. The monument is usually entered from its east side.

Characteristics

Unlike the other monuments, this temple is not surrounded by a wall as such, but the great wall surrounding the city of Angkor Thom may be considered its enclosure, four of whose massive gateways are situated on the two axes of Bayon. An intricate labyrinth of galleries and towers, from afar the monument resembles a sandstone quarry.

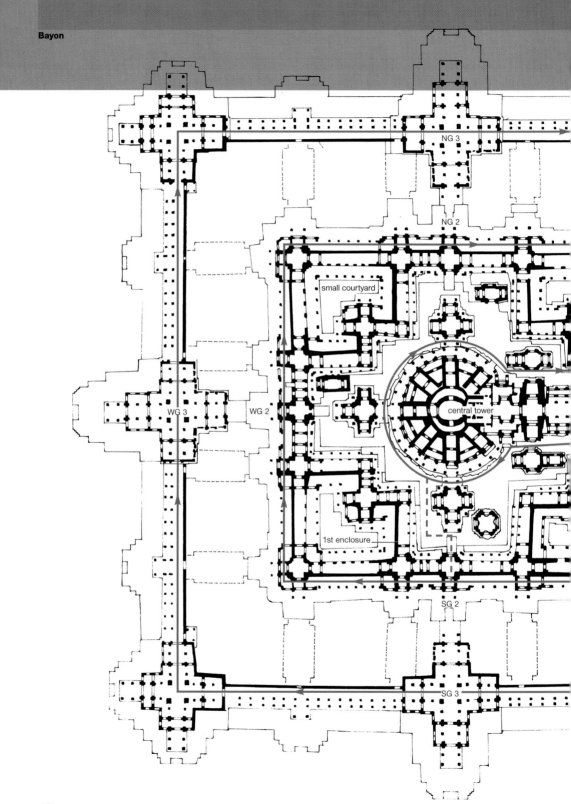

NG 3

NG 2

small courtyard

WG 3

WG 2

central tower

1st enclosure

SG 2

WG 3

SG 3

NG 2

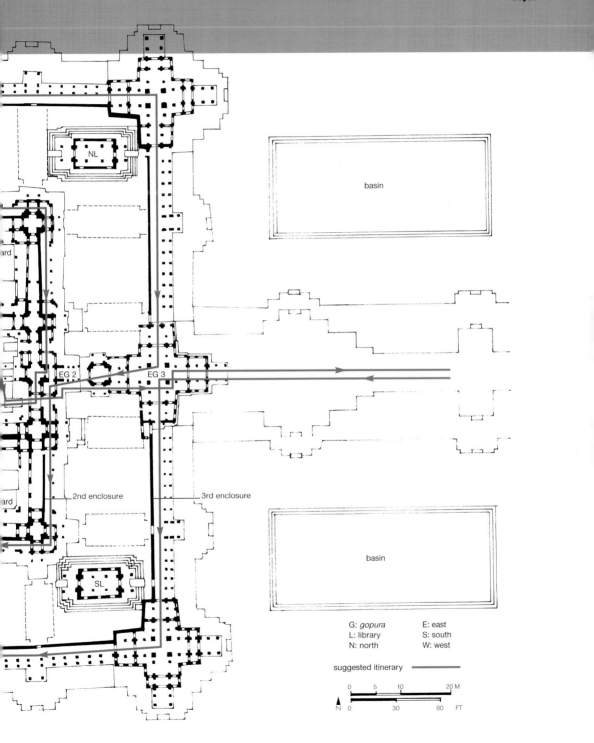

basin

NL

ard

EG 2 EG 3

2nd enclosure 3rd enclosure

ard

basin

SL

G: *gopura* E: east
L: library S: south
N: north W: west

suggested itinerary ————

0 5 10 20 M
N 0 30 60 FT

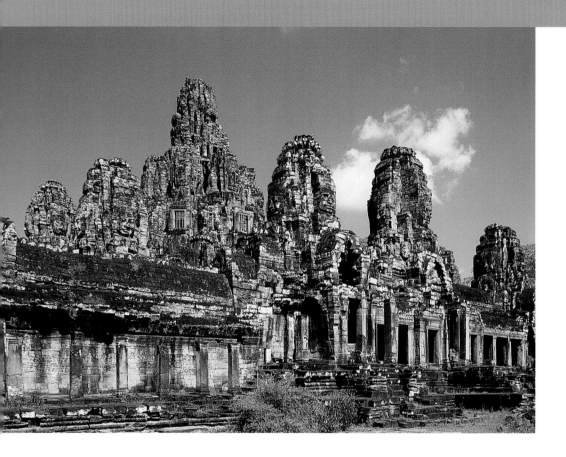

The southwest part of the third gallery, Bayon.

Despite its complicated exterior, the basic ground plan is strict and orderly, although difficult to grasp.

The layout is based on a *yantra*, a type of geometric diagram of Indian Tantric Buddhist inspiration used to create the mandala, the concentric diagram symbolizing the universe and the place of divine powers within it. The most extraordinary features of the Bayon, however, are its towers with faces and the abundantly informative bas-reliefs of the second and third enclosures.

Today there are only thirty-seven towers, but it is thought that initially there may have been as

many as fifty-four, with 216 faces whose identification remains problematic. Several inscriptions mention certain Mahayana Buddhist divinities, but also numerous Brahmanic gods synthesized in the figure of Lokeshvara, the compassionate Buddha radiating kindness to the four corners of the kingdom.

Description

The Bayon is the state temple of King Jayavarman VII. As a true pantheon, it was built to shelter the different gods venerated throughout the Khmer empire. Bayon is a temple-mountain (albeit not particularly tall) representing Mount Meru. The temple has three levels, the first of which is a platform 1.5 m above ground level that forms a rectangle (125 m by 136 m). This entrance platform is interspersed with eight gopuras and supports the third enclosure, which is a gallery 4.6 m wide containing the celebrated bas-reliefs. The second platform is surrounded by a court 17 m wide bordered by another gallery adorned with bas-reliefs, known as the Inner Gallery of Bas-Reliefs. This second terrace measures 68 m on its width and 78 m on its length and stands 1.3 m above the first terrace. The third and upper level is laid out in a Greek cross. The galleries of this last platform, which is 4.6 m above the side court, enclose the first enclosure. The center of the cross forms the base for the majestic central tower.

Entrance

The Bayon is entered from the east by means of a slightly elevated sandstone causeway in two sections. The first section is 27 m wide by 75 m long, while the second, which is slightly higher, is only 6 m wide. The causeway was originally lined by *naga* balustrades. On the north and south sides of the causeway steps lead down to a reservoir (17 m by 44 m), formerly curbed in sandstone.

Third Enclosure

The third enclosure wall stands on a platform 10 m wide that surrounds the center of the monument. The celebrated bas-reliefs can be found on the inner wall (4.5 m high). On the opposite side, facing outward, a double row of pillars circling the monument forms a gallery approximately 445 m long, interrupted at the axial points by *gopuras* and at the corners by corner pavilions. *Gopura* and pavilions have identical cruciform structures. The galleries once had vaults, which rested on the wall, and the first pillars and a half-vault covered the passage between the pillars; the porches in front of the *gopuras* and the corner pavilions were covered with barrel vaults, and the central section where the galleries intersected was covered by a groin vault.

Outer Gallery of Bas-Reliefs

The most famous feature of this long alignment of galleries measuring nearly 300 m are the bas-reliefs (approximately 3.5 m high). Several other images also appear on certain *gopura* walls and corner pavilions. Starting from the east *gopura* and walking south, you will see mostly images of battle scenes and a few evocations of daily life, especially in the southeast section (see appendices for a detailed description).

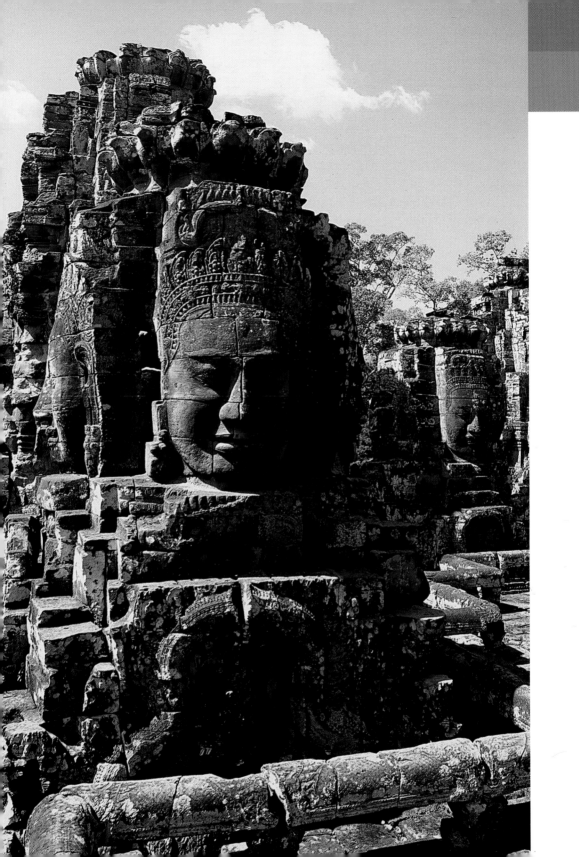

Second Enclosure

Entry to the second enclosure is via the *gopura* of the third enclosure. You will notice that the walls with bas-reliefs have small doors on the axes of the *gopuras* and the corner pavilions of the second enclosure. The doors lead to a vast side court (average width 18 m) now covered by dirt. The dirt floor still bears the traces of the foundations of long passages that connected the two enclosures. The court is also the location for the libraries (4 m high), which stand on profiled bases. There are staircases at the east and west porches leading into the libraries, but the ascent is not easy. The libraries are rectangular buildings with rooms measuring 4.5 m wide by 8 m long; each room has four pillars. The libraries were once covered by half-vaults just outside the rooms and full vaults above the pillars.

The second enclosure rests entirely on a raised platform 75 m wide and 85 m long. This level supports a recessed terrace that is 1.30 m higher

than the courtyard. The ground plan, which becomes more complex at this stage with the introduction of small interior courts, pavilions and gallery intersections, contrasts strikingly with the stark linearity of the classical Khmer plans. The four small courtyards niched in the corners of the second enclosure barely provide enough light for the surrounding galleries. The second enclosure is composed of a triple gallery interrupted by pavilions and cruciform corner pavilions often with small adjoining rooms; the entire unit can be inserted within a square. The pavilions are crowned with "face towers."

The triple gallery is a combination of a blind wall and passages with pillars, windows and doors. The outward side is a passageway with a single row of pillars. Opposite this open passage, there is a blind wall that faces on its inner side another open gallery lined with windows and doors. Thus, both open galleries border the blind wall decorated by bas-reliefs. The second open gallery looks out onto a third open gallery, which delimits the little courtyards.

In the opposite corner to the corner pavilion there is a further pavilion topped by a face tower and linked to other galleries. These three galleries have a central vault and two half-vaults.

Inner Gallery of Bas-Reliefs

The bas-reliefs of the second enclosure have a totally different setting from the others, adorning the walls of small cells and on the walls that make up the other elements of the gallery. Each small tableau treats a separate theme. The images are diverse, complex and occasionally vague; they

The upper terrace and the face towers, Bayon.

illustrate palace scenes, military processions and sometimes religious subjects (see appendices for detailed description).

First Enclosure

The terrace of the first enclosure can be reached by any one of five stairways. Two of these flank the entrance pavilion, while the other three are situated in the axis of the other pavilions. As the stairs are dilapidated, a new staircase has been added on the south side. The last terrace is 3 m above the lower level and supports a massive stone edifice. Three face shrines are placed about this imposing structure, one on the north-south axis and the other on the west side. The great building is not perfectly symmetrical, but stands some 6 m off-axis in relation to the center of the four-sided base of the second enclosure. On its east side, it is composed of rooms of different sizes and is crowned by the celebrated Bayon "face towers." There are five other small rooms on the terrace.

Central Tower

The central tower is a round edifice with a diameter of 20 m. The center of this shrine consists of a round cella (4 m in diameter), open on the east and west side and surrounded by a passageway. Radiating from the cella are thirteen small rooms that give the whole shrine the structure of a wheel with spokes. The rooms are lined with a row of columns. Seven of the rooms are rectangular and six, triangular. The thirteenth room is, in fact, the large enclosed space connecting the central shrine with the four easterly rooms. The shrine rises in gradually shortening tiers with barred windows and huge blocks of stone carved into faces; these colossal stone face towers support a rotunda whose highest point, which is also the top of the monument, is 43 m from the ground.

Although extremely dilapidated, this temple summit must originally have borne other faces. In 1933, during an excavation of the cella of the central shrine, the fragments of a great stone statue 3.6 m high were found 14 m below. It was the image of the Buddha-king (the equivalent to the *linga*) Jayavarman VII, the builder of the Bayon, seated with his legs folded on the coils of a *naga.* The statue was restored and placed in safe keeping beneath a shelter 100 m east of the Bayon on the right side of the road leading to the Gate of the Dead at Angkor Thom.

Chau Say Tevoda

ចៅ សោយ ទេវតា

Date: c. 1150

Built by: Suryavarman II

 or members of his court

Religion: Brahmanic

Cleared: 1919–20 and

 1925–27

Pron.: tee-yao-sa-ee tay-voda

Map: F 26

Interest * archeo., art.

Visit: am

Access

Take the Petit Circuit on the left to arrive at the Royal Plaza of Angkor Thom, then take the road on the right that passes through the Gate of Victory. The northern part of the temple comes into view on the right 550 m beyond the gate.

Characteristics

The temple, which has only one enclosure, may originally have been entered by a road on the banks of the Siem Reap River.

Description

On reaching the monument, turn left to reach the river bank and continue along the path, which is more than 5 m wide and around 125 m long; it is lined with sandstone posts 1.40 m high every 5 m. This path leads to a vast terrace in the form of a dentate Greek cross, 25 m by 28 m. Continuing west, three steps lead up to a raised stone walkway (1.30 m high, 4 m wide), the paving stones of which have disappeared. It rests on two rows of strong short octagonal columns on the sides and a row of square pillars in the center. A *naga*

balustrade used to protect the causeway, but nothing remains of it today. After 10 m, the causeway widens into a cross then continues to the east *gopura* of the sole wall, which is 33 m wide by 42 m long. The foundations are all that remain of this laterite wall.

The wall is interrpted by four *gopuras*. Those of the north and south, today collapsed, measured 7 m wide and 11 m long. On the outside, a simple staircase gave access to an elongated room connecting with a small hallway which leads to an inner courtyard. The inside of this T-shaped room, was lined with a row of laterite blocks.

Measuring 8 m by 15.50 m, the east *gopura* is the largest and most noble. It stands on a molded sandstone base on short columns that is linked to the causeway by four steps. A hall with two windows leads to a room that is almost square, off which branch two side rooms which lead to two passages linking the courtyard with the outside. A tiny room situated on the east-west axis leads to a new, very short causeway on short columns. Although some courses are loose, this building is still in good condition. On a few door lintels, it is

possible to make out scenes from the *Ramayana*: above the north passage, representations of monkeys; on the south passage, the fight between the monkey kings Valin and Sugriva. On leaving this *gopura*, take the short, elevated causeway that leads to the central shrine. The causeway is flanked on the north and south sides by the vestiges of libraries. Built on sandstone foundations, these libraries are small rectangular buildings 5 m by 10 m. A little hallway lit by two windows leads

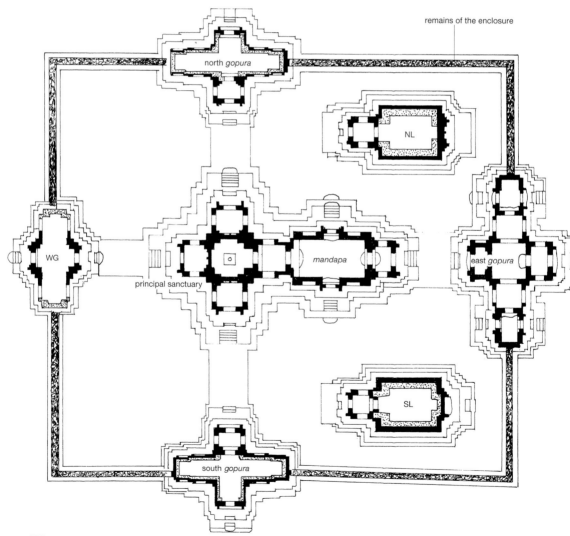

into the single dark room. The interior of the room was lined with laterite.

The principal shrine stands on a dentate, highly molded, sandstone base 1.50 m high. Seven steps lead from the short causeway up to the top of the

General plan.

base and the shrine itself, which begins, on the east side, by an antechamber (*mandapa*) measuring 3.40 m by 6.70 m. On the north and south façades, two doors give access to staircases leading down to the floor of the inner courtyard. Another door connects with the shrine's tower. This *mandapa* has lost most of its corbeled roof. All the doors flanked by colonettes and topped by pediments are in a poor state. On each of the façades, there remain two blind windows with balusters. The corners of the buildings are adorned with carved *devatas*. The shrine tower is linked to the north, west and south *gopuras* by a path.

The central sanctuary contains a cella (3 m on each side) with four vestibules that have windows with balusters. The doors, as well as the corners of the tower, are decorated with *devatas* under arches. The stepped roof is partly missing, although the false story is still in place.

The west *gopura*, which is in quite a good condition, is the smallest of the pavilions (5 m wide by 8 m long). The colonettes, lintels and pediments are still in place, but they are eroded and their carvings are largely illegible. The decoration of the superstructure, however, is in better condition.

To the southeast, outside the enclosure wall, several lintels and trefoil pediments have been reassembled. These show scenes involving Vishnu with *apsaras*, as well as Shiva and Uma, his wife, on the bull Nandi. There are also scenes from everyday life arranged in several tiers, such as a god helping a dying man surrounded by grieving relatives and friends.

South of the north library an interesting statue of Nandi was discovered.

Bayon

Gate of the Dead

moat

south gate

Prasat Chrung

Location.

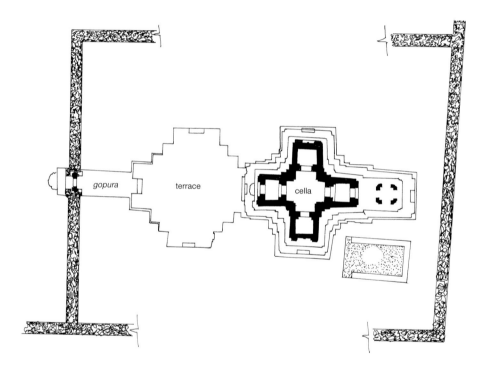

gopura

terrace

cella

Plan of the southeast Prasat Chrung.

0 5 10 M

N 0 10 30 FT

enclosure wall

Chrung (Prasat Chrung)

ជ្រុង ប្រាសាទ

Meaning: the shrine of the corner

Date: end 12th–beginning 13th c.

Built by: Jayavarman VII

Religion: Buddhist

Pron.: shrun, prassat shrun

Map: J 25

Interest: archeo., walk

Visit: am or pm

Access

Take the Petit Circuit on the left. Once you have passed the south gate of Angkor Thom, turn right and climb the slope. Then walk for a distance of 1.5 km along the path that follows the outer wall of Angkor Thom.

Characteristics

Of great archeological value, the monument's foundation stela is also worth visiting for its pleasant setting beside a shady road and breathtaking view of the moats south of Angkor Thom.

Description

The four similar shrines that make up this monument stand at the corners of the tall outer wall around Angkor Thom. The visit will concern the Prasat at the southeast corner.

The laterite enclosure has been totally destroyed; only fragments of the original foundations remain. The only entrance door to the enclosure, on the west, has a thick sandstone frame dominated by a pediment with a flattened band where there are images of the *naga* rearing its several heads at the ends. The tympanum sculptures show an abnormally large and dominant Lokeshvara towering over the worshippers gathered around him. Above this first pediment, a decorated band indicates the existence of a second pediment with a tympanum that is too eroded to make out clearly the themes of its sculptures. After this door, you will follow a small paved causeway 5 m wide leading to an elevated terrace with four steps. The edges of the terrace are extremely jagged and the whole area could be contained within a square measuring 24 m on each of its sides. The terrace is also joined to a cruciform sandstone base supporting a structure of several levels. The cella in the center is a Greek cross measuring 8 m on its side and surrounded by four small square vestibules. (4 m on each side). The west and east vestibules have a door to the exterior; but, their counterparts on the north and south have false doors and communicate only with the cella. The sandstone base extends at the east vestibule, where it used to support a small structure mounted on pillars and sheltering a stela. The small building no longer exists and the stela has been removed and placed elsewhere. On the walls outside the vestibules, the bas-reliefs of false doors with balustrades and drawn shades are accompanied by huge images of *devatas*. Several pediments still in place portray Lokeshvara; in other areas, this avatar of Vishnu was sculpted into a *linga*. Several vaults covering the vestibules are missing. The superstructure of the shrine terminating in the traditional budding lotus is fairly well preserved.

Kravan (Prasat Kravan)

ប្រាសាទក្រវាន់

Meaning: The temple of
the "Kravan" flowers
Date: 921
Built by: Isanavarman II
Religion: Brahmanic (Vishnu)
Cleared: 1929, 1931, 1935

Restored: 1962, 1966
Pron.: prassat kravan
Map: L 31
Interest: *** archeo.
Visit: am

Facing page: Prasat Kravan from the southwest.

Access

Take the Grand Circuit on the right. The temple is 3.5 km beyond Angkor Wat and 800 m before Banteay Kdei. Its five towers can be seen on the right.

Characteristics

Khmer edifices include several monuments of the Prasat Kravan type, built on a single axis either in brick like Bei Prasat and Prasat Batchum, or in sandstone, like Phnom Bok and Phnom Krom. The main features of this monument, in addition to its linearity, are its brick-molded sculptures covering several interiors of the towers and the decorations on the piers with their inscriptions.

Description

The monument consists of an alignment of five towers lying on the north-south axis. The whole complex with its indistinctly defined surrounding

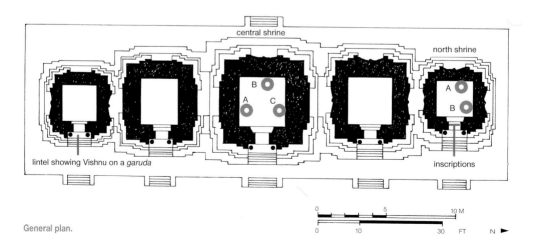

General plan.

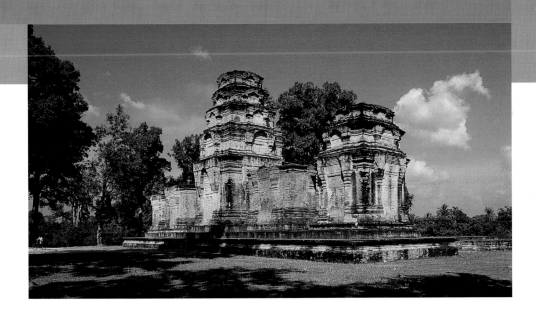

basin is placed on a base of brick platforms whose first level (1.10 m wide, 10.4 m long) is molded in its upper section. On the east side, at the level of this platform, five stairways opposite each tower lead to the brick terrace. A second brick terrace, 50 cm high, encompasses the whole monument and its five towers. The four towers, which are in symmetry with the main shrine, become gradually smaller the further they are from the center. The central tower traces an almost perfect square 6 m by 6.60 m, but the intermediate towers are 5.10 m by 6.20 m and the ones at the extreme north and south only 4.70 m by 4.80 m.

A base of thickly molded and decorated brick surrounds the central shrine. The corners of the building are adorned by images in low relief of the *dvarapala*, enclosed in their niches; these temple guardians are over 2 m tall. A thickly molded cornice is placed above a border decorated with festoon carvings. The tower has only one opening on the east side (1 m wide, 2.30 m high). The sandstone door frame is surrounded by small octagonal columns ringed with a multitude of sculpted

bands supporting an imposing stone lintel where tiny figures on the upper level compose a vivid frieze. The rest of the lintel is in very poor condition, except for its leaf adornments.

The other "doors" of the central shrine are false and appear simply as empty niches carved in the brick. The pilasters support an unadorned concave pediment with a plain tympanum.

The superstructure is a crown of four false stories arranged in shortening tiers. Each story is decorated and profiled and reproduces a detailed, reduced version of its counterpart below. The visitor will notice the ornamental "porticoes" on each story.

The central shrine stands alongside the truncated towers (4.5 m high). The outer walls of these accompanying edifices are unadorned. The east doors of these towers form a passageway 2 m high that is slightly lower than that of the central shrine.

Only the intermediate "door" between the extreme north aperture and the central entrance still has a lintel with decorations, which unfortunately are almost indistinguishable.

The shrines on the north and south ends are smaller, with entrances not exceeding 1.85 m in height. The walls are unadorned. The door of the north tower is still in place, with its accompanying molded and ornamented supports and its lintel.

The shrine to the far north has been razed.

The tower at the southernmost end is the best preserved with its lintel displaying a line of praying figures represented only to the waist. Also typical of the Bakheng style are the floral embellishments swirling about the well-known figure of Vishnu on his *garuda*. You will see that the top of the tower with its two false receding stories is only partially ruined.

The Interior Sculptures

These immense sculptures carved into the bricks are exceptional examples of Khmer art.

Apparently, they were not intended to receive a protective coating. Given the evenness of the courses and the nearly perfect joins between the individual bricks that form the panels, there are two possible answers:

— The bricks were modeled as soft clay on their individual panels before the panels were put into place. If this were the case, the craftsmen could easily have obtained even joins before firing.

— The wall might have been erected with an extra layer of brick in the section designated for the bas-reliefs, something which would have required the labor of exceptionally skilled craftsmen. Fired bricks are difficult to carve, easy to break and hard to repair.

Only the central and the north shrines contain these decorations.

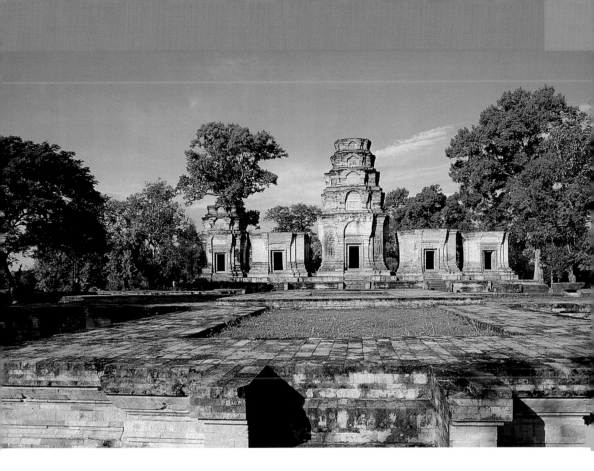

Prasat Kravan from the east.

Central Shrine

The cella of this shrine is a square measuring 3.4 m on each of side. On the south façade, to the left at entrance (A), there is a magnificent wall decoration showing Vishnu beneath a lovely trefoiled arcature; the god is first represented as a Brahman dwarf who grows miraculously into a giant ready to dominate the world in three paces. Vishnu is holding his four symbols—a ball, a discus, a conch and a club—in his four arms. The god's left foot is resting on a pedestal, while his right foot is placed on a budding lotus flower held by a goddess emerging from the Ocean represented by three wavy lines (see box facing page).

On the west façade opposite entrance (B), there is another Vishnu image with eight arms; the god is encircled by mostly masculine worshippers occupying six tiers and becoming more numerous as they ascend. The whole scene is dominated by a frieze of other praying figures and an enormous reptile resembling an iguana of unknown meaning; 10th-century portraits of Vishnu occasionally include this strange lizard.

The north façade, to the right of entrance (C) is decorated with the well-known image of Vishnu and his four attributes carried on the shoulders of a *garuda* wearing a diadem. The god and his mount are placed beneath a richly carved arch and are flanked by two seated praying figures.

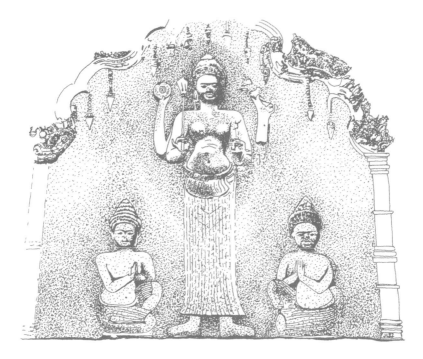

North Shrine

The small square cella, not more than 2.60 m on each side, is entirely devoted to representing Laksmi, Vishnu's consort.

On the west side (A), facing the entrance, the goddess is standing with her four sacred objects in her four arms, the discus and the trident on the right and the elephant hook and lotus on the left. The customary praying figures are stationed at her feet.

On the north side to the right of the entrance (B), the crowned goddess now displays only two arms and holds objects that are too unclear to be identified. There are three people at her side.

Laksmi and her four sacred objects, nothern shrine (motif A on the plan, p. 188).

Inscriptions dating the erection of a Vishnu statue to 921 appear on the pedestals beneath the door.

Between 1962 and 1966, a team of experts employed by the Conservation d'Angkor worked very successfully to restore this almost totally ruined monument. This was a tricky task, because brick is a difficult material to restore.

West Mebon
មេបុណ្យខាងលិច

Date: 11th c.

Built by: Suryavarman or
 Udayaditiavarman II

Religion: Brahmanic

Restoration: 1942–44

Pron.: mebon khang litch

Map: I 9

Interest: ** archeo., walk

Visit: am

Access

From the Grand Hotel d'Angkor at Siem Reap, follow the road west toward Sisophon. After 7.5 km, take the road on the right leading to the West Baray. After 2.5 km, you will arrive at a large paved dike by a reservoir. If you climb the dike, you will see a small fleet of motor boats, which will take you for a very reasonable fare to the island of West Mebon.

Characteristics

This monument has no shrine and only one enclosure wall around a central platform that is surrounded on three sides by a basin of water. The largest bronze statue in Khmer art was found here.

Description

The West Mebon is only accessible by boat, but since there is no quay it is not known where the boats used to dock. The temple might also have been accessed by a causeway linking the monument with the moats of Angkor Thom on the east—a causeway than can be seen from the air, especially during the dry season. The West Mebon is built on an earth levee which is 10 m higher than the floor of the *baray* and which supports a sandstone base (0.70 m high), topped by a square side enclosure 100 m on each side. With a height of 2.65 m, the stone enclosure wall supports a fairly large molded coping imitating a corbeled vault whose contours are accentuated by a lotus petal motif. On each side of the enclosure,

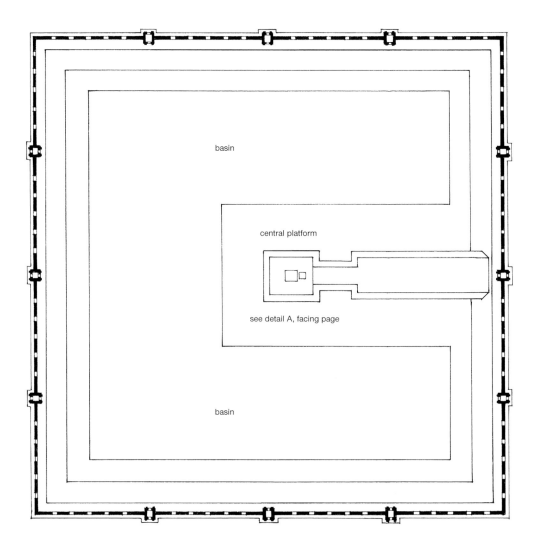

basin

central platform

see detail A, facing page

basin

0 5 10 20 30 M

N 0 10 30 60 90 FT

General plan.

the wall is interrupted by three small rectangular sandstone tower-passages (2.50 m long, 2.40 wide, 7.80 m high).

Only part of the east façade of the enclosure remains; the ruined state of the façade reveals that towers were placed at 28 m intervals and that the wall between two towers had five windows with bars (1.16 m by 1.23 m). Each tower has two doors with lintels, above which there are decorated pediments. The towers are crowned by two equally large dentate tiers ending in a lotus flower crown. The pilasters of these towers are brilliantly ornamented with bas-reliefs portraying particularly realistic-looking animals inside small squares. Most of the bas-reliefs are in poor condition.

The vast courtyard, which is smothered in vegetation and flooded during the rainy season, has a terrace (9. 65 m by 8. 65 m), which probably once served as a base for a lightweight structure.

During restoration between 1942 and 1944, it was discovered that a stone block once stood in the center of the courtyard, joined to the east side of the enclosure by a causeway (43 m long, 8 m wide, narrowing to 4 m). This masonry element rose more than 2 m in a series of spiral sections and housed a circular well (2 m deep) in its center; opposite the well, on the east side, was a square ditch (1.85 m on each side, 1.50 m deep). It was found to contain several jewels. This central part of the courytyard is enclosed in a U-shaped basin (26 m by 32 m).

A huge bronze statue of a reclining Vishnu was found on the site. It is not impossible that it was brought to the Mebon from another location. Only the upper part of the statue's torso, the arms and the head remain; their colossal size indicates that the complete sculpture must have measured about 6 m.

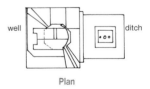

Plan

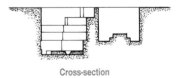

Detail A. Plan and cross-section. Cross-section

The Strange Discovery of the Statue of Vishnu

The Khmers have always been steeped in Buddhism and are generally very pious, and sometimes their dreams are inspired by their religious beliefs. One such dream yielded an unexpected benefit for archeology. In 1936, a farmer who lived in a village neighboring Angkor Wat dreamed that Buddha came to him to complain about the heavy burden of stone and earth that were covering his body. Buddha then asked him to go to a specific area where the peasant would be able to deliver him from his fetters. That area was the central platform of the Mebon temple in the middle of the West Baray. So the brave little farmer took a spade and started to dig. However, his digging was interrupted by a violent storm, which he saw as the wrath of the sky pouring down on him and he took to his heels. Returning to his village, he breathlessly related his adventure and it was not long before his tale reached the ears of Maurice Glaize, the curator of Angkor at that time. Although the Frenchman was justifiably skeptical, intuition told him that the peasant's tale might have some link with reality. Great was his surprise when, after removing the sandstone rubble, he beheld the head, arms and bust of a bronze statue. The complete statue would have been colossal, the largest in bronze ever to be molded in Cambodia and also one of the finest and most monumental sculptures ever to appear in southeast Asia. It was nearly 6 m tall, dwarfing other Khmer sculptures. It represents Vishnu reclining on the *ananta* floating above the cosmic waters during an intermediate period between two cosmic eras. It is likely that gold or silver was inserted in the holes meant for the brows and the mustache. Jewels might have gleamed from the statue's eye sockets. In 1296, following a visit to Angkor, the Chinese diplomat Zhou Daguan wrote in his memoirs of a Vishnu statue that he called a great supine Buddha whose navel spurts water; but he erroneously situates the statue in the great East Baray. The statue can now be seen in the National Museum at Phnom Penh.

Fragment of the great bronze statue of Vishnu.

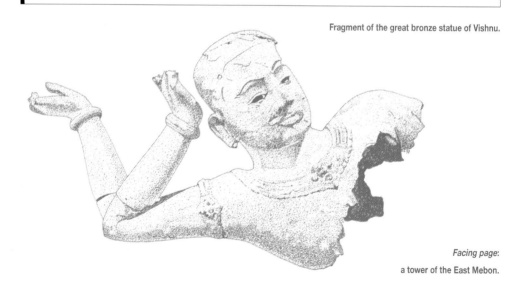

Facing page:
a tower of the East Mebon.

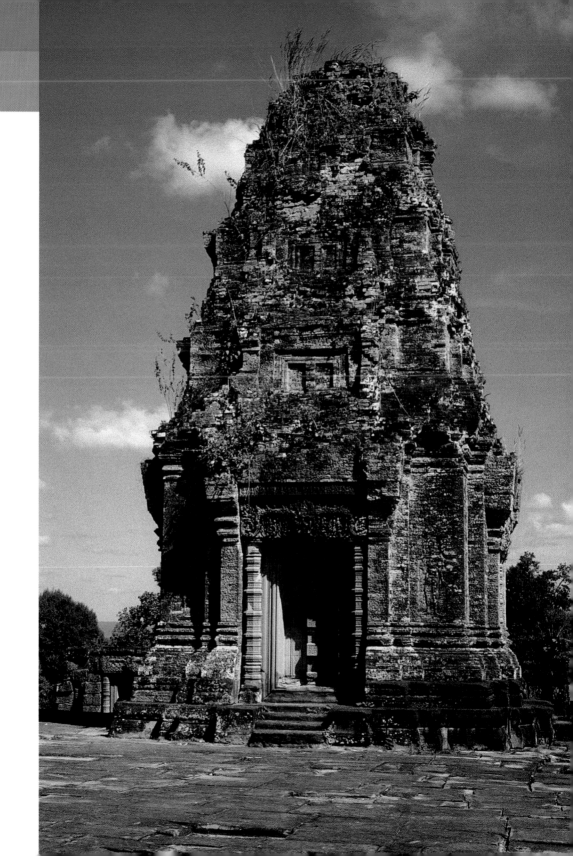

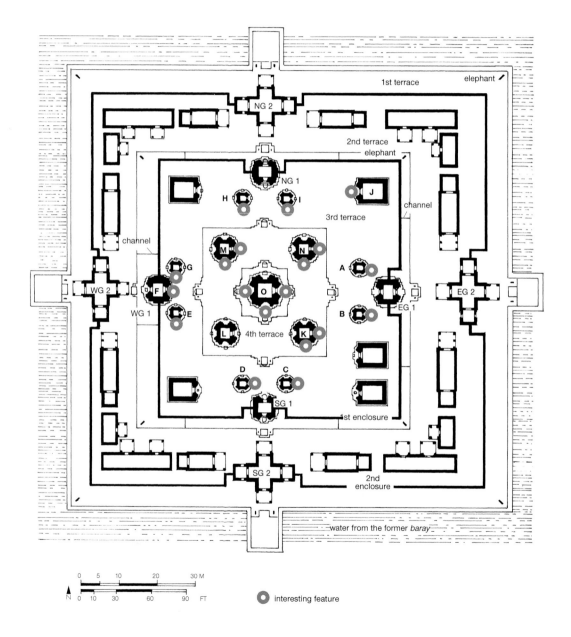

1st terrace

elephant

NG 2

2nd terrace

elephant

NG 1

H

I

J

channel

3rd terrace

channel

M

N

A

G

WG 2

F

O

EG 2

WG 1

E

B

EG 1

L

4th terrace

K

D

C

1st enclosure

SG 1

SG 2

2nd
enclosure

water from the former *baray*

0 5 10 20 30 M

N 0 10 30 60 90 FT

○ interesting feature

East Mebon

មេបុណ្យខាងកើត

Location and Description of the Lintels

First Enclosure
Towers
A - East side, east façade: mitered *garuda* kneeling down and holding a plant stem.
B - East façade: Indra on an elephant.
C - South side, east façade: mitered *garuda* in an upright position, holding a leaf stem.
D - East façade: Indra standing beneath an arcature and mounted on his three-headed elephant; small figures mounted on the volutes at the ends.
E - West side, south façade: a destroyed image of Indra on a three-headed elephant. Also tiny, finely made figures at the end of the lintel.
F - East façade: Vishnu as a man-lion disemboweling the king of the *asuras*.
G - South façade: Indra on an elephant under an arcature.
H - North side, south façade: Indra on an elephant kneeling on one knee.
I - South façade: Kala's head swallowing an elephant skull. Small, unusual subjects riding on the ends of the volutes.

J - **Northeast building**, west façade: two elephants spraying the goddess Laksmi.

Shrines surrounding the central shrine
K - Southeast side, east façade: the central motif is in poor condition, but the side motifs are extremely interesting. South façade: Shiva riding on the bull Nandi.
L – Southwest side: the whole lintel is in very poor condition.
M - Northwest side, east façade: Indra riding his elephant beneath an arcature framed by two upright lions. On the end volutes, Ganesha is riding his own trunk that grows into a horse's body. South façade: a figure riding an upright lion that spits out a stem of foliage.
N - Northeast side, east façade: Indra riding the three-headed elephant. There are figures at the end of the lintel. South façade: two upright lions joined together spit out a leafy stem.

Central shrine
O - East façade: Indra and his mount, the three-headed elephant, under an arcature. South façade: Shiva is riding the bull Nandi. West façade: Skanda, god of war, on his peacock.

Date: 952
Built by: Rajendravarman
Religion: Brahmanic (dedicated to Shiva)
Cleared: 1935
Restoration: 1935–39
Pron.: mebon kan'g keut
Map: F 35
Interest: *** archeo., art.
Visit: am

Access

Take the Grand Circuit on the right. The East Mebon is 1.3 km beyond Pre Rup on the north.

Characteristics

The monument is constructed on an artificial island (114 m by 117 m) in the center of the East Baray and consequently could only be reached by boat. There was no principal entrance, but rather a number of identical landing terraces. Nevertheless, the east façade was the traditional point of entry. Today the *baray* is dry. The East Mebon lies on the same axis as the Gate of Victory, the central *gopura* of the royal palace and the Phimeanakas, a temple-mountain with three terraces.

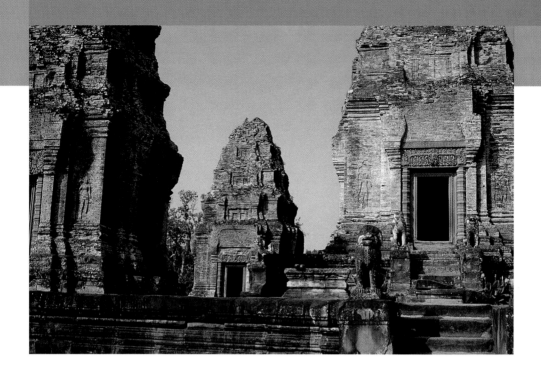

Description

The visit to the monument starts on the east. The landing terrace here (10 m long) is part of the main wall (2.60 m high) that once retained the waters of the *baray*. This wall rests on a sturdy base (average height 1.35 m), most of which would have been submerged when the Mebon was built. The lower platform of the monument is accessed by a stairway (1.80 m wide), guarded by a pair of majestic lions crowning the string walls. From here, a laterite-paved path (6 m wide) follows the edge of the second enclosure. At the four corners of the perimeter path, visitors are greeted by elephants on sandstone pedestals, which face the four intermediate directions. The elephants' heads are 1.85 m above the ground; their tusks are raised, but their trunks curve downward to touch the base. Their adornments include harnesses and a heavy collar with small bells. You will also see small gullies in the

Main sanctuary and corner towers.

sandstone to drain rainwater. In the west part of the north wall, at about 20 m from the *gopura,* there is an open-mouthed monster head that once functioned as a gargoyle.

The tour will continue at the east façade by the second enclosure.

Second Enclosure

This wall (2.10 m high) is topped by a large molded coping. There are four centrally placed cruciform *gopuras.* They have porches with windows and bars; the central halls are surrounded by small open rooms that extend the arms of the cross. The enclosure is 12 m to 15 m wide depending on which side you are standing and contains a succession of oblong laterite buildings with porches and doors framed in sandstone. Curiously, their high and low windows are closed off by balustrades or even by simple stones placed upright. These buildings are in very poor condition, particularly those to the north. They may have been used to store cult objects or served as rooms for meditation.

Second Terrace and the First Enclosure

The laterite retaining wall (2.40 m high) around the second terrace can be climbed by four stairways with string courses topped by seated lions. Another comparatively narrow paved path with no railing borders the laterite wall of the first enclosure. As on the first terrace, stone elephants appear at the four corners of this second platform. They are slightly smaller replicas of their companions lower down (1.75 m). The four laterite towers with square plans (7m on each

side) are nearly identical. Although partially ruined, their basic architectural plan can still be made out. It is likely that their superstructure, now gone, consisted of tiers; some of the door lintels are of great iconographic value and will be discussed below.

Third Terrace

Another esplanade measuring 11 m on its west and 19 m on its other three sides encircles the central terrace. A library stands in each of the northeast, northwest and southwest corners; two identical buildings are to be found in the southeast corner. The towers are surrounded by two other towers in brick with low bases. All eight towers are built to a square plan (5 m on each side) and all at one time housed a *linga.* They open only on the east side, with their other three sides merely roughed out to outline false doors with surrounding pillars and pediments. They rise in short recessed tiers. The brick is dotted with many little holes made for a lime-based mortar coating which has vanished. The decorated octagonal columns and their illustrated sandstone lintels are still standing. The three libraries are rectangular brick constructions (6 m by 8 m), with columns framing the entrances and the sandstone lintels; they open only on the west. Their upper stories no longer exist.

Fourth Terrace

The sandstone base of the uppermost terrace (2.65 m high) has a highly molded facing. It can be reached by a stairway (1.60 m) flanked by string walls supporting seated lions. This square

Detail from the east lintel, northwest corner tower.

Facing page: corner tower and lion on a string wall.

terrace (nearly 35 m on each side) with sand-stone paving supports the central shrine, which is surrounded by four auxiliary shrines. They are all made of brick and open only on the east.

Secondary Shrines

Each tower forms a square of nearly 6 m and rests on a low sandstone base with two projec-tions. They have false doors embellished by octagonal sandstone columns which have pearled bands and floral designs and, at the base, figures under arcatures. The false doors have two stone bars and are divided lengthwise by a highly profiled band studded with five intri-cately ornamented stone knobs. Above each door, there is a finely sculpted sandstone lintel supporting a plain brick pediment resting on the ends of the pilasters.

The corner panels of the main buildings are animated with brick sketches of figures that are standing beneath an arcature. The roof resem-bles a crown rising in four recessed tiers sup-ported by a thickly molded cornice. These sec-ondary shrines, like the eight small towers on the lower level, once had a lime-based mortar coat-ing that penetrated the brick wall through spe-cially placed round holes.

Central Shrine

The central shrine is the same type of construc-tion as its neighbors, except that it is mounted on a four-sided molded sandstone base (1.85 m high and 13 m on each side). There are four stairways with string walls and seated lions guarding the upper terrace. The shrine is a square (8 m on each side) and has a cella (4 m on each side). The height of the central shrine is 18 m, while the side towers are nearly 13 m high. The lintels of the central shrine are of exceptional quality.

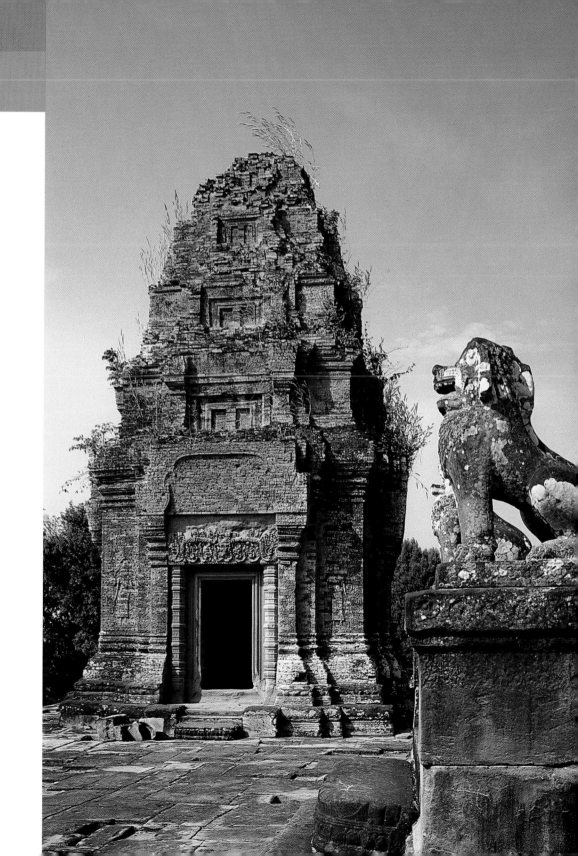

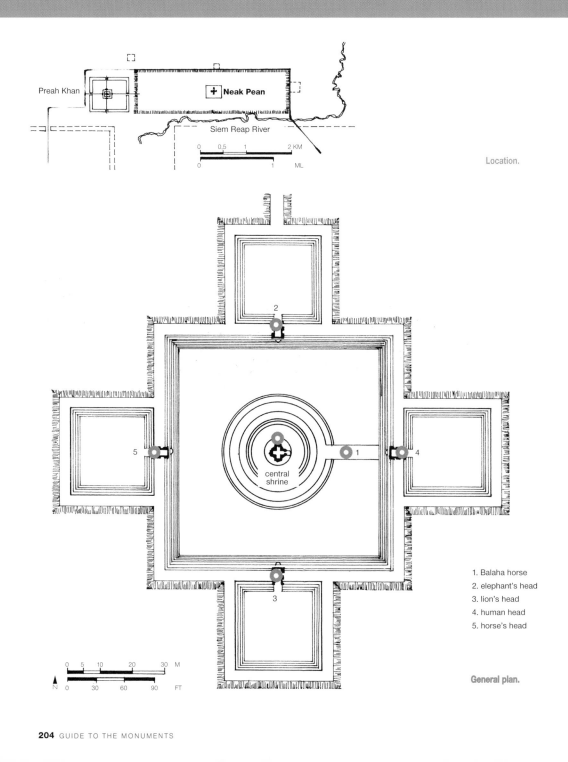

Location.

General plan.

1. Balaha horse
2. elephant's head
3. lion's head
4. human head
5. horse's head

Neak Pean

ឞា ក ព ន្ត

Meaning: the knotted serpents	Restoration: 1938–1939, 1956
Date: end of 12th–beginning	Pron.: nayak pwo-an
of 13th c.	Map: B 30
Built by: Jayavarman VII	Interest: *** archeo., art.
Religion: Buddhist	Visit: am
Cleared: 1922–24	

Access

Neak Pean can be reached via the Grand Circuit from Siem Reap by going either right or left. If you head to the right, go to the Ta Som temple and then, about 2.1 km northwest of the temple, on the left, you will see a path leading to Neak Pean. If you opt to go left, the path 200 m long that leads to this group is 2.5 km from the north *gopura* of the Preah Khan of Angkor.

Characteristics

Neak Pean is actually a monument surrounded by five basins located on an artificial island in the center of the *baray* of the temple called Preah Khan. The reservoir (900 m wide, 3.5 m long) is now dry. A unique layout and purpose distinguish Neak Pean from other monuments in Khmer art.

Description

The writings on the stela of Preah Khan inform us that King Jayavarman VII had the Pond of Victory constructed and that in that pond there is "an eminent island whose charm comes from the outlying basins, cleansing from the mud of Sin all those who enter into contact with it and transporting as if it were a boat those who cross the ocean of existences."

The island in the middle of the *baray* of Preah Khan is square (nearly 400 m on each side). It is bounded by an enclosure 2 m high with laterite steps and stairs lying in the main axes. Four elephant statues guarded the corners of this earth platform, on which were built several small ponds (now buried by forest vegetation) and the five basins of Neak Pean in the center.

The basins are laid out like a traditional shrine, with its central cella containing the idol and its entrances, which usually take the form of vestibules. In Neak Pean, the great central basin and its small temple form the cella as the center of a temple, surrounded on four sides not by vestibules but by auxiliary basins and their "chapels."

The Great Basin and the Shrine

The great basin traces a square measuring 66 m on its side and is bordered by seven sandstone steps. In its center, standing on a large earth levee, there is a round sandstone base, 33 m in diameter, encircled by two *nagas* whose bodies meet in a tail knotted on the west side. The serpents gracefully

Lokeshvara, north façade, central shrine.

part on the east side to greet the traveler (or pilgrim) with their open hoods sheltering a multitude of heads. The round base rises in six steps to another round sandstone platform supporting a sandstone curb (diameter 16 m) in the shape of a corolla that surrounds a sandstone paved terrace where the shrine is located. The shrine is surrounded by large concentric sandstone rings adorned with the sculptures of lotus petals.

The shrine itself is a round structure with a cross-shaped cella (9 m long). The only opening is on the east side; the other sides have false doors that were originally real doors. On each of the doors there is an image of the compassionate *bodhisattva* Avalokiteshvara in an upright position, his huge size dominating the circle of praying figures. The tympanums of the pediments are in poor condition, but several sculptures depicting episodes from Buddha's life are still recognizable; the scene of the Great Departure—Siddharta leaving his father's palace to lead a monk's life—appears on the north tympanum; the "Cutting of the Hair" scene, in which Buddha sacrifices his royal locks for the ascetic's shaved skull after having given his garments to a beggar, adorns the east tympanum; the scene of Buddha sitting in meditation under the bodhi (awakening) tree after his illumination is on the west tympanum. The southern tympanum is completely ruined and illegible. The walls between the doors have become the backdrop for a great sculpted motif of the foreparts of a three-headed elephant surmounted by an upright lion replacing the traditional imagery of Indra.

The superstructure of the shrine consists of four recessed stories, the uppermost of which ends in a lotus flower in bloom.

In former times, at the ground level corresponding to the great basin, there were four platforms bordering the *nagas*; they were aligned with the two major axes and had carved motifs; the north and west platforms are now totally obscured, but on the south platform, there are two blocks of stone belonging to a *linga* that might have been part of the 1,000 *lingas* mentioned in the inscription of Preah Khan. Another unusual feature was found directly below the east entrance to the shrine: a

large statue of a flying horse made of blocks of sandstone that seemed to be seeking entry into the shrine. With head, tail and forelegs in an upright position, this marvelous Khmer Pegasus carries several realistically drawn figures gripping its neck and sides. The statue may represent the Buddhist folk legend of Lokeshvara, which is another name of Avalokiteshvara, the compassionate *bodhisattva*, the savior of humanity who, in the shape of a horse, rescues the merchant Simhala and his companions from the ogresses of the island of Lanka, where they were shipwrecked. The statue was reassembled but, unfortunately, most of the horse's body has not yet been found, which meant that replacement stones had to be used.

Merchants take flight clinging to the horse's tail, Balaha horse group.

The Secondary Basins
and the Small "Chapels"

The basins surrounding the central basin are identical squares measuring 25 m on each side; they have seven steps made of sandstone. In the extension of the two main axes running through the median of the central shrine, the architects placed small sandstone buildings (2 m high), known as chapels, that join the great and secondary basins. They have barrel vaults carved with coffers ornamented by lotus flower motifs. From the outside, each of these chambers resembles the roof of a corner pavilion. Their vaults are topped by finials placed like ridges and their sides form gable walls adorned with superposed trefoiled pediments. They show very fine carvings of Lokeshvara.

Near the great basin, on the same level as the penultimate step, there is a receptacle in sandstone that feeds a gargoyle head with water to be poured onto a pilgrim kneeling inside the chamber. Each gargoyle has a different motif; on the north side, it is an elephant head; on the south, a lion head; on the east, a human head; and on the west, a horse head. The sculptures are generally not very well executed.

No information has been found relating to the chapels; but, as the waters of Neak Pean are said to have curative powers, it may be that pilgrims wishing to be purified from "the mud of Sin" adopted a squatting position in the chapel under the gargoyle. An officiating priest standing outside poured water from the great basin into the receptacle with the spout from where it flowed over the pilgrim.

Royal Palace
of Angkor Thom

Access

Take the Petit Circuit on the left. Travel 500 m around the north side of the Bayon. You will see the entrance to the palace on the left, facing the path leading to the Gate of Victory of Angkor Thom.

Characteristics

Nothing remains of the original buildings except for the enclosure walls and a few *gopuras*. Several palace quarters would have been assigned specific functions and several basins were used as cleansing pools. In later times, other monuments were added to the original architectural complex, notably the temple of Phimeanakas (see p. 213).

Date: 10th–13th c.

Cleared: 1908, 1916–18, 1944

Excavated: 1952–53, 1956

Map: F, G 21, 22

Interest: ** archeo., walk

Visit: am or pm

General plan.

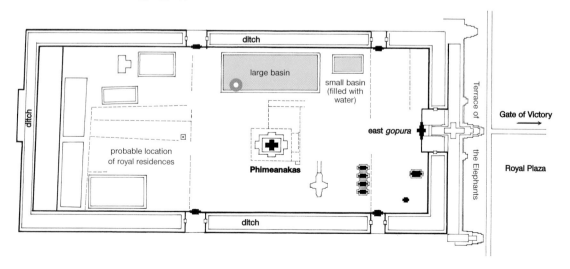 Facing page: the strange bas-reliefs of the large basin.

Description

The royal palace was built by King Rajen-dravarman during the 10th century, after he had moved the capital back to Angkor from Koh Ker. Later, at the end of the 12th century, Jayavarman VII covered the whole palace area with a layer of earth 1.20 m deep.

The main entrance to the royal palace is at the center of the Terrace of the Elephants, which was built at the end of the 12th century. Entering via a flight of stairs which projects from a decorated wall, the visitor arrives at a cruciform platform with a view of the east entrance *gopura* below. Considered one of the crowning achievements of the Khleang style, the *gopura* has a spacious, elegant layout. Unfortunately, little remains of its decorations, apart from two lintels, one of which may be seen on the ground by the east façade, while the other still rests on small columns to the west. These are the finest specimens of lintels from that period; the central motif, which is typical of the style, shows a *makara* disgorging a branch surrounded by croziers.

Leaving the east *gopura,* to the west you will notice that the sandstone jambs between the two windows of the vestibule bear inscriptions reproducing the oath of allegiance that King Surya-varman I imposed on his civil servants.

Beyond the north and south wings of this *gopura*, a first laterite enclosure appears. This wall (average height 5 m) forms the boundary for the royal palace, which is 260 m wide and 600 m long in its east-west direction. The north and south sides are interrupted by two identical *gopuras* shaped as crosses and enclosing a passageway topped by a pyramidal roof composed of gradually shortening tiers. The corbeled roofs of both wings have gable walls with arabesque pediments bearing simple, refined decorations.

The west wall has no opening.

The first wall is surrounded by a ditch at its side 25 m wide and encircled by a second enclosure built at a later date with the four intervening *gopura* described above.

After the east *gopura,* follow the road on the right that leads to the three basins lying in an

east-west direction near the north wall. The first is the smallest (30 m by 50 m). The four sides are curbed by a stairway faced in sandstone descending to the depth of 4 m. Filled with earth, it served as a nursery for young plants. In 1956, when the basin was cleared and its earth was sifted, several gold rings, nuggets and ribbons with golden guilloches were discovered. Other objects included square wooden beams in perfect condition and finely braided mats. The basin now holds water.

The adjoining basin is the largest of the royal palace (50 m by 145 m). Like its companion, it is edged by sandstone steps, thirteen in this case, seven of which are molded. The bottom level is in laterite. It was built during the 10th century, but filled up during the reign of Jayavarman VII concomitantly with the palace area; at a later date it

The large basin of the royal palace.

was dredged and refilled with water. The wall lining its embankment on its west and south sides and part of its east side forms a backdrop for the sculptures of mythical creatures associated with water: *nagas*, *naginis*, and the male and female *garudas*, as well as other sea monsters whose

representations are so lively that they seem to dart in and out of the crowds of fish. It is quite possible that these edges, decorated with Bayon-style bas-reliefs, were also supports for a *naga* balustrade that separated the sovereign and his court from the events, festivals and sports performed on the water.

At the southwest corner, a rather shaky stairway that descends to the level of the basin will lead you to the bas-reliefs. To return to ground level, walk to the middle of the south side and use the blocks of sandstone arranged to form steps.

Further away, on the west side, beyond a *gopura*, there is another basin (25 m by 50 m) with coping and laterite steps. Still further, you will find a terrace situated on the axis of the previous basin. It is supported by a base decorated with bas-reliefs under a frieze representing sacred geese (*hamsa*) and a mixed throng of people, elephants and horses. A fourth basin is located to the south of this terrace and a fifth basin by the enclosure wall.

In the third and last section of the west façade of the palace, hidden under the heavy undergrowth, the outlines of several courtyards and the remains of the walls of the living quarters are faintly visible.

The two exits of the palace permit the visitor to leave either by the east *gopura* or by crossing the *gopura* at the north wall to join Preah Palilay or Tep Pranam. We suggest taking the first exit, with its interesting vestiges of minor importance and the temple of Phimeanakas (see p. 213).

The filling up of the Royal Palace is the source of many questions. Why did Jayavarman VII need to raise the ground of the palace and why was it done in such an uneven way, although it still reaches the height of nearly 2.50 m in the vicinity of Phimeanakas!

Many years ago, certain materials used in light constructions that had been destroyed in fires—the remains of bricks, tiles and the charred fragments of wood—were unearthed. There are, in addition, apparently several layers of earth filling which are impossible to date. Nevertheless, in an intermediate layer, the excavators discovered two stelae of the great Buddhist king, Jayavarman VII. The first stela proves the religious syncretism that has always been the rule in Cambodia, and was particularly true at the close of the 12th and at the start of the 13th centuries. The fig tree, sacred because it was beneath its branches that Buddha received his Enlightenment, appears on the stela with the Trimurti, the Brahmanic tree showing Brahma at the roots, Shiva on the trunk and Vishnu on the branches. Not surprisingly, the stela bears the name of the "Stela of the Fig Tree." The second stela is dedicated to a certain queen who entered Nirvana after a saintly life.

It is difficult to explain the layout of the different architectural elements of the temple given the limited information available and the strong likelihood that fires had ravaged large sections of the palace in the course of its existence. The various theories put forward have never been conclusively proved.

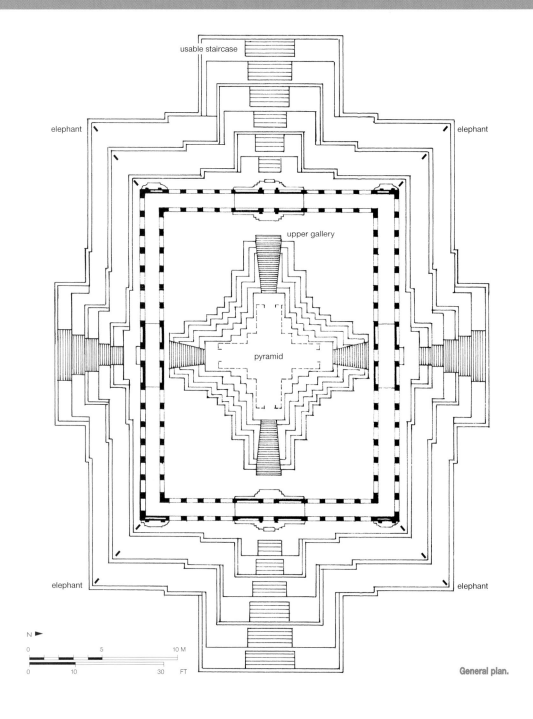

usable staircase

elephant

elephant

upper gallery

pyramid

elephant

elephant

N ▶

0 5 10 M

0 10 30 FT

General plan.

Phimeanakas
វិមានអាកាស

Meaning: celestial palace

Date: 10th century

Built by: Rajendravarman and
Suryavarman I

Religion: Brahmanic (Shiva)

Cleared: 1908, 1916–18

Pron.: peemen akas

Map: F 21

Interest: ** archeo., walk

Visit: am

Access

Follow the same circuit as for the Royal Palace and then take the central stairway of the Terrace of the Elephants. Pass through the east *gopura* of the royal palace, continue west and 250 m further on you will arrive at Phimeanakas.

Characteristics

The monument's high, massive base creates the illusion of a particularly steep mountain. Its location within the royal palace and its accompanying legend make it a lovely and mysterious temple.

Description

In the 13th century, when the Chinese diplomat Zhou Daguan visited Angkor, he noted that in that section of the royal palace reserved for the king's living quarters, there stood a tower that he called the "tower of gold" that gleamed in the sun. Today, this tower is known by its Sanskrit name,

East elevation.

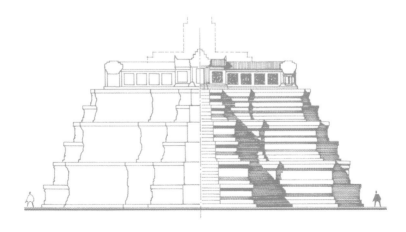

Phimeanakas, meaning "celestial palace." Despite its pyramidal shape, Phimeanakas has none of the symbolic features of Mount Meru and cannot be classified as a temple-mountain like Pre Rup or Angkor Wat. Judging by its layout, the practice of cult rituals would have been extremely difficult. There is evidently no causeway to the pyramid; the enclosure (traces of which remain) would have been too narrow to accommodate crowds of pilgrims or devotees. In addition, the highest level of the pyramid supports only one shrine and not the usual quincunx formation of five. It would appear then that Phimeanakas would have been a privileged sacred area to receive the king or a restricted number of initiates.

The edifice is a three-tiered laterite pyramid resting on a rectangular base with stone projections on either side of the stairway. The first platform is 36 m long, 29 m wide and 12 m high, while the third and uppermost level is 27 m long, 22 m wide and 3.50 m high. The three stories rise to a height of nearly 12 m. A thick band course in its higher section and a series of deep moldings accentuate the edge of each tier. The pyramid's four stairways have progressively narrowing steps, but no landings; the visitor can reach the summit by climbing these stairs, but the ascent is very difficult, especially on the north side, which rises at an angle of sixty degrees. It is recommended to use the west stairway, which has been adapted to make it easier to climb. The four stairways have sandstone string walls with six projections supporting a sandstone base topped by a seated lion. There are small stone elephants

ornamenting the corners of the three stories. Several of these sculptures are still in place.

The last and uppermost terrace is occupied by a gallery 20 m wide by 25 m long, and 1 m wide by 2.37 m high under its vault; it has a series of closely spaced windows (0.95 m wide, over 1.02 m high) on both sides. The seven mortices on the outside sills were added to accommodate bars. Other holes indicate that the window frames were once equipped with wooden shades. The structure has a vault with a dome-shaped intrados. The gallery's four cardinal points are marked by four *gopuras* that extend its length by 6 m. Outside and inside, there are pilasters with unadorned pediments. The roof on the side of the *gopuras* is slightly higher than that of the gallery and the first windows on both sides of the doors are in reality only false windows on the

The Legend of the King and the *Nagini* (following a tale recorded by Zhou Daguan)

In the palace, there is a tower of gold whose summit encloses the bed chamber for the king. All the locals claim that the tower is haunted by the spirit of a nine-headed serpent who is the real master of the kingdom. This serpent, disguised as a woman, appears every night before the king, who has to sleep with her. Even the chief wives of the king do not interrupt their trysts. The king can spend the subsequent nights with his wives and concubines. However, if the spirit of the serpent does not appear before the king, he will have to prepare for his death. And, if the king misses a night . . . woe to him!

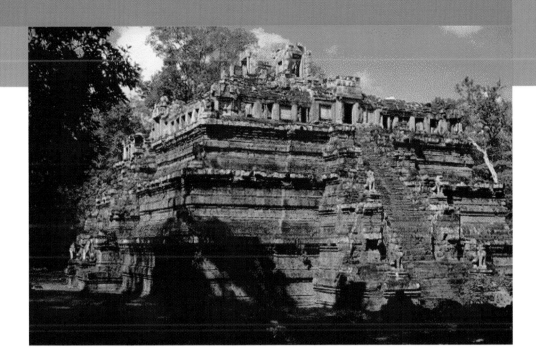

Phimeanakas from the northeast.

inside of the gallery. The remains of a pediment dominate the east and west corners of the gallery façades. The inner court (16 m by 21 m) is limited by the gallery, which encompasses another five-tiered sandstone pyramid, now in a very poor condition. The pyramid's upper terrace (5 m above ground) may be reached with a great deal of difficulty by using one of the four axial stairways. If the visitor is energetic enough to make the climb, he will see the remains of a sandstone pavilion and enjoy a fascinating view of the temple of Baphoun behind a screen of trees. Prior to

the clearing of the temple, the first terrace was buried in more than 2 m of earth. The clearing uncovered this marvelous edifice and the foundations of the galleries and buildings surrounding the monument.

In the 10th century, during its first existence, Phimeanakas consisted of only one upper sandstone gallery decorated in the style of that period. Nevertheless, since the gallery is false, the purpose of the monument is a mystery. Even if there had been a ceiling resting on the cornice, the gallery is only 1m wide and 1.67 m high and would thus only have admitted one person. In addition, the windows in their current position illuminate only the lower half of a person's body.

It is probable that neither the small pyramid on the last story nor its crowning sandstone pavilion were part of the original edifice. In its place, there would have been a small lightweight building where the king met the woman-serpent, the *nagini*, every night to the great benefit of the kingdom.

Preah Khan of Angkor

ព្រះ ខ ន្ធ

Meaning: the sacred sword	Restoration: 1939-59, in progress
Date: 1191	Pron.: praya khan
Built by: Jayavarman VII	Map: C 25
Religion: Brahmanic,	Interest: *** archeo.
Buddhist	Visit: am or pm
Cleared: 1927–32	

Access

Take the Grand Circuit on the left. After the north gate of Angkor Thom, continue walking for 1.5 km. The west access road to the temple will appear on the right after the second bend in the road. As entering the temple from the east is difficult, the visit will start and conclude on the west side.

Certain areas of this monument are in a very poor condition and are virtually inaccessible. The temple's two main axes divide the Preah Khan into a succession of porches, entrance halls, chambers and galleries. The visitor who wishes to spend more time viewing the fascinating sites along the sides of the monument while avoiding the dangerous zones is advised to use the map (page 218-219).

Characteristics

A world in itself, Preah Khan—temple, monastery and center of learning—was erected on the battle-field where Jayavarman VII defeated the Chams after their invasion of Angkor in 1177. The monument covers 56 hectares of land and consists of a large number of buildings whose complex arrangement is due to the various religious foundations established on the site. To the east, the great temple is joined to the Jayatataka Baray (now empty), site of Neak Pean.

Description

A dirt track 10 m wide, bordered by decorated stone posts mounted on a low sandstone base, leads to the west façade. Each post is a molded pillar of two vertical square blocks 2 m high; erect lions emphasize each side of the base and, at the other end, a lotus bud is sculpted from a rounded block of stone. A portrait of a sitting Buddha framed in a flame-shaped arch once embellished the upper part of the pillars; it was destroyed during the 13th century by the Brahmans, who, after assuming religious power, eradicated such images. The dirt track broadens to 15 m immediately after the line of posts, becoming a sandstone road lined with stone giants holding *nagas*; it bridges the moats before reaching the fourth enclosure.

Large upright *garuda*, fourth enclosure, Preah Khan.

sandstone sculpted with Buddha images, (now destroyed). A few of the finest *garudas* can be seen just to the north of the east *gopura*.

The typical *gopura* of the fourth enclosure includes a central tower linked by galleries to two side towers. The middle tower has five graduated tiers; the others have only three. A budding lotus crowns each tower. The *gopuras* are typical of the Bayon style, with a delicately lacy décor, false windows, balusters and drawn shades. The east side gives the visitor the best general view of the *gopura*.

After the fourth enclosure, a long path of 185 m passes through a dense forest, ending at the third enclosure.

Third Enclosure

The enclosure is entered through a cruciform terrace (17 m wide by 25 m long), with a staircase at the end of three of its branches. It is almost the same height as the platform beneath the west *gopura*. In former times, it had *naga* balustrades.

Wall of the Third Enclosure

This laterite wall forms a rectangle 200 m by 222 m and is over 2 m high. The wall is interrupted on each of its sides by a *gopura*. The *gopuras* of the third and fourth enclosures are identical in their ground plans, but differ in dimension and shape. The north, south and west *gopuras* are only 40 m long, unlike the larger east *gopura*, which is 106 m long, illustrating the marked preference in Khmer architecture for this orientation.

Fourth Enclosure

The laterite wall of the fourth enclosure traces a rectangle 700 m wide by 800 m long and rises to a height of more than 5 m. It is celebrated for its sandstone *garuda* images in relief. The monsters wear miters and ornaments as they battle snakes and other reptiles with their clawed hands and feet. These motifs can be found at the corners of the enclosure and along the entire length of the wall at 50 m intervals; in all there are sixty-two representations of upright *garudas* over 3 km of enclosure wall. Originally there was a ridge of

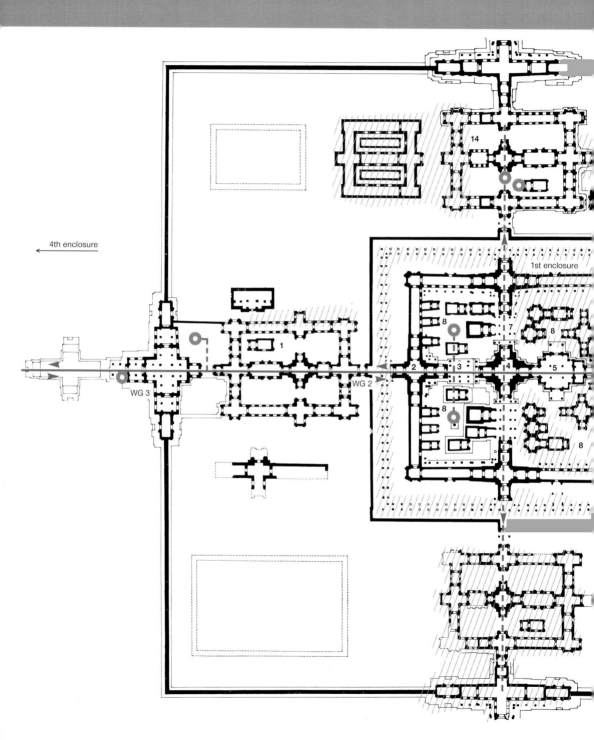

4th enclosure

1st enclosure

14

1

WG 3

WG 2

2

3

4

5

7

8

8

8

8

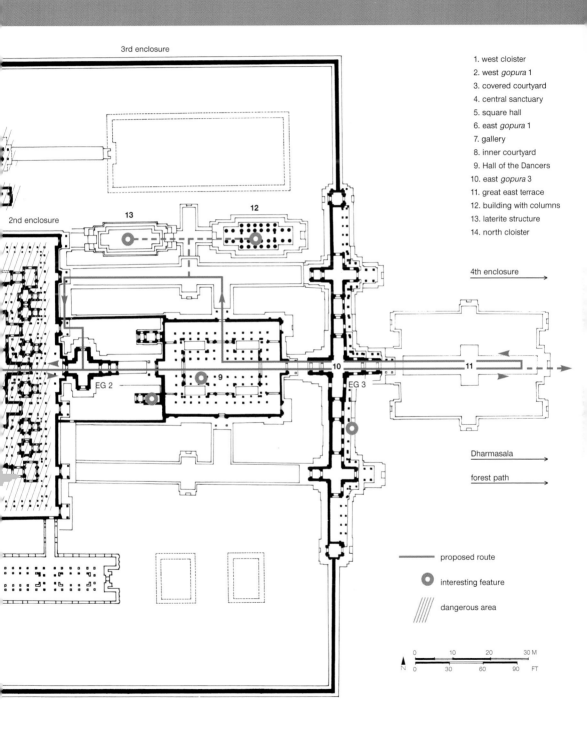

3rd enclosure

2nd enclosure

4th enclosure

1. west cloister
2. west *gopura* 1
3. covered courtyard
4. central sanctuary
5. square hall
6. east *gopura* 1
7. gallery
8. inner courtyard
9. Hall of the Dancers
10. east *gopura* 3
11. great east terrace
12. building with columns
13. laterite structure
14. north cloister

Dharmasala

forest path

proposed route

interesting feature

dangerous area

0 10 20 30 M
0 30 60 90 FT
N

West *Gopura* of the Third Enclosure

This is a cruciform *gopura* (25 m wide by 40 m long) with extensions on its north and south arms. It has a porch with four pillars and a carved pediment. In front of the entrance are sandstone *dvarapalas* or temple guardians who have unfortunately been decapitated. The interior of the *gopura* consists of a cruciform hall with eight pillars and is flanked by two rooms. At the ends of the north and south arms there is a small elongated hall. The only openings of the *gopura* are on the east and west, but the hall and its annexes receive light on two sides through windows. The central hall ends in a groin vault resting on the interior pillars; the aisles are covered by half-vaults. There are several very interesting pediments on this *gopura*: the one on the east side depicts a chess game played by characters on a boat; another one, on the west side, narrates the Battle of Lanka, a chapter from the *Ramayana*.

Leaving the *gopura* on the east side, the visitor will find to his left a small courtyard filled with stone blocks. The outstanding features of this tiny area are two trefoiled pediments reassembled on the ground. The first displays in two tiers a group of worshippers, waist-length portraits of interlaced people and a tall standing figure holding two kneeling people by the hair representing the triumph of Vishnu. In its upper sections, the decayed second pediment shows a scene in which Kama, the god of love, aims an arrow at Shiva, who retaliates by shooting a ray of light at the mischievous lad from his third eye. At the bottom of the pediment, the god of love reappears with his head on his mother's lap.

The visit continues eastward to arrive at a rectangular cloister. An identical cloister will reappear on the north and south sides between the third and second enclosures.

Cloister on the West Side

The cloister is a rectangular structure 30 m wide and 40 m long with a side gallery and a central gallery on the east-west axis. It is a complicated complex that includes corridors, oblong rooms and pavilions with an average width of 2 m. A tiny library is set within the small northwest courtyard. The cloister is nearly a total ruin, except for some very fine pediment sculptures representing Vishnu and his avatar. The interior of the gallery is rather dark, but the visitor with the help of a pocket flashlight may see the outlines of a few fine pediment sculptures.

Leaving the cloister by its eastern pavilion, you will arrive at the second enclosure.

Second Enclosure Wall

The wall (3 m high, 76 m wide, 96 m long) is made of laterite and has a molded sandstone coping. The north, south and west façades of the enclosure have just one door (1 m wide) and a porch, but the east side displays six identical openings in addition to the central passage.

Interior of the Second Enclosure

On the north, south and west sides, you can find a sort of peripheral avenue (10 m wide), which is almost inaccessible. It is interrupted by a gallery with a double row of pillars creating a passageway 2 m wide which overlooks a kind of courtyard. On

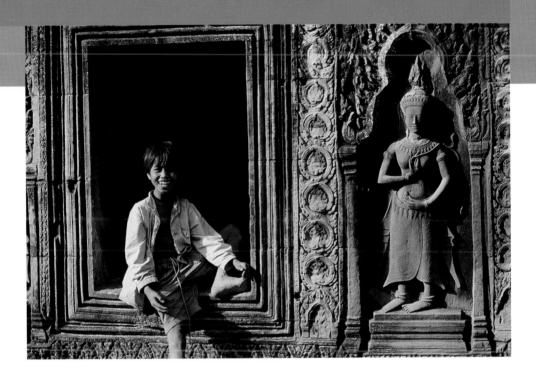

Boy at a window, Preah Khan.

the east side there is a free passage of over 5 m. The avenue widens on this side to a broad 17 m, providing sufficient space for several small chapels (see below).

We shall remain on the west side and cross the gallery leading into the first enclosure.

First Enclosure

This rectangular enclosure is 58 m wide and 63 m long. The same cloister principle that inspired the constructions on the west side reappears here in the form of a U-shaped gallery, as it is interrupted on the east side. A *gopura* and two small doors form the openings for the outer wall on the north and south sides. The west side with its solitary *gopura* offers a striking contrast with the complexity of the architectural elements on the east side, which has *gopuras* and pillared porches, combined with a labyrinth of buildings and pillars placed between the first and the second enclosures.

The double walls of the first enclosure create an interior gallery 2 m wide with windows lining the second wall, in front of which on the north and the south sides there is a portico. The other sides are hidden either by a solid wall (east side) or by other buildings joined to the gallery (west side).

Interior of the First Enclosure

On entering the enclosure, the first thing the visitor sees is a cloister lying on the two main cardinal axes. Then, on the east-west axis, he finds successively a cruciform *gopura* (17 m by 20 m) and a rectangular courtyard (8 m by 9 m), with twelve

pillars, leading to the central shrine, in the center of which there is a *stupa*.

The central cruciform shrine consists of a square cella (6 m on each side) and four square annexes (on average 3 m on each side). The shrine is topped by a tower. The tiny holes in the sandstone may have been made for sheets of metallic facing or a protective coating.

Leaving the central shrine and crossing the north-south axis, the visitor passes through a pillared gallery (eight columns on the north and ten on the south) and reaches a *gopura* similar to the ones on the north and south sides.

The north *gopura* leads to the north cloister outside the second enclosure. This cloister is composed of several admirably decorated buildings. On a trefoiled pediment Vishnu is in the midst of his deep cosmic slumber bedded on a dragon; another pediment is carved with the image of a goddess raising her right arm as a signal to a group of wild geese to gather at her feet; this pediment is attached to a small chapel.

Inside the first enclosure, the two cruciform passages border four unequally proportioned courtyards containing other buildings.

First Enclosure, Inner Northwest Court

The court (20 m wide by 23 m long), which has been restored, encloses several buildings that display attractive and interesting sculptures and a "lantern pillar."

In this particular area of the temple, the visitor will find, adjoining the west wall of the gallery, three identical chapels that include two rooms measuring 2.50 m by 5 m. One of the most surprising

features of these structures is their barrel vault, which has caused some experts to interpret their presence as possible family burial places.

First Enclosure, Inner Southwest Court

The area here is slightly larger (25 m long) than the one described above; its "lantern pillar" stands in the center and the buildings are symmetrical to those in the northwest court. Like most of the chapels, the walls are decorated with the images of *devatas* in the corners and ascetics sitting beneath arcatures; the background of lush undergrowth is a true masterpiece of Khmer decorative carving. However, some motifs under the arches have been completely destroyed.

Originally, each corner pavilion of the first enclosure had a tiered tower, but only the one in the southwest corner has survived.

The visit continuing eastward approaches a nearly perfect square (9 m on each side) chamber joined to the central shrine. The room is surrounded by a wall with windows and in its center there are four pillars. Another room with an adjacent porch follows the first room and is in turn followed by the east *gopura*, which is similar to the one on the west side.

Goddess in a gallery, Preah Khan.

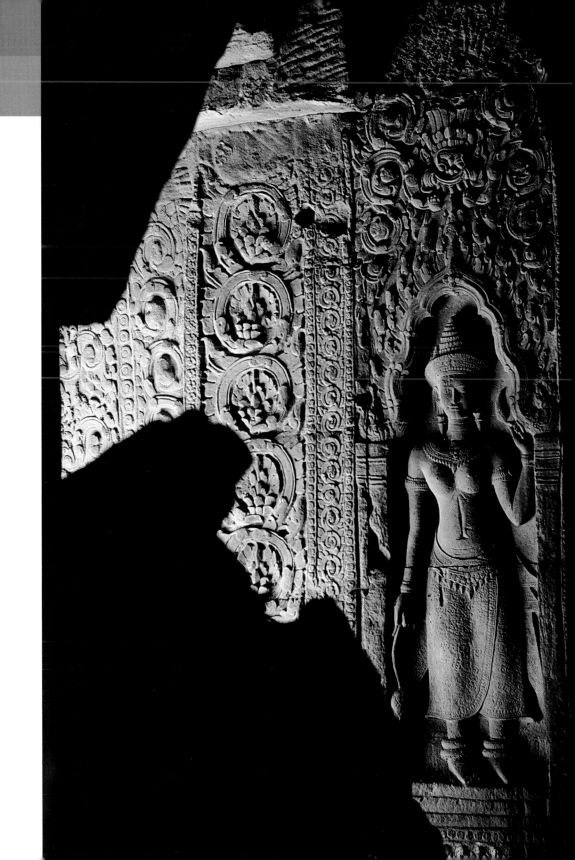

First Enclosure, Northeast and Southeast Inner Courtyards

Fallen masonry clutters both courtyards, making visits perilous undertakings. These sections contain cruciform structures that are symmetrical to the east-west axis and have annexes that are open on four sides. The annexes are also linked to the wall on the east side of the courtyard through an oblong construction encompassing three rooms. There is a very small library (2.50 m wide by 4.50 m long), open to the west, wedged in between these structures and the central passageway. Other cruciform buildings have vestibules of varying dimensions on their east sides and lie near the north-south central passage.

First Enclosure, East Gallery

The clearing of this cluttered area's central passage has made it possible to visit a few tiny buildings on the south side, but visitors are advised to enter with extreme caution. This section of the monument is in fact a false gallery, since its west wall is practically shut and it thus "turns its back" on the inner courtyard of the first enclosure, of which it is supposed to be a component. The central cruciform *gopura* (12 m long) appears on its north and south sides, creating an imposing mass over 35 m in length that is extended even further by a gallery (7 m on the north side, 10 m on the south side). On the east side, between the branches of the cross of the *gopura*, there are four tiny cruciform buildings with axial openings preceded on the east by a vestibule. These four buildings are joined on their east side, as is the custom, by an alignment of a double row of pillars that is actually part of the courtyard around the second enclosure.

The *gopura* of the first enclosure is immediately followed by the *gopura* of the second enclosure, which is a similar building except for an extra vestibule on its east façade.

Lintel with a frieze of dancers, Hall of Dancers.

We have now come to a vast sandstone-paved terrace bordered on the north and south sides by a laterite wall (2.45 m high) capped by a ridge of sandstone once adorned with images of Buddha beneath tiny obliterated arches. The wall surrounding the terrace is open on its east-west axis by a narrow doorway.

The sandstone east wall is interrupted in the center by a stone doorway with a porch; the wall belongs to a large building, which we shall enter and pass through. The porch is surrounded by small sandstone structures (3 m wide by 8 m long). The northern structure has three rooms with windows and has corbeled roof abutting pediments. Its southern counterpart, which has a vestibule on the west side leading into a single room, has become the unlikely home for an astonishingly tall tree.

Passing through the central doorway, the visitor enters the large room known as the Hall of Dancers, which owes its name to its carved lintels of dancing *apsaras*.

Hall of the Dancers

A 5 m-high laterite wall raised 0.80 m from the ground forms a rectangular area measuring 26 m by 36 m. The north, south and east sides have doors 1.50 m wide with pillared porches; the one on the east side is centrally placed and has a narrow passage on either side. The room contains 102 pillars, which divide it into four squares separated by axial passages measuring 3 m and 3.50 m. The roof structure of this large room is quite complex, especially at the intersection of the passageways, combining vaults and half-vaults.

The upper compartments of some of the door lintels contain magnificent friezes of dancers. There are also arcatures that used to frame tiny figures.

Leaving the building by the central east door, the visitor reaches the *gopura* of the third enclosure.

Third Enclosure, East *Gopura*

This long axial *gopura* (around 100 m long) is actually a combination of three cruciform *gopuras*; the central element measures 14 m on its east-west axis and 18 m on its perpendicular north-south axis. At the north and south ends there is a fairly small gallery that receives daylight from a series of windows opening the east façade. Both galleries connect the central structure with the other smaller cruciform *gopuras* (15 m on each side). The complex is further enlarged by the addition, on each side, of a gallery (13 m long), open to the east by pillars and an end room (5 m by 6 m).

The entrances of the three *gopuras* have porches with four pillars, in front of which are small terraces with stairways. You will notice that several pediments are missing and others, still in place, display tympanums that are barely distinguishable.

Two gigantic trees growing on the top of the south gallery create an extraordinary atmosphere.

The central *gopura* is followed by a vast terrace.

Great East Terrace

The rectangular sandstone-paved terrace (30 m wide, 40 m long, approximately 1 m high) forms the base of a low cruciform terrace (5 m wide) which starts at its center and extends east-west. The main terrace has two stairways on its west

side, three on its east and one on its north and south sides; the flights have four steps. A few seated lions guard the string walls and the remains of a *naga* balustrade are visible at the edge of the terrace.

A forest path (317 m long) starts just beyond this terrace to the east. At this point, the visitor has a choice of two possible itineraries: he can either head for the east *gopura* of the fourth enclosure and from there reach the landing stage of the Jayatataka Baray; or he can return to the temple to view several interesting features in the outer sections of Preah Khan.

First Itinerary

From the great terrace, follow the long dirt road east. After 150 m, the visitor will see on the left a small sandstone edifice slightly set back from the road called the Dharmasala.

The Dharmasala

The inscription on the stela found at Preah Khan mentions a "house with the fire" where weary travelers could regain their strength; surprisingly for a roadside shelter, it contained four statues (possibly of gods). The building (6 m by 16 m) has sturdy walls and stands on a low base. It consists of a small rectangular room with two doors and a main building. On the south side there are four windows with double bars. There is only one door on its east side. The tiered roof of the central building has a full vault supported by small walls with high windows and, above that, a half-vault. It is crowned by sandstone finials. The entrance is topped by a tower of gradually shortening tiers.

Continuing east (167 m), we reach the fourth enclosure, which is similar to the one on the west. A sandstone-paved path (15 m wide) spans the moats and is bordered on both sides by stone giants (2 m high), twenty-three *asuras* and as many *devas*, all unfortunately decapitated.

After a dirt path (10.20 m wide) flanked by forty-two posts followed by a flight of fifteen laterite steps, you will come to a levee which forms the west bank of the *baray*, with Neak Pean in its center.

By retracing his steps and returning to the terrace of the third enclosure, the visitor will be able to follow the second itinerary.

Second Itinerary

After returning to the center of the Hall of Dancers, turn right to exit by the only door on the north façade. Parallel with the hall's north wall there is a road with a *naga* balustrade leading to one of the most unusual and mysterious buildings in Khmer architecture.

Building on Columns

Standing on a laterite base (1.60 m high) an irregularly indented platform (11 m by 28 m) supports a building consisting of thirty-two drum columns set back from the edge of the platform. Eight of these huge columns (2.70 m in circumference, 3.50 m high) form square porches at the east and west ends measuring 5 m on each side. The other twenty-four are set in rows at 1.90 m intervals and support a sturdy sandstone lintel and wall. This was part of an upper story that used to contain a room (7 m by 10 m), whose floor would probably have been made of wood. The walls of

the room have five windows placed low (1 m wide by 1.30 high). There are scroll patterns and *apsara* decorations. A balcony at each end, at the level of the lintel, supports a carved pediment of which only a few elements remain. The building may originally have had a tiled roof. There was apparently no stairway leading to the upper story of the building. The platform is not sufficiently wide to accommodate a flight of stairs and there is no way of linking such an element to the upper story. Where could it have begun and where could it have led? The purpose of this building is unknown. According to some experts, it might have been used to store cereals; other specialists have elaborated the more plausible theory that it served as a sort of viewing platform from where the king and his court could enjoy the dances on the terrace opposite and activities taking place on the waters of the reservoir.

Laterite Block

Some 11 m to the west of the building on columns, there is another building made of shortening tiers. Its rectangular base is considerably larger (10 m by 28 m) than its upper tier (6 m by 18 m). This top elevation (3.50 m above the ground) is approached by two stairways flanked by seated lions on the east and west façades. This building, like the one on columns, has a mysterious function. Could it have served as a platform for dances? Was it a holy ground for royal cremations? Both hypotheses are plausible.

To exit on the west side, it is necessary to leave by the terrace supporting the mysterious edifice. Take the road going west, follow the wall of the second enclosure heading south, go through a small door leading onto the terrace of the east *gopura* and then enter the central shrine. Here, take the south passage that cuts across areas of fallen masonry until you reach the forest. This area contains a large rectangular building, but it must be approached with care because of its ruined state. This edifice is attached to the southeast corner of the second enclosure and only its sandstone base, a few fragments of wall and the south cloister are visible. The east and west galleries of this cloister are off limits because of the quantity of dangerous rubble.

The visit to Preah Khan is now complete. Following the same road in the opposite direction to the central shrine, you will arrive at the fourth enclosure to exit the monument.

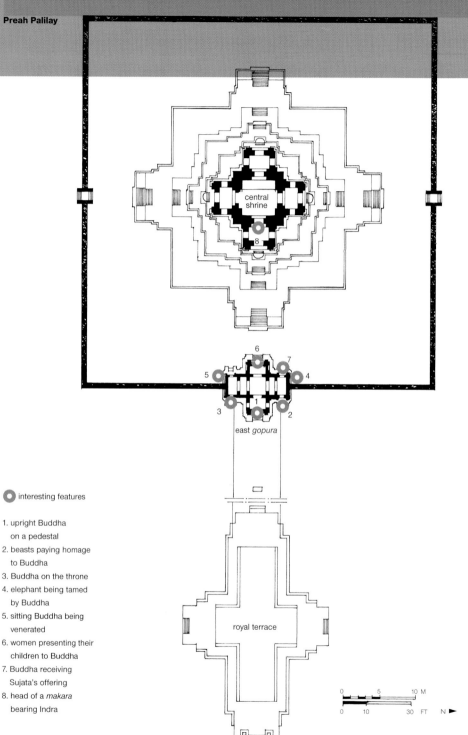

central
shrine

8

6

7

5

4

3

1

2

east *gopura*

royal terrace

○ interesting features

1. upright Buddha
 on a pedestal
2. beasts paying homage
 to Buddha
3. Buddha on the throne
4. elephant being tamed
 by Buddha
5. sitting Buddha being
 venerated
6. women presenting their
 children to Buddha
7. Buddha receiving
 Sujata's offering
8. head of a *makara*
 bearing Indra

0 5 10 M

0 10 30 FT N ▶

Preah Palilay

ព្រះប៉ាលិលៃ

Date: end 13th–early of 14th c.	Pron.: prah palee-lai
Religion: Buddhist	Map: F 21
Cleared: 1918–19	Interest: * archeo., walk
Restoration: 1937–38	Visit: am or pm

Access

Take the Grand Circuit on the left. On reaching the Royal Plaza, you can reach the monument by one of two ways:

— By the path that turns left after the Terrace of the Leper King. Preah Palilay is approximately 200 m beyond the temple of Tep Pranam.

— By going through the Royal Palace. Take the path through the west *gopura* of the north wall of the Royal Palace; Preah Palilay is then 190 m directly north of this *gopura*.

The visit will now start at the east terrace of the monument.

Characteristics

For many years, this edifice was hidden by dense vegetation. Once cleared, it became a popular destination for walks. More importantly, it is the only site where the Buddha images were not destroyed after the reign of Jayavarman VII, which means that it was built after this period.

Description

The temple consists of three parts: a terrace followed by a causeway; a single *gopura*; and a central shrine.

Terrace and Causeway

The cruciform causeway (14 m wide, 31.50 m long) rests on a sandstone base supporting two platforms. The upper one, reserved for the monarch, is 1 m higher than the lower one, which was used by members of his court. On the base, there are remnants of a decorative frieze showing sacred geese (*hamsas*) poised as if about to take flight. *Naga* balustrades coil about both platforms and in certain places end with the fan of seven heads rising out of the single neck of the snake. The first string wall of the east stairway has the customary guardian lion. Walking in the direction of the shrine along a slightly elevated sandstone-paved road (33 m long by 7 m wide), we arrive at the east *gopura*. Formerly there were two temple guards, *dvarapalas*, halfway along this road, but these have unfortunately disappeared.

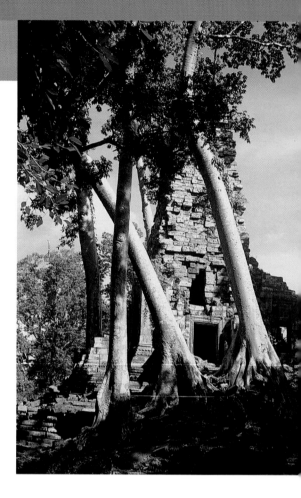

In front of the entrance to the *gopura* is a huge sandstone statue of a Buddha set on a pedestal (2.70 in height) of a recent date. The sage is sitting cross-legged on a lotus—a position known as "calling the earth to witness." The immense head of the statue has the characteristic skull protuberance, the *ushnisha*, spreading out like a flame. The statue is now protected by a shelter.

Enclosure Wall

The single enclosure wall (more than 3 m high and 65 cm thick) is a laterite addition to the east *gopura*. The wall traces a square of 50 m on each side. The main entry is through the *gopura*, although there are two small axial passages (1.20 m wide) through the north and south walls. Several sections of the wall have collapsed.

East *Gopura*

The *gopura* at the entrance to the enclosure is a cruciform building (8.50 m wide by over 9 m long). It contains a square room (2.50 m on each side), two adjoining vestibules and a side passage leading to two small annexes. The annexes can only be reached from the exterior by seven very steep stairs and their doors are small (0.70 m wide and only 1. 50 m high). The main door of the central room, on the other hand, is 1.40 m wide for a height of 2.40 m. The *gopura* was successfully restored in 1937–38 using the anastylosis technique. The interior of the central room rises in the manner of a chimney flue to a height of nearly 12 m above the paved floor. The annexes have vaults and gable walls.

View of the main tower in the grip of tree roots.

The octagonal colonettes framing the doors are ringed with groups of bands; the lintels are carved with scenes from the life of Buddha and present an interesting combination of the Angkor Wat and Bayon styles. The tympanums of the pediments luckily escaped destruction at the hands of the Brahmanic fanatics in the 13th century, although a few images have fallen victim to time and harsh climatic conditions.

On the east façade of the *gopura* there are representations of:

1. (above the central door) Buddha on a pedestal with praying figures at his sides and other worshippers below in a frieze
2. (above the door to the north annex) the forest beasts paying homage to the Buddha
3. (above the door to the south annex) Buddha sitting on the throne below the Tree of Enlightenment
4. (two superposed pediments on the north façade) the one below displays an image of the drunken elephant Nalagiri being tamed by Buddha
5. (two superposed pediments on the south façade) a sitting Buddha being venerated by his disciples and worshippers arranged in a frieze pattern.

On the west façade:

6. (above the central door) the presentation of infants to the Sage by their mothers standing under trees; below this scene are harnessed elephants

7. (above the north door) a sitting Buddha shaded by parasols receiving from Sujata the offering of rice porridge in a golden bowl

Central Shrine

The shrine at the center of the temple enclosure rests on three successive sandstone terraces with molded contours; the terraces have a combined height of over 6 m. The first terrace forms a square 25 m on each side, while the highest level is only 12 m on each side. The terraces have laterite substructures. Each of the four arms of the cruciform terrace is served by a stairway of gradually shortening steps. The shrine itself is a square edifice (7 m on each side) flanked by four open vestibules (now ruins) lying along the main axes and projecting 3 m from the monument. The vestibules adjoin a square cella (5 m on each side) that is strewn with rubble. The roof of the central tower seems to be made of reused sandstone blocks and rises 19 m above the floor of the cella. Five majestic trees grow out of the base wall on the north and south sides of the shrine. The only vestige of the temple's decoration is a magnificent carving on an interior lintel showing a huge *makara* head with open mouth supporting Indra on his three-headed elephant. When the temple was cleared in 1918, numerous fragments were unearthed, including several heads belonging to Brahmanic or Buddhist statues, together with thin sheets of stamped gold, leaves of silver cut into trident shapes and a baked clay vial containing cremated bones.

Pre Rup

ស្រែ

Meaning: turn the body	Cleared: 1930–35	1.2.3. north towers
Date: 961	Pron.: pra-ye-roup	4.5.6. south towers
Built by: Rajendravarman	Map: I 35	7. vat
Religion: Brahmanic (dedicated	Interest: ** archeo., art.	8. library
to Shiva)	Visit: at sunrise or sunset	9. stela shelter
		10. central shrine

point of interest

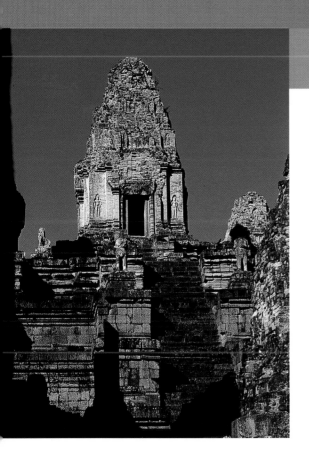

The main tower.

Access

Follow the Grand Circuit on the right from Banteay Kdei, then continue along the shore of the Srah Srang. After 2 km, Pre Rup will appear on the left.

Characteristics

The monument lies on the same north-south axis as the East Mebon, which was constructed approximately nine years earlier and lies 1.3 km to the north. This temple-mountain is distinguished by its harmonious proportions and the exquisite colors created by the combination of laterite (the Khmer word for which means "a stone of the same color as grilled rice") with red brick. The monument may have served a funerary function, as its name indicates the shifting of a dead body; it may also have been the heart of an urban area with religious institutions and a state temple.

Description

In its early years, the temple was probably protected by a moat, the southeast portion of which now forms part of the Grand Circuit. A causeway marked by boundary stones (which the Grand Circuit cuts across) once led to the monument but now ends in the forest.

Pre Rup is a two-tier temple-mountain crowned by a three-story pyramid. The monument probably lay within a multitude of enclosures, of which only two remain.

Second Enclosure

The road takes us to the east side of the monument near the entrance *gopura*. When it was originally built, the sight that greeted visitors traveling along the wide causeway must have been an impressive one.

The enclosure is made of laterite and contains a first, elevated terrace (120 m by 130 m). The wall (3 m high) is topped by a heavy molded coping and is interrupted at its cardinal points by four identical *gopuras*. Their porches are made of sandstone, but their central chamber and two wings are made of brick. They are illuminated by two long windows carved out of the porch wall. The north, west and south *gopuras* are totally ruined. The carvings on the pediments, some of which are still in place and some of which are on the ground, are difficult to distinguish. The superstructure of the east *gopura* is missing completely. The best-preserved elements are the banded and decorated columns and a lintel inside the porch.

Inside the hall, on the ground, is another lintel beautifully carved with leafy branches. There are volutes at the ends and, in the center, a sitting figure under an arcature. Crossing the east *gopura*, we arrive at an inner courtyard.

Inner Courtyard of the Second Enclosure

This courtyard is nearly 20 m wide and extends for nearly 430 m; it is occupied by towers and buildings of varying dimensions.

East Façade Towers

Starting on the right side, to the northeast, you will notice two brick towers placed on a high common plinth. The tower in the corner of the enclosure wall is truncated. Three towers were originally planned on this side, one large structure flanked by two smaller ones. The central tower is still standing. Built to a square plan (8 m on each side), it has thick walls and encloses a cella (25 m^2). The flanking north tower (7 m on each side) is built along similar lines, but has a smaller cella (10 m^2). The south tower was left unfinished, although the stones for the base were laid. The two finished towers have roughed out false doors with lintels; the lintels over the east doors, on the other hand, are finely carved. The lintel of the main tower has cracked.

Returning to the southeast section, you will notice that three other towers of a similar type occupy that area of the courtyard. The decorations

View from the east. In the foreground is a vat the purpose of which is unknown.

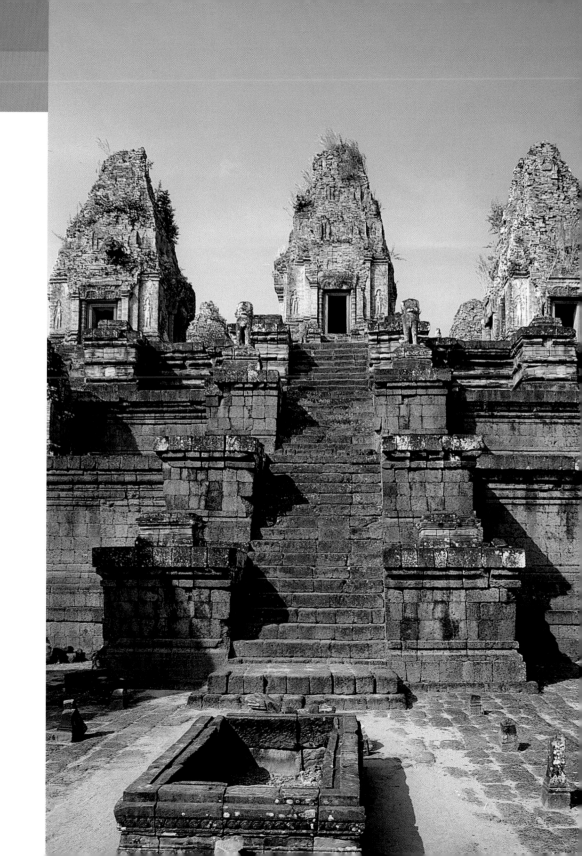

on the columns and the lintels are interesting, despite their poor condition. The southernmost tower, which has lost its roof, had to be reinforced because it had several dangerous cracks running down its length. These three towers have unusually large east doors (1.70 m wide, 3.70 m high) and unfinished lintels. The most impressive scene on the lintels is undoubtedly that of Narasimha, the lion-man and an avatar of Vishnu, who is tearing the demon king of the *asura* apart with his claws.

On the north and south sides of the same courtyard, you may take two steps to enter several buildings near the first enclosure's retaining wall.

North Buildings

A mixture of laterite and sandstone, these buildings are composed of two oblong chambers (5 m wide by 20 m long; 5 m wide by 17 m long). They are in ruins except for several sections of laterite wall and sandstone window frames with balusters.

West Buildings

This façade has two other buildings of similar layout, except that they have only one porch. They are 18 m long and the remaining walls are 5 m high. A large groove has been carved in the upper part of the cornice and probably served to hold a wall plate or the ends of a rafter for a pitched roof.

South Buildings

These are aligned with the north buildings. Behind the one that is placed furthest to the southwest, there is a monster protruding from the first enclosure wall.

First Enclosure

The second terrace of the monument supports the wall of the first enclosure. The terrace rests on a laterite base (80 m by 90 m, 1 m high). The edge of this first base is surmounted by a second basement wall (0.70 m high), supporting a laterite wall (2.35 m high). The wall is interrupted by four *gopuras* aligned with those of the second enclosure.

The east and west *gopuras* are identical and are reached by a stairway. They consist of a porch resembling the ones of the second enclosure *gopura,* a square passage and two side passages in the enclosure wall. The east *gopura* is in rather poor condition, but its companion on the west side displays on its eastern façade a fine lintel with a scene of Indra on his three-headed elephant. The north and south *gopuras* (6 m by 7 m) are also identical. Made of brick, they have only one passageway. The *gopuras* of the first enclosure are not better preserved than those of the second.

Note on the Meaning of "Pre Rup"

Pre Rup means "turn the body" in the current definition. However, certain monks studying in the pagodas of the enclosure of Angkor Wat have suggested another meaning. The "Pre" would be in fact "Prae," which means not only as "turn" or "return," but also "change" or "alter." These religious scholars adhere to the second interpretation of the name. The "Prae" spelling would thus link the temple with the concept of the transmigration of souls.

Inner Courtyard of First Enclosure

Beyond the east *gopura* of the first enclosure lies another courtyard (35 m by 13 m) paved with laterite. The courtyard contains a large stone rectangular "vat" resembling a sarcophagus (almost 2 m wide by over 3 m long). Its sides are carved and the top is notched as if for a lid. This receptacle is surrounded by sandstone pillars, only a few of which were present until recent times. They were mostly short and thick at the base and topped by a stone tenon. Some experts think they supported a roof on a wood frame that sheltered a statue of Nandi.

Libraries

Located on the north and south sides of the vat, the libraries (over 6 m by 9 m) are made of brick. They stand on a crudely molded brick base, which rests on a layer of laterite. There is a real door on the west side and a false one on the east side. The upper sections of the north and south sides over two levels were given ventilation windows, blocked by nine piles of bricks.

Secondary Chambers of First Enclosure

Dotting the first enclosure are a series of chambers similar to those of the lower terrace. On either

Note on the Stela Shelter

The stela shelter contains a basin-shaped vat with a drain in the form of a furrow carved into the rim. The Khmers believe that this recipient was used to wash the bones that remained after the deceased had been incinerated.

side of the east and west *gopuras* there is a building (4 m by 18 m) that contains three chambers; it has a porch supported by four sandstone pillars. The five other constructions all have different ground plans and range from a single room (4 m by 14 m) to oblong chambers (4 m by nearly 40 m). All these structures are made out of laterite, stand on molded bases, and have entry porches resting on sandstone pillars and long barred windows. They would have had tile roofs.

Shelter for the Stela

In the northeast corner of the first enclosure, there is a curious little laterite edifice that has been completely restored. It stands on a square base (3 m on each side). A sturdy corner pillar (2.20 m high) stands at each of the four cardinal points. A pronounced cornice is surmounted by a pyramidal roof ending in a vague lotus flower motif. The design of this roof was influenced by a type of roof found in India and rarely used in Cambodian architecture.

Pyramid

The pyramid is located on the second terrace and consists of three tiers. The first platform (50 m on each side) has laterite foundations and a heavily molded base. On each side of the terrace there is a staircase projecting 6 m from the retaining wall. These staircases have string courses with two indentations surmounted by thick sandstone pedestals with sitting stone lions that have mostly disappeared. The seventeen steps that lead to the highest terrace shorten gradually toward the top.

At each of the corners on the first platform,

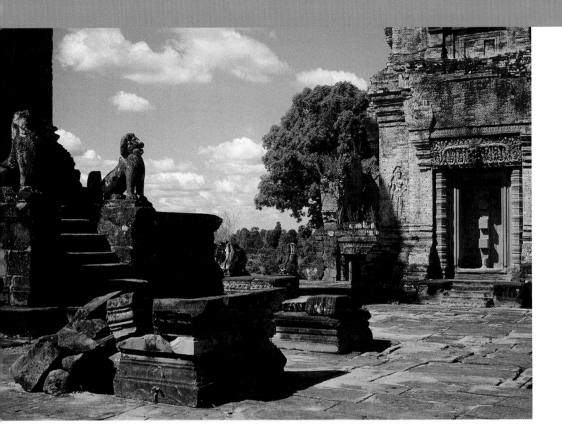

there are three reduced versions of the temple, linked by a perimeter path 4 m wide. These twelve reduced models appear at regular distances and are 3 m high. Made of brick, they are open only on the east by a single door, which is surrounded by colonettes and has a carved sandstone lintel. The three other façades of these tiny temples have roughed-out false doors and lintels with vague decorations.

The second platform is faced with laterite; the visitor can reach this level by ascending nine steps leading to another path 3 m wide.

The highest terrace at Pre Rup.

The third and last platform is faced and paved in sandstone and forms a square (35 m on each side). It is bisected on the east side by a stairway of eight steps (3.10 m wide) on either side of which there is an ornamental stairway that leads nowhere. The three other sides have only one stairway.

Corner Towers

Each of the four corners of the top platform has a brick shrine in the form of a tower. The towers are built to a square plan (6 m on each side) and stand on a sandstone base with a height equivalent to three steps. As usual, there is only one opening on the east side. The other façades have false doors, which, like the real one, are surrounded by stone columns with decorated lintels that are in a poor condition.

The brick pyramid is a tall structure (13 m high) and it contains a square cella (3 m on each side). Each tower shelters a god. The inscription of Pre Rup informs us that the southeast tower is intended for the veneration of Shiva; in another tower, Vishnu is worshipped; and in the last two towers, the statues of Shiva and his spouse Uma were erected in memory of the uncle and aunt of King Rajendravarman, who was the temple's founder.

Central Shrine

In the center of the top platform there is a pyramid of reduced dimensions supporting the central shrine, also made of brick. The sanctuary is set on a square double plinth with wavy contours and moldings. The square plinths are respectively 15 m and 12 m on their sides. Each axial orientation has a stairway of nine steps embellished by the traditional string walls and sitting lions. The tower itself was built to a square plan (8 m on each side) and, like many other Khmer tower shrines, it has a real door on the east side with columns adorned with bands and carved lintels. The other façades have similar columns and lintels. The tower has a pyramidal superstructure that rises in five gradually shortening tiers adorned with false windows and the outlines of figures in relief. The tower is nearly 7 m high. At the corner piers there are the indistinct silhouettes of standing figures: female on the west side and male on the east side. Inside there is a square cella (4 m on each side). The temple's inscription says that the cella was once the guardian of the main *linga*. As with many brick structures, the walls of all five towers are pierced by numerous little holes indicating that a lime-based coating once protected the exterior. On the north lintel of the central shrine there is a portrait of Indra on his three-headed elephant.

Srah Srang

ស្រះស្រង់

Access

Follow the Grand Circuit on the right until you reach Banteay Kdei. The lake lies across the road from the east entrance to Banteay Kdei.

Characteristics

A restored landing terrace overlooks the water and is the only example of this type of construction at Angkor. Its design and decoration complement the tree-lined lake magnificently.

Meaning: the royal bathing pond
Date: 10th c., and end of 12th c.
Built by: Jayavarman VII
Cleared: 1920
Restoration: 1956, 1963–65
Pron.: srah srang
Map: J 32
Interest: ** archeo., walk
Visit: am or pm

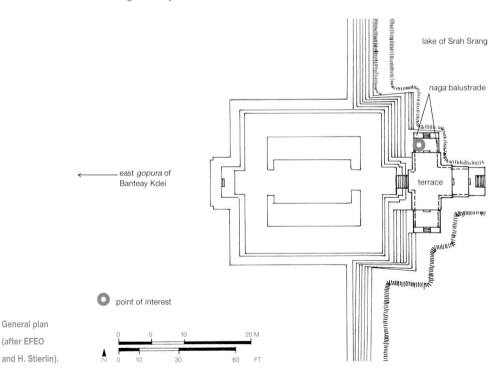

lake of Srah Srang

naga balustrade

east gopura of Banteay Kdei

terrace

point of interest

General plan
(after EFEO
and H. Stierlin).

0 5 10 20 M

N 0 10 30 60 FT

Description

The site of the Banteay Kdei temple was origi-
nally occupied by a Buddhist monument. It is
also probable that a first lake, possibly larger
than present-day Srah Srang, was created dur-
ing the first half of the 10th century conjointly
with the erection of this Buddhist sanctuary.
King Jayavarman VII initiated a program to
redesign Srah Srang whose dimensions were
reduced. The lake is nearly 400 m wide and
700 m long. It is bordered by steps with a sand-
stone coping. There are also blocks of stone
that may have formed part of a base for an islet
in the center of the lake supporting a light-
weight structure.

Landing Terrace

This axial cruciform terrace is located on the
lake's west side, adjacent to a levee of earth with
laterite steps. The terrace is reached by a stair-
case situated on the west arm of the cross; the
other three sides each have a step leading to
three small rectangular landings ending in small
flights which facilitated embarking and disem-
barking. Particularly striking are the *naga*
balustrades whose bodies are supported by dice-
shaped blocks of stone carved with "atlas" mon-
sters. The ends of these balustrades are particu-
larly remarkable with their upright *nagas*. From
the front, each one displays a snake with three
heads mounted by a *garuda* whose spread wings

The end of a *naga* balustrade (rear view).

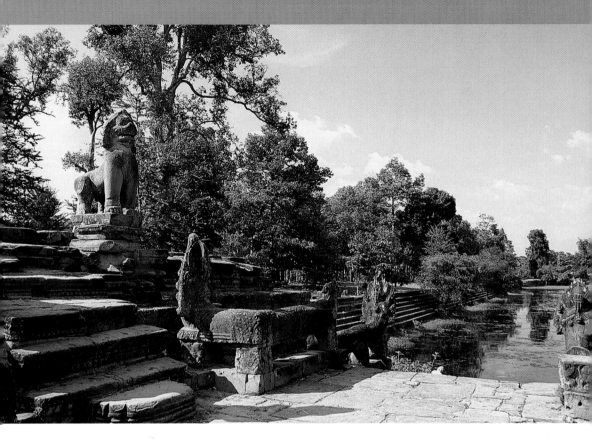

form the background for other figures. At the other end of the *naga*, the three heads of the snake are caught in the thighs of a bird with a long upraised tail. Tiny images of the snake's hood dotting the bird's feathers echo the larger motif.

Following studies of the north part of the terrace undertaken in the year 1963, a large reserve of funerary recipients was unearthed. Their position and contents corresponded to particular practices, attested by the presence in these jars of boxes containing ashes, by the presence of

The upright figures of a lion and *naga* stand guard at the landing terrace.

other articles placed around the jars according to a certain orientation and by the presence of mirrors facing east. These discoveries seem to be linked to the end of the Angkor period and similar mortuary customs were revealed during the excavation of certain sites in Thailand.

Suor Prat (Prasat Suor Prat)

ប្រាសាទសាប្រៃក់

Meaning: tower of the tightrope dancers

Date: 13th century

Built by: Indravarman II
 or his successor

Cleared: 1908, 1919, 1920

Restoration: 1955–58

Pron.: prassat suor prat

Map: F G 22

Interest: * view, walk

Visit: pm

Plan of the twelve *prasats* of Suor Prat.

Access

Take the Petit Circuit on the left to the Royal Plaza of Angkor Thom; the twelve towers of the monument will be found on the east side of the square.

Characteristics

The twelve towers add a touch of grace to the royal square, their russet tones giving them the appearance of soft garnet stones against the emerald backdrop of the trees. Their purpose remains a mystery.

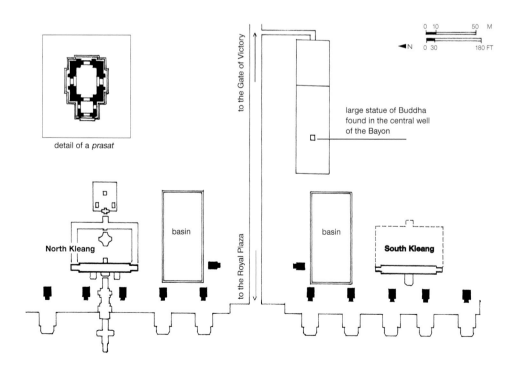

detail of a *prasat*

to the Gate of Victory

large statue of Buddha
found in the central well
of the Bayon

0 10 50 M

◀N 0 30 180 FT

North Kleang

basin

to the Royal Plaza

basin

South Kleang

Description

The twelve towers are arranged in a row, six on either side of the road leading to the Gate of Victory, opposite the Terrace of the Elephants leading to the Royal Plaza. They are placed at 25 m intervals from each other. The two towers nearest the road are set back slightly from the others. A long sandstone-paved terrace (10 m wide) extends beyond the towers; part of the terrace stops in front of each tower where it projects and forms both an access and a platform.

The towers, which are fairly well preserved, are rectangular laterite structures consisting of an entrance porch open on the east and lit by two windows, and a rectangular chamber (4 m by 6 m) opening onto the outside through three large bays with sandstone frames and balusters. The doors are surmounted by a lintel and a sandstone pediment carved with the vague outlines of sculptures that once represented stems transmuted into *naga* bodies. Other adornments include small animal figures wandering through labyrinths of scroll patterns.

The upper section of each tower is accentuated by the presence of large, unadorned cornices that do not detract from the feeling of heaviness pervading the entire laterite complex. The main building of each tower carries two other laterite rectangular constructions rising in gradually shortening tiers ending in corbel vaults halted on the east and west sides by a sandstone pediment. There are other pediments above the bays and also at each tier of the roof on the north and south sides.

This monument gives the impression of being incomplete. What was its purpose? No wholly convincing explanation has ever been given. The Chinese diplomat Zhou Daguan may have had the first—and final—word on the matter when he wrote in his memoirs: "In the event that two families enter into conflict without any clear cut indication of who is right and who is wrong . . . In front of the palace there are twelve small towers made of stone. Each of the contestants sits in one of the towers and he watches his rival closely. At the foot of the towers, the two families keep an eye on each other. After one, two, three or four days, the one who is wrong will reveal his error by developing an illness, like ulcers, catarrh or malignant fever. The man who is right will be in perfect health. That is how they decide who is right and who is wrong and they call it 'celestial justice.'"

The second explanation for the towers comes from the Khmers, who see them as huge "posts" to which ropes were fastened so that tightrope walkers could perform extraordinary feats to entertain the king and his court. Finally, another, more improbable explanation suggests that the towers were used by the king and his court to watch the different events taking place on the square of the royal palace.

Immediately after seeing the pool situated to the south, the visitor will notice, along the road leading to the Gate of Victory, a laterite terrace (35 m wide by 128 m long). On a pedestal in the western part of the terrace there is a great stone Buddha seated in the lotus position. The statue was rescued from the bottom of the central well at the Bayon.

One of the twelve massive "towers of the tightrope dancers," Prasat Suor Prat.

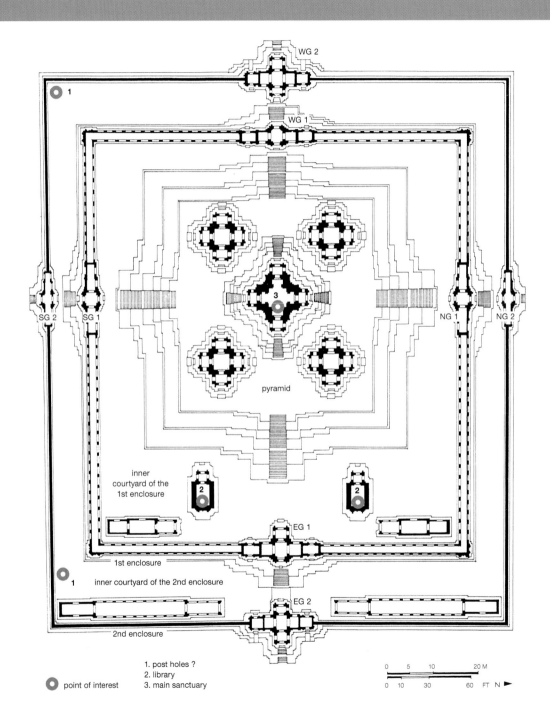

WG 2

WG 1

1

SG 2 SG 1

3

NG 1 NG 2

pyramid

inner
courtyard of the
1st enclosure

2

2

EG 1

1st enclosure

1 inner courtyard of the 2nd enclosure

EG 2

2nd enclosure

1. post holes ?
2. library
point of interest 3. main sanctuary

0 5 10 20 M

0 10 30 60 FT N ▶

Ta Keo
or Prasat Keo

ភាគេវ

Meaning: the ancestor of Keo
 or the crystal sanctuary
Date: c. 1000
Built by: Jayavarman V in its early stages
Religion: Brahmanic (dedicated to Shiva)
Cleared: 1920–22
Pron.: ta kayo
Map: G 27
Interest: ** archeo.
Visit: am

Access

One way of reaching the monument is to take the Petit Circuit on the right and continue past Banteay Kdei and Ta Prohm. A quicker way is to take the Petit Circuit on the left toward Angkor Thom, continuing past the Gate of Victory and Thommanon. The temple is located 500 m away on the opposite side of the river; it is usually entered from the south.

Characteristics

The monument is the epitome of the temple-mountain. Its unfinished condition and simple layout heighten the general impression of robust simplicity and harmonious arrangement of volumes.

Description

The temple appears in inscriptions as the "The Mountain of the Golden Summit" and may have received King Jayavarman V's patronage for a short period. Begun at the end of the 10th century, construction was interrupted when a struggle for the throne broke out. It was resumed during the reign of Jayaviravarman, who came into conflict with Prince Suryavarman, a pretender to the throne. The latter's victory and seizing of power might explain why construction was abandoned, as a new king would undoubtedly have wanted to build his own state temple.

It is also probable that Ta Keo was the center of a larger complex extending beyond its outer enclosure; on its east side, the temple doubtlessly extended as far as the west bank of the East Baray; the east-west axis of the temple still has a landing stage linked to the monument by a road (500 m long) lined with boundary stones that are molded and carved at their top as miters. Ta Keo and its moat (195 m by 225 m) occupy an artificial mound. The moats, once faced by laterite and sandstone, are in an advanced state of ruin. Two ponds existed on either side of the main axis, but these have now been filled in. The temple lies off-axis to the west. It consists of two raised enclosures and an elevated pyramid with five shrines arranged in quincunx formation. The monument is approached from the south façade of its second enclosure, but we will stay on the east side, where the stairs are more manageable.

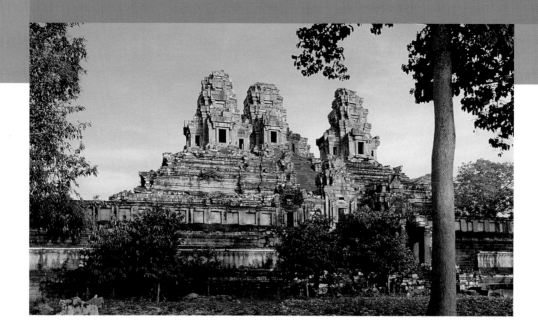

Second Enclosure

The enclosure is built on a laterite foundation (2.20 m high), which supports a sandstone wall (2.70 m high). The wall forms a rectangle (106 m by 122 m) and is interrupted by four *gopuras* at its cardinal points.

Gopuras of the Second Enclosure

The identical north and south *gopuras* (2 m wide by 12.50 m long) each have a main room with centrally placed doors. The wall facing the exterior of the temple is ornamented with false windows, unlike its companion on the side of the temple, which has four openings.. The roof must have been a tower located above the central room flanked by two corbel vaults. The east and west *gopuras* are larger than the others (3.50 m by 15 m); their two porches lead to a large chamber whose two doors access two vestibules with separate passages; the enclosure wall stops at the vestibules. The roofs of the *gopuras* have almost completely disappeared; their central chambers probably originally supported a tower structure and their wings were vaulted. Both *gopuras* are entered through either a central stairway or two side stairways, which are preceded by two small terraces.

After the south entrance, we reach a perimeter courtyard.

Inner Courtyard of the Second Enclosure

The courtyard of the first enclosure is paved with laterite, except around the *gopuras*, where it is paved in sandstone. The southeast and southwest corners have round holes, possibly for posts or flagpoles. There are also a large number of

holes, in part under the enclosure wall, that may have been for fence posts before the sandstone wall was built. The width of the courtyard varies: 13 m on the east, 10 m on the west and 6.50 m on the north and south sides. The greater width on the east side enabled the construction on either side of the *gopura* of two identical buildings, located at the corners close to the enclosure wall. These structures (27 m long by 3.50 m wide) include a six-pillared porch and a long hall (over 18 m long). They are illuminated by eighteen large low windows (nine on each side). The last section of the long hall receives daylight through two openings. The windows originally all had balusters, a few of which remain. The shape of the cornice suggests that the buildings had tiled roofs. Most of the courtyard is strewn with blocks of stone.

First Enclosure

Like the previous enclosure, the first enclosure rests on a coarsely molded laterite base with a thick band. The base (5.73 m high) supports the first enclosure, which takes the form of a side gallery. The visitor will mount a stairway carved from a projecting section of the superposed terraces. The last step takes us close to the east *gopura* of this side enclosure (over 114 m wide by 120 m long). On the outside, the gallery is lined by a sandstone wall (2.30 m high) and is decorated by square false windows (1.30 m on each side), with seven bars each separated from each other by a pier (0.70 m wide). There are thirty of these windows on the east and west sides and thirty-three on the other sides, for a total of 126 windows

covering the whole gallery. Inside, there are 110 windows with frames set on a sandstone base wall (0.70 m high, 1.60 m wide, 1.50 m long). The gallery has no door, suggesting either that this was a false gallery or that the pilgrims used to enter through the windows—unless there were once doors that have been walled up.

Each corner of the enclosure once had a small tower crowned by a crude pinnacle. Nothing remains of the gallery's roof, which was probably a corbeled vault.

The gallery wall is interrupted by four slightly different *gopuras*.

Gopuras of the First Enclosure

The east *gopura*, which is the largest (8 m wide by 18 m long), includes a square central chamber adjoining a vestibule with windows on the side of the sanctuary. The room is prolonged by two wings that are closed on their outside walls but communicate with the main chamber through two doors. Each annex has a small passageway that leads down to the inner court of the second enclosure (5.73 m below), whose access is extremely hazardous!

The west *gopura* has the same dimensions and ground plan, but without any vestibule. The north and south *gopuras* are of identical dimensions (5 m by 16 m), but are more simply structured. They have a long square chamber extended on each side by an oblong room that is closed on the outside but open inside by windows on the wall parallel to the shrine. The *gopuras* do not communicate with the gallery. Together with the gallery, they form an inner courtyard.

Inner Courtyard of the First Enclosure

The first enclosure forms an inner courtyard of unequal width due to the presence of the axial terraces and their accompanying stairways, which narrow the space. On the west side the courtyard is only 6 m wide, on the north and south sides it is 11 m wide, while on the east side it averages more than 20 m. It is on the east side that a library and a long room are situated.

There are two libraries in this section of the monument, one on each side of the east-west axis. Both structures are open on the west side, while the east side has the roughly carved outlines of a false door. The libraries are placed on dentate stone bases (1 m high) and have an entrance framed by two colonettes, a vestibule (2 m by 3 m) opened by two windows and a closed room in laterite (2.80 m by 4.50 m). The thick walls are on average 3 m high and 1 m thick, making them sturdy supports for the heavy cornice carrying a half-vault.

This half-vault supports another wall of smaller dimensions (0.80 m high), pierced by a horizontal window (2 m long) with nine stone bars. Another cornice supports the final corbeled vault. In the main room of the axial library on the north side, there is a flat niche with a trefoiled upper part. The northeast and southeast corners of the courtyard enclose long rooms similar to the ones in the second enclosure courtyard, but smaller. They are identical in width but shorter (only 16 m), and their porches have only four columns. The east wall of the main room is solid, unlike the west wall, which has one window, as does a small annex.

These two buildings would have had a tiled roof, as indicated by the grooves and slots for rafters on the upper reaches of the sandstone cornice 3.50 m above the ground and the five holes placed on the gable wall that once received the ends of a purlin.

Pyramid

This is a three-tiered sandstone edifice rising in gradual stages with each of the stages respectively 5.69 m high, 4.60 m high and 3.60 m high. The shortening levels produce a lengthening optical effect reinforced by the progressively diminishing steps. The visitor reaches the highest platform by means of one of four central stairways of varying steepness, with forty-three steps to a flight and few landings. The east stairway happens to be the easiest, with "only" a forty-four degree slope, compared to a forty-seven degree slope on the north and south façades and a fifty-seven degree slope on the west side. The stairways are enclosed in a block of masonry composed of six offsets that diminish in size as they ascend. The dimensions of the offsets vary on each side; for the west it is 3 m, for the north and south it is 6 m and for the east it averages 7 m. Each stone block rests on a base of 25 m. The three tiers of the pyramid are almost square in form (58 m by 60 m for the first, 52 m on each side for the second and 45 m by 46 m for the last). The walls of the pyramid are in sandstone with thick moldings and bands along the upper section. In contrast to the generally unfinished appearance of the monument, a few of these moldings display magnificently carved rose patterns, flower motifs and scroll patterns.

Third Terrace of the Pyramid

The terrace supports cruciform sandstone towers standing in each of its four corners. These buildings are unfinished, providing a relatively rare opportunity to see what such structures were like in their "raw" state, before the walls were carved with decorations.

Towers

These four towers are identical. Each one stands on a double plinth (1.60 m high) to a cruciform plan (15 m on each side). Each one encloses a square cella (3.20 m on each side), with doors at each cardinal point surrounded by four vestibules (1.50 m by 3.20 m), each communicating with the other and each with a door opening on the outside; illumination is provided by two windows. As elsewhere in this monument, there is little in the way of decoration. Nevertheless, each door is framed by narrow pilasters with roughly outlined capitals and several door jambs have moldings. The lintels and the pediments are indistinctly sculpted. Each vestibule has a corbeled vault and the cella is crowned by a three-tiered tower of gradually shortening levels. The total height of each tower is thought to be 17 m.

Central Shrine

The main shrine is located in the middle of the third level. It is another tower set on a sandstone plinth with five levels, reaching a height of 6 m. The plinth has a Greek cross plan and measures 27 m by 30.2 m. The four central stairways have twenty-one steps, with their first step (2.60 m) notably wider than their final step (1.50 m). There is only one flight leading up to the summit from the third terrace. The tower's main building is very thick (2 m) and has a very irregular outline. The branches of this square cella (4.50 m on each side) are wider and longer at their ends to create an internal plan in the form of a potent cross. Adjoining the passages are four small vestibules (1.90 m wide by 2.30 m long), each with a door and two windows. The re-entrant corners of the central building are adorned with square false doors placed at each corner. The roof above the vestibules rises in corbel vaults; a tower of successively shortening tiers once protected the cella; originally it must have risen 17 m above the ground of the first level base and 23 m higher than the third platform of the pyramid. Like the rest of the monument, the five towers are in an unfinished condition.

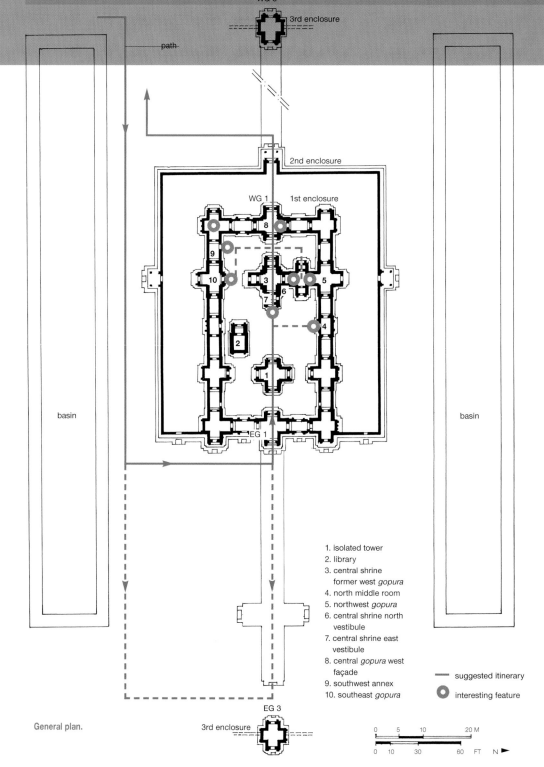

WG 3

3rd enclosure

path

2nd enclosure

WG 1 1st enclosure

8

9

10 3 5
 6
 7

2 4

1

basin basin

EG 1

1. isolated tower
2. library
3. central shrine
 former west *gopura*
4. north middle room
5. northwest *gopura*
6. central shrine north
 vestibule
7. central shrine east
 vestibule
8. central *gopura* west
 façade
9. southwest annex
10. southeast *gopura*

——— suggested itinerary

⊙ interesting feature

EG 3

General plan. 3rd enclosure

0 5 10 20 M

0 10 30 60 FT N ▶

Ta Nei

 តា នៃ

Meaning: old Nei

Date: end of the
 12th c.

Built by: Jayavarman VII

Religion: Buddhist

Pron: ta ne-ye

Map: E 28

Interest: * archeo., walk

Visit: am or pm

Access

Take the Petit Circuit on the right until you arrive at Ta Keo. When you have reached the south side of this monument, walk around its southeast corner; then head right on a sandy road leading into the forest. The remains of Ta Nei will appear after about 1 km on the right.

Characteristics

The monument has little archeological value and is thus rarely visited, which is a shame. It provides a lovely walk in the forest and the sight of the building enmeshed in vegetation is an impressive one. Although it lacks the grandeur and intensity of better-known monuments such as Ta Prohm, Ta Nei provides a sense of discovery that is absent from the more popular temples. It also contains some beautiful lintels and pediments carved with scenes dedicated to Buddha.

Description

The sandy track leading to the monument gives no hint that this is an area especially rich in ruins, but in fact it abounds in laterite and sandstone masonry, terraces, the remains of enclosures, ditches, mounds of earth and even sculptures. It is possible that this space, bounded on the west by the Siem Reap River and on the east by the west dike of the East Baray, was the hub of intense activity, with a large number of houses. It is also possible that the royal residence of Jayaviravarman was erected here.

Ta Nei is located near the northeast corner of the East Baray, approximately 150 m from its west dike. It consists of three enclosures, a main shrine, annexes and two basins, north and south of the monument. The access road leads to the southwest corner of the monument. Our visit will go along the south side and then turn east to join the long path ending with the east *gopura* of the third enclosure.

Third Enclosure

The third enclosure is not easy to make out, although it is marked by two small *gopuras* in the shape of a Greek cross (6 m on each side) that open to the east and west. On either side of these gateways are traces of a laterite enclosure wall that seems to have run between the second enclosure and the north and south basins. The west *gopura* is 55 m from the second enclosure and the east *gopura* 75 m from it. The *gopuras* are rudimentary sandstone constructions ornamented by scrollwork images, *devatas*, and false windows with balusters and blinds. They can be

identified as dating to the end of the Bayon era. Both *gopuras*, although in poor condition, have retained their intricate decorations, notably the east façade of the east *gopura*, which has a pediment showing a standing Lokeshvara poised gracefully on a lotus flower while *apsaras* and other creatures hover above. Above this scene, there are images of kneeling people with bloated stomachs apparently praying to the Lokeshvara for a cure. Each *gopura* is linked to the temple by a long road. The one on the east measures 75 m by 5 m and turns at its midpoint into a cruciform terrace with three stairways. The north and south basins are elongated rectangles (approximately 17 m by 123 m).

Second Enclosure

The enclosure rests on a sandstone base. Its laterite wall forms a rectangle (47 m by 55 m) and it is interrupted on its north and south sides by a small porch set on pillars with one door; on the west side there is a short projection with a two-pillared porch. More complex, the east side has three cruciform *gopuras* occupying the center of the wall and two plain doorways located at its north and south ends. The *gopuras* form the beginning for the gallery surrounding the first enclosure. On the axis of the road, there is a cruciform *gopura* (7 m on each side) open on all four façades. Its north and south wings communicate with a long hall (4 m by 3 m), which is itself connected to two other cruciform *gopuras* that are open on three sides and closed on their fourth side by a false door. The two *gopuras* are reached by stairways on the east side. Both

doors at the end of the east enclosure wall are also preceded by stairways. Their east façades have triangular sandstone pediments above an entrance that might have been the start of a gallery inside the second enclosure. The outer laterite wall is pierced by false balustered windows made of sandstone. There are a few remaining superstructures, but most of the numerous corbeled vaults have collapsed.

First Enclosure

The first enclosure (27 m by 46 m) is a series of chambers and pavilions forming a side gallery. The current arrangement is a modification of the original galleries, which were only 35 m long. The western end was enlarged in the direction of the west wall of the second enclosure so that the centrally positioned *gopura* of the west side became a separate building linked to the gallery by a room that was also modified to include two small vestibules.

Along this outer gallery (3 m wide) lies a succession of rooms that are of varying dimensions, six *gopuras* and four corner pavilions including the ones on the east. Both sides of its laterite walls have sandstone windows with balusters. There are also doors essentially for the *gopuras*, the corner pavilions and the small central chambers; the latter look out onto the inside of the courtyard. The rooms have sandstone corbeled vaults and the *gopuras* and corner pavilions have intersecting vaults. The *gopuras* on the west were the only ones to be crowned with a tower, which consisted of two false tiers crowned by a lotus flower.

Inner Courtyard of the First Enclosure

This courtyard is the location for three buildings:

— An isolated sandstone tower mounted on a cruciform base. The tower is 3 m from the west vestibule of the central east *gopura*. It is topped by a two-tiered pyramid.

— A small library (4 m wide by 7 m long). This tiny building is open on the west side and closed on the east side by a false door. The laterite walls are decorated with false windows with balusters. The library stands very close to the north section of the south wall and thus blocks the only door of the small room on the south side.

— The former west *gopura* (15 m tall), which has been transformed into a central shrine. Small vestibules with barred windows have been built on to the ends of the arms of the *gopura*.

The whole courtyard is strewn with fallen masonry. A few pediments with Buddhist decorations remain in the courtyard. They show good craftsmanship and seem to have escaped the Brahmanic reaction after the death of Jayavarman VII.

— On the southern trefoiled pediment of the central room on the north side there is the lower half of the body of a Lokeshvara mounted on a pedestal and surrounded by people carrying sticks. The figures on the tier below are kneeling in prayer.

— The northwest *gopura* of the south façade has a tier that shows the portraits of kneeling mitered creatures and a bucking horse mounted bareback by a knight brandishing a weapon.

— The pediment of the north vestibule in the central shrine is the background for a strange image of a gigantic figure standing in a pirogue propelled by rowers. There are flying figures carrying parasols; the dominant central figure is blessing the crowd.

— On the east pediment of the central west *gopura* the main subject is very indistinct and may have been defaced. The lower row presents a scene of praying figures on their knees with their right or left hands crossing their hearts as a sign of devotion.

— The upper sections of the pediment on the north side of the southwest annex no longer exist, but immediately beneath the pediment there is a fine carving of a troop of marching warriors wearing miters and carrying weapons. The subject is treated with energy and freshness.

— On the north side of the southwest *gopura*, there is a lovely portrait on a pediment of a central figure enthroned in a palace with flying *apsaras* who seem to be blessing the children. The upper part of the pediment is in a very poor condition.

Several other lintels reassembled on the ground have remained intact.

— The lintel inside the west *gopura* above the *kala* head shows two devotees with offerings and a Buddha on a plant stem.

— The southwest corner pavilion has a lintel decorated with another *kala* head and a Buddha in the center flanked by two other disciples.

Names of the idols venerated in the temple appear as brief inscriptions on several window piers.

Ta Prohm

កាប្រហ្មាណ៏

Meaning: the Brahma ancestor

Date: 1186

Built by: Jayavarman VII

Religion: Buddhist

Cleared: 1920

Pron. ta proh-me

Map: I 28

Interest: *** archeo., walk

Visit: am or pm

Access

There are two ways of reaching the temple. The first entails taking the Petit Circuit on the right, first following the enclosure wall north of Banteay Kdei and then the enclosure wall south of Ta Prohm. Once you have come to the end of this wall, turn right and walk 300 m until the west gate of Ta Prohm comes into view.

Alternatively, take the Petit Circuit on the left to the Royal Plaza of Angkor Thom, then follow the road on the right that leads to the Gate of Victory, passing Thommanon and Chau Say Tevoda; skirt Ta Keo on its south side and shortly after you will arrive at the west entrance of Ta Prohm.

These routes are the easiest ones to follow. Visitors wishing to explore alternative routes are advised to exercise caution, since certain paths are so cluttered with masonry that they can be dangerous. Also, the temple of Ta Prohm itself is a labyrinthine place where it is extremely easy to lose one's way.

Characteristics

One of the most remarkable aspects of Ta Prohm is that it was deliberately left in an uncleared state. A riot of extravagant forest vegetation has been allowed to grow unchecked, smothering the buildings while reinforcing them at the same time! The Conservation Française d'Angkor left this monument in its present state to re-create for the visitor the romantic atmosphere surrounding the first archeological discoveries at Angkor and also to give an idea of the enormous tasks involved in clearing and restoring these monuments.

Description

The visit, which starts from the west, does not have an especially architectural slant, despite the presence of several valuable carved motifs. It is an incursion into an eerie world where ruined towers and fallen or crumbling galleries create a disturbing, dramatic and slightly oppressive atmosphere.

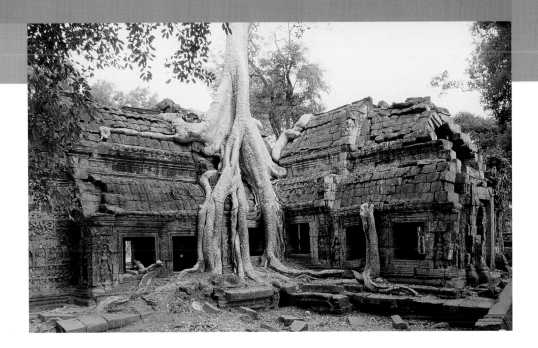

The roots of this tree at Ta Prohm reach out like tentacles.

The temple is a vast Buddhist monastery covering sixty hectares and consisting of two sections. The first, and largest, covers an area of fifty-five hectares; according to the foundation stela discovered on the site, 12,640 servants once lived here. The other section of only five hectares was the site of the temple.

Starting from the west, this monument consists of:

— a first wall that might have formed a fifth enclosure, a vast rectangle 1,000 m on its east-west axis and 600 m on its north-south axis;

— a fourth enclosure wall (200 m by 220 m);

— a third enclosure or courtyard (107 m by 111 m) facing outward;

— a second square enclosure or courtyard (50 m on each side) facing inward and finally a first square enclosure or gallery (30 m on each side) around the central shrine.

After passing the *gopura* of the fifth enclosure, which is crowned by a tower with four faces, a road (350 m long) leads to a cruciform causeway (30 m long) that spans the moats. This area has a number of monstrous cotton trees, whose silvery roots grip the sandstone slabs like giant fingers. The visit continues past the second door of the fourth enclosure to arrive at a courtyard (40 m by 55 m) bordered on its north and south sides by right-angled walls. From here, the visitor will skirt the third enclosure. There is a long sandstone-paved road leading to the *gopura*, which communicates with a courtyard lined with a double row of pillars. You will notice two large cotton trees perched on a wall to the left. Crossing the west *gopura* of the third enclosure, the visitor enters a second courtyard that is clear of vegetation but has immense trees with roots coiled around isolated towers or "sitting" on walls, some of which have given in under their weight. At this point,

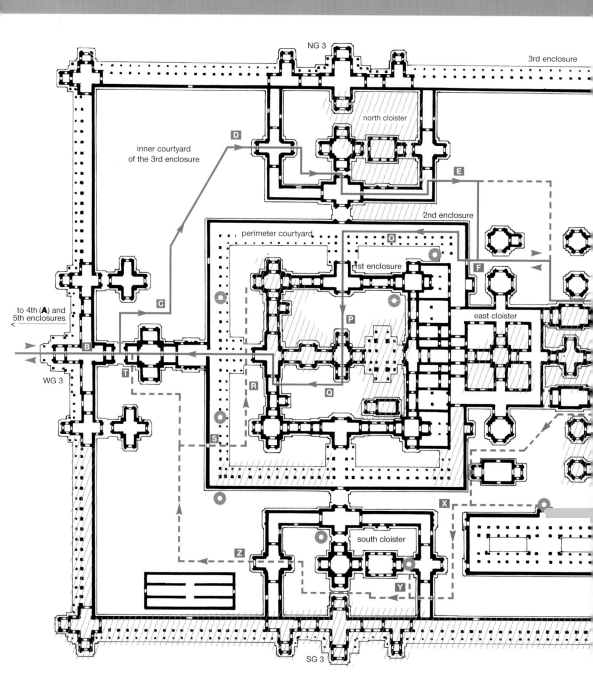

NG 3

3rd enclosure

north cloister

D

inner courtyard
of the 3rd enclosure

E

2nd enclosure

perimeter courtyard

Q

1st enclosure

F

to 4th (**A**) and
5th enclosures

C

P

east cloister

B

Q

WG 3

T

R

Q

S

X

south cloister

Z

Y

SG 3

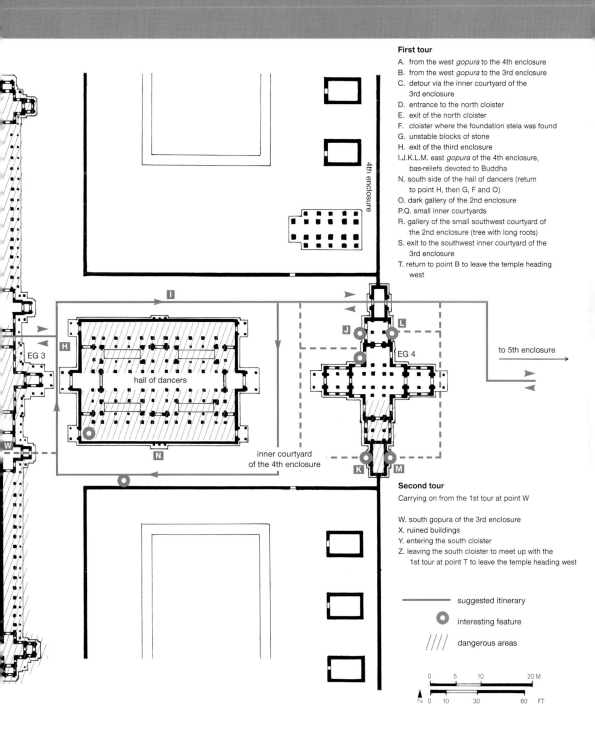

First tour

A. from the west *gopura* to the 4th enclosure

B. from the west *gopura* to the 3rd enclosure

C. detour via the inner courtyard of the
3rd enclosure

D. entrance to the north cloister

E. exit of the north cloister

F. cloister where the foundation stela was found

G. unstable blocks of stone

H. exit of the third enclosure

I.J.K.L.M. east *gopura* of the 4th enclosure,
bas-reliefs devoted to Buddha

N. south side of the hall of dancers (return
to point H, then G, F and O)

O. dark gallery of the 2nd enclosure

P.Q. small inner courtyards

R. gallery of the small southwest courtyard of
the 2nd enclosure (tree with long roots)

S. exit to the southwest inner courtyard of the
3rd enclosure

T. return to point B to leave the temple heading
west

Second tour

Carrying on from the 1st tour at point W

W. south gopura of the 3rd enclosure

X. ruined buildings

Y. entering the south cloister

Z. leaving the south cloister to meet up with the
1st tour at point T to leave the temple heading west

———— suggested itinerary

⊙ interesting feature

//// dangerous areas

4th enclosure

hall of dancers

to 5th enclosure

inner courtyard
of the 4th enclosure

EG 3

EG 4

A goddess is ensnared in roots at Ta Prohm.

the route becomes complicated and should be followed with the aid of a map.

In this courtyard, by turning left and following the northwest corner of the second enclosure, we will enter a small cloister north of the west entrance. This tiny structure has almost disappeared under the embrace of the immense trees, but it has interesting pediments, mostly on the west side of the central cruciform shrine (also "crowned" by trees). We will circle the central shrine on the right as we pass the fore-parts of two buildings that are very close together. After entering the south gallery of the cloister and continuing east on the left along the gallery, we will leave the inner courtyard of the third enclosure on its east side, where a few small temples are situated. The path takes us close to the east cloister that is joined to the second enclosure where the foundation stela was discovered. Then, our tour continues eastward between two tiny buildings with shaky stones. Having now avoided the traps of this rather hazardous journey, we enter and cross the third enclosure or courtyard area. In this section, there is a large rectangular laterite building with no roof. Its walls (5 m high) define a room (23 m by 30 m) open on the east and west sides by small doors. The fallen rubble from collapsed buildings blocks a large part of the edifice. Despite the interesting door lintels with fine images of the dancing *apsaras*, visitors are recommended to stay clear of this area. The presence of these lintels hints that there might have been a room similar to the celebrated Hall of Dancers at Preah Khan.

The blind north wall of this building leads to the northern part of the east *gopura* of the fourth enclosure. Here, "trapped" in the northwest corner of the *gopura*, is a gigantic tree. The northwest and southwest façades have magnificent bas-reliefs consisting of several tiers. These show images of Buddha, but sadly most of them have been defaced. The northeast and southeast sides have similar bas-reliefs displaying other scenes. On the east side, there is a large raised sandstone terrace (35 m by 25 m) extending the *gopura* described above.

If the visitor wants to conclude his tour of the temple and return to his vehicle at the east *gopura* of the fifth enclosure wall, he may take the long road (nearly 500 m) which leads to it; on the left are the ruins of a sandstone roadside shelter.

For the visitor who wishes to end his tour with the west *gopura* of the fifth enclosure, where he started his visit, he will retrace his steps via the east *gopura* of the fourth enclosure, then return to the south side of the "Hall of the Dancers." There are several remarkable decorations on a false door and an interesting upright *garuda* carved on the upper part of a corner pillar on the south side; this point also marks the start of a Buddha frieze which is now completely defaced. Opposite, there is another tree astride a wall.

After skirting the "hall of dancers," we come to the middle door of the north part of the third enclosure of the east *gopura*, where our tour began. The visit takes us past this door and down a narrow passage sealed by precarious stones, continuing between two small sandstone towers standing on either side of the northeast door of the second enclosure. Once past this door, we have arrived at the north side gallery of the second enclosure, with its double row of sandstone pillars (50 m long). On entering the gallery, you will see on the left a tree clinging to the gallery and to a small building on the northeast side of the first enclosure. The gallery must be crossed with care as it is dark and strewn with blocks of stone. We will leave the gallery at its midpoint on the left to enter the inner courtyard of the north side of the first enclosure, where another large tree is wrapped around a gallery.

The rather austere central shrine is located in the middle of the courtyard. Its exterior was smoothed over for the purpose of applying a protective coating and its interior exhibits evenly placed holes, suggesting that the walls were coated in varnish or clad in sheets of wood or metal. We shall cross the shrine, which leads into the small south courtyard, keeping to the right. You will notice a mysterious but magnificent "lantern pillar" standing in the south court. Opposite the pillar, there is a door we will go through to join the main east-west axis.

Once the west *gopura* has been crossed, the visitor is confronted by the amazing sight of an enormous cotton tree clinging like an octopus to the roof of the gallery. The monstrous finger-shaped roots of this tree plunge into the ground and then spread out across the surrounding area. The tour may end by going through the small door behind these roots that leads to the main axes of the temple by the inner southwest courtyard of the third enclosure. The exit will be made in stages, through the west *gopura* of the first, then the third and finally the fourth enclosures to emerge from the monument through the fifth enclosure.

Another partial circuit (marked by a dotted line on the map) suggests exiting by the south cloister. In that event, the visitor will leave through the south vestibule of the third enclosure *gopura*, reaching the south cloister. The south cloister displays a fine lintel representing the Great Departure of the future Buddha, in which the gods muffle the sound of the horse's hooves beating against the pavement. Leaving the south cloister, the visitor can either enter the southwest section of the inner courtyard of the third enclosure by a small door, leading to the axis of the temple and enabling him to leave (marked by dashes on the map), or go via the west *gopura* of the third enclosure, leaving the monument by its western flank.

Ta Som
តាសុំ

Access

Take the Grand Circuit on the right. After Srah Srang, Pre Rup and the East Mebon, Ta Som appears near the northeast corner of the *baray* of Preah Khan with Neak Pean in its center.

Characteristics

An atmosphere of languor and nostalgia, typical of abandoned temples, surrounds this monument.

Meaning: the ancestor Som

Date: end of 12th c.

Built by: Jayavarman VII

Religion: Buddhist

Restoration: 1930

Pron.: ta som

Map: B 34

Interest: * walk, archeo.

Visit: am or pm

General plan.

——— suggested itinerary

◉ interesting feature

1. library
2. central tower
3. lantern pillar

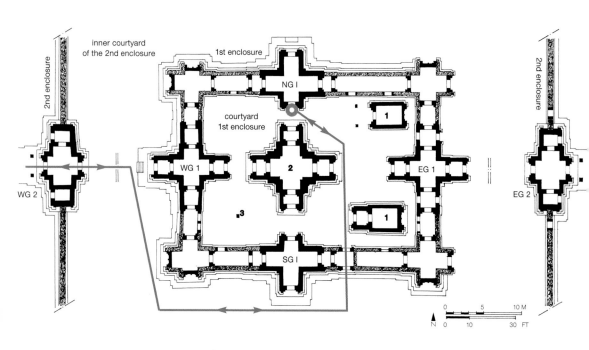

Description

Ta Som, with its three enclosures and principal shrine, is aligned with Preah Khan and Neak Pean. Its main shrine, which is asymmetrical on its north-south axis, is placed 25 m to the west in relation to its outermost enclosure. The third and second enclosures have only one *gopura* on their east-west axis. The tour of the temple will begin on the west side, despite the monument's easterly orientation.

Third Enclosure

The visitor arriving by road will enter the temple by the west *gopura* of the rectangular third enclosure (200 m by 240 m). Its laterite wall (over 2 m high) bears a "crest" of sandstone running its entire length; this upper section is a succession of ogive-shaped niches once adorned with bas-relief images of Buddha. The west *gopura* of the third enclosure is a laterite structure in the shape of a Greek cross (10 m on each side). Its central passage (almost 3 m wide) is flanked by two tiny rooms. Each *gopura* wing is decorated on its outside by false windows with balusters hidden behind curtains and each window is framed by a *devata* image beneath an arcature. Each arm of the cross forming the *gopura* is covered by vaults in sandstone; the entry pavilion is surmounted by a tower with four Lokeshvara faces. The east *gopura* at the opposite end is similar to the west *gopura*. Continuing east, we reach the second enclosure 80 m farther on.

Second Enclosure

The laterite wall with its sandstone "crest" forms a rectangle of 70 m by 24 m. The west *gopura* is set on a rectangular sandstone base (4 m by 11 m). In front of it is a cruciform terrace (5 m wide) that crosses the moats and was once bordered by *naga* balustrades. There are two small projections placed at the center of the *gopura*; the one on its west side has a doorway preceded by a pillared porch; its companion on the east side has a plain door surrounded by two colonettes. The *gopura* includes a central cruciform chamber with side rooms each receiving light through a single balustered window; the wings also have false windows with shortened balusters and drawn decorative curtains. There are images of *devatas* under small arches adorning several sections of the wall.

Inner Courtyard of the Second Enclosure

This courtyard, which surrounds the first enclosure, averages 20 m on its north, south and west sides and 30 m on its east side. Certain parts of it are cluttered with blocks of fallen masonry. The easiest way to avoid these obstacles is to head for the southwest corner and follow the south side until you come to the small door between the south *gopura* and the southeast corner pavilion.

First Enclosure

Like other monuments of that period, the first enclosure (25 m wide by 35 m long) contains four *gopuras* and four corner pavilions linked by a series of chambers. The walls are made of laterite, while the *gopuras*, vaults, window piers and false doors are in sandstone.

On the east-west axis, there are two identical cruciform *gopuras* (12 m on each side). They

consist of a cruciform central chamber with tiny rooms on the end of each arm of the cross. The northeast and southeast corner pavilions have centrally placed doors, but those on the west are shut on the outside. The chambers linking the *gopuras* and the corner pavilions are 3 m wide, but their lengths vary. Made of laterite, they have corbeled sandstone roofs topped by a carved ridge. The roofs of the corner pavilions consist of intersecting sandstone vaults, while the *gopuras* are surmounted by towers with two false receding tiers ending in lotus flower representations. The sandstone walls alone are ornamented by false windows with balusters and curtains framed by *devatas* beneath small arches.

Courtyard of the First Enclosure

The piles of sandstone blocks occupying some areas of the courtyard do not obstruct the view of two libraries. The one in the southeast corner is made of sandstone and measures 12 m by 3.50 m. It has a vestibule with a westerly opening and a small room with no openings. The other library to the north is in ruins: only the faintest outlines of a pillared porch and a room can be made out.

Central Tower

The central sanctuary is cruciform and made of sandstone. Inside there is a cruciform cella with vestibules. The doors are framed inside and outside by colonettes and lintels topped with pediments, and there are false windows adorned with *devatas*. Above the cella rises a tower with four false receding tiers and crowned by a majestic lotus in bloom. The sculpted tympanums of the

gopuras are interesting, particularly the one on the south façade of the north *gopura* showing a large figure. Now defaced, this may have been a representation of Buddha or Lokeshvara holding a lotus flower. At the figure's feet, there are four praying figures "budding" from other lotuses with a common stem. At the corners of the tympanums, several miniature figures are bent in prayer. Elsewhere there is an abundance of "embroidery" motifs combined with leafy stem and scroll patterns.

Like its larger companions built in the same style, this monument has a "lantern pillar," the purpose of which is unknown. Located in the southwest corner of the courtyard, it is small and square, and is topped by a tenon.

Ta Som may have been the temple referred to as the "jewel of the fortunate white elephant" in an inscription on the stela of Preah Khan. If that is true, then according to the inscription the temple shelters twenty-two gods.

A *gopura* at Ta Sohm imprisoned by roots.

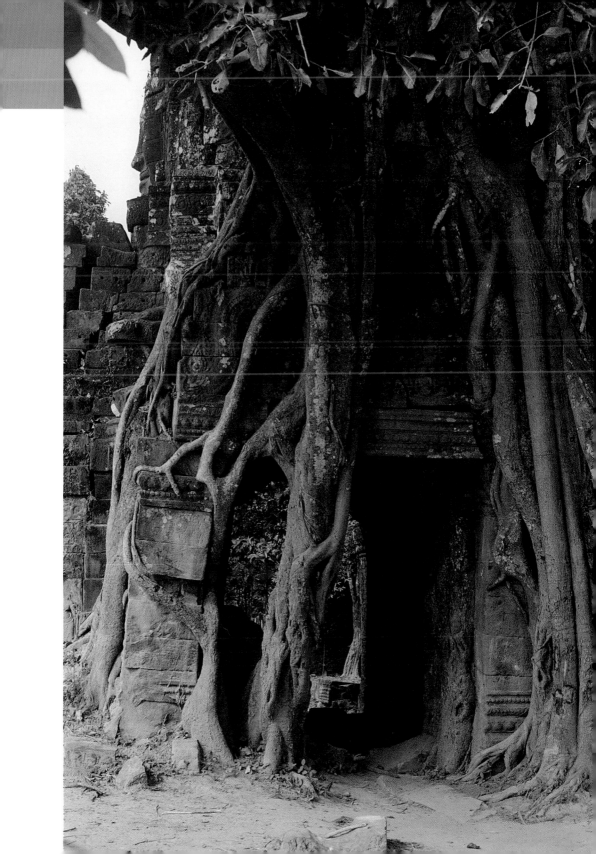

Terrace of the Elephants

ព្រលានដំរី

Access

Follow the Grand Circuit on the left and go to the Bayon at the center of Angkor Thom. The Royal Plaza and the Terrace of the Elephants are located just to the north.

Characteristics

This imposing terrace is celebrated for its bas-reliefs that form a backdrop for a magnificent esplanade.

Description

The monument stands on the axis of the Gate of Victory at Angkor Thom and in the middle of the enclosure surrounding the Royal Palace. Overlooking the great esplanade of the Royal Palace, the terrace is a platform of earth (15 m wide). A sandstone wall (averaging 4 m high and 360 m long) borders its east and west sides. A large flight of stairs cuts through the center with two small axial stairways and two secondary flights of stairs at the end of the terrace.

Date: end of 12th c.

Built by: Jayavarman VII

Cleared: 1911, 1916, 1952

Restoration: 1996

Pron: tilleum damrei

Map: F 22

Interest: *** archeo.

Visit: am

Plan.

Facing page, top: carved wall at the Terrace of the Elephants.

Facing page, bottom: detail of the east façade of the Terrace of the Elephants.

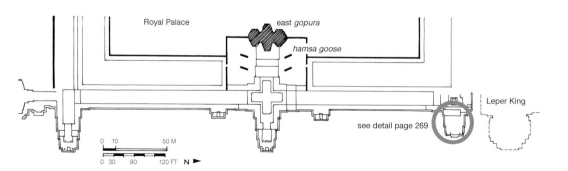

Royal Palace east *gopura*

hamsa goose

see detail page 269 Leper King

0 10 50 M

0 30 90 120 FT N ▶

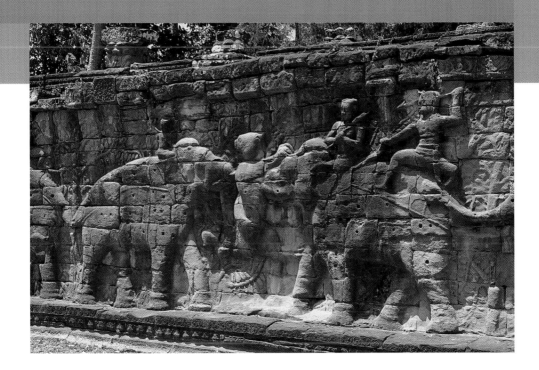

The central stairway projects 32 m from the wall on the side of the Royal Palace. It consists of three flights, which lead to the platforms.

The last flight of stairs is cruciform in plan and looks out over the east *gopura* of the Royal Palace enclosure.

The flight of stairs on the south side is similar but rests on a narrower base. The stairs on the north side differ from the others (see below).

The most outstanding feature of the terrace is the long column of life-size elephants carved in relief along the wall and in the round at the stair corners.

The sandstone wall parallel to the Royal Palace has a molded base and a forest scene showing harnessed elephants led by their driver; an upright warrior with raised arms mounts each beast in pillion.

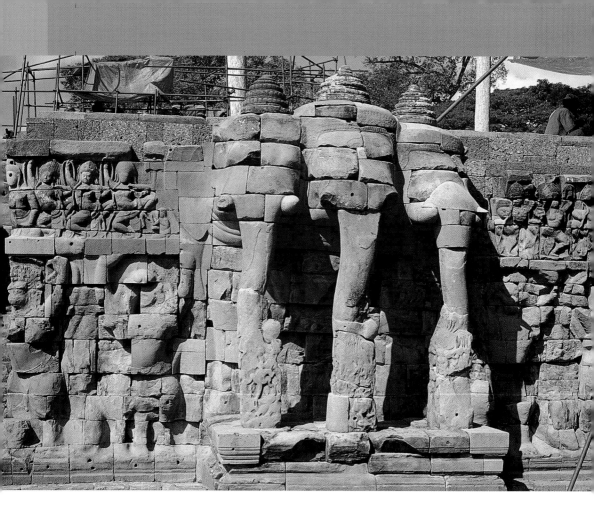

The walls at the sides of the central flight of stairs have dentate corners and reliefs of *garudas* and upright lions. The low plinths of these various terraces are ornamented by other, smaller motifs representing genies (*yakshas*) and winged feminine figures (*kinnaris*). There are stone lions on bases above the string walls and *naga* balustrades.

The two small steep stairways on either side of the great central stairway are framed by three-headed elephants rising as high as the string wall. They are shown gathering lotus flowers with their trunks (the same motif appears on the corners at the doors of Angkor Thom). The flight of stairs at the southern wing is lined with the same three-

Indra's three-headed elephant gathering lotus buds with its trunks, Terrace of the Elephants.

headed creatures. The corner wall of the projection continues the theme of the elephants, with the mythical beasts becoming progressively smaller.

Unlike the others, the north façade has, instead of a great stairway on its eastern side, two small, very steep flights of steps (0.90 m wide) positioned exactly on the axis. In addition to these two smaller stairways, there is a third stairway, located on the north side of the perron. The east side of

Above: bas-relief of the dwarf with a polo stick (detail A).

Right: woman clinging to an elephant's trunk (detail B).

Below: north perron.

1. first projection
2. second projection
3. third projection

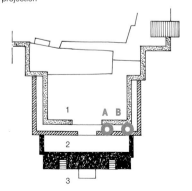

the base is decorated with motifs that resemble those of the main central stairway; but the reliefs on the north and south sides have totally different subjects. Both these sides show first the *garudas* and lion-atlantes beneath magnificently attired kneeling goddesses. These are followed by a circus scene on two tiers: the lower section shows images of chariot races, acrobats, wrestlers and gladiators; the upper part features polo players with raised sticks (polo was of Indian origin). These scenes resemble the sculptures of the metopes that once stood in the Parthenon (now in the British Museum).

In fact, of the three successive projections which make up the north perron, the first is ornamented by images that are both finely carved and well preserved because they had been lying under earth for many centuries. They can be seen from an upper area of the terrace. In the central panel, the necks of a five-headed mitered horse

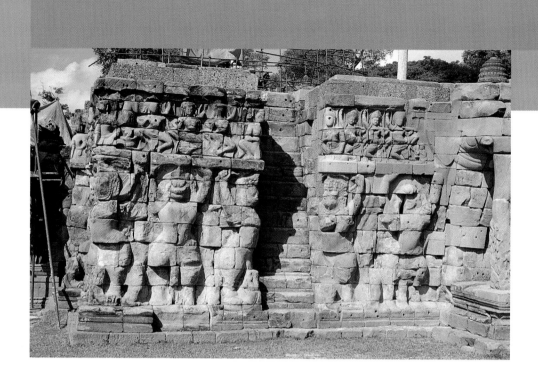

Perron with upright lions.

appear under a canopy of parasols arranged in tiers. Small grotesquely expressive figures and large warriors form a ring around the mythical beast. The warriors are shown in combat position, with legs wide apart and feet resting on lotuses; they carry sticks and wear crested helmets (an image not seen anywhere else in Khmer art). The stern demeanor of the warriors is counterbalanced by the images of lotus flowers and graceful dancers, who wear ornamented tiaras.

At the northeast corner of the base, there is a beautiful and original representation of an elephant. Its tusks are thrust forward and two figures hang from the trunk, their heads facing the earth.

Returning to the central stairway, in the direction of the east *gopura* of the Royal Palace enclosure, you will see on both sides of the main gate two inner courtyards with high walls that form the backdrop for some fine carvings of *hamsas*, the mount of Brahma.

As the long terrace may have been used by the king and his court to watch dances performed on

the Royal Plaza, it probably had a roof of some sort. Zhou Daguan, in *The Customs of Cambodia* written in 1296, described its appearance: "The Council Room of the Kingdom had golden window frames surrounded on their right and left by several square columns bearing forty or fifty mirrors hanging from the sides of the windows. The elephants are depicted beneath these." This splendid room may have been reserved for ambassadorial receptions.

Since 1996, the Ecole Française d'Extrême-Orient has been carrying out some major restoration work on the northern flight of stairs and its excavations have resulted in the discovery of numerous sacred metal objects, most notably representing tortoises. These had been placed alongside plant matter and cereals, suggesting cult practices.

Terrace of the Leper King

ទិលានសេ្ដចគំលង

Date: 13th c.

Built by: Jayavarman VII

Cleared: 1911, 1917

Restoration: 1992–96

Pron.: tilieun sdech komlong

Map: F 22

Interest: *** archeo.

Visit: am

Access

Take the Grand Circuit on the left to the Royal Plaza of Angkor Thom. The Terrace of the Leper King is just north of the Terrace of the Elephants.

Characteristics

The Terrace of the Leper King does not seem to have been linked to the Terrace of the Elephants. The manner in which some of its walls intersect indicate that the monument may have been a part

Statue of the Leper King.
The original statue is in the National
Museum, Phnom Penh.

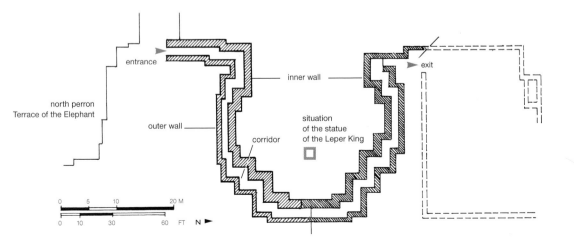

A court dignitary carrying a sword on his shoulder.

Facing page: east façade of the terrace where the École Française d'Extrême-Orient is at work using the anastolysis method.

of a larger complex that was modified in the course of its existence.

Description

This monument is a fine example of Khmer architecture and carving. The terrace stands on a sandstone base 25 m on each side and approximately 6 m high. The west façade is supported by an earth levee. Each of the terrace's façades originally had seven tiers of mural decorations in high relief, but the seventh tier has now largely disappeared. The terrace projects from the vestiges of a rear wall that is almost aligned with the Terrace of the Elephants.

Clearing of the monument revealed that behind the outer wall was another wall on the east and south sides at a distance of nearly 2 m. The decorations on this earlier wall are similar to those of the outer wall. A false corridor with an opening at the southwest corner of the terrace makes it possible to see the reliefs on the first wall. Further clearing of the corridor to the north has revealed other carvings executed in the same style as those previously discovered. As these reliefs were protected against the ravages of the climate and human destruction for centuries, they are well preserved and are among the finest examples of Khmer art.

The north façade of the outer wall displays decorations of figures sitting beneath palace porticoes in rather rigid poses; in their midst, there is a king or an important member of the court holding a sword while looking at the performance of a sword swallower.

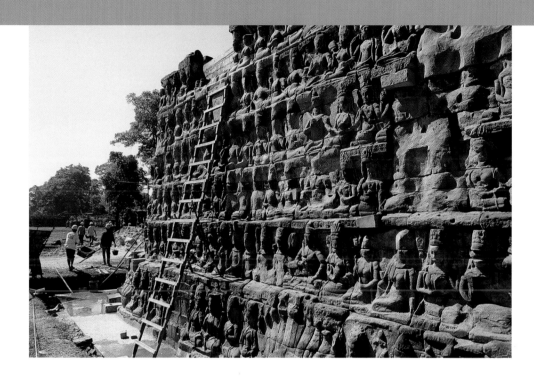

All the tiers on the east and south sides are adorned with images of seated bare-breasted women wearing high flame-shaped tiaras. Interspersed among the female assembly are stick-bearing masculine figures who are presumably keeping watch over their female charges. The lower tier is animated by giant erect *nagas* whose nine heads sprout like a budding flower while strange diabolical beings are placed on top of them. Most of these creatures carry swords and are framed by goddesses with fans in their hands. A note of grace and elegance is introduced by the *apsaras* launching into a dance movement.

The inner wall, the best preserved, is adorned with an image of a nine-headed *naga* with a prominent nose. The *naga* is surmounted by other reptiles with five heads flanked by kneeling companions that are wearing tiaras consisting of tiny upright *nagas* rising like flames. Several of these *naga* companions hold lotus buds. On the lower tier, you will notice mitered figures astride strange beasts.

There have been several theories concerning the meaning and purpose of the Terrace of the Leper King. According to an interpretation based on Indian texts, the terrace represents Mount Meru and the *nagas* were there to support the sacred mountain above the cosmic waters. Another hypothesis is that a new wall nearly identical to the old one was built in order to enlarge the terrace.

For many years, there were three stone statues on the terrace: two small decapitated statues carrying clubs on their right shoulders flanking the

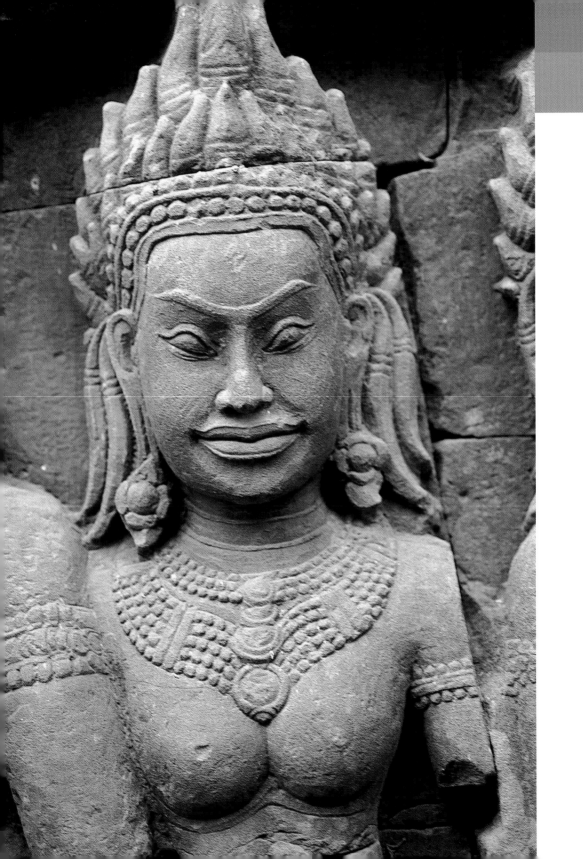

Jewel-bedecked female assistant to a dignitary.

Kneeling women, decoration on an interior wall.

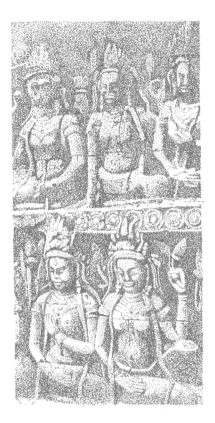

larger figure of the Leper King (now on exhibit in the National Museum of Phnom Penh). A fourth statue has since been unearthed intact.

At the present time, there is a copy of the Leper King statue on the platform of the terrace. Placed on a simple slab of stone, he is seated in the Javanese manner with his right knee supporting his forearm; his hand at one time probably held a weapon. He has a complicated hairstyle, including braided and curled locks hanging down his back and a faint leer slants his lips that reveal two "fangs"; his mustache is elegantly trimmed and curled. The sculptors had portrayed him entirely naked, which is rare in Khmer art, and he appears to have no gender, and more significantly, no traces of the disease that gives him his apparently erroneous moniker. The Leper King is probably a legendary rather than a historical figure. Some experts believe the statue represents Shiva, the ascetic, but others, referring to the brief inscription on the stela, think the statue is a likeness of Yama, the Hindu god of death and the Supreme Judge.

Given the location of the terrace on the north side of the Royal Palace, the platform, as at the Royal Palace in Phnom Penh, may well have been reserved for royal cremations, which would explain the presence of the god of death.

Georges Coedès suggested that the terrace was a representation of the base of the Supreme Tribunal symbolizing Mount Meru and that the statue of the Leper King was an effigy of the Lord of the Law watching over it. When the monument was cleared, the remains of wooden columns were discovered; these might have belonged to the Tribunal that was erected here.

In legend, the Leper King is identified with Prince Preah Thong who came from India to marry the daughter of the *naga* king; he founded the city of Angkor, the capital of the land of the Khmers.

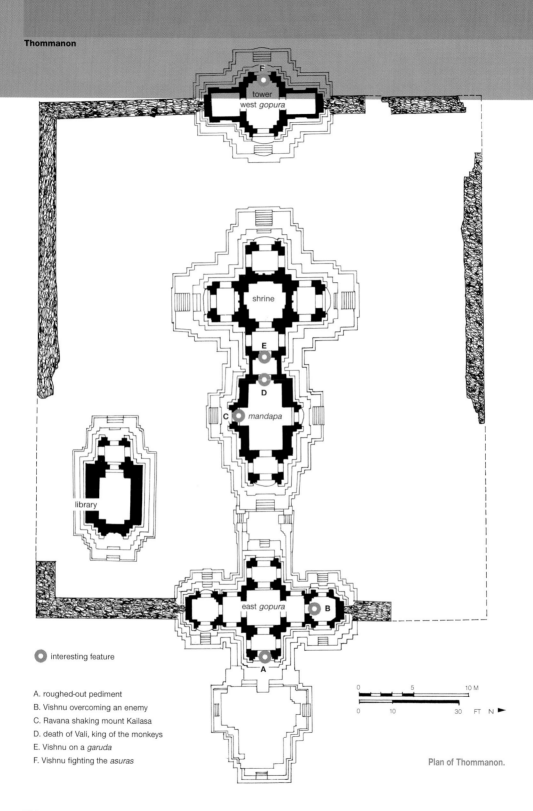

interesting feature

A. roughed-out pediment
B. Vishnu overcoming an enemy
C. Ravana shaking mount Kailasa
D. death of Vali, king of the monkeys
E. Vishnu on a *garuda*
F. Vishnu fighting the *asuras*

F
tower
west *gopura*

shrine

E

D

C *mandapa*

library

east *gopura* B

A

0 5 10 M

0 10 30 FT N ▶

Plan of Thommanon.

Thommanon

ធម្មនន្ទ

Date: end of 11th–first half
of 12th c.
Religion: Brahmanic
Cleared: 1919–20, 1925–27
Restoration: 1955, 1956, 1960

Pron.: tom-ma-nonne
Map: F 26
Interest: ** archeo.
Visit: am

Access

This temple can be reached by going right or left on the Petit Circuit. The easiest way to get there is to start from the Royal Plaza at Angkor Thom and then take the road to the Gate of Victory. After around half a kilometer, Thommanon will come into view on the left, opposite Chau Say Tevoda.

Characteristics

The temple remains an enigma; there is no inscription giving its precise date of construction or its original name. Neither do we know who founded it or what its purpose was.

Description

The monument consists of an enclosure wall with two *gopuras*, a courtyard with a pavilion and a shrine, and a single library in the southeast corner of the courtyard.

Coming from the road, the visitor approaches the monument from the south, but it is necessary to walk around to the east side where the terrace is located. There may have been a causeway extending east from the terrace towards the east, as at Thommanon's twin temple, Chau Say Tevoda, but if so, nothing remains of it.

Enclosure

The only remnants of the enclosure wall (40 m by 45.50 m) are its foundations and a few isolated sections of wall beside both *gopuras*.

East *Gopura*

The east *gopura* stands on a double sandstone base (14 m long). It consists of an axial square chamber (4 m on each side) and, at each of the four cardinal points, a porch with windows. At the ends of the north and south porches, there is a two-door vestibule that can be reached by external stairways. The middle room has a barrel vault ending in two pediments. The wings of the *gopura* have identical superstructures. The building's carved lintels, pediments and pilasters are

either very eroded or unfinished, but they include several valuable pieces representing the legend of Vishnu.

Leaving the *gopura* on its western flank, we descend a few steps before taking another stairway nearby. The layout of the temple is reminiscent of Banteay Samre. The stairs lead to a *mandapa* or passage-pavilion, placed on a double base plinth of molded sandstone.

Mandapa

This small building includes a long room (6 m by 3 m) with vestibules on the east and west sides; the vestibules are lit by two windows facing east. On the north and south façades, there is a door flanked by colonettes; both openings lead to stairways descending to the courtyard. The roof consists of a corbeled vault resting on a sturdy cornice at the top of a parapet wall, which is slightly recessed from the lower wall. The two side doors have pediments. The east and west vestibules have barrel vaults ending in pediments with scenes from Brahmanic legends; these are mostly in a poor condition. The lintels are for the most part decorated by foliated scroll patterns, except for a scene from the *Ramayana* appearing on the lintel above the east door. The west vestibule of the *mandapa* accesses the shrine.

Shrine

The shrine rests on a sandstone base (2.50 m high) with thickly molded contours. It encloses a square cella (3 m on each side). The shrine is similar to the east *gopura*, being surrounded by

four vestibules each one with a single passage and two windows. The north, west and south façades of the cella have false doors; the holiest region of the shrine is entered on the east. Each of the porches has a corbeled vault with two projecting pediments rising in tiers. The central tower consists of four tiers with receding false stories ending in a triple lotus corolla.

The outside of the shrine is decorated with magnificent sculptures; Against scroll-pattern backgrounds, they show small figures ascending toward intricately ornamented cornices, trefoiled, flame-shaped pediments and acroterions consisting of erect *naga* bodies. *Devatas* stand guard at the corners of the building and at the windows. The vestibule interiors also have fine decorations, consisting of false doors that rank among the loveliest in the Angkor group. Several lintels and pediment tympanums are eroded; some display fascinating scenes of the Vishnu legend.

West *Gopura*

The west *gopura* (10. 70 m long) has a simple layout. Its double sandstone base plinth has irregular contours and includes a central rectangular room (3 m by 4 m) joined to two dark rooms (2 m by 2.50 m) that communicate with the central chamber through one door. That single door opens out onto two axial east-west passages. Both stairways lead down to the ground level. Above the central chamber is a rectangular tower with two receding tiers ending in a narrow barrel vault; the two wings of the building also have barrel vaults.

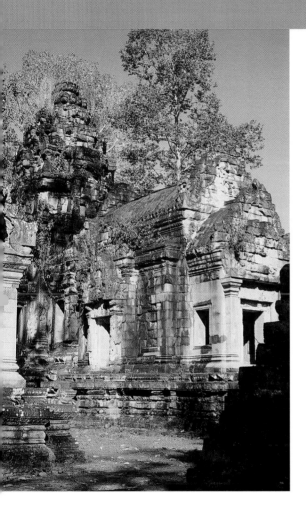

The *mandapa* at Thommanon seen from the southeast.

Externally, the *gopura* has remarkably pure lines. On the east and west façades, the walls are discreetly adorned with false windows carved in relief. The east and west doors have large decorated pediments in four tiers.

The decoration of the *gopura* is mainly restricted to the pediments above the central chamber and those on the parapet wall of the adjoining rooms. The tympanums, which are more or less intact, show scenes from Brahmanic legends. The false tiles on the end of the vaults are decorated with the images of miniature lions, while the bases of the pilasters represent small scenes animated by human figures.

Library

The library (9 m long by 5 m wide) stands in the southeast corner of the inner courtyard. It is set on a double base (1.40 m high) made of sandstone with an irregular border. It encloses a small vestibule opening on the west side and a single room. The former has two windows, but the latter has none.

The roof consists of a half-vault and a full barrel vault. A low parapet wall with a false barred window rests on the half-vault and supports the barrel vault through a sturdy cornice.

On the outside, the walls of the library are decorated with a frieze in both the upper and lower sections. On the east side there is a false door, while on the west side carved pilasters support the pediment of the porch. The lintels are eroded, but the pediments and half-pediments are partially preserved and are decorated with scenes from Brahmanic legends.

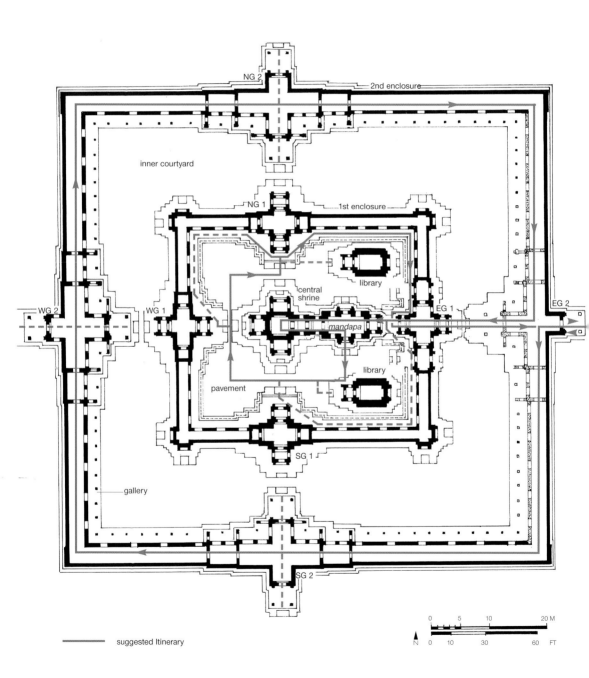

inner courtyard

NG 2

2nd enclosure

NG 1

1st enclosure

library

central shrine

WG 2

WG 1

mandapa

EG 1

EG 2

library

pavement

SG 1

gallery

SG 2

0 5 10 20 M

N 0 10 30 60 FT

———— suggested Itinerary

Monuments outside the Angkor Group

Banteay Samre

 បន្ទាយសំរែ

> See description of major bas-reliefs
on pages 359-365.

Meaning: the citadel of the Samre

Date: mid-12th–13th c.

Built by: unknown,

Religion: Brahmanic (dedicated
 to Vishnu)

Cleared: 1930

Restoration: anastylosis 1936–44

Pron.: bantee-ay samrai

Map: see map in the appendix

Interest: *** archeo., art.

Visit: am

Access

Banteay Samre and Banteay Srei can be visited together; tours of both monuments require a full morning.

Follow the Grand Circuit on the right past Srah Srang and Pre Rup. Just before the East Mebon, you will see a dirt track on the right. After about 1.5 km, and after passing through the village of Pradak, you will see on the right the north *gopura* of the second enclosure of Banteay Samre.

Plan of Banteay Samre (facing page) and overall plan.

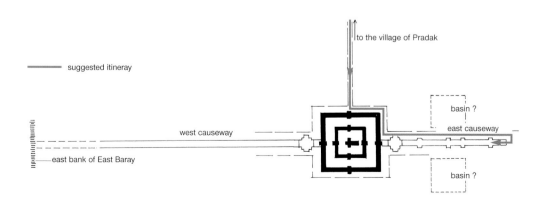

suggested itineray

to the village of Pradak

west causeway

east bank of East Baray

basin ?

east causeway

basin ?

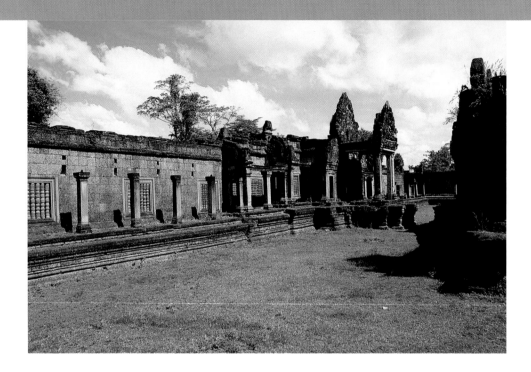

Characteristics

Banteay Samre contains carvings of exceptional quality and iconographic interest. Architecturally, it is mostly built in the classic style characteristic of Angkor Wat and the temple's isolated location lends it a certain romantic aura.

Unfortunately, there is no inscription corresponding to this monument; however, the temple is linked to one of the most fascinating of Khmer legends, which relates how a young Samre peasant becomes king of the land.

Description

Banteay Samre is a remote, isolated complex located near the southeast corner of the East Baray, approximately 400 m from the dike. A

The gallery circling the second enclosure at Banteay Samre.

levee joins this dike to the temple before continuing east. Like many other Khmer temples, Banteay Samre probably originally had more than the two existing enclosures. However, given that the monument was modified and then abandoned, it is also possible that other enclosures were never built. In any event, no trace of other

enclosures has ever been found. The outlines of the moats and the two basins located on either side of the east road are today visible only from the air.

After arriving at the north side of the monument, we will skirt it on the left to begin the visit by the long east causeway.

East Causeway

The east causeway (nearly 7 m wide by 140 m long) is bordered on both sides by *naga* balustrades (0.95 m high), but only vestiges of these remain.

There are four stairways on both sides of the causeway that lead to the fields and to two reservoirs that are dry. The causeway leads to a great cruciform terrace (over 23 m by 27 m and 0.90 m high) with an axial stairway of eight steps guarded by sitting lions. The *naga* balustrade reappears here on its outer edge, projecting from the wall base supported by a series of low columns. This first terrace resembles a giant step enabling the visitor to reach another platform 0.60 m above it. From this second platform, we will enter the east *gopura* of the second enclosure and cross another remarkably wide causeway supported by a retaining wall decorated with some fine reliefs.

East *Gopura*

The distinguishing features of the east *gopura* (77 m by 83 m) of the second enclosure are a small sandstone porch, whose pillars have now disappeared, and a projecting section of wall made of laterite and set on a large molded base

(1.40 m high). At the east entrance, there are two laterite pilasters supporting a dilapidated sandstone pediment. Only the lower section has retained its decoration. The doorway (1.40 m wide) is framed by two sandstone columns with multi-edged bands supporting a small lintel with spirals of foliage. The superstructure has disappeared.

Second Enclosure

After passing through the *gopura*, the visitor enters the second enclosure. Turning left, he can walk around the enclosure by taking the gallery (2.70 m wide), which has several beautifully carved lintels and pediments. The four *gopuras* are all identical. The south *gopura*, like its companions, has two small vestibules and a porch opening out onto the courtyard (1.85 m below); on the opposite side, a stairway leads out of the complex.

On the north, south and west sides, the outer laterite wall is pierced with windows making it possible to see into the courtyard. The gallery is supported with square sandstone pillars (0.34 m on each side) spaced at 3 m intervals. The bases of the pillars are adorned with floral motifs. This gallery originally had a tiled roof. Roof timbers would have been fixed to the tenons on the capitals and inserted into the holes that can be seen in the wall. On the interior of the south wall of the enclosure 2.10 m above the ground, there is a series of small windows enclosing vertically placed laterite mullions. The lintels and pediments of the *gopuras* are decorated with fascinating carvings.

There is no outer gallery on the east side—either it was never built or it was demolished at some point.

The visit will return to the east *gopura*, which leads into the first enclosure. Curiously, the enclosure is entered by first descending a flight of stairs then immediately ascending another flight opposite it. The stairways divide the interior courtyard into four L-shaped sections averaging 13 m in width. A small axial stairway leads to the ground level of the east *gopura*. The base and the stairway at the second enclosure are joined to the stairway of the first enclosure. The visit will proceed by the latter, which is difficult to negotiate since this means moving from one stairway to the other.

First Enclosure

The first enclosure wall forms a dentate rectangle (38 m by 44 m). It is interrupted by four *gopuras* and four corner pavilions. On the east side, the *gopura* contains a cruciform hall adjoining two axial vestibules and two side chambers forming a passageway. Each corner pavilion has two external staircases leading to two crudely carved false sandstone doors.

Eight years of anastylosis have proven that the side gallery of the first enclosure replaced the original enclosure wall. Unlike the wall on the outside of the gallery which is blind, the walls inside, also in laterite, are opened by windows with balusters; at the present time, these bays (1.50 m) offer the only way into the galleries, as all the entrances from the *gopuras* have been walled up. The gallery has a vault of sandstone blocks. The lintels

and pediments of the *gopuras* all have interesting carvings.

The enclosure wall is flanked on the inside by a sidewalk (1.30 m wide) with irregular edges. Paved in sandstone, it rests on a decorated base (1.60 high) bordered by *naga* balustrades. Until the 1950s, the ends of the balustrade featured imaginative carvings of five-headed cobras, considered some of the finest examples of Khmer art. Unfortunately, only vestiges of these sculptures remain today, the best preserved being at the northwest corner of the enclosure.

The sidewalk, which is an addition to the original building, leads to five stairways that communicate with a second inner paved courtyard, which in turn gives access to the libraries.

Libraries

The libraries are located in the northeast and southeast corners of the inner courtyard. Of small dimensions (4.50 m by nearly 9 m), they are made of sandstone and are identical in layout. Both are set on a base that is nearly level with the sidewalk and both are reached by two stairways, but only the west side stairs are manageable. They also include a small vestibule open on the west and a chamber (2.50 m by 5 m). Each library has corbeled vaulting and small horizontal barred windows that let in a small amount of light. The doors of the libraries have carved decorations.

Central Shrine

The base of the shrine compound is on the same level as the east *gopura* of the first enclosure. It is usually entered from the east, although it can be

The south *gopura* of the second enclosure seen from the outside, Banteay Samre.

also reached by the five stairways from the court-yard. The complex consists of a *mandapa*, the antechamber to the shrine, and the shrine itself. The *mandapa* is a long sandstone cruciform con-struction (2.50 m by 7 m) flanked on its main east-west axis by two small vestibules; there are also two side doors with stairways leading to the floor of the inner courtyard. The main and side doors are flanked by pilasters and columns with multi-edged bands. The lintels and pediments are adorned with ancons. Windows with double rows of balusters light the interior. Like the neighboring libraries, the *mandapa* is topped by a small story with an off-axis parapet wall supporting a cor-beled vault with a "crest" of finials. The abutments of the roof are masked by decorated pediments. Inside, most of the lintels above the doors are dec-orated. The funeral vat is also well preserved.

The visit continues west, passing through two adjoining vestibules before coming to the most sacred area of the shrine, a square cella (3 m on each side). The façades on the north, south and west sides are barred by false doors. On the out-side, there are vestibules (1.70 m deep) in the form of cul-de-sacs; these have two windows and an opening on the axis of a stairway leading down to the inner courtyard. Each vestibule has a vault composed of two projections ending in decorated pediments. The cella is crowned by five receding tiers forming a perfect ogive, topped by the tradi-tional lotus bud. Each level of the roof is adorned with a small carving of a temple.

The long west causeway, flanked by stone posts, extends to the southeast corner of the West Baray.

Banteay Srei
បន្ទាយស្រី

Meaning: the citadel
 of the women

Date: 967

Built by: Yajnavaraha, the guru
 of Jayavarman V

Religion: Brahmanic (dedicated
 to Shiva)

Cleared: 1924

Restoration: 1931–36

Pron.: bantee-ay s'rai-ye

Map: 23 km northeast of Angkor

Interest: **** archeo., art.

Visit: am

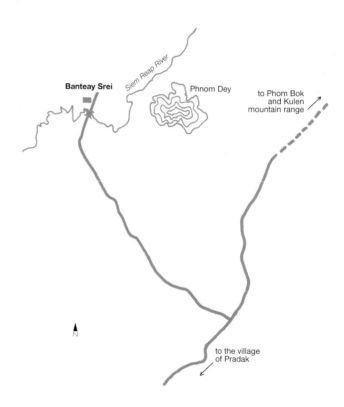

Access

Take the Grand Circuit on the right. After passing Pre Rup, turn right and you will come to a dirt road. When you reach the village of Pradak, take the road on the left until you come to a fork 19 km farther on. Take the left fork, which will lead you to a bridge over the Siem Reap River. Banteay Srei is approximately 10 m from the bridge.

Characteristics

Banteay Srei is a flat temple with a distinctive ground plan in the shape of a racket. With the beautiful hues of its pink sandstone, the exceptionally fine decorations and the temple's small size, this is one of the jewels of Khmer art. It was also the first monument in the Angkor region to benefit from anastylosis.

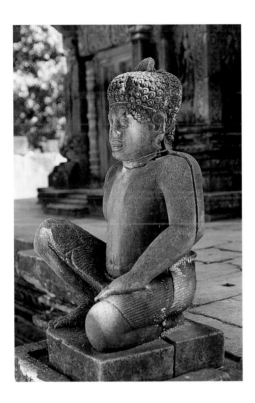

A guardian of the main shrine with African features.

Description

East *Gopura* of the Fourth Enclosure

The visit of Banteay Srei proceeds from east to west and starts with an edifice that might have been the *gopura* of the fourth enclosure. Both façades of the *gopura* have a porch with sandstone pillars and the doorway is flanked by colonettes with bands. There are also pilasters supporting a triangular pediment with a tympanum displaying an image of Indra on his three-headed elephant. Holes were made in the upper borders of this pediment to support the five beams of a tiled roof (now missing). The entry hall, lit by four windows with balusters, is a cruciform structure adjoining the north and south branches of the cross; there is also a vestibule. The west porch opens out onto a long causeway.

Central Causeway

The causeway (about 67 m long by 3.20 m wide) is lined on both sides by thirty-two square sandstone posts (0.22 m on each side, nearly 1.50 m high) ending in a miter-shaped top. On either side of the causeway are galleries (3 m wide) with decorated pillars (2.25 m high) and a laterite wall that has all but disappeared. It has been estimated that these walls were nearly 57 m long and must have been at least 4 m high in order to accommodate a tiled roof. The walls meet at right angles at their extremities, but curiously they do not abut the fourth enclosure *gopura*, nor the two buildings surrounding the east *gopura* of the third enclosure.

On either side of the causeway are two laterite vestibules (8 m long), situated symmetrically in relation to the axis of the central causeway; these

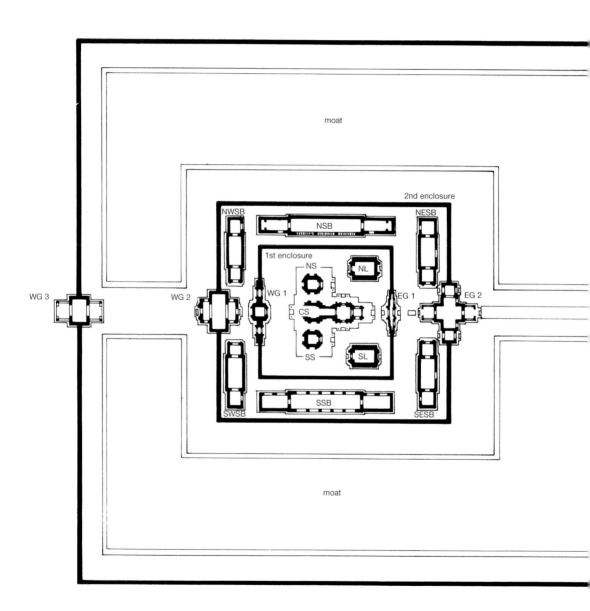

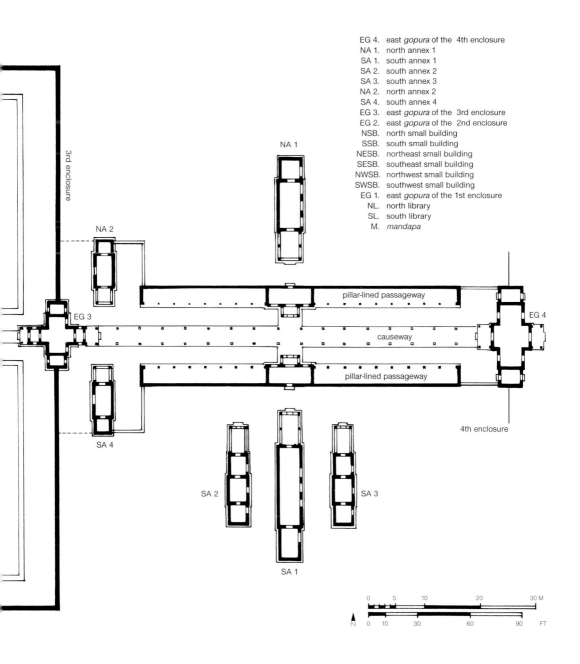

EG 4. east *gopura* of the 4th enclosure
NA 1. north annex 1
SA 1. south annex 1
SA 2. south annex 2
SA 3. south annex 3
NA 2. north annex 2
SA 4. south annex 4
EG 3. east *gopura* of the 3rd enclosure
EG 2. east *gopura* of the 2nd enclosure
NSB. north small building
SSB. south small building
NESB. northeast small building
SESB. southeast small building
NWSB. northwest small building
SWSB. southwest small building
EG 1. east *gopura* of the 1st enclosure
NL. north library
SL. south library
M. *mandapa*

3rd enclosure

NA 1

NA 2

EG 3

EG 4

pillar-lined passageway

causeway

pillar-lined passageway

4th enclosure

SA 4

SA 2

SA 3

SA 1

0 5 10 20 30 M

N 0 10 30 60 90 FT

small halls are preceded by porches facing the causeway and have doors leading to adjoining north-south oriented buildings.

On the north side there is a single dilapidated building. It has a four-pillared porch and contains a rectangular chamber (4 m by 8 m) with windows that connects with a small square room with no openings. Above the entry to the main chamber there is a decorated tympanum.

The south vestibule precedes three other annexes. One of these is on the same axis as the entrance and the north annex. It is similar to its northern companion, but is larger; its main room measures 13 m by 4 m and its adjoining chamber is about 3 m by 5 m. The pediment north of the main room has five recesses that once held the wooden beams of a roof. The tympanum has fine decoration.

The other two very dilapidated constructions of similar appearance surround this first building. Worth seeing is a magnificently adorned pediment placed near the east *gopura* of the third enclosure.

Third Enclosure

The third enclosure wall is in the form of a rectangle (95 m by 110 m; 2.20 m high). It is made of laterite blocks set on a large base. The upper part of the wall is molded and has a heavy coping. The enclosure only has *gopuras* on the east and west sides.

East *Gopura* of the Third Enclosure

The east *gopura* (10 m by 11 m) has two pillared porches, a central cruciform open chamber and two vestibules also functioning as passageways on the north and south sides, adjoining the enclosure wall. The whole edifice is in laterite, except for the frames of the balustered windows which are in sandstone. The *gopura*'s superstructure has gone, but the remaining lintels and pediments are filled with charming decorations and one of the piers has an inscription.

A laterite path (28 m by 2.20 m) flanked by two dirt paths extends beyond the *gopura*. In addition, the path is flanked by two U-shaped moats (8 m by 18 m), which once had stepped borders. The moats are empty during the dry season.

Second Enclosure Wall

The rectangular enclosure (38 m by 42 m) is formed by a laterite wall (2.17 m high) that has a heavy coping (40 cm high) and a base (37 cm high) with a pronounced recess (42 cm). The wall is interrupted on the east and west sides by a *gopura*.

East *Gopura* of the Second Enclosure

The east *gopura* is identical to its counterpart in the third enclosure but it is smaller (only 4.50 m by 10 m). It is a laterite edifice with two windows with balusters on its east façade illuminating the central cruciform chamber. Two vestibules that are entered through this room lie at the north and south ends. Its porch on the east side is guarded by a sitting lion; two pillars support an extraordinarily beautiful pediment whose decorations are duplicated on another pediment placed behind it.

Exiting from the west side of the *gopura* and entering the second enclosure, the visitor will

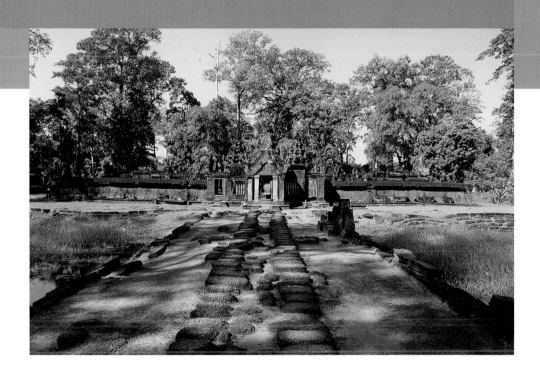

immediately see a statue of Nandi, Shiva's mount. The statue has unfortunately been split in two along its length.

Second Enclosure

The second enclosure contains a courtyard surrounding the wall of the first enclosure. The courtyard varies in dimensions, measuring 9 m wide on the east side, 7 m on the north and south sides, and only 6 m on the west side.

Almost abutting the enclosure wall is a group of six small laterite buildings. The identical north and south buildings (3 m wide by 23.50 m long) are larger than the others and are located symmetrically in relation to the main axis. They are mostly complete ruins, but it is possible to make out a long central chamber flanked by smaller rooms.

The other four identical buildings (3.50 m wide by 12 m long) stand at the northeast, southeast, northwest and southwest corners; they include two small chambers linked to a central room. Their most interesting feature is the decoration on the lintels and pediments. All six buildings originally had tiled roofs.

The perimeter courtyard incorporates a *gopura* on its west side.

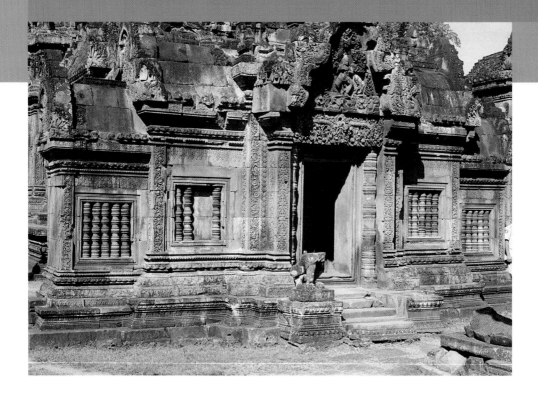

First Enclosure

The wall of the first enclosure forms a square (23.50 m on each side) and, unlike the other walls, is made of brick. It can be entered through two doorways, one on the east and the other on the west.

East *Gopura* of the First Enclosure

This small *gopura* (over 7 m long, 2 m wide, 6 m high) can only be entered through two central doors (0.75 m wide, 2.20 m high), that admit only one person at a time.

Each one of its façades has four false windows with balusters. The lintels and the pediments are beautifully decorated.

Leaving the *gopura* on the west side, the visitor arrives at a second inner courtyard occupied by two libraries, the central shrine and some secondary shrines.

Libraries

The two identical libraries (5.30 m by 4 m) are placed to the north and south of the east *gopura* of the first enclosure. They each stand on a stone base (0.50 m high). Only the walls along the sides are in laterite; the other walls, together with the corner pillars, the door jambs, the window piers, the cornices and the pediments, are made of a pink sandstone. The roof consists of two tiers. The first consists of a half-vault supporting a false level with a false window with bars, while the second has a corbeled brick vault.

The single door (0.60 m wide by 1.25 m high) is located on the west side and leads to a single dark room. The east side has a false door.

Although similar in plan, the libraries differ remarkably in the decoration of their pediments. The north library pediments feature scenes from the lives of Indra and Vishnu, while Shiva and his

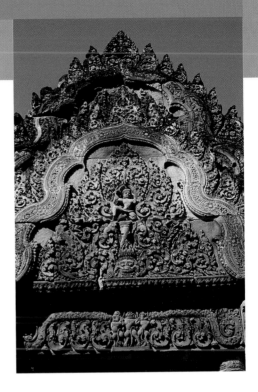

legends were the inspiration for the carvings of
the south library.

Terrace and Shrines

From the west door of the east *gopura* extends a
T-shaped terrace (the upper bar of the T measur-
ing 15 m by 6 m) resting on base forming a rec-
tangle (5.50 m by 7.50 m). The central shrine and
the two secondary shrines (0.95 m high) are
made of sandstone and have highly molded,
beautifully decorated walls. The central shrine is
approached by five stairways situated on the east
part of the terrace and by a single stairway on the
west side. Once, the stairways had string walls
embellished by stone figures in the "Javanese
position," with their right knees raised. The stat-
ues had human bodies, but their heads varied
according to their position on the terrace. Among
the strange mythical creatures guarding the

antechamber of the shrine were monkey-headed
beings crowned with miters.

Two *garuda*-headed figures watch over the east
section of the north secondary shrine and its
counterpart on the south side is guarded by two
figures with lions' heads. The west side of the cen-
tral shrine is the location for two figures with
Negroid features. Most of these statues are
copies, the originals being preserved elsewhere.
The few originals that remain have been decapi-
tated or smashed.

Mandapa

The *mandapa*, or antechamber to the central
shrine (7.50 m by 3 m), lies on the axis and in the
vicinity of the east *gopura* of the first enclosure.
Reached by a flight of five stairs, it consists of a
vestibule with a narrow door (1.40 m high) on the
east side as well as two windows. The *mandapa*

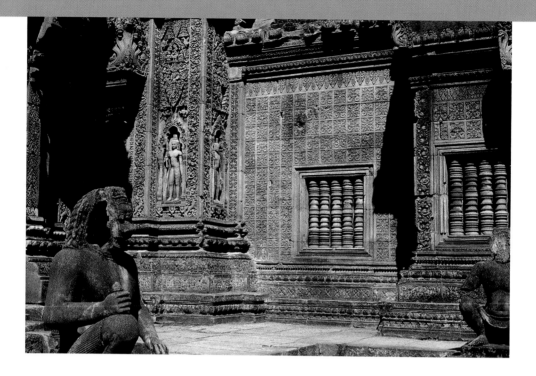

is followed by a square room (2 m on each side) with two doors leading to two secondary stairways. Its four sides are ornamented by false windows with balusters. The roof is a two-tiered corbeled vault made of brick. The walls, columns and pilasters are decorated with a wealth of varied plant and floral images. Forest imagery also invades the lintels, where monsters peep out from maelstroms of foliage. The three horseshoe-shaped pediments of the *mandapa* also have plant motifs combined with human figures. Inside the *mandapa* are images of the gods Indra and Shiva accompanied by other divinities.

A dark corridor (2.50 m long) extends from the main room of the *mandapa* to the central shrine; on the outside of the corridor are two false windows with bars.

Central Shrine

The principal shrine has a square ground plan (3.70 m on each side), as does its cella (2 m on each side), which has no openings. This part of the monument is entered by a dark corridor.

Externally, the shrine has three false doors flanked by colonettes with bands and festoons. Wonderfully intricate ascending scroll patterns

Above: the *mandapa* of the central shrine with its tapestry-like decoration.

Facing page: one of the charming *dvarapalas* standing guard at the main shrine.

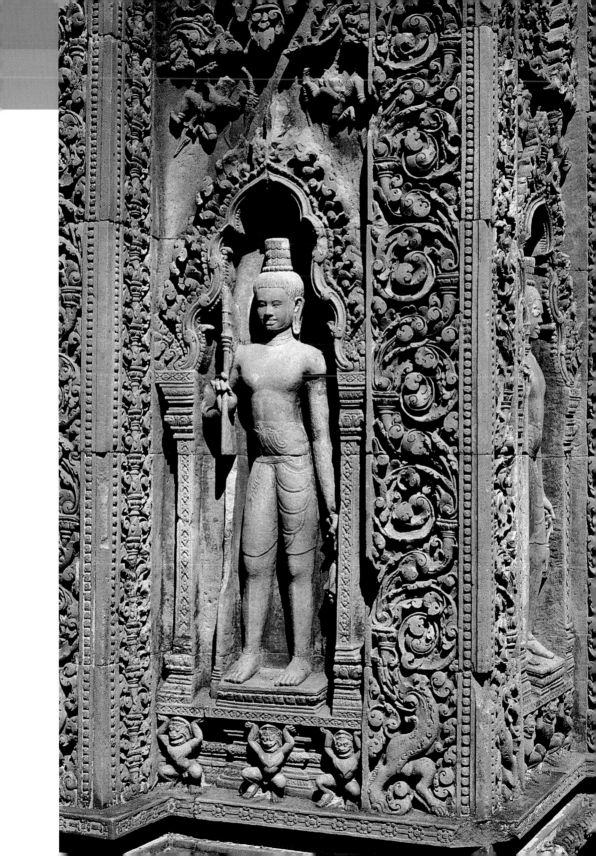

cover every centimeter of space on the pilasters, while the lintels are carved with episodes from the *Mahabharata* and the *Ramayana*. The three horseshoe-shaped pediments are dedicated to different Brahmanic gods.

On the corners of the central tower are svelte male guardians of the shrine. Their hair is swept up in a cylindrical bun and they are draped in the traditional *sampot*. They hold a spear and a long-stemmed flower in each hand. They stand beneath highly decorated arches and are supported by a pedestal ornamented by lotus decorations carried by three lion atlantes. Flying figures holding a flowery garland hover above the crowd.

The roof of the shrine is a stepped pyramid of five false successively receding tiers ending in a flower motif 9.80 m above the terrace. Another delightful feature is the ornamentation on the small pediments bordering each tier; you will also notice the decoration enhancing the corners of the projecting sections. Different themes have been treated, including the occasional sitting figure and images of people ranging from menacing spear-bearing individuals to male and female dancers.

There are two secondary shrines, located on the north and south sides of the central shrine.

North Shrine

Resting on a low base, this shrine consists of a square tower (3.30 m on each side) with a dentate outline. Three of the four sides have false doors; the single, small opening (0.60 m wide, 1.20 m high) is located on the east side. The square cella (1.70 m on each side) is difficult to enter.

The north shrine, like the central shrine, is intricately decorated. The lintels are adorned with scenes from the legends of Indra and Vishnu, while the horseshoe-shaped pediments feature Vishnu and other Brahmanic deities.

At each corner of the main tower are figures beneath arches representing goddesses in a delicately stylized pose with heads slightly inclined and a faint smile on their finely drawn lips. Their hair is gathered in fine braids and pulled back; there is a jewel above their temples and their earlobes are distended by heavy earrings. The goddesses each hold a long-stemmed flower over their shoulder with one hand, while their other hand, also holding a flower, hangs straight down. They are adorned and bejeweled with necklaces

The ascetic Karaikkalamaiyar, votary of Diva.

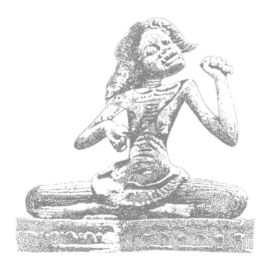

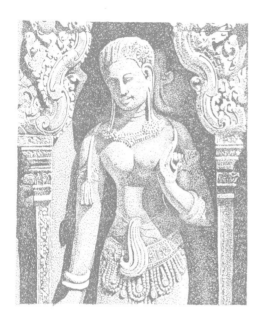

One of the graceful *devatas* of the north shrine.

and bracelets and wear long skirts maintained with S-shaped flaps and a large fringe ending elegantly about the belt. There is a certain heaviness about their feet, the only discordant note to this graceful composition. As on the central shrine, each statue is set on a pedestal, but here each statue is supported not by lion atlantes but by sacred geese with spread wings (*hamsas*).

The superstructure of this shrine is similar to that of the main shrine, although it is smaller (8.34 m high). Indeed, iit can admit only one person at a time through its single easterly opening.

South Shrine

This shrine is a replica of its sister on the north side, displaying identical decoration. The lintels are carved with themes from the legends of Indra, Yama, Varuna and Kubera. The pediments feature some interesting scenes inspired by Brahmanic legends.

Less than 3 m from the single stairway on the west side of the terrace is the west *gopura* of the first enclosure.

West *Gopura* of the First Enclosure

The west *gopura* (11.50 m long) is larger than its counterpart on the east side. Unusually, it has a central chamber with no doorways and two wings with very low doors.

This shrine is a partial ruin, except for its east side, where three magnificent lintels have surprisingly remained intact. They portray gods, monsters and multi-headed *nagas* slithering across leafy backdrops.

Beyond this *gopura*, we come to the second enclosure.

West *Gopura* of the Second Enclosure

This cruciform structure (7 m on each side) encloses a central chamber (2.50 m by 6 m) with no openings, flanked on the east and west by a vestibule with two windows.

The lintel and pediment on the east façade are finely carved and they are worth a close look for the admirably executed scene from the *Ramayana*.

The west *gopura* of the third enclosure is too dilapidated to be of much interest.

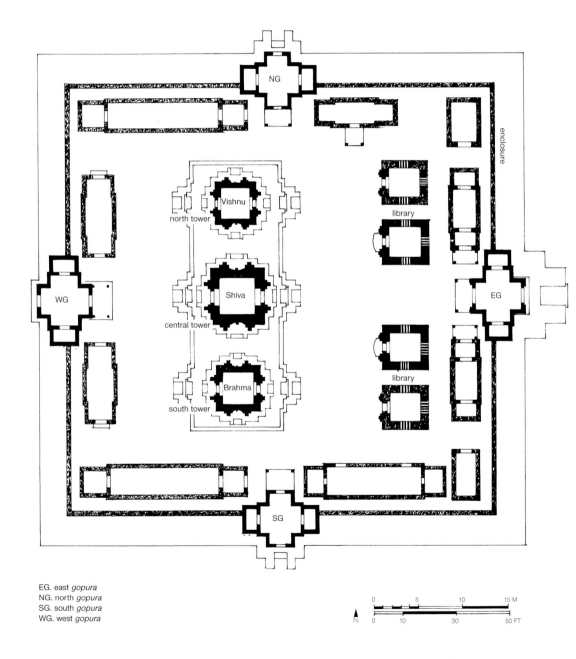

EG. east *gopura*
NG. north *gopura*
SG. south *gopura*
WG. west *gopura*

Krom (Phnom Krom)

ភ្នំ ក្រោម

Meaning: the downstream mountain	Cleared: 1938
Date: end of 9th–beginning	Pron.: krom
of 10th c.	Map: see "Access"
Built by: Yasovarman I	Interest: * archeo., view
Religion: Brahmanic	Visit: early am or late pm

Access

This monument is near the Great Lake (Tonle Sap), about 10 km southwest of Siem Reap. It is easy to reach if you follow the river south and then the earth dike overlooking the rice fields. Continue in this direction until you reach the east slope of the hill, where the monument is located. The ascent (137 m) can be made by car, preferably a four-wheel drive, or on foot, by means of a path reached by a stairway.

Characteristics

The temples of Phnom Krom, Phnom Bakheng and Phnom Bok were all built during the same era.

The Siem Reap River is lined with typical Cambodian houses and is the center for all sorts of activities, making this a charming walk. From the heights of Phnom Krom, you can enjoy a breathtaking view over the surrounding plain and

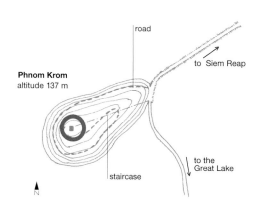

road

to Siem Reap

Phnom Krom
altitude 137 m

staircase

to the
Great Lake

N

the Great Lake, which becomes a mirror during the rainy season for the spectacular natural phenomena such as sunsets and the "green ray" that sends a flash across the sky above the Great Lake.

Description

When Yasovarman I decided to create his city around Phnom Bakheng, he had his state temple placed on that same hill, but he also constructed on the adjoining hills the monuments of Phnom Bok and Phnom Krom. For the latter, the summit was razed and then a square laterite enclosure approximately 50 m on each side was built. A rise of earth was then built around the wall on its east, north and south sides as the first step to erecting a platform, to be reached by three stairways. The temple is entered from the east. The single enclosure wall has four identical axial *gopuras* (6.50 m wide by 10 m long). Each entrance pavilion has a cruciform chamber, two side rooms without openings and a pillared porch leading to the inner courtyard. The ruined state of the monument has left only remnants of these architectural elements. After going through the porch, you will notice an alignment of small buildings of different dimensions facing the wall; they average 4 m in width and have lengths ranging from 6 m to 9 m. Four of these buildings are located on the east, while the remaining two are on the other two sides. They had tiled roofs and apparently served as storerooms. Only the platforms and a few isolated walls remain.

These buildings are followed on both sides of the main east-west axis by four square libraries (5 m on each side) open on their west side. The

two libraries near the axis are in sandstone, unlike their counterparts at the north and south ends, which are made of brick. Each library is partially covered by a vault repeated on a false receding story and each one also ends in corbeling terminating in a gable wall. Three of their four façades have diamond-shaped holes.

The libraries precede the three shrines, which are made of sandstone. Set on a base plinth oriented along the north-south axis, they are almost completely ruined. Their base is molded but undecorated (1.50 m high, 11 m wide and 22 m long). Each tower is reached by a stairway with sitting lions on string walls.

The central tower stands on a dentate square (7 m on each side). It has real doors on its east and west façades and false ones on the other two

sides. The superstructure is a truncated pyramid with only two receding tiers.

The secondary towers (5 m on each side) are similar, their two openings also facing the east and the west, but their superstructures have three tiers.

The monument has suffered the ravages of time and climate and most of the sandstone blocks are now chipped. A few decorative elements are still visible, notably the ornamentation embellishing the bases of the shrines, the carvings of dancing girls under arches on the stairways and the images of figurines and leafy foliage enlivening the pilasters and the false doors. The door figures are the familiar *devatas* holding flyswatters and offering lotus flowers. There are hints of a central motif on the pediments, enhanced by great leafy volutes lined with miniature subjects. The superstructures rising above the cornices, the antefixes and the small stone edifices are adorned with the images of dancers in bell-shaped skirts, indicating the Bakheng and later Banteay Srei styles.

Like the temple of Phnom Bok, the three shrines represent the Trimurti of the three major Indian gods, with the south shrine dedicated to Brahma, the central one to Shiva and the north one to Vishnu. The pedestals of these statues are in good condition; that of Brahma is particularly well adorned with its décor of lotus petals and *hamsas*. This round pedestal enclosed the sacred foundation stone.

In the sandstone north library, a badly eroded "stone of the nine planets" was uncovered.

A huge *dvarapala*, or gateway guardian (3.20 m high), was unearthed at the foot of the east façade. The statue, in the Angkor Wat style, was placed at this monument during a later period.

The majority of archeological artefacts from this monument are now kept at the Conservation d'Angkor.

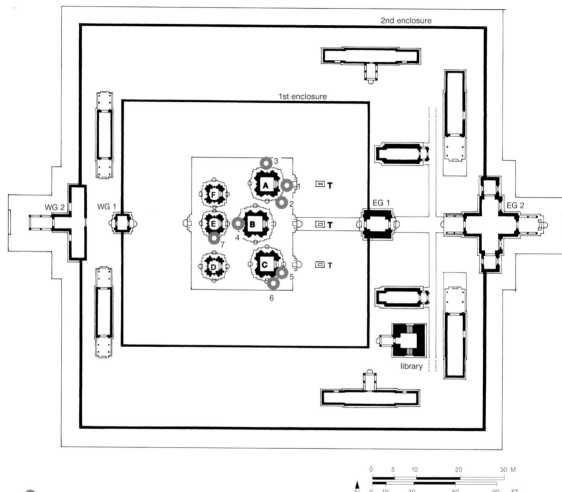

2nd enclosure

1st enclosure

WG 2 WG 1

EG 1

EG 2

library

0 5 10 20 30 M

N 0 10 30 60 90 FT

● **interesting feature**

T Nandi, Shiva's mount

Shrine A
1. Under an arch, a small figure seated on a *kala* head disgorging a leafy stem which turns into horses and riders. A *makara* appearing at the end of the stem above figurines mixed with croziers, from which a five-headed *naga* emerges.

2. Interesting decorative elements made of a lime-based mortar. From the throat of a mitered *kala* springs a wreath with a small figure in the center, performing a dance or preparing to fly into the air.
3. The lintel: in the center, a *kala* head disgorges an elephant head whose ears grow into a leafy cord

ending in an upright lion. There are figurines sporting among the foliage and riding the croziers in the lower section.

Shrine B
4. The lintel: a mitered *garuda* with spread wings holding a leafy stem with croziers ending in an erect five-headed *naga*.

Shrine C
5. A few vestiges of decorations made of lime-based mortar and a large *kala* head mounted by a figure under an arch.
6. Fragments of decoration, notably a garland with pendants.

Shrine E
7. Decoration made of lime-based mortar and a well-preserved false door.

Roluos Group

Preah Ko

ប្រាសាទគោ

Meaning: the sacred bull (Nandi)

Date: 879

Built by: Indravarman I

Religion: Brahmanic (Shivaist)

Cleared and restoration: 1932

Pron.: pray-ya ko

Map: see Roluos group

Interest: *** archeo.

Visit: am

Access

From Siem Reap, head east on the road to Phnom Penh. After 13 km, turn right onto the wide dirt road. The Preah Ko temple, which is the first monument of the Roluos group, is 500 m from the road on the right. The temple is located on the right-hand side.

Characteristics

This monument is of particular interest because of the symbolic arrangement of its six towers, the inscriptions on the door jambs and the use of lime-based mortar for the decorations on its brick walls. The temple also gave its name to the Preah Ko style which sparked several artistic advances.

Description

It is possible that Indravarman I, a ruler of obscure origin, built Preah Ko in an attempt to link himself to the prestigious dynasty of Jayavarman II, the founder of the Khmer empire; the new and contested sovereign dedicated the temple to Jayavarman II and the spirits of the kings and queens preceding him.

The temple lies on the eastern edge of a vast rectangular area (330 hectares) surrounded by moats. The monument, which covers only a small part of this zone, has three enclosures with an easterly approach.

Third Enclosure

The enclosure's laterite wall is in a very dilapidated state, except for a few isolated fragments of its east *gopura* lying near the access road. The cruciform *gopura* is preceded by a portico with an axial entrance and two wings whose openings create lateral passageways. The *gopura* is made of laterite. Its windows, which are framed in sandstone, have very large balusters. Fragments of triangular pediments adorned with volutes unearthed during the excavations indicate that there was once a pitched roof.

A laterite-paved path (3.40 m wide) leads to the second enclosure. On the left of the path there is a laterite terrace (7.50 m by 11.50 m), the purpose of which is unknown.

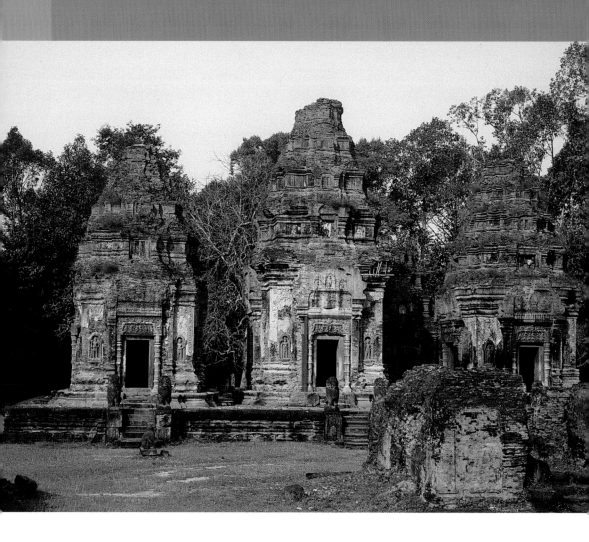

Second Enclosure

The second enclosure, reached by a flight of four steps, is set on a laterite base (103 m by 107 m), with projections on its east and west sides. The enclosure's laterite wall (95 m by 66 m) has all but disappeared, except for a few vestiges on the west side revealing that it's height was 2.15 m. The west and east *gopuras* are located in this area.

Some of the most interesting features of this enclosure are listed on page 302.

The towers on the east side are dedicated to the spirits of the dead sovereigns.

Of the east *gopura*, only the base wall and a section of wall with balustered windows remain. The building was a cruciform structure similar to its counterpart of the third enclosure.

Inner Courtyard of the Second Enclosure

The *gopura* is followed by two identical oblong buildings (20 m by 5 m) located on either side of the principal axis and parallel to the east side of the enclosure; only the bases of these edifices remain. The buildings are preceded by pillared porches and include rooms 14 m long. They might have been used as storerooms.

A short distance beyond this point, on the main east-west axis and parallel to this axis, are two laterite constructions (5 m by 13 m) containing small east-oriented vestibules. Little remains of these buildings.

There is also a sturdy square brick library in the form of a tower (8 m on each side) with a single westerly opening. It consists of a base (about 5 m high) supporting a pyramidal structure that appears to support another, smaller brick pyramid. The walls are particularly thick in their lower reaches (1.50 m). There is some extraordinary decoration on the exterior. At the foot of the tower, above a molding, an alignment of carved figures under an arcature encircles the building. On the north and south sides, there are large windows with brick frames. They are studded with "webs" of brick pierced by sixteen openings. The small upper structure is carved with images of ascetics beneath arcatures and, on each side, false windows adorned with honeycomb patterns.

Near the north and south enclosure walls are other oblong laterite buildings (24 m by 3.50 m) with porticoes. Only the bases of these constructions are intact.

We now have reached the axis of the temple, where a laterite paved path (3.40 m wide) leads us to the east *gopura* of the first enclosure.

First Enclosure

The brick wall of the first enclosure (58 m wide by 60 m long) is almost entirely missing. There are only two *gopuras* along its length.

Of the east *gopura*, only a few wall panels, a handful of door frames and accolade-shaped steps have remained in place.

The *gopura*, a square-shaped brick building (7 m on each side), encloses only one small chamber that formerly contained the temple's foundation stela (which is now conserved elsewhere). To the right of the door, you will see two interesting cylindrical columns that have now been set upright.

Inner Courtyard of the First Enclosure

The east *gopura* of the first enclosure is followed by a laterite-paved causeway leading to a great terrace (0.80 m high, 25 m wide, 31 m long) located at the center of the tower. This sandstone terrace forms the base plinth for the six shrine towers. There is also an axial stairway corresponding to each of the six towers accompanied by string walls adorned with representations of *dvarapalas* and *devatas* and guarded by the traditional sitting lions. The stairway leads to the upper story of the terrace. Approximately 6 m in

front of the base, there is a sculpture of a reclining Nandi, the sacred mount of Shiva.

The west façade of the terrace has only one axial stairway.

Shrines

The six shrine towers form two rows on the north-south alignment, with the central tower set back from the eastern alignment.

The towers on the east side are dedicated to the souls of the founding king's predecessors. The central tower, the largest one (12.50 m high), is dedicated to Shiva, the divine "associate" of Jayavarman who was deified following his death. It contains a cella (3.70 m on each side). The north tower was built to glorify the founder of Preah Ko and the south tower is dedicated to his father; both towers also have cellae (3.40 m on each side).

The three towers on the west are shorter (just over 7 m high). They were built as offerings to the sacred spirits of the former queens. They also contain cellae (2.50 m wide).

The brick towers are all pyramids rising in four gradually shortening tiers set on a low sandstone base. Their single opening is on the east side and each of the other sides has a false door made of sandstone. The octagonal colonettes surrounding the doors are among the finest examples of decorative carving in Khmer art. The lintels above the colonettes are decorated with wonderfully imaginative and fantastic scenes. The lower register is decorated with beautiful swags of garlands. The lush undergrowth is dotted with images of small figures riding animals or leafy croziers that sometimes turn into three-headed *naga*. A short decorated frieze separate from the lintel displays a series of praying figures. The brick pediments crowning the doors and the *dvarapalas* and the *devatas* on the outer walls of the towers have often been left in roughed out form. The most important feature of the shrines is their stucco sculptures, although many sections have sadly disappeared.

The eastern shrines were not shelters for the *linga,* as might have been expected, but contained statues of idols.

Other Constructions on the West Side

The west *gopura* of the first enclosure has the same ground plan as its counterpart to the east, but is smaller. Beyond the *gopura* two oblong rooms (12 m by 4 m) are flanked at each of their ends by a four-pillared porch. Only scattered elements from this building remain.

The west *gopura* of the second enclosure no longer exists except for the remains of a porch.

Bakong

ប្រាសាទបាគង

Date: 881

Built by: Indravarman I

Religion: Brahmanic

 (Shiva)

Cleared: 1936

Restoration: 1936–43

Pron.: bakong

Map: see map of Roluos group

Interest: *** archeo.

The central tower seen from the east.

Access

To reach Bakong, take the road to Preah Ko but continue for a further 500 m. At the north façade of Bakong, you will skirt its northeast corner to reach the east *gopura* of the second enclosure.

Characteristics

This was first temple-mountain to be built in sandstone and was the starting point for this type of monument in Khmer architecture. The temple-mountain was conceived as an earthly replica of Mount Meru, the abode of the gods. Bakong was the state temple of Indravarman I and was the symbolic center of his kingdom.

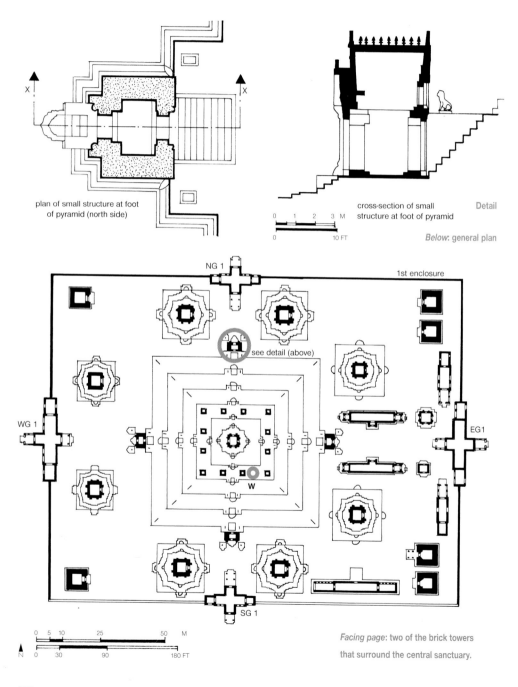

plan of small structure at foot
of pyramid (north side)

cross-section of small
structure at foot of pyramid

Detail

0 1 2 3 M

0 10 FT

Below: general plan

NG 1

1st enclosure

see detail (above)

WG 1

EG1

W

SG 1

0 5 10 25 50 M

0 30 90 180 FT

N

Facing page: two of the brick towers

that surround the central sanctuary.

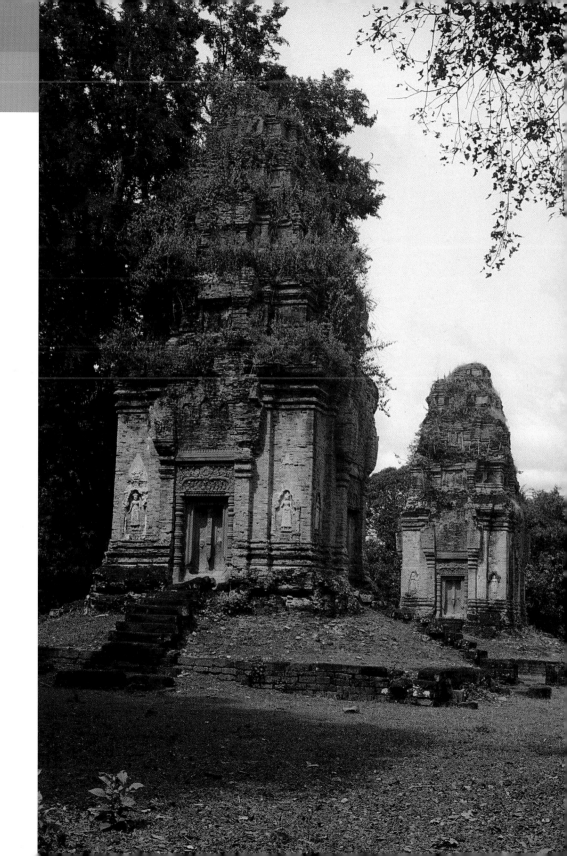

Description

Bakong, like Preah Ko, is caught in a vast web of canals and moats. Of the three enclosures surrounding the monument, the largest traces a huge rectangle (more than 800 m long) made up of dikes (30 m wide) that have been converted into rice fields. Following this rectangle is a vast expanse of earth (200 m wide) encircling the second enclosure. It is in this area that the remains of twenty-two small separate brick towers were found; these opened to the east or toward the shrine.

Second Enclosure

The wall of the second enclosure is made of laterite but is partially buried. It traces a rectangle (400 m by 450 m) and its east and west sides are interrupted by dilapidated cruciform laterite *gopuras*.
Causeways lead from the entry pavilions toward the shrine; they were originally bordered by *naga* balustrades which have unfortunately disappeared. Beyond the east *gopura*, on the left, there is a large seven-headed *naga*.

The *gopuras* on the north and south sides are smaller.

The causeways on the east and the west sides cross the moat (about 55 m wide), which surrounds the first enclosure.

First Enclosure Wall

This wall, made of laterite, is relatively low and forms a rectangle (120 m by 160 m). It originally had four axial *gopuras*, of which only the molded bases remain.

First Enclosure

After passing through the east *gopura* of the first enclosure, the visitor arrives at two oblong laterite buildings (20 m by 50 m) surrounding a paved road (4 m wide) dotted with the bases of stone posts. The buildings enclose three rooms, which have all been destroyed except for the wall bases.

In the northeast and southeast corners of the enclosure, there are two heavy brick towers similar to the library at Preah Ko. In the northwest and southwest corners, there is only one similar tower.

Each building includes a principal square structure (9 m on each side) which supports a pyramidal roof, which in turn supports a small cubic structure with a corbeled vault. There is a single doorway on the west side cut from a slab of sandstone. The north and south façades are each pierced by holes set in a molded frame and separated into groups of four by small, slender pilasters with capitals. Each façade of the upper structure has holes pierced in the sandstone. The southeast corner towers are the best preserved; one of them is adorned by a frieze of ascetics in niches.

Just in front of the *gopuras*, on either side of the central road, you will find two small laterite buildings that are total ruins. The northern structure is missing its roof and its southern counterpart, which once contained the foundation stela, has retained only its base and a sandstone door jamb. The foundation stela is now conserved elsewhere.

Slightly farther to the west, there are two adjacent oblong buildings (4 m by 25 m) that have

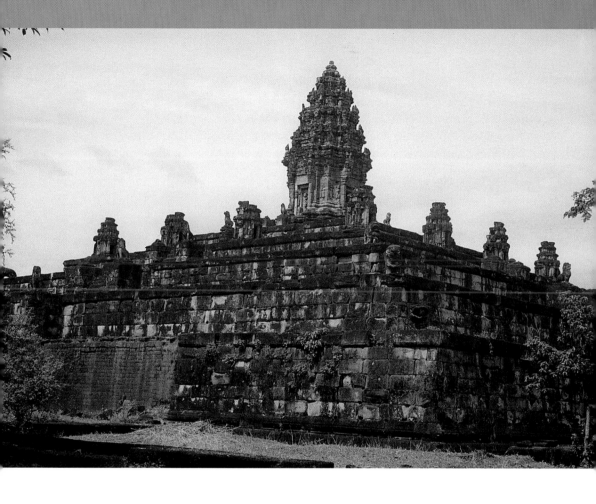

The temple-mountain.

porticoes facing the central causeway; the buildings' walls, which are made from reused sandstone, are still intact and have false windows with balusters. The corbeled vaults no longer exist. These buildings were certainly added to the temple compound at a later date and were probably used as storerooms.

By the south wall of the enclosure is a very long building (33 m by 4 m) containing three chambers. Only the laterite base, four door frames and a sandstone lintel remain of this structure.

Eight large brick towers surround the central shrine, two on each side. The two towers on the east side, which are taller, have retained only their wide bases, a few sections of wall and several sandstone door frames; their companions on the west side are more complete and in a better condition. The remaining towers stand on square bases that support two other dentate square bases. The second level can be reached by axial stairways guarded by lions.

The towers are square in plan (8 m on each side). They have high brick walls, molded at the base and ending in a pronounced cornice. There is only one opening on the east side, the other sides being decorated with false doors. Each door, whether false or real, is carved from a single piece of sandstone and framed by cylindrical colonettes that are highly ornamented with a multitude of bands. The colonettes are topped with remarkable lintels with decorative motifs, including small human figures. The false doors also have exceptionally fine decorations that imitate woodworking techniques. Each one is divided vertically by a wide band adorned with "knobs," with carvings on either side. The colonettes are flanked by brick pilasters supporting a high pediment with a flat tympanum rising to the level of the cornice. *Dvarapalas* and *devatas* appear at the corners of the towers in roughed out form. Bakong, like its sister temple Preah Ko, was once covered in sculpted lime-based mortar; a few finely sculpted sections remain.

Each tower was dedicated to an avatar of Shiva, the patron god of the temple.

Pyramid

The pyramid in the center of the first enclosure stands 8 m to the west of the north-south axis. The huge interior rests in part on earth filling and a layer of laterite. The five tiers of the pyramid are faced in sandstone and gradually shorten as they rise; the first is 4.70 m high, while the fifth and final terrace is only 1.70 m high. The top terrace is 14.30 m above the courtyard. The terraces are square in plan, the first measuring 65 m on each side and the fifth only 20 m. The space between the terraces forms a passageway nearly 6 m wide.

Linking the terraces are axial stairways, which match the steps of the pyramid with their gradually decreasing widths: the first flight is 3 m wide and the last 1.40 m. The stairways have beautiful accolade-shaped steps and are lined with massive string walls acting as pedestals for sculptures in the round of guardians or goddesses. Several nearly intact sitting lions can be seen.

At the foot of the pyramid and on each of the axial stairways stand tiny one-room buildings that are unique in Khmer architecture. They project abruptly from the wall of the first terrace, they have a single entrance and corbeled vaults topped by a finial. The one to the north has been restored. It is decorated on the outside by pediments with figures that surround a small aperture admitting light. The entrance is flanked by large stone pedestals that probably supported idols. Other representations of note include carved gargoyles for draining rainwater, pedestals and the remains of a reclining Nandi facing the temple.

The corners of the first three terraces of the pyramid are ornamented with statues of elephants

adorned with harnesses and bell necklaces; they guarded the intermediate directions of the Universe. Their size decreases with each successive terrace.

The edge of the fourth terrace is lined with twelve small sandstone towers placed at equal distances from each other. These undecorated sandstone structures (2.50 m high) are open only on the east side and rest on a small base. At one time, each edifice sheltered a *linga* beneath a three-tiered pyramidal roof. The retaining wall of

Fighting *asuras*, bas-relief on the south wall of the last terrace, Bakong.

the fifth and last terrace is decorated with a bas-relief displaying human figures. Unfortunately, they are badly eroded. There are a few clear silhouettes, however, mainly on the south façade, where a sandstone block (45 cm by 65 cm) displays a magnificent scene of a fighting *asura*. The very fine treatment of the subject exhibited on this fragment makes the loss of the rest of the scene all the more regrettable.

Shrine

The central shrine is made of sandstone and rests on a square base (9 m on each side). It is reached by the traditional stairway bordered by lions. The tower was a later addition. The decoration is in the Angkor Wat style, indicating that it was erected approximately two hundred years after the pyramid. The base wall is the only remaining vestige of the pre-Angkor period. The tower that replaced it was built on a square plan (nearly 6 m on each side). Its single opening is on the east side and the other sides are ornamented with false doors framed by colonettes and fascinating lintels, a feature that is typical of the end of the 11th century.

The tower is crowned by a pyramid of four tiers ending in an open lotus flower. This superstructure is 15 m high and its general appearance is quite reminiscent of Angkor Wat. The square cella (2.70 m on each side) has no particularly interesting feature.

The stela, discovered in 1935, is a fine sample of very elegant calligraphy. The inscription praises Indravarman, the king and founder, recalls the establishment of the royal *linga* and mentions the eight representations of Shiva. It also recounts the excavation of Indratataka, the great reservoir that was constructed by Indravarman, at the center of which is Lolei.

The central well in the shrine's cella was plumbed to the depth of 20 m, but it yielded nothing. The treasure had been stolen by plunderers who cut through the base of the pyramid to get to the sacred area.

Several interesting statues were unearthed when the temple was cleared. At the beginning of this work in 1936, Bakong was a chaotic mass of earth and stones. Its present well-preserved condition is the result of seven years of painstaking labor.

Lolei

 លៃ លើ

Meaning: the abode of Harihara (Vishnu-Shiva)	Pron.: lo-leyee
	Map: see map of Roluos group at the end of the book
Date: July 8, 893	Interest: * archeo.
Built by: Yasovarman	Visit: am
Religion: Brahmanic (Shiva)	

Access

Take the road from Siem Reap to Phnom Penh. After 13 km, on your left, you will come to an intersection; 600 m beyond this crossing, on the left, a dirt track leading north appears. After traveling for 600 m on a dike passing through rice fields, you will arrive at the temple of Lolei.

possible location of towers

0 10 50 M
N 0 30 180 FT

General plan.

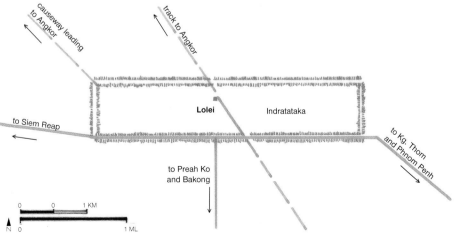

causeway leading to Angkor

track to Angkor

to Siem Reap

Lolei Indratataka

to Kg. Thom and Phnom Penh

to Preah Ko and Bakong

0 0 1 KM
N 0 1 ML

Characteristics

Lolei was the first temple to be built in the center of the first *baray*, the Indratataka. The monument also has a distinctive inscription on its door piers and decorated lintels.

Description

Indravarman ordered the construction of the Indratataka (3,800 m by 800 m) five days after his coronation in 877. Sixteen years later, his successor, Yasovarman I, decided to have a temple built

on an island in the middle of the reservoir. According to the monument's stela, he dedicated it to the memory of his ancestors. The island is located on the *baray*'s east-west axis, but it is 150 m to the north of the other north-south axis.

The monument consists of four brick towers on a double platform, which has gargoyles to drain rainwater. The two levels of the platform are accessed by stairways with string walls and sitting lions.

The highest terrace is 80 m wide and 90 m long in the north-south direction, but as both terraces have been radically modified since they were built it is impossible to ascertain the original layout of the base. The higher terrace, which is now almost completely buried, once supported four shrines in two rows. The position of both northern towers placed on the main east-west axis of the terrace suggests that, as at Preah Ko, there were originally six towers; the other two towers positioned on the north side were not part of the original scheme, since the stela mentions only four idols.

Each tower has a square ground plan (6 m on each side); the two eastern towers are slightly larger than the others. All the towers have a single opening on the east side with a sandstone frame, as at Bakong. Each door is flanked by colonettes made of segmented panels enhanced by bands in the Preah Ko style; the walls are adorned with a proliferation of leafy carvings. The lintels rest on small columns and end in a frieze. There is an extraordinary wealth of decorative elements, but unfortunately the majority of them are either incomplete or eroded.

False sandstone doors with a host of decorative figures ornament the three sides of the temple. The doors at Lolei display a more sophisticated artistry than at Preah Ko or Bakong, and marked the beginning of a decorative style that was adopted throughout the Angkor period.

The sandstone colonettes are framed by brick pilasters supporting undecorated pediments. The large motifs located at the tower corners are made of sandstone and are set in the brickwork. In the east shrines, they represent the temple guardians (*dvarapalas*) beneath intricately adorned pavilions. At the west towers, there are goddesses (*devas*) instead of *dvarapalas*.

The roofs of the towers are pyramidal with four successively receding tiers. The remains of finely molded band courses, false windows and niches under small arches are still visible.

Each tower is set on a high, coarsely molded base supporting a series of string courses which end at the door frames.

Facing page: decoration on a colonette.

Female guardian on the north shrine.

Also of note at Lolei are the inscriptions on the door frames and the sitting lions on the string walls. The lions have an unusual pose, reminiscent of a sprinter at the start of the race, with their front legs in line but their back legs out of line with each other.

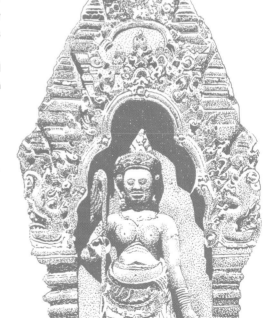

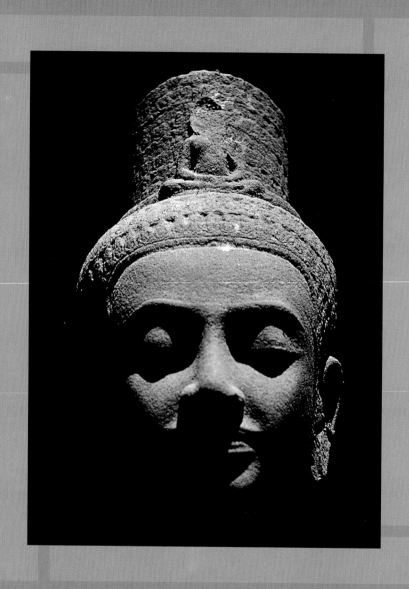

Appendices

Additional Monuments and Temples

Angkor Group

Banteay Prei

Meaning: the citadel of the forest
Date: end of 12th–beginning of 13th c.
Built by: Jayavarman VII
Religion: Buddhist
Pron: bantee-ay pray
Map: A 26
Interest: * archeo.
Visit: am or pm

Access
From Siem Reap, take the Grand Circuit on the left. Leaving the north gate of Angkor Thom, skirt Preah Khan until you reach the north gate. Continue for another 750 m until you see a dirt road on the left. This road will pass the ruins of Prasat Prei; 150 m beyond this monument, you will see Banteay Prei.

Characteristics
Banteay Prei, Preah Khan and Ta Prohm, all of which were erected during the Jayavarman VII era, have identical structures. The compact size of Banteay Prei makes the study of the larger temples easier.

Description
The remains of a third enclosure lie east of the temple.

The second laterite enclosure is a low, thickly molded wall topped by a ridge of sandstone once decorated with a series of Buddha carvings. Its east gopura is a cruciform sandstone structure. Only part of the central hall and its wings have remained intact, with high reliefs of a few devatas and windows with balusters and half-drawn blinds. The superstructure has collapsed. A small gopura was built on the west side in addition to the one on the east. The north and south gates no longer exist. The second enclosure is surrounded by moats (80 m by 60 m).

The east gopura of the first enclosure is typical of the Jayavarman era, with its main entrance and side passageways flanked by carvings of devatas in niches, its windows with their balusters and half-drawn blinds, and its central tower crowned by a budding lotus flower sculpture.

Following this gopura, there is a second enclosure 25 m wide and 30 m long enclosing a dark, narrow gallery that has sandstone pillars and a low roof; the enclosure wall has a prominent ridge. At each of the cardinal points there is a gopura with simple decoration. Each entrance is ornamented with devatas in niches. A tower with recessed levels ending in a lotus flower covers the central passage. Each corner of the gallery has a low false corner pavilion.

At the center of the courtyard formed by the gallery is the central shrine, which is not linked to the gallery. The shrine and the main hall are cruciform, unlike the cella, which is a square measuring 2 m on its side with four openings. The false windows here have neither balusters nor blinds. The Buddhist images on the pediments have been erased. The superstructures are still partially standing, but only half of the central tower above the cella remains.

Among the fallen masonry cluttering the southwest part of the monument, there is the strange "lantern pillar" typical of the great temples of that era.

A rectangular laterite-faced vat of unknown purpose was found in the rock-cluttered southeast part of the courtyard.

Bat Chum

Date: 953
Built: during the reign of
 Rajendravarman
Religion: Tantric Buddhist
Restoration: 1952
Pron.: bat chee-youm
Map: K 32
Interest: * archeo.
Visit: am

Access
Take the Grand Circuit on the right. At approximately 500 m beyond Prasat Kravan, you will encounter a dirt road suitable for vehicles that curves to the

left. If you travel this road a short distance along a pond, you will sight the three brick towers of Bat Chum on the left.

Characteristics

This small monument was once a Buddhist-Tantric shrine. The paving stones of the innermost sanctuary display a motif intended to stimulate visions and inspire meditations. The sandstone door jambs of each tower bear inscriptions.

Description

The earliest Buddhist monuments in Cambodia did not appear until the 10th century; they differ from the Brahmanic temples of the same period only in their inscriptions and decorations. Bat Chum has a similar ground plan to its companion Brahmanic temples, Bei Prasat and Prasat Kravan. The temple, which stands on a low embankment, consists of a double base of laterite supporting three brick towers. There is a single central staircase of a dozen steps on the east façade. Two seated lions stand guard beside the first flight, while for the second flight there is only one. The central tower rises to a height of 8 m high and is built to a square plan measuring 5 m on each side. The only opening to the tower is a door on the east with a molded sandstone frame with two colonettes. The colonettes are carved with bands adorned with garlands and support a lintel decorated with a frieze showing people sitting in prayer and a full-length scroll pattern that is typical of the period. The central theme of the lintel resembles the one at Bei Prasat and shows Indra on an elephant surrounded by two lions with their backs turned to each other. A plant stem comes out of their throats and sprouts croziers.

The storied tower has suffered a certain degree of erosion. The two brick towers that lie beside the central shrine were built in the same style. The south tower has lost its colonettes and its lintel, but the north tower has a well-preserved door and, more importantly, a lintel with a complete plant-stem decoration ending in volutes "ridden" by small figures. The central motif is in a very poor condition but the contours of an elephant's head can be made out.

Each tower has a real door on the east side and false doors on the other sides; the latter are merely outlined in brick without any additions in sandstone. A road leads from the east façade of the central shrine to a rectangular reservoir situated in its own axis 300 m away. The reservoir is mentioned in the inscriptions on the door jambs as being a holy place. Composed by different authors, the inscriptions are identical in spirit. They begin by giving the date the temple was built (953) and praise its founder; then they elaborate a series of instructions, one of which advises keeping the waters of the sacred basin absolutely pure.

One of the most interesting features of the temple is a *yantra* (see box) discovered on the floor behind the door of the central tower. It consists of a geometrical design resembling a chessboard of forty-nine squares bordered by lotus petals. The design has a symbolic function and relates to the divinity honored in the temple, ensuring that the founder's soul would be united with the divine being.

The Bat Chum *Yantra*

The stone *yantra* discovered in the central tower of Bat Chum had broken into seven fragments. Reconstructed, it formed a chessboard of forty-nine squares (7 x 7), each of which had a lotus petal with a Sanskrit character engraved at its center. The division of the square into forty-nine squares

The *Yantra* of Bat Chum

made it possible to place, around a central square, concentric bands representing respectively 8, 16 and 24 squares. In India, the central position is always occupied by Brahma surrounded by the world of the gods in eight squares. Humanity appears in the sixteen intermediate squares while the twenty-four outer squares are occupied by demons. The positioning of the Sanskrit characters in the three concentric bands reflects the Tantric conception of the division of the letters of the Sanskrit alphabet into "solar," "lunar" and "fire." Each letter is associated with a particular sound emanating from the lower regions of the body and rising to the mouth. Thus the *yantra* of Bat Chum may also be a symbolical representation of the voice.

Bei Prasat

Meaning: the three towers
Date: 10th c.
Religion: Brahmanic (dedicated to
 Shiva)
Cleared: 1919
Restoration: 1960–70
Pron: baay prassat
Map: K 21
Interest: * archeo., art.
Visit: am

Access
Take the Grand Circuit on the left. Just before crossing the south causeway of Angkor Thom, you will see, on the left, a series of ruins preceding the three towers of Bei Prasat.

Characteristics
The luxuriant vegetation about the temple and the proximity of the Angkor Thom moat add a rustic touch to the visit. The unfinished sandstone lintel of the north tower gives an idea of how the Khmer sculptors conceived their preliminary stone sketches.

Description
The first building standing closest to the road is a double sandstone base supporting a brick tower leveled to the height of 1.3 m. Further on, you will see a central passage in the axis of another smaller base with a *linga*. On the base there is a door frame in sandstone flanked by columns and topped by a lintel with vestiges of carvings. Farther on, aligned with this door, is the last platform, which is made of laterite and measures 1.4 m high, 10 m wide for a length of 25 m. Although there are four flights of five steps, the upper level of the platform can be reached only by climbing the central staircase on the east façade,

situated on the axis of the main tower. The main axis of the platform is oriented north-south. The central brick tower, which is in good condition, stands on a sandstone base 0.35 m tall. It is a dentate square structure, 5.40 m on each side, enclosing a square cella of 3.30 m. On the east side, there is a single opening consisting of a sandstone doorway framed by two small pentagonal columns ringed with bands and decorative garlands. The lintel, typical of the Bakheng style, has an illustrated frieze with plant stems curling at the ends, croziers of leaves occupying the entire height of the lintel and a central motif of Indra on his three-headed elephant. There is a concave brick pediment over the lintel that has lost its decoration.

The temple consists of three tiers and is 10.50 m tall. Most of its superstructure remains and the motifs on its projecting elements are in good condition. On the west, north and south sides of the central shrine, there are false doors framed by pilasters. Both towers beside the central tower rest on low bases accessed by four stairways. The dentate square towers are smaller (4.60 m on each side) and have square cellae (2.70 m). Only the main building of the south tower is intact. Its superstructure above the level of the lintel is missing. The lintel itself is similar to the central tower's

General plan of North Khleang

Detail of North Khleang

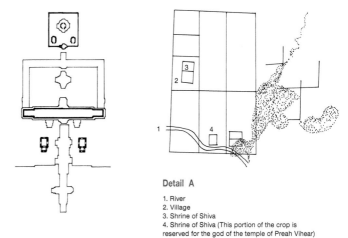

Detail A

1. River
2. Village
3. Shrine of Shiva
4. Shrine of Shiva (This portion of the crop is reserved for the god of the temple of Preah Vihear)

lintel and shows Indra on his elephant, which unusually has only one head. Above this motif, there is another meandering plant stem disgorged by two upright lions facing each other. The lintel on the east façade of the northern tower has only been roughed out.

North Khleang

Meaning: the north store
Date: end of 10th–beginning of 11th c.
Built by: Jayaviravarman?
Cleared: 1908, 1919, 1920
Pron.: klee-ang kang chun'g
Map: F 22
Interest: * archeo.
Visit: am or pm

Access
Take the Petit Circuit on the left. Once you have arrived at the Royal Plaza of Angkor Thom, stand opposite the Terrace of the Elephants on the east side and you will see two very long sandstone buildings on either side of the road leading toward the Gate of Victory. You are now at the North and South Khleang.

Characteristics
The distinguishing features of this monument are its unusual structure

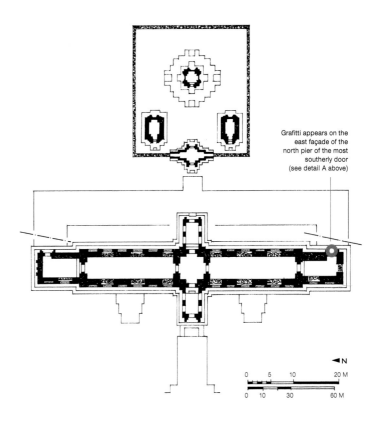

Grafitti appears on the east façade of the north pier of the most southerly door (see detail A above)

◄N

and its isolated site. The purpose of the building remains enigmatic; but its rather unusual decoration lent its name to the Khleang style.

Description

A great deal of mystery surrounds these buildings. Some experts think that they were the residences of princes or courtiers because they stand directly opposite the palace; but, as it is unlikely that a prince would sleep in a building that was only 4.7 m wide, such theories seem rather implausible The Khmer word *khleang* means "store," as well as "treasure" or "royal attic." It is possible to link the meanings of the word *khleang* with other very long structures that are a part of other monuments located, for example, on the south façade of the first enclosure of Pre Rup; however, the North and South Khleangs belong to no monument group.

Perfectly symmetrical in relation to its east-west axis, the North Khleang overlooks a cruciform terrace on the side of the Royal Plaza; the remains of *naga* balustrades can also be seen. The building is disproportionately long (8 m wide for 66 m long) and rests on a base 4 m high with rich decorations of lotus petals, festoons, scrollwork and floral motifs in lozenge-shaped patterns. Its moldings are of superior craftsmanship and display classical types of Khmer carving and refined taste.

The main entrance lies on the west side. After the cruciform terrace, a stairway of nine steps leads to a small vestibule (2.5 m wide, 3.6 m long) with four windows. There is another flight of four steps to a central square room (4.30 m on each side). A rectangular room with a remarkably long façade (4.7 m

wide, 18.8 m long) is located on both its north and south sides. The façades receive light through a row of windows with balusters (three real, the others false) set into the sandstone walls, which are 1.65 m thick. A passageway connects this room with a smaller one measuring 3.6 m wide and 8 m long; it is slightly asymmetrical in relation to the first and receives its light from only one window and one small easterly opening. Both wings of the building are identical to the central room, but the small room on the south end has a boarded-up door.

The building was planned and erected with the utmost care. Its sandstone rows were minutely laid and the paving stones are extremely regular. The sandstone walls (5 m thick) form an ideal backdrop for the highly decorated cornice and support a false story surmounted by a tile-covered roof. The attic walls still bear the holes where the roof timbers went.

The holes in the sandstone lintels above the north and south passages of the central room were placed to receive wood filler blocks; unfortunately, they were weakened not reinforced by these additions. The fairly well-preserved decorations on the lintels above the west and east doors of the central room include plant stems curved in the center and curled at the ends. Although the west lintel's motif has disappeared, a *makara* head beneath a seated figure under an arch surrounded by leafy croziers can clearly be seen on the east lintel. The outlines of another *makara* head surrounded by tendrils of foliage adorn the overhead pediment.

When the monument was cleared, two magnificent bronze statuettes of Vishnu and Lokeshvara were discov-

ered in the "gallery rooms"; they are now in the museum at Phnom Penh.

On the east façade of the north pier of the most southerly door, can be seen a map representing a river town divided into six sections. It shows the location of the village and a shrine to Shiva, and states the portion of the crop offered to God.

South Khleang

Meaning: the south store
Date: end of 10th–mid-11th c.
Built by: Suryavarman I (?)
Cleared: 1908, 1919, 1920
Pron.: klee-an'ghang t'bong
Map: G 22
Interest: * archeo.
Visit: am or pm

Access

The South Khleang, like its northern counterpart, is located within the city of Angkor Thom, east of the Royal Plaza. The building lies to the south of the road leading to the Gate of Victory.

Characteristics

At first glance, the South Khleang looks similar to its northern counterpart. In fact, it dates from another period; its dimensions are different and it was left unfinished.

Description

The South Khleang was built after the North Khleang and is smaller. It has only one continuous gallery (4.20 m wide by 45 m long). The main building stands on a molded unadorned sandstone plinth (2 m high) and is entered through the central porch on its west façade. A flight of eight steps leads to a small vestibule with two windows. Six other steps lead to a

long gallery, which, unlike the North Khleang, is not interrupted by a central room. The walls (0.90 m thick) are lined by free windows with balusters and false windows that are half-engaged into the wall. The supports for these bays have holes on them indicating the presence of a double row of balusters. There is a slight difference between the level of the gallery floors and the annexes, which are barred by a false door. A window illuminates the room from the west side, while the southern part of the east side communicates with the exterior by a door once connected to a U-shaped gallery, now missing. The gallery joins the south and north parts.

You will see another entry porch on the east façade in the center of the monument with stairs leading to an alley that seems to be bordered by the remains of boundary posts. The building's walls (4 m high) are cut off at the level of a molded cornice that probably supported a tile roof. The monument has very simple decorations; lintels and pediments are often missing. Its rather stark appearance is interrupted on the east door of the south annex or wing by fine colonettes and an interesting lintel.

Leak Neang

(Prasat Leak Neang)

Meaning: the tower of the hidden maiden
Date: 960
Built by: Rajendravarman
Religion: Brahmanic
Pron.: lay-yak nyan'g
Map: I 36
Interest: * archeo.
Visit: am or pm

Access

Take the Grand Circuit on the right to Pre Rup. At the northeast corner of its outer wall, you will see on the other side of the road, around 100 m away, the single tower of Prasat Leak Neang.

Characteristics

This small monument is near the great Pre Rup and may be the only surviving element of a group of temples that was once part of it. The inscription on the door jamb gives the date of 960.

Description

The monument is a heavily leaning brick tower that traces a nearly perfect square, 4.50 m on each side. There are no decorations on the exterior except for a very simple molding. The sandstone lintel above its single door is adorned with the motif of Indra on his three-headed elephant. The upper part of the lintel shows a

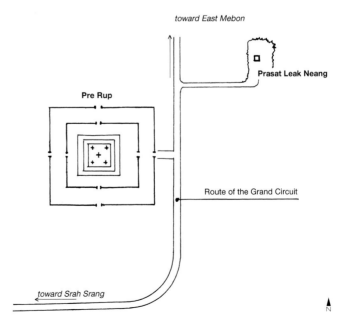

Leak Neang

frieze of praying figures. False brick doors are placed at the sides of the tower. Inside the tower, there is a square cella measuring 2.30 m on each side.

Monument 486

Date: after the 13th c., but built with
 elements from the 10th c.
Religion: Brahmanic, Buddhist
Cleared: 1918
Map: H 20
Interest: * archeo.
Visit: am or pm

Access

Follow the Petit Circuit on the left. When you reach Bayon, walk along the long path (1.5 km) on the left that leads to the west gate of Angkor Thom. Halfway along, you will come to a clearing in the forest on the left; the north side of the monument will appear 100 m from the path.

Characteristics

The monument has no name just a number, "486," corresponding to its reference in the *Inventaire des monuments du Cambodge* (Lunet de Lajonquière).

Description

After passing through an area that contains the remains of a laterite enclosure, the visitor will cross an extended terrace made of sandstone (0.80 m high) leading to the monument. The terrace is surrounded on both sides by Buddhist stelae defining the sacred space. At the end of this platform is the main shrine resting on a cruciform triple sandstone base (4 m high). The pyramid has an opening on each side. The stones

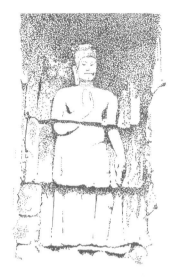

False door (west) Buddha in his "absence of fear" position.

Monument 486

are fairly unstable. The doors leading to the cruciform cella are low (1.60 m) and narrow. Originally, the monument was built over a Brahmanic temple; a laterite base, which the Buddhists covered with sandstone blocks, is a vestige of that period. The small columns were carved in the Banteay Srei style, with bands, palmettes and beads added during the monument's later period. The Brahmanic pediments of the same period on the east show Shiva on his mount, the sacred bull Nandi, and on the north side, Indra atop his elephant. The colonettes and lintels of this period are all delicately executed. At one time, two other shrines, also from the later period, lay in a north-south direction on both sides of the central shrine. They stood on the same level as the base of the first tier of the central tower. Today, they are in ruins, although certain sections, particularly the false doors of the north shrine, have been reassembled on the ground. There is a coarsely executed image of Buddha in his "absence of fear" position. The other

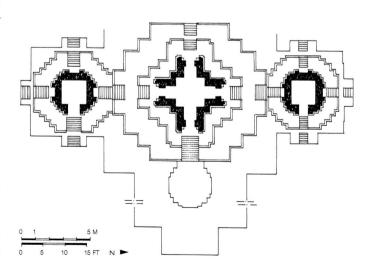

stone fragments found during the clearing include a Buddha seated under a trefoiled arcature, a typically Indian image of a vase with water gushing from it, the tops of stupas and decorated paving stones. The monument, therefore, may be said to have Brahmanic lintels although the general decor of the three shrines is Buddhist.

Preah Pithu

Date: 13th c.
Religion: Brahmanic/Buddhist
Cleared: 1908, 1918–20
Pron.: pray-a-peet-u
Map: F 23
Interest: * archeo., walk
Visit: am or pm

Access
Follow the Grand Circuit on the left. Around 130 m beyond the Terrace of the Leper King you will see the complex of Preah Pithu on the right.

Characteristics
Preah Pithu is a group of five monuments: four Brahmanic temples and one Buddhist temple. Four of these shrines have identical cruciform ground plans with entries on the west. The site, shaded by tall trees, is a pleasant place for a walk.

Description
For the purposes of this description, the reference numbers given to the five temples in the *Inventaire des monuments du Cambodge* have been used.

Temple 481 T
The first temple (57 m by 134 m) is oriented east-west and surrounded by a large dry ditch nearly 20 m wide. The causeway, which spans the west side of the ditch, takes the form of a double cruciform terrace 27 m long, with corbeled edges resting on short fluted columns. Several *nagas* define its perimeter. The terrace is accessed by three stairways with an entrance on the west side. The west *gopura* consists of a central hall with doors opening onto small wings that have no windows. It was originally flanked by a sandstone enclosure wall now in ruins (41.50 m wide, nearly 45 m long) with coping in the shape of a barrel vault. The courtyard is occupied by numerous blocks of finely carved stones. The *gopura* on the east side is smaller, consisting of a single room with neither annexes nor wings. There is a small door providing access on the north and south sides.

Off-axis, slightly to the east, is the shrine. This pyramidal structure stands on a cruciform base (6 m high) consisting of three highly molded tiers of gradually diminishing proportions. The first is a square base of 16.50 m on each side and the last is only 7.30 m. Four axial stairways with steps that narrow as they ascend lead to the cella. The very core of the shrine, which is square (5 m on each side), has passages leading off all four sides to small vestibules (2 m by 3 m), which are lit by two windows with balusters. The outer doors all open onto stairways. The corners of the main building are sculpted with *devatas* wearing skirts with floral motifs set in a decor of miniature figures dancing around them. The colonettes on either side of the doors were mounted in sixteen sections and once held lintels; their decoration is delightfully fresh and exuberant. The cella also contains a great *linga* placed on a pedestal. The shrine's superstructure, once a proud tower with tiers, is totally destroyed, cut off at the level of the lintels.

Temple 482 U
The second temple resembles the first and lies toward the north on the east-west axis. There is a single sandstone enclosure (28 m by 35 m), which has largely collapsed. Flights of stairs followed by four identical passageways lined with roughly carved pillars lead to an inner courtyard. The courtyard is more accessible through its south side. There are two false doors at each corner of the enclosure. The west side provides an alternative entry. A pyramidal base supports a shrine that is an identical but smaller version of the one found at the first temple. The pyramid on the north-south axis was placed slightly more to the east. Its tiny cella is only 2 m on each side. Several of its porches are totally ruined, but its roughed out colonettes are in fair condition. These small columns support several lintels carved with scenes from the legends: the Churning of the Ocean of Milk animates the north lintel, the south lintel is adorned by the head of Kala with a standing Krishna-Vishnu, while the west lintel becomes the stage for the Brahmanic Trimurti and its image of the multi-armed Shiva dancing between Brahma and Vishnu. Each passage is framed with images of the guardians (*dvarapalas*) instead of the customary *devatas*. Most of the superstructure of the temple is missing.

Temple 483 X
The third temple, which is approximately 55 m east of temple 482 U, is Buddhist; it lies 25 m to the north of the preceding one. During the dry season, visitors can enter by crossing the ditch. There is no enclosure. The temple consists of three terraces, the first

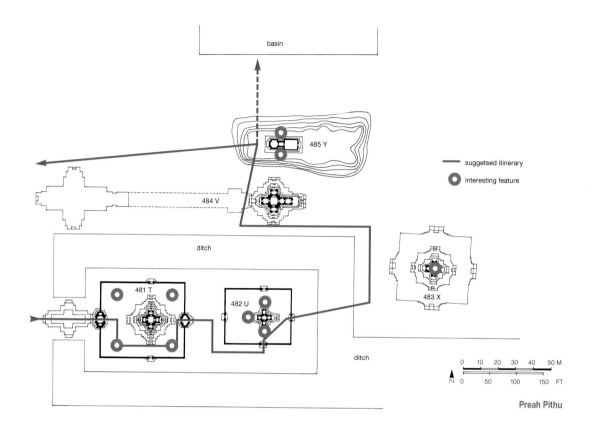

basin

485 Y

suggetsed itinerary

interesting feature

484 V

ditch

481 T

482 U

483 X

ditch

0 10 20 30 40 50 M

N 0 50 100 150 FT

Preah Pithu

of which is 40 m on each side and 4 m high. The terrace is supported by a highly decorated sandstone wall and is reached via four axial stairways with string walls topped with stone lions that are now missing. The two other square terraces are to be found at the end of gradually narrowing stairways that lead to the cruciform sanctuary. The temple's vestibules contain passageways and windows with balusters. Despite its various elements, the building gives the impression of being unfinished. Inside the square cella (2.20 m on each side) there is

a double frieze of Buddha on the walls. Another image of Buddha, this time ringed by worshippers, adorns the east lintel, while the tympanum of another pediment shows the "Cutting of the Hair." On a lower tier, the Buddha's horse and groom give vent to their grief; the horse is pictured dying while the equerry lays his head on the animal. A row of mitered figures adds pathos to this scene.

Temple 484 V

After touring temple 483 X, the visitor will have to walk around the

south side of temple 484 V to reach its western entrance. There is no enclosure to this shrine, which is preceded on its west side by a large cruciform terrace (35 m by 55 m). This terrace, now in poor condition, rests on a series of short stone colonettes and is paved with sandstone. It was linked to the pyramid by a raised sandstone causeway (7 m wide by 70 m long). The shrine itself rests on a low cruciform pyramid in sandstone with three molded steps. In keeping with traditional Khmer architectural practice, the east side is the most elaborate. Like the other monuments

of Preah Pithu, the main building is square (7 m on each side) and there are four vestibules with doors and windows. The cella (4 m on each side) houses a *linga*. The exterior decor gives the impression of being incomplete, although the pilasters display magnificent lyre-shaped sculptures. The monument no longer has its superstructure.

Temple 485 Y

This temple is located to the north, around 15 m from the preceding shrine. It stands on an elongated levee of earth and has an unusual ground plan. It resembles the road-side shelters (*dharmasala*) built during the Jayavarman VII period and its purpose remains unknown. It includes two windowless rooms: on the west side, a cella (3 m by 3.50 m) that has a false door on its west side; on the east side, a larger room (7 m by 8 m), with one door, also on the west side. These two chambers are joined by a passage with doors to the north and south.

The pilasters have decorations consisting of floral stems ending in birds' heads. The false door of the cella is surmounted by a lintel and on the west side two interesting half-pediments can be seen. The north pediment features an image of Vishnu straddling a *garuda* while he assails and fells the demon Bana. The south pediment shows the figure of Vishnu taking his three steps over the world. There are a number of other scenes carved above the vestibule doors. The visit can be concluded by a short walk through the forest to the great basin 45 m north of the monument. The basin (75 m by 100 m), which has a delightful setting, was once bordered by steps, only a few of which are intact.

Prei Prasat

Meaning: the sanctuary of the forest
Date: 13th c.
Built by: Jayavarman VII
Religion: Buddhist
Restoration: 1934
Pron.: praay prassat
Map: A 26
Interest: archeo.
Visit: am

Access

You can reach the monument via the Grand Circuit by one of two ways:
— by going to the left and circling Preah Khan on its north and west sides you will find the road leading to Prei Prasat, on the left at the northeast corner of Preah Khan;
— by turning right and then, after Ta Som, going along the north bank of the *baray* as far as the northeast corner of Preah Khan, from where a dirt road branches on the right. The monument is about 100 m from the track.

Description

The building stands on an earth levee and is approached from the east side. The laterite enclosure (20 m by 24 m) has been almost completely destroyed. The single *gopura*, also made of laterite, has lost its entrance façades and its superstructure. All that remains of this little building are a doorframe and a sandstone window jamb.

A library, also made of sandstone, can be found in the southeast corner of the enclosure; it has an opening on the west side. The whole building is in very poor condition, except for the molded false door on the east side. On the opposite side, in the northeast corner, there is a laterite base of approximately the

same dimensions as the library. The sandstone shrine, located at the center of an inner courtyard, has remained intact. Its long vestibule on its restored east entrance leads into the square cella (3 m on each side). Small blind vestibules on the other three sides project from the monument and are adorned with false doors. The cella is topped by a tower of four receding tiers and the vestibules have corbeled vaults. The temple's flamboyant carvings are typical of the Bayon style. The corners of the central shrine are decorated with *devatas*, which also frame the false windows with their balusters and partly drawn shades. A few *apsaras* can be seen on the pilasters. Several carved pediments were erased during the Brahmanic reaction following the reign of Jayavarman VII.

Spean Thma

Meaning: stone bridge
Date: late 15th–early 16th c.
Cleared: 1920
Pron : spee-yen t'ma
Map: F 26
Interest: archeo., walk
Visit: am or pm

Access

Take the Petit Circuit on the left to Thommanon or Chau Say Tevoda. From these temples, which stand close to each other, continue east. Spean Thma will appear at a distance of 120 m, on the left. It is visible from the modern bridge over the Siem Reap River.

Description

The Siem Reap River was clearly diverted from its original course where the bridge once stood. The

foundations of the bridge are noticeably higher than the level of the river, even during periods of flooding, suggesting that the river bed is also deeper than it used to be. The bridge is composed of a succession of fourteen corbeled arches (span 1.10 m), a few of which have collapsed. The bridge's main piers are approximately 1.20 m wide.

Some of the bridge's sandstone blocks are reused materials, which explains their decorations of the 13th century. The total length of the bridge was 40 m, although the distance between the river banks upstream is barely 15 m. The Khmer engineers might have been planning to enlarge the river in the vicinity of the bridge so that the arches would not interfere with the normal flow of the waters even during the rainy season. Other experts think that the closeness of the main pillars was intended to dam up the waters and raise their level so that they would flow into the moats and the basins located upstream.

Ta Prohm Kel

Date: end of 12th c.
Built by: Jayavarman VII
Religion: Buddhist
Cleared: 1919
Pron: ta prom kel
Map: M 22
Interest: * archeo.
Visit: am

Access

Take the Petit Circuit on the left. Some 300 m north of the west causeway of Angkor Wat, you will see the monument at approximately 100 m from the road on the left in a forest clearing.

Characteristics

A stela informs us that Jayavarman VII issued a decree to build hospitals all over his kingdom and that these hospitals were accompanied by chapels. This small monument in the Angkor complex is a rare example of the 102 such chapels constructed throughout the realm.

All of these chapels had similar layouts and dimensions. There is an enclosure wall, generally in laterite, interrupted on the east side by a cruciform sandstone gopura and a central tower with a rectangular base. This latter element supports a circular superstructure in laterite or sandstone, and can be entered on the east side by a porch. On the southeast side of the tower, there is a small annex with a door on its west side. A basin is located outside the enclosure.

Inscriptions on the stelae indicate that the chapels and the hospitals were placed under the protection of Buddha, the "Master of Remedies," and that doctors, accompanied by astrologers and religious men specializing in ritual sacrifices, attended the patients. All patients had access to the hospitals and the inscriptions list the medicines distributed to them.

After negotiating a passage between several blocks of stone, some of which are decorated with carvings, we arrive at the remains of a sandstone gopura, which the enclosure wall presumably originally abutted. A bit farther on stands the main tower, also made of sandstone. Its east porch, set on a molded and decorated base plinth, projects from the wall along with the remains of the superstructure; the porch receives daylight through two windows. There used to be three false doors on three sides but only the one on the north

side remains; it displays colonettes, a lintel in the Bayon style and a pediment carved with images of worshippers on two tiers. Surrounding the false door on both sides, at the corners of the tower, there are two standing devatas beneath arcatures. The tower still has its three false receding tiers on its north side, but no roof at its southwest corner. You can still see in the paving, passing through the north wall, a channel for draining lustral waters. The scroll pattern décor in the Bayon style is rather intricate, although not of the finest craftsmanship. On the door jambs at the entrance can be seen carved images of energetic figures caught in a web of circular medallions; these are rather crudely carved as well. The annex on the southeast of the central tower is too dilapidated to be precisely identified.

Ta Prohm Kel is connected with the legend of Pona Krek, a helpless beggar whose limbs were paralyzed. He regained the use of his members at the site where the temple was built and rode to heaven on the horse of Indra.

Tep Pranam

Date: 15th–16th c.
Religion: Buddhist
Cleared: 1918
Restoration: 1950
Pron.: tep pranam
Map: F 22
Interest: * excursion, walk
Visit: am or pm

Access

Take the Grand Circuit on the left; around 100 m north of the Terrace of the Elephants you will see the long terrace of Tep Pranam with a Buddha statue in a shelter at the end.

Description

The entrance to the temple is reached by a laterite causeway (75 m by 8 m) perpendicular to the axis that cuts through the north and south gates of Angkor Thom. This small road ends with two small stone lions carved in the Bayon style, which mark the entrance to the elevated, molded sandstone terrace (14.30 m by 45 m). The first part of the terrace is paved with sandstone, but this is followed by an unpaved section that terminates at a cruciform platform (30 m by 30 m) surrounded by *naga* balustrades fashioned from reused materials. North of this terrace, you can see the vestiges of funerary monuments (*stupa*) found in the vicinity

On the cruciform platform, placed on a molded stone pedestal, is a large Buddha (6 m high) made out of blocks of stone brought from another region. He is making the gesture of "calling the earth to witness." The body is crudely sculpted and the head has an *ushnisha* (flame-shaped protuberance). To the west of the first Buddha there is another Buddha (4 m high) set on a plain stone slab. This Buddha is shown in a standing position, with his hand making the gesture known as the "absence of fear." Like the preceding one, this statue is made of vertically aligned stones brought from other districts. The original head has been lost and was replaced with a one in cement. Today, both Buddhas are venerated by Cambodians. Behind the statues, what was once a great basin curbed with laterite steps extends to the west of the statue. A stela of uncertain origin was discovered near the monument. The inscription spoke of an ancient Buddhist monastery founded at the end of the 9th century by King Yasovarman. The text of the inscription, which set out the different rules governing the organization of the monastery, closely resembles the one dictated by Yasovarman when several other Brahmanic monasteries were founded south of the East Baray.

Roluos Group

Bok (Phnom Bok)

Meaning: the humped mountain
Date: late 9th–early 10th c.
Religion: Brahmanic
Built by: Yasovarman I
Cleared: 1939
Pron.: bok
Map: see "Access"
Interest: archeo., view
Visit: early am or late pm

Access

Follow the Grand Circuit on the right past Banteay Kdei, Srah Srang and Pre Rup. Before arriving at the East Mebon, take the road suitable for vehicles that passes through the village of Pradak. Continuing along this road, you will pass the temple of Banteay Samre. Some 4 km farther on, you will come to a village called Phum Tchrey at the southeast foot of Phnom Bok.

Bok, orientation map

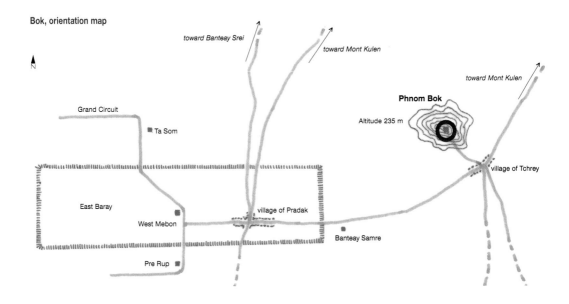

As the slope is rather steep, only those who are physically fit should undertake the ascent. To avoid the hot sun, the visit should take place either early in the morning or late in the afternoon. The villagers will indicate the path that leads to the top.

Characteristics

Phnom Bok (235 m high) is the highest peak in the Angkor region, excluding the Kulen massif, dominating the plain (Phnom Bakheng is 68 m high and Phnom Krom 137 m high). When Yasovarman I established his state temple at Phnom Bakheng, he built another temple on each one of the other hills.

The Phnom Bok temple possesses the largest *linga* ever to be found in Khmer art.

Description

Phnom Bok typifies the Khmers approach to building hilltop temples in the 9th and early 10th centuries. It is the twin of Phnom Krom, which is located in the Great Lake region. In the absence of a stela giving their date of construction, it is not known when either of these temples was built, but in terms of their decoration they clearly belong to the same stylistic group.

The three sandstone towers that make up the monument are all the same size and rest on a sandstone base; three stairways lead to their single opening on the east side. Each tower has a square ground plan and a pyramidal superstructure, which is at the present time truncated.

Exposed to the wind and rain, the monument shows obvious signs of deterioration and ruin. However, a number of elements have been found that were protected by rock-slides and are therefore better preserved. These reveal mural decorations of excellent quality. Octagonal colonettes support heavy pediments. Although in poor condition, the latter still show vestiges of their Bakheng-style decorations: leafy stems ending in volutes combined with small figures and, at the ends of the pediment, large *makaras*. There are also *devatas* standing in rather narrow niches. The very intricate decorations on the walls of the central shrine have been left unfinished on the north and south towers; there were once four secondary shrines; those in brick have collapsed, while the others, made of sandstone, are still standing. The vestiges of their bases are the only indication of the position of the laterite galleries within

the temple complex. The enclosure wall is still intact.

During excavations of the north tower, a broken pedestal and an Angkor-style *linga* were discovered. In front of the central shrine, a statue of Vishnu was unearthed, together with a magnificent head of Brahma with four faces (now in the Musée Guimet, Paris).

The whole monument is dedicated to the Trimurti (Brahma, Vishnu and Shiva). All the towers once sheltered an idol: the central tower was dedicated to Shiva, the north tower to Vishnu and the south tower to Brahma. The statue of this last one was mounted on a circular pedestal.

A deep rectangular ditch (8 m by 12 m), once faced in brick, lies to the east of the towers. It may have been a reservoir.

Approximately 150 m to the west, a square laterite platform (10 m on each of side) supported a huge monolithic sandstone *linga* that is now broken. The dimensions of the object, 1.20 m in diameter and 4 m in height, make it the largest to be found in Cambodia. Weighing 11,000 kilograms, it must have required a superhuman effort to put it in place, unless the sculptors had chosen to work with stone quarried and carved on site, which would have simplified their task.

Bas-Reliefs

Angkor Wat

The Third Enclosure

The Gallery of Bas-Reliefs in the third enclosure of Angkor Wat contains eight different wall panels. One (the Gallery of the Historical Parade) commemorates the power and glory of King Suryavarman II, while another (the Gallery of Heaven and Hell) depicts the delights of paradise and the torments of hell. The other six are centered on the legends of Vishnu.

The purpose of these bas-reliefs remains shrouded in mystery. Were they created to praise Vishnu or the god-king? Were they moral tales for the visitors and pilgrims to the temple or were they purely decorative?

Seen from afar, a marvelous artistic anarchy reigns over the eight panels. The figures "dance" their tales before the visitor's eyes with apparently no rhyme nor reason, and certainly no regard for chronological order; each section is a world unto itself, separate and equal to the others. The theme of the battle between good and evil forms a leitmotif for five of the eight panels. Given this disordered state of affairs, the visitor need not be too concerned about how to progress. However, in keeping with tradition, we will begin with the Battle

of Kurukshetra in the south wing of the west gallery, circling it counterclockwise, just as the ancients would have done.

West Gallery, South Wing, Battle of Kurukshetra

This bas-relief (48 m long) depicts a scene from the great Indian epic the *Mahabharata* recounting the last battle between the Pandavas and the Kauravas, rivals for the throne of Hastinapura in northeast India (present-day Delhi). Both sides turn to the god Krishna-Vishnu, who offers either his army or himself as an ally. The hotheaded, impulsive Kauravas speak first and choose the army; the angry god, considering himself dishonored, joins the Pandavas. Krishna offers Arjuna, the youngest of the Pandava sons, who is also a skillful and valiant warrior, an entire arsenal of terrifying weapons. In the heat of the battle, Krishna can be seen driving Arjuna's chariot. Both armies are shown, marching symmetrically from right and left to converge in a central knot of wildly twisted bodies of men, horses and overturned chariots.

The bas-relief is usually approached from the left, the Kaurava side. The foreground shows Kaurava warriors,

with spears on their shoulders marching in file; a musician is seen beating on a gong to keep the soldiers in step. Farther up, in the background, horses whipped to fury draw chariots.

Around 3 m from the start of the panel, toward the top, the image of the dying Bhisma can be seen (1). Related to both clans, he fights for the Kauravas out of a sense of duty, but his heart is on the Pandavas' side. He is being impaled by Arjuna's arrows. Five Pandavas sit on the right of the dying man, while the Kaurava warriors beneath appear to be waiting.

The marching Kaurava army about to enter into combat extends the whole height of the panel.

Near the center of the bas-relief, by the panel's upper edge, there is a warrior with hair gathered high in a round bun ending in long strands streaming down his back; he is standing in a chariot and is about to release an arrow. This is the Brahman Drona (2), who had instructed the Kaurava and the Pandava youths in the art of war; like Bhisma, he feels obliged to fight for the Kauravas.

The scene gathers momentum toward the center of the panel, where heaps of fallen soldiers agonize helplessly below the warring armies' clashes. Of the Pandava army, which enters the scene from the right, only their

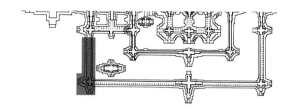

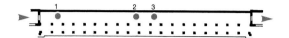

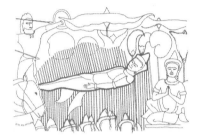

1. The death of Bhisma

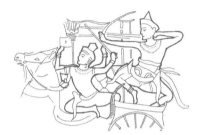

3. Krishna driving the chariot of Arjuna

chief Arjuna can be made out (3), some 2 m from the center, shooting an arrow. Krishna-Vishnu, his charioteer, guides the horses from up high. He can be identified by his flared cylindrical headdress and the attributes he holds in his many hands.

Southwest Corner Pavilion

Most of the bas-reliefs here center on Vishnu. The visit proceeds counterclockwise. The first panel will be found on the left, immediately after the door of the west gallery.

North Wing

A. East side

The upper area of this panel is in poor condition. Krishna-Vishnu lifting Mount Govardhana creates a gigantic covering for the shepherds and their troops to protect them from the rainstorm sent by Indra.

B. North side

A scene from the *Ramayana* is depicted above the door, under a trefoil arch. The god is in a forest inhabited by wild beasts and hermits wearing high headdresses. Rama-Vishnu bends his arch to shoot an arrow into the golden gazelle, who is in reality the demon Marica, sent in disguise by the ogre Ravana to distract Rama while he abducts Sita, Rama's wife.

C. West side

The panel above the window is badly eroded. The scene, a variant of the Churning of the Ocean of Milk, curiously takes place in a forest. Vishnu, in his incarnation as a tortoise, supports Mount Mandara, portrayed here as a long stem ending in a lotus flower surmounted by a seated figure. The head of a woman (probably Sri, *shakti* of Vishnu) and that of a horse appear. Vishnu participates in

the churning from the top of the stem. The two discus shapes on either side of the god may symbolize the sun and the moon lamenting the theft of the liquid of immortality (*amrita*) by the demon of eclipses, Rahu. Another panel placed to the left of the window shows sitting warriors arranged in several tiers.

West Wing

D. North side

Several areas of the panel above the window are eroded. There is a faint indication that one of the scenes relates how the ogre demon Ravana assumes the shape of a chameleon to gain entry into Indra's harem to seduce his wives.

E. West side

On the panel directly above the door; Krishna's mother ties her turbulent son to a mortar to discipline him, but

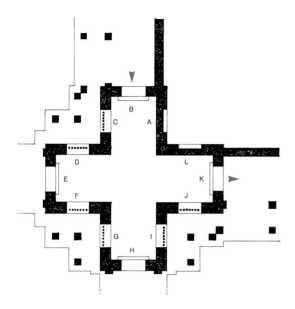

Southwest Corner Pavilion

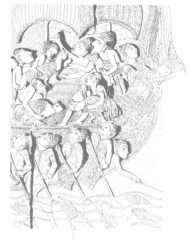

L. Water festival at Dvaravati

the divine rascal drags on the cord and pulls down two *arjuna* trees, which liberates two men from a curse that had imprisoned them in the roots.

F. South side

A scene from the legend of Shiva appears above the window. One day, Ravana; the demon with a thousand arms and heads, steers his magic chariot to the foot of Mount Kailasha where Shiva and his consort, Parvati, are sporting. Enraged at the sight of the happy couple, the demon grabs the mountain and shakes it, causing the ascetics and animals that inhabit it to flee. Irked by this unwonted intrusion, the king of the gods pounds some rocks with his heel and they tumble down to crush Ravana. The same theme is magnificently rendered on the tympanum of a pediment at the Banteay Srei monument.

South Wing

G. West side

As the greatest of the ascetics, Shiva retreats to the mountains to lead a life of austerity far from the lovely Parvati. The gods, wishing him to cease his meditations, ask Kama, the god of love, to bring Shiva back to the real world. Kama complies with their wishes, but Shiva is furious at having been disturbed in his thoughts. Turning his third eye on Kama, he aims a ray of light at him and thus reduces the god of love to ashes. This panel consists of two separate registers. At the top, Shiva, wearing a short beard and the ascetic's chignon, counts his prayer beads while Parvati in all her charm appears at his right side. Beneath, Kama bends his arch and lets an arrow fly; beside this image is the one of the poor god of love struck by

the lightning bolt and resting his head on his mother's lap.

H. South side

Above the door, under a trefoil arch, the vagueness of the carvings conceals the identity of their subjects. The panel shows a mountain dotted with wild animals; on the right side, Vishnu seems to be fighting with some other person or god. The other scene shows Vishnu and a monk seated in front of a fire, which another subject crosses on foot.

I. East side

Above the window is a scene from the *Ramayana*. The monkey brothers Valin and Sugriva are locked in a fight. Sugriva is about to deliver a mortal blow to his brother with a huge sword, while on the left of the tableau, Rama-Vishnu assisted by Laksmana aims an arrow at Vali. On the right side, sitting monkeys watch the combat intently;

their chief, Hanuman, crowned by a *mukuta*, can be sighted in their midst. In the lower register, Valin expires in the arms of his wife, Tara. Nearby, the two bowmen, Rama and Laksmana, are speaking with the victor, Sugriva. On the four rows of the panel to the left of the window, the monkeys mourn their respective kings.

East Wing

J. South side

The panel has been badly eroded, making the scenes difficult to identify. The upper part may represent two people in a discussion.

K. East side

Above the door, under a trefoil arch, is a scene that is hard to read. In the center of the panel, there is an image of Vishnu with his symbolic objects. Three worshippers kneel at his feet while, on the left, servants hold trays of offerings in small boxes with cone-shaped lids.

L. North side

The panel is in poor condition and nearly illegible. Its theme, a water festival in the city of Dvaravati, is totally divorced from the legends and the heroic deeds represented in the other panels. Two superposed launches set sail together. Heavenly nymphs grace the sky. On the higher launch, a game of chess is in progress, while on its partner below adults are entertaining children while the rowers watch a cock fight.

South Gallery, West Wing, Gallery of the Historical Parade

This bas-relief (90 m long) is a hymn to the glory of King Suryavarman II, as the embodiment of Vishnu on earth. In the afterlife, the king is reunited with the gods and assumes the name of Paramavishnuloka ("he who dwells in the house of Vishnu"). The link

between the god Vishnu and Suryavarman II is, thus, clearly established and this illustration in stone of the divine nature of the Khmer royal class governing a highly stratified and hierarchical society stands apart from the battle scenes depicted on most of the other bas-reliefs.

The first tableau, composed of two registers, should be viewed from the left; the scenes it depicts take place in a forest (4). In the lower register, in the foreground, a cortege of nobles and courtiers is in progress; queens and princesses are transported in palanquins with *naga*-shaped poles; their servants follow with parasols and fans.

The upper register is reserved for a cohort of warriors, possibly the king's personal guard, armed with spears and shields; they are crouched, as if waiting for an order from their leader. Particularly striking is the arrangement of the spears, fanning out elegantly from left to right (5). Approximately 10 m from the edge of the panel, King Suryavarman II (6) is holding court and accepting the homage of his entourage on Mount Shivapada. The sovereign is distinguished from the courtiers, ministers and servants by his godlike commanding appearance and lavish personal adornments. Parasols—fourteen in all—shade him from the sun. Crowned with both a tiara and a diadem, he radiates grace and serenity as he sits on his throne, which is embellished with *naga* armrests and supports. The servants on his right and left wave fans, horsetail fly swatters and peacock plumes.

On their right, learned hermits, or pandits, with their typically tall chignons, listen attentively to the king's words; other servants are busy preparing the king's food. King Suryavarman II raises his left hand to

indicate that a minister may read a report. Two other court dignitaries, their right arms placed over their hearts as a sign of allegiance, kneel on thick mats behind the minister (7). Appearing behind the ministers are several warriors making low bows to the king with joined hands placed on their brows. This is their final gesture of fealty and devotion before they depart to join the other soldiers descending from the mountain to take part in the great military procession, whose ranks are swelling on the right and throughout the forest landscape. The trees are so minutely rendered that the knowledgeable observer can even identify their genus; strangely, there is almost no bird nor any other animal in their foliage.

Feudal lords, identified by a brief inscription, lead the battalions of the empire. Their rank is signified by the number and size of the parasols above their heads. They stand on one foot on their war elephants; most wear plates of armor with several cutlasses fixed to their left shoulders, while others have nothing more than shirts on their backs. The latter hold in their right hands spears or a type of Khmer machete (*phkak*) with a long wooden handle and in their left hands bows and shields. The drivers seated on elephants prod their mounts with special hooks. They are followed by foot soldiers wearing breastplates and extravagant helmets decorated with the images of forest animals like deer and birds of prey. The cavalry officers flanking the troops ride bareback. The center of the panel is filled with the larger-than-life presence of the king, Suryavarman II (8), magnificently upright and noble on his richly adorned elephant crowned with the royal miter; the sovereign wears a plate of armor that would have been made either of bronze or iron, unlike

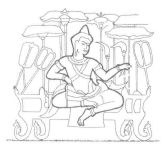

6. King Suryavarman II on Mount Shivapada

8. King Suryavarman II on his elephant

10. The ark of the Sacred Fire

that of the soldiers under his command who have only tree bark or braided rushes to protect them from enemy arrows. The king carries a *phkak* on his right shoulder and wears on his head a miter held by a diadem; he is protected by fifteen parasols and surrounded by five fans, six fly swatters and four banners held aloft. An attendant holding a banner with the royal insignia appears in front of the king. The patron god, Vishnu, with his four sacred objects, straddles a *garuda* with its wings spread in flight.

Several meters before the image of the sovereign, there is a group of bearded devotees of Shiva with their hair worn in buns secured by a net fixed at the base by a necklace of large pearls. The figure in the hammock is the court chaplain (9). Other

priests are shown ringing small bells with trident-shaped handles or striking cymbals. Servants marching before the group of priests carry the sacred fire in an ark (10) in the form of a miniature temple similar to a *stupa* or a *linga*. The sacred fire contained within the ark may have also been a reminder of other fires that were kept burning within the palace or temple confines to symbolize the presence of the god and the permanence of the kingdom. Alternatively, it may have been intended to recall the first *linga*, the emblem of Shiva that had sprung forth from the ocean rimmed in flames. Treated as if it were a noble dignitary, the ark is protected by parasols and fans and preceded by the figure of Hanuman, the monkey general, on a plant stem.

In front, a merry throng with drums,

trumpets, flutes, conches and gongs greets the arrival of jugglers, who dance and hold aloft banners. Unfortunately, this part of the bas-relief was damaged during clashes between government troops and the Khmer Rouge during the 1970s (11).

The bas-relief continues with vivid images of foot soldiers and knights commanded by generals atop elephants until it arrives at the end of the panel and the beginning of the cortege. A group of "barbarian" warriors marching in disorderly fashion comes into view (12). With their sharp protruding jaws and almond eyes, these soldiers are clearly distinguished from the Khmers; some of them have mustaches and most wear their long fine hair in braids covering their necks. Heavy pendants adorn their earlobes and their helmets, which are in the

form of a stepped pyramid topped with a plume. The strange appearance of this battalion is enhanced by their attire. They are dressed in shirts with occasional floral motifs and skirts that descend to their knees and are secured and ornamented by a double belt ending in an acorn-shaped buckle. They carry spears with highly sharpened points at one end and feathers at the other; for protection, they have large rectangular shields. The mounted commanders carrying swords with flared bevel-edged blades, the prince riding an elephant and holding a bow and the elephant driver all wear the same clothes. The origins of these strange soldiers, called the "Syam Kuk," remain unknown; they may have been vassals of Suryavarman II or mercenaries. They are thought to be Thais, although some experts see them as natives of the northwest territories on the borders of the Khmer empire. Another celebrated bas-relief follows the south gopura.

South Gallery, East Wing, Gallery of Heaven and Hell

This bas-relief (63 m long) shows the Khmer interpretation of Judgement Day with its rewards and punishments. The thirty-two inscriptions engraved in the stone enumerate the trespasses of those destined to suffer the torments of hell, while the righteous depart for a peaceful and leisurely existence in the thirty-seven heavens. Heaven and hell have no place in Indian iconography and are rare even in Cambodia. The sequence depicted on this bas-relief, like its counterparts in medieval Europe, may have been created to reinforce the convictions of believers and induce them to obey the precepts of their faith.

The bas-relief is composed of three tiers: the heavenly upper region of the saved, the people on earth in the center and the damned below.

On the left in the upper region, a ramp ascends directly to the sky (13); this is the privileged pathway for princes, powerful lords and noble ladies transported in palanquins beneath parasols and fans (14), all traveling from earthly to heavenly palaces.

The knights of the middle level (13) are climbing a rather steep slope to reach the "earth" section of the bas-relief. They are followed by a column of women and men who are of smaller stature than the ones in the upper tier and who are standing beneath parasols. Their left arms cover their hearts in deference to the forthcoming judgement of the gods (14). This long file ends with a group of women who are coifed by an elaborate diadem surmounted by a miter (15). Other women with high round buns kneel in homage to the princesses.

Also kneeling, litter-bearers await those about to be judged, so they can escort them ceremoniously to Yama, the god of death. They are escorted by the god's henchmen armed with sticks. Several servants bear gifts to cajole the god into favorably receiving their master's request to enter heaven.

Yama, occupying the first quarter of the bas-relief (16), is a gigantic figure covering both the middle and upper tiers. He is riding a buffalo in "Javanese" style with his right knee raised and his left leg folded under his body. He is crowned by a miter in the form of a stepped pyramid. Each of his many arms holds a stick. By extending two of his hands toward the left side, he indicates to two of his assistants that there is a decision to be made; a group of his acolytes

kneel, clubs in hand, ready to swing into action.

Dharma and Citragupta, Yama's assistants and his doubles (17), although they have only two hands, are standing before the god Dharma, who, with the help of the staff he holds, decides who deserves the torments of hell. Citragupta, his subordinate, identifiable by his conical miter and diadem, has precise knowledge of the acts that the candidates for heaven have committed during their lifetime.

The damned have less of a presence, appearing as skeletal, pleading figures. They are dealt with by the god's minions, who throw them into the infernal flames. However, their sojourn will not be everlasting because the Hindu religion has no conception of eternal damnation. In hell, the damned are treated according to the gravity of the misdemeanors they committed on earth and their trespasses may be of a very varied nature. If they had stolen flowers from the garden of Shiva, their heads were perforated with nails. If they had mocked the gods or scorned their families and friends, they were to be thrown into a ditch of worms. The greedy and the gluttonous were sawed in two, the bones of vandals were broken and the thieves were destined to be plunged into ice. Dharma's acolytes, who are also identical to him physically, prod the poor damned souls as if they were cattle into the region reserved for their torments. There they are beaten, suspended by their feet, attacked by wild beasts and burned, while the righteous rejoice in their new existence, filled with earthly delights, in celestial palaces supported by garudas. In 1947, the part of the gallery directly beneath the celestial palace tableau collapsed (18). Sadly, many of the stone blocks that were broken were imperfectly restored.

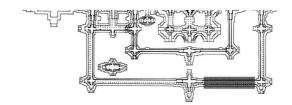

13 14 15 16 17 18

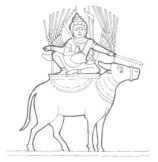

16. The god Yama

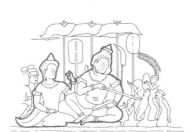

17. The assistants of the god of the last judgement (Dharma)

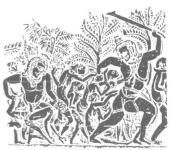

Scene from Hell

**East Gallery, South Wing,
Churning of the Ocean of Milk**

This rigorously symmetrical panel (47 m long) is entirely devoted to glorifying Vishnu and the myth of the creation during which the forces of good and evil enter into combat.

The legend recounts the unending struggle between the evil-doing *asuras*, the fallen gods and demons, and the *devas*, the benevolent deities who, exhausted from continually fighting their enemy, supplicate Vishnu to intervene in the conflict. Vishnu suggests that they join forces temporarily with the *asuras*, to churn the Ocean of Milk in order to obtain the *amrita*, the liqueur of immortality.

It became immediately apparent that Mount Mandara would make an excellent "stick." The five-headed serpent *naga* Vasuki agreed to help the churning by forming a cable around the stick in exchange for a portion of the *amrita*. Nevertheless, with the first rotations, the mountain started to sink into the sea. At the sight of this disaster, Vishnu graciously incarnated himself as the tortoise Kurma, his second avatar, and descended to support the mountain with his shell. The churning resumed and caused many wonderful things to happen, such as the births of Sri, the *shakti* of Vishnu, Airavata, the elephant mount of Indra, and Uccaisravas, his horse, as well as the celestial dancers

(*apsaras*) and the daughters of the waters. This long bas-relief, like that of the Gallery of Heaven and Hell, is composed of three horizontal planes.

The lower section is occupied by the ocean, where crowds of fish and reptiles mingle with extraordinary beings. All of these creatures are crushed together during the churning and the sea bottom is draped with the ropelike body of the *naga*, a sea genie, with his five heads rising up on the left side of the bas-relief. The *naga* is Vasuki before he concluded his pact with Vishnu. Kurma, the marvelous tortoise, is visible in the center of the lower part of the panel.

In the center, the faint silhouette of Mount Mandara (19) nearly vanishes

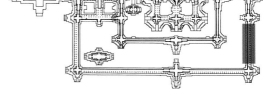

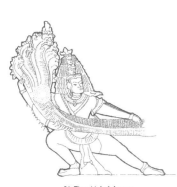

21. The chief of *Asuras*

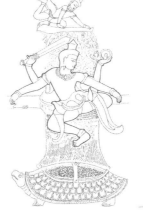

19. The god Vishnu directs the churning

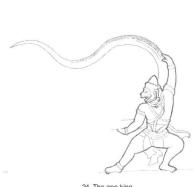

24. The ape king

beneath the large superimposed figure of Vishnu, two of whose arms are directing the movement of the *naga* rope, while his other two arms hold the discus and a sword. To the left, the *asuras* show their demoniacal faces, which are similar to those of Yama's assistants in the preceding bas-relief (20). The ninety-two *asuras* are hideous creatures with dark scowling brows, bulging eyes and long fangs. Two larger demons with a multitude of arms and heads regulate the pace of their tugging. The chief of the *asuras* on the extreme left with his thirty-six heads and eighteen arms holds the serpent Vasuki and his five raised heads (21).

On the right, eighty-eight *devas* are working under the auspices of two higher gods. The first one at Vishnu's left curiously wears the same crown

as the *asura*; he may be Vibhisana, the brother of the ogre Ravana, who became Rama-Vishnu's ally (22). Farther right, the god with five superposed heads is probably Shiva (23).

The large monkey with the royal headdress holding the long raised tail of Vasuki at the end of the panel is either Hanuman or Sugriva, the ape king and ally of Rama (24). In the upper tier, the lovely *apsaras*, who like Aphrodite spring from the waters, take flight and circle Mount Mandara.

On both sides of the main tableau, the armies of the gods and demons wait vigilantly.

The mountain pivot was only roughed out, which might explain the absence of the elephant and the steeds of Indra and the goddess Sri, Vishnu's spouse. Also missing is the

vial of the *amrita*, the liqueur of immortality, which motivated this strange union between gods and demons.

East Gallery, North Wing, Victory of Vishnu over the *Asuras*

Although there is some doubt surrounding the theme of this panel, which is 50 m long, it is thought to represent the combat between Vishnu and the four *asuras*—Muru, Nisunda, Hayagriva and Pancanada—who are defending a city belonging to the demon Naraka.

The quality of the workmanship on this bas-relief, which was executed at a later date, during the 16th century, is noticeably inferior to that of the others. Structured vertically around a central motif, the composition consists of five superimposed levels. Two battalions of

East Gallery, North Wing,
Victory of Vishnu over the *Asuras*

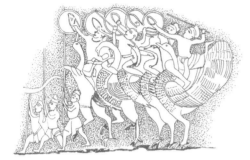

26. Warriors mounted on birds

North Gallery, East Wing,
Victory of Krishna over Bana the Demon

27. Garuda tries to extinguish the fire in the city

asuras converge toward the center of the panel with elephants, horses and mythical beasts. Chariots and warriors approach Vishnu on the *garuda*. The god, holding his four sacred attributes, is successfully repulsing the demon assailants who are circling him (25).

At approximately 4 m from the central motif, a strange troop of warriors, armed with spears and shields, rides upright on great birds, possibly ostriches. Their right legs are hooked about the animals' necks (26).

North Gallery, East Wing, Victory of Krishna over Bana the Demon

This panel, which is 63 m long, was also carved in the sixteenth century. It is not a great work, but the movements of the subjects are portrayed with a certain grace.

The panel portrays one of the legends of Vishnu. To deliver Aniruddha imprisoned by the demon Bana in the city of Sonitapura, Krishna and his allies attack and defeat the demons; but, after Shiva intervenes, Krishna spares Bana.

At approximately 10 m from the east end of the bas-relief, a *garuda* with open wings is shown trying to extinguish the fire raging in the city (27). In front of the *garuda* is the six-faced Karttikeya, an accomplice of Bana, who rides on a rhinoceros and blocks the passage.

The panel also shows a *garuda* with spread wings carrying Krishna on his shoulders (28). The god's avatar shows his thousand faces (according to the texts) placed one over the other. His eight arms wield his sacred objects: discus, conch,

mace, arrow, spear, lightning bolt, bow and shield. Behind him, also carried by a *garuda*, is Pradyuma, the son of Aniruddha, who is being held prisoner. Krishna's brother, Balarama, stands on the left wing of the marvelous bird and holds a ploughshare as a weapon.

This bas-relief displays other similar images of Krishna on a *garuda* (29). The encounter between Krishna and the multi-armed demon Bana mounted in his chariot that is drawn by lions (30) ends in a victory for Krishna and his companions.

At the end of the bas-relief, Krishna is shown kneeling before Shiva, who is enthroned on Mount Kailasha with his wife Parvati and one of his sons, the elephant-headed Ganesha (31). Shiva is pleading for the life of the defeated Bana.

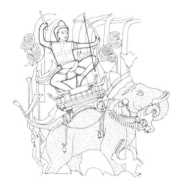

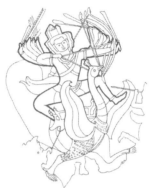

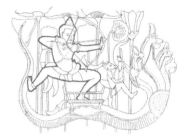

35. The god Indra on his elephant

34. The god Skanda on a peacock

42. The god Varuna on a Naga

North Gallery, West Wing, Battle between the *Asuras* and the *Devas*

This bas-relief almost 90 m long represents the struggle between the gods (*devas*) and the demons (*asuras*) and, symbolically, between good and evil.

The assembly of gods progresses from the sinister on the left to the virtuous on the right, while for the demons the progression is the reverse: they enter the hostile reaches of the universe on the left. The combat involves no fewer than twenty major god figures; some of which have not yet been clearly identified. The warring deities become a chaotic knot of bodies from which figures in chariots drawn by elephants or horses emerge; the identity of these figures has still not been determined.

The first identifiable god is Kubera (32), who can be seen at about 28 m after the beginning of the panel, riding on the shoulders of a demoniacal genie (*yaksha*). Kubera is associated with the north and is the god of wealth. However, some experts believe this figure represents Nirrti, another guardian of the cardinal points, the south and the west. The next recognizable god is Agni, the master of fire, in his chariot drawn by a rhinoceros (33).

The center of the bas-relief shows in order of appearance:

— Skanda (34), god of war, mounted on a peacock. He has many heads and numerous arms holding bows and arrows.

— Indra (35), god of storms and lightning, wearing a miter and a breastplate and carrying a bow and arrow. He rides his elephant, Airavata, who is strangling an adversary with his trunk. Airavata's importance is emphasized by his *mukuta* (conical tiara) and by his four tusks.

— Vishnu occupies almost the entire center of the bas-relief (36). He is wearing a tall miter and holds in two of his hands the conch and the discus, and in the other two, a bow and arrows. His mount is a mitered *garuda* with open wings; with his arms the *garuda* cuts a path through the enemies' horses and with his claws he kneads the spine of two agonizing chargers. The duo Vishnu and his *garuda* will be obliged to fight a very dangerous enemy, the *asura* Kalanemi, whose nine heads form a pyramid (37). One of Kalanemi's right arms (of which he has

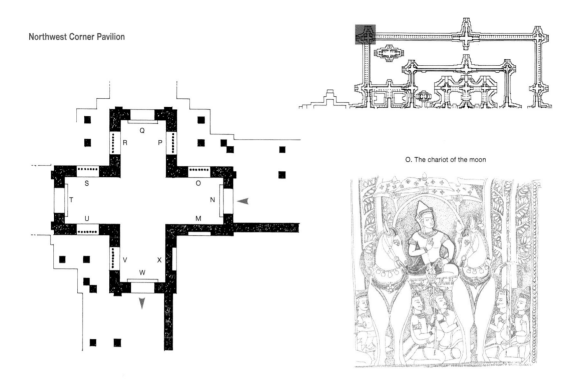

O. The chariot of the moon

many) stretches a bow, while the others wield sabers; his left hands appear to be holding swords.

— Yama, god of death, the supreme judge and guardian of the south, is the sixth identifiable deity in this bas-relief. Armed with a sword and protected by a round shield, he enters into the fray riding a chariot drawn by buffaloes, his sacred animals.

— Next comes Shiva. Covered by numerous parasols and surrounded by several fans and a fly swatter, he makes his entrance preceded by banners. His colors fly high on a staff. A humped bull, his standard mount, pulls the chariot on which he stands, apparently pulling his bow (39).

— Brahma, the eighth identifiable god, rides on a vehicle drawn by the sacred goose, the *hamsa*. The bow

he is preparing to use is in the pack-saddle bristling with spears (40).

— Surya, the sun god, is riding in his horse-drawn chariot, guided by his strange equerry, half-man and half-bird, Aruna (dawn). A great solar disc encompasses the whole scene (41).

— Varuna, the tenth and final identifiable god, is a water deity. He rides a five-headed *naga* and is preparing to shoot an arrow from his bow while standing on his rather precarious vehicle. To maintain his balance, one foot rests on curves in the *naga*'s tail (42).

Northwest Corner Pavilion

The highly ornate decorations of this cross-shaped pavilion are its most outstanding feature. Note as well, their appreciable iconographic value.

East Wing

M. South side

Krishna, Vishnu and a *garuda* dominate this panel. Krishna is shown with his sacred objects, the mace, the conch, the globe and the discus; he rides a *garuda*, whose wings are open. In its right hand, the *garuda* holds the lovely and elegant wife of Vishnu, Satyabhama, and in its other hand, Mount Maniparvata, the summit of Mount Meru, which he has reclaimed after a fight with the *asura* Naraka. The army of Krishna-Vishnu forms a ring about the god, occupying several tiers.

N. East side

This scene from the *Ramayana* under a trefoil arch above the door shows the alliance of Rama-Vishnu with the monkey king Sugriva in their fight

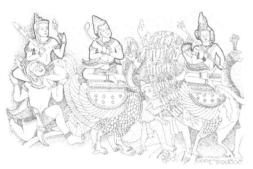

O. Frieze of the god

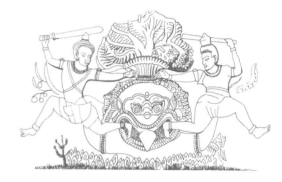

W. Rama and Laksmana battling the demon Kabandha

against the ogre Ravana, who has abducted Rama's wife. Rama and his brother Laksmana, both seated on Mount Malaya, are holding council with Sugriva, who is wearing the royal headdress; the simian subordinates to the king, scattered around him, appear attentive to the outcome of this conversation.

O. North face, above and next to the window

The central part of the panel is in very poor condition, but the outlines of the slumbering Vishnu, a favorite subject, can be made out. The god is reclining on the Ananta snake which floats on the cosmic waters and he is preparing the world between two *kalpas*, or cosmic eras. Although his head is missing, his supine form placed over the *naga* and his wife holding his feet make him unmistakable. Other gods and priests assemble in adoration

around Vishnu, while the *apsaras* in flight dominate the scene.

Just above the window, there is a frieze of a series of important deities mounted on their sacred animals; they are coming to plead with Rama to free the world from the demon Ravana. The left side of the frieze shows the following subjects: Surya on his chariot drawn by horses, Soma, above, riding a chariot, Nirrti mounted on the shoulders of a *yaksha*, Brahma on his *hamsa*, Skanda on his peacock, Vayu, the wind god on a horse, Indra on an elephant, Yama on his buffalo, Agni on a rhinoceros and Kubera or Ketu on a lion.

North Wing

P. East side, above the window

Two people are conversing in a palace. Directly above them, two men are lying on the floor in what

may be a gesture of submission. The pier to the left features scenes from the harem in several tiers.

Q. North side, above the door

At the center of the panel is a scene from the *Ramayana*. In a forest décor, Viradha, a demon envoy of the giant demon Ravana, is attempting to carry off Sita, the wife of Rama, to devour her. Sita is shown on the demon's left leg. On either side of the tableau, Rama and his brother Laksmana are attacking Viradha with bows and arrows while the demon staves off their attack with a spear.

R. West side, above the window

A scene from the *Ramayana* in very poor condition. After her liberation from Ravana's palace, Sita must prove her virtue. Unfortunately, Sita's body has disappeared; the other figures—Rama, Laksmana and the monkeys Sugriva and Hanuman—are depicted as vaguely outlined silhouettes.

On the left wall panel between the window and the corner there are figures of monkeys appearing in several tiers; they are sitting and gazing at Sita's ordeal.

West Wing

S. North side, above the window

The tableau is in very poor condition. Following his victory over Ravana, Rama has the marvelous chariot Puspaka transport him to Ayodhya, a land seized by Ravana that formerly belonged to Kubera, the god of wealth.

This chariot is magnificently decorated and drawn by sacred geese (*hamsas*). The eroded figures were undoubtedly Sita, Laksmana and the monkey king Sugriva. The representation of the monkeys, frolicking and playing music, extends the joyfulness of the scene to the lower part of the panel between the window and the corner wall.

T. West side, above the door and under an arch

Another scene from the *Ramayana*. Surrounded by a group of monkeys in the center of the scene, Rama and his brother Laksmana are listening to the demon Vibhisana, Ravana's brother. Vibhisana is negotiating an alliance with Rama. The monkey wearing a crown and standing behind Laksmana is either Sugriva or Hanuman.

U. South side, above the window

The right side of the section over the window is partially damaged. Sita is seated in the middle of the demons (*rakshasas*); she is hiding in a small wood of *asoka* trees on the island of Lanka (Sri Lanka), the fief of Ravana. Hanuman the monkey is with her and she is handing him a pearl ring as a message to Rama. On Sita's left, Trijata, a female demon, seems to share her plight.

South Wing

V. West side, above the window

The panel above the window is not very clear; it might show the adoration of the four-armed Vishnu by the *apsara*.

W. South side, above the door and beneath a trefoil arch

A scene from the *Ramayana* animates the trefoil arch over the door. In the center, Kabandha, a formidable *rakshasa*, with a terrifying demon face, battles with Rama and Laksmana, who are charging from both sides.

X. East side

This scene from the *Ramayana* recounts the archery tournament at the court of King Janaka. Janaka gives his daughter Sita to Rama as a reward for his force and adroitness. Rama dominates the tableau; he is targeting a bird perched on a post that must be shot through a spinning wheel. Sita is richly attired and sits on a low throne on the left. Rama's unsuccessful competitors are probably those figures beneath the building in the center.

West Gallery, North Wing, Battle of Lanka (Sri Lanka)

The panel (50 m long) depicts an episode from the *Ramayana* in which Rama-Vishnu on a *garuda*, assisted by the forces of Hanuman, lays siege to the fortress of Ravana, where Sita, Rama's spouse, is imprisoned. The bas-relief vividly conveys the tumult of the encounter involving different participants, which include the monkeys, armed with stone blocks, attacking the demons mounted in chariots drawn by lions. It is impossible to identify the various adversaries.

Some 20 m from the start of the panel, there is the grandiose figure of Rama with his bow in his hand stand-

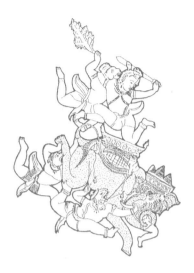

West Gallery, North Wing
45. The attack of the monkey, Nila

ing on Hanuman's shoulders (43). Hanuman caught in the heat of the battle is making ready to throw a stone block at his adversaries. Laksmana, also handling a bow, is standing next to Rama with the *rakshasa* turned ally, Vibhisana, Ravana's brother.

There is also a finely carved scene with two lions just above Rama and Hanuman; the lion on the left, smitten on its neck by a monkey, frames a *rakshasa* impaled by arrows; the demon falls to the earth from his chariot in a gracefully executed movement.

At a distance of 5 m, in the center, the scene represented is believed to depict the fight between the *rakshasa* Prahasta and the monkey Nila, who has seized two harnessed lions in his powerful fist (44).

The monkey warrior Angada, shown 3 m further on, is tearing off one of the tusks of a large elephant wearing a

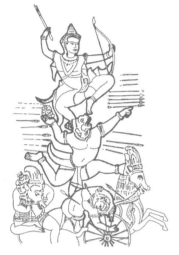

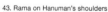

43. Rama on Hanuman's shoulders

46. The giant Ravana

three-peaked miter and mounted by a demon, Mahodara. Above this scene, Nila charges the *rakshasa* and strikes him on the head with a rock sprouting a tree that the monkey has ripped from a mountain (45).

The diabolical multi-armed ruler of Lanka, Ravana (46), appears in the next scene, which occupies three quarters of the top section of the panel; his numerous heads and arms carry all sorts of weapons, sabers, swords, bows and arrows. His lion-drawn chariot is protected by parasols, fans and banners. A mitered monkey, possibly Sugriva, is charging him from above.

Taking a few steps toward the south, the visitor will come across the image of a large monkey separating a team of harnessed lions while squeezing the one on the left with his powerful arms (47). Farther away, the monkey Angada, wearing red paint, attacks the demon Narantaka by biting the jaw of one of his chariot horses (48). Some 3 m further on, another monkey separates a team of lions, suspending them by their hind paws while strangling them with his legs (49).

Next is the encounter of the monkey general, possibly Hanuman, and the *rakshasa* Nikumbha. The demon, armed with a stone-studded mace, is surprised by Hanuman, who grips onto his ankle while squeezing his body with one of his legs. In front of the demon's chariot, one of his horses is knocked over by another monkey, who strangles it (50).

The final scene shows the mitered monkey king, Sugriva, hanging onto a team of lions as he snatches the arrow from the bow that the *rakshasa* Kumbha is aiming at him (51).

N. north
E. east
S. south
W. west
G. gallery
D. door
CP. corner pavilion

East Gallery, South Wing

Bayon

Outer Gallery of Bas-Reliefs, Third Enclosure

Our visit starts at the east with the first *gopura* of the third enclosure and continues west, in clockwise direction with the temple remaining on our right.

East Gallery, South Wing

The scenes of this long panel run from south to north:

1. A representation of the palace bordering the Great Lake or a river occupies several tiers of the wall panel between the east *gopura* of the third enclosure (EGIII) and the small doorway (Da). Between doorways Da and Db, the Khmer army marches over the three tiers.

2. The foot soldiers portrayed here include mercenaries wearing headdresses resembling cages and skirts made from crossed sections of material.

3. The slight figure with the horn blowers is striking a gong probably to set the pace for the knights and war elephants that appear parallel to

the soldiers pictured in the middle tier (middle ground). A few mounted men and many foot soldiers are marching on the upper tier.

4. In the next scene, carts and elephants enter with the supplies. A chariot has become unhitched from its horse and there is a figure kneeling over an oven made from an earth stove. A pig and some dogs are running beneath the carts. A man with his infant daughter on his shoulders appears. The men in the trees are picking fruit and hunting birds.

5. In the middle tier, among the spear-bearing warriors, there is a man with a pig on a leash. Other figures are disemboweling a slain deer or removing bundles from poles. The section between doorways Db and Dc reverses the south to north progression; the sculptures must now be read from north to south.

6. The two tiers here show, at the bottom, a group of foot soldiers armed with spears passing through a forest followed by elephants with drivers and saddle packs (possibly wicker) sometimes conical in shape. In the upper tier, lightly armed infantrymen march in unison with their comrades-in-arms described above.

7. At the end of the tableau, the visitor can see a sacrificial bull with long horns tied to a post.

8. After the doorway Dc, there are figures coifed with small buns; they are preparing meals on earth ovens, while above there is a palace scene that is rather hard to decipher.

Southeast Corner Pavilion

9. Some of the carvings here show water scenes and views of the palace. The unfinished state of many of the carvings reveal how the Khmers created their bas-reliefs. After this corner pavilion, the visit continues on the right, approaching the monument from its south side.

South Gallery, East Wing

The first panel extends from the corner pavilion to the door (Dd). The upper section is illegible.

10. The scene illustrates the daily tasks of people living in huts along the banks of the Great Lake; a squatting man is drinking out of a straw from a jar while other people are chatting. Meat on skewers is being grilled on a stove.

11. This is a scene in a forest, where

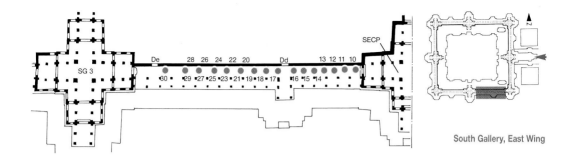

a hunter prepares his bow and arrow to target the roaming beasts. In the upper tier, Cham and Khmer war boats with the *makara* symbol on their prows engage in fierce combat on the waters of the Great Lake. The Khmers cast grapnels from all sides of their ships as they board those of the enemy, while the Cham warriors with helmets in the shape of inverted flowers sink to their watery deaths. The rowers protected from the flurry of arrows and flying spears by wicker shields stoically await the end of the fighting. The crocodiles devour the numerous bodies that have fallen into the water. Above the boats, a harp player strums his instrument for a dancer who seems to be locked into a very acrobatic step with his left leg raised high. Although merely outlined, the figure of the king gazing at it all dominates the scene.

12. These are scenes of everyday life: men set off with poles on their shoulders.

13. A hunter within a thicket lies in wait for geese and doe hidden under the foliage.

14. The people here are sitting under flimsy shelters; they are resting and attending to their children.

15. A woman in the company of a midwife feels the first labor pains.

16. This panel ends in a boar hunt.

17. The panel here after door Dd includes several superimposed tiers. The lower part may represent an "infirmary" showing a person vomiting while his friend holds his head. Another person under the pavilion seems to be suffering from stomachache, but a "doctor" is about to administer a remedy.

18. A cockfight is shown in this scene. The owners prepare their birds for the combat, while above them gamblers place their bets.

19. A big fish is displayed on a wood block under a light shelter and nearby two seated women tell each other's fortunes while two men point fingers at them as if commenting on a feminine foible.

20. The tableau ends with a figure seated at a low table while a small animal, possibly a tortoise, wanders below.

Above the aquatic scenes 17 through 20, you will notice on the right side of the panel three rafts moored to a floating quay made from a tree trunk. Two of the rafts are laden with kneeling Khmer warriors holding spears and shields; the third raft, above the first two, introduces a portico as a stage for musicians with a harp and mandolin

and a dancer whose energetic movements arouse enthusiastic reactions on the part of the spectators. There are two other rafts in the upper reaches of the panel; one brings more warriors and the other transports the inhabitants of a gynaeceum. A figure on the floating wharf or tree trunk fishes for plaice and another person, standing in the front part of his skiff, is conversing with fishermen seated in a boat. One of the fishermen proudly exhibits a newly caught fish while his companion at the prow casts his net.

Every part of the space between the tree trunk image and the intricately lacy border of the panel teems with tiny subjects performing amusing gestures. For example, a merry group of passengers revel in a long boat circled by big fish. The small figure in the center, who seems to be the boat's captain and wears a distinctive headdress in the form of a pagoda, points at the sailor at the helm. While this is happening, another figure at the stern does a dance to entertain several passengers. In the bow, another dancer seems inspired by a gong. A cable lowered from the prow moors the pleasure boat to a large stone on the bank. The upper section of the tableau is completed by the image of

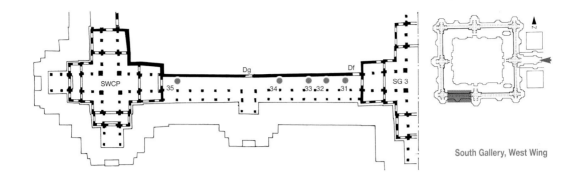

South Gallery, West Wing

another large ship that has cast its anchor and whose crew rushes to attend to the sails while two passengers on the ship's prow continue with their chess game.

The following composition is framed by two vertical plant stems and consists of indoor scenes. The lower register is devoted to sport:

21. Two boars are about to fight.

22. Two men are executing complicated wrestling figures.

23. Men are fighting with sticks and spears.

24. This scene shows a group of warriors sitting with their spears pointing to the ground and their high shields in front of them; they are waiting for orders. Above them, people spread over several tiers are indulging in gossip. An inner view of a kitchen displays foodstuff tied to the beams. There are pigeons on the roof and elsewhere a chess game is in progress. In the top two registers, there are scenes of the gynaeceum.

Next, between the vertical stem near no. 24 and the door De, comes a large carved fresco showing naval battle scenes between the Khmers and the Chams, followed by tableaux depicting stops in the forest and several combats on land.

In no. 25, Cham ships with *garuda* figureheads and propelled by rowers coifed with small buns prepare to disembark their warriors brandishing spears and shields. A landed Cham soldier (no. 26) is in the process of tying the boat to a tree. The raging battle appears also in the other registers. Behind the soldier tying the boat, at the same level, the battle between the two armies rages (nos. 27 and 28). Military camps under the trees of the forest inhabited by monkeys and birds are shown in no. 29. To shelter the kitchens, pieces of cloth are fixed. In no. 29, meat roasts on skewers and nearby a pig is about to be plunged into a cauldron. In no. 30, meals are being prepared and plates removed. At the end of the tableau near door De, carpenters carry beams and use adzes to chisel tenons and mortices. Directly above, still in the forest, a large group sits under vast awnings attached to the trees and feasts on the delicacies that the cooks in the lower tier have concocted. At the top of the same tableau, the king's large silhouette can be made out in discussion with court advisers; standing near them, to the right, a musician strikes cymbals arranged in stacks. Between door De and the

south *gopura*, several battle scenes and group scenes appear, together with wrestling matches.

South Gallery, West Wing

Only the lower part of this panel is decorated. The upper register is sometimes carved, sometimes roughed out and sometimes only traced out. Most of the images are composed of series of processions in which the Khmer army moving from west to east forms a motley crowd of infantrymen, foot soldiers and war elephants advancing to the sounds of gongs. Despite the monotonous character of the imagery, these bas-reliefs are valuable sources of information about the Khmer army in the 13th century, particularly in its use of the ballistas, those war machines which, in ancient Cambodia, were transported on the backs of elephants, and were used to hurl arrows at the enemy from great distances. They appear in nos. 31, 32, and 33. The Khmer machete called the *phkak* (34), now a common agricultural tool, is seen here used as a weapon.

At the western end of the gallery (35), a scene showing the sacred elephants being bathed provides a welcome break from the repetitiveness of the other subjects.

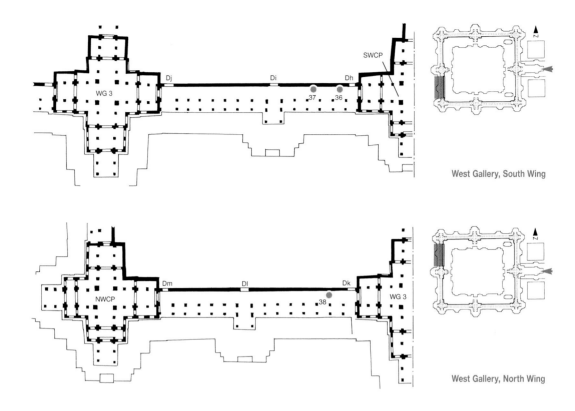

West Gallery, South Wing

West Gallery, North Wing

West Gallery, South Wing

Much of the upper register of this long bas-relief 35 m long is unadorned. Near the door Dh, an advancing column of armed soldiers led by generals mounted on elephants makes its appearance against the backdrop of stylized images of forests and mountains, represented at tableau 36 by a group of small joined lozenges. At no. 37, an ascetic, chased by a tiger, clambers up a tree. Other images reveal how the monuments were built. One represents a group of workers pulling and sliding a block of stone as a foreman holding a stick stands nearby. Other subjects carry materials or haul sandstone blocks onto a wooden frame where they are being refined. Beside door

Pi, a long panel contains images of stone haulers with whips flung over their shoulders, followed by those of a crowd gathering in a village street identifiable by the alignment of the houses. The population mixes and mingles in heated exchanges with overtones of physical menace. Bloody encounters appear on the other tiers: two severed heads are brought to a person, who appears to show them to the populace. Aloft, a high official indifferent to all the brouhaha, passes by in his palanquin.

West Gallery, North Wing

Starting from door Dk, we see a continuation of the combats portrayed on the walls of the south gallery. Some are taking place near a body

of water judging by the images on the lower tier, where a large fish is gobbling up a small animal (38). A brief text near this image informs us that "deer make up its basic food." Below an animal that seems to be a large shellfish, there is another inscription with a text describing the scene as "the king pursues the defeated enemy by fighting." After door Dl, there is a procession of—for the first time—peaceful warriors extending to door Dm. They pass through leaf formations in whose midst the sacred fire appears at the head of the cortege followed by the king astride an elephant. Women and children bring up the rear of the procession. A final inscription notes that the king will retreat into the forest to celebrate the ancient Vedic rite consecrating the god Indra.

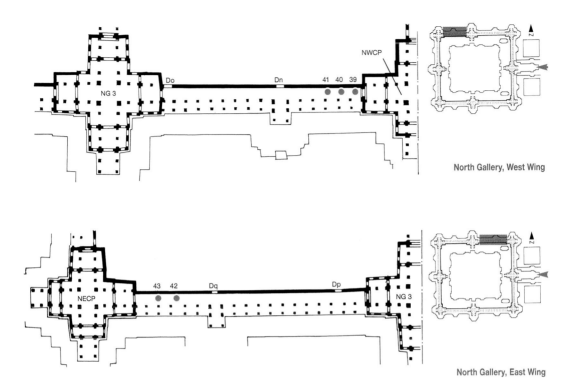

North Gallery, West Wing

North Gallery, East Wing

North Gallery, West Wing

Like its companion panels, only the lower register of this wall is carved, some parts only being sketched out. It is a good illustration of the working practices of Khmer sculptors, since the images range from the simplest burin-executed sketch to the completed bas-relief. The section near the corner pavilion corresponding to tableau no. 39 shows a palace scene and directly beneath it, in the foreground on a register below, there is a parade of human subjects and animals. In no. 40, a circus performs in merry chaos; the bodies of the tumblers, wrestlers and acrobats were left unfinished or only rapidly traced in the stone. The circus feats and the horse races were likely to have accompanied Indra's

consecration. In the section after door Dn there is a return to battle scenes, although most of these are just sketches.

North Gallery, East Wing

The wall situated after door Dp had collapsed but has been restored. The images show the warring Khmers and Chams with, however, a bizarre twist to the usual battle representation since it is the Chams who are pursuing the frightened Khmers (no. 43). The panic of the fleeing Khmer warriors is vividly conveyed. In the west and east wings of the northeast corner pavilion, there are a few more images of the inevitable processions and battles between the Khmers and the Chams.

East Gallery, North Wing

Another representation of the battles occupies several tiers of this bas-relief, whose workmanship is superior to that of the north and west façades. The Chams arriving from the north and the Khmers from the south meet against a forest backdrop while high banners flap in the wind. Situated at no. 44 around door Ds, the terrible clash projects a few unlucky warriors right into their enemy's camp. The Khmer soldiers shield themselves with rectangular wicker panels. Some experts believe that these shields were used for protection, while others view them as elements of honorific insignia carried by certain Khmer battalions. At no. 45, in the third register, there is a chariot filled with warriors protected by an unusually

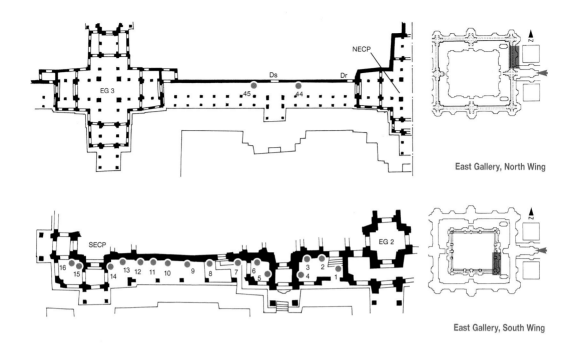

East Gallery, North Wing

East Gallery, South Wing

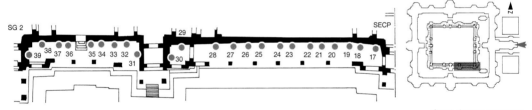

South Gallery, East Wing

high shield. Just behind them, after what appears to be Vishnu on a *garuda*, can be seen a sort of rake and pitchfork holding in their tines another smaller rectangular shield. The Vishnu image, the rake and pitchfork would also have been symbols of honor.

Inner Bas-Reliefs of the Second Enclosure

Unlike the outer galleries of the third enclosure where the sculpted elegies to King Jayavarman VII were visible to all his subjects, the inner gallery of the second enclosure was

solely for the initiated; the stone tableaux with their magical signs were only to be viewed by those possessing the knowledge and experience to interpret them correctly according to the cosmic scheme of the gods and the omnipresent king. The chosen themes and the composition of each scene obey a certain logic. Military themes with a historical slant continue to appear, but, it is the images of Shiva and Vishnu that prevail throughout the galleries. The bas-reliefs, placed in superposed tiers, contrive to create greater distance between the subjects and the viewers.

The galleries consist of a series of vestibules of various dimensions that are separated from each other by intermediary pavilions connecting the outer and the inner sides of the temple.

East Gallery, South Wing

In tableau no. 1, the visitor will see a retreat for hermits in a mountain represented by a vertical cluster of lozenges. An ascetic and his ring of disciples are in meditation beneath a portico. The hermit's hands are turned left as if he were pointing toward another tableau, no. 2, which shows the same hermit leaving his retreat in the company of a

disciple; the hermit carries a fan on this shoulder. Below, there is a scene of country life with a cowherd helping his female buffalo wean her calf. At the right, you will see near the opening, a great statue of a goddess under an arch and a palace scene (3) displaying figures in discussion beneath a pavilion. The ascetic of the first tableau is bearing a fan on his shoulder and descending the staircase after having paid a visit. A little further on (4), a god or a king is seated in a palace with *apsaras* in flight, an image that highlights the importance of the figure surrounded by his retainers. Below them, two dancers are performing a dance. Entering another small vestibule, we see in tableau no. 5 a palace scene. To the right of a person in the center, an assistant seems to be scolding a kneeling figure while below them, on the mountain, hermits meditate and pray. In the lower section of the panel, there are images of people passing through a forest while a hunter aims at a deer with his crossbow. Walking further left, the visitor will see Brahmans (7) surrounded by their disciples covering their hearts with their right arms as a sign of respect; they are portrayed under pavilions ringed by the flying *apsaras* The priests in this tableau may be performing a crematory ritual or an offering to the fire.

Entering the main gallery, you will again see, in no. 8, a pavilion occupied by a figure being fanned. On both wings of the building there are seated dancers. In the background, a temple shaded by parasols displays a façade with openings and balusters. In no. 9, a military procession progresses from right to left; in its center, a warlord on an elephant leads a group of infantrymen followed by several Chams and mercenaries. A second procession is introduced at no.

10, including a figure with a three-cornered hat who may be King Jayavarman VII. Seven parasols, fly swatters, fans and an escort of faithful warriors are there to insure his protection and comfort as he stands, bow in hand, mounted on a mitered elephant. In no. 11, a great decorated urn possibly holding the Ark of the Sacred Fire or the ashes of a cremated luminary (see 7) stands on a platform carried on the shoulders of several marchers. Standards, banners and a fanfare herald the entry of the urn circled with parasols and protected by fans. Beneath these images in the foreground, the troops enter with a ballista mounted on a carriage drawn by horses. The procession continues in nos. 11 to 13, with elephants, horses and warriors. At the corner corresponding to no. 14, there is a figure with his servant holding a parasol walking in the forest; a *phkak* is placed on his right shoulder and he is protected by his guards' shields that are either small and round or high.

In the small corner vestibule (15 and 16), the parade continues with the general riding an elephant and leading his men, who are on foot or on horseback. They are followed by the "supply corps" bringing the food. These last tableaux form a transition between the previous representations and the next ones.

South Gallery, East Wing

In nos. 17, 18 and 19, the procession encountered in the galleries of the east side continues, although the quality of the carving is mediocre. In no. 20, there is a wrestling match between two large figures surrounded by their armies hinting that the two rivals may be the king on the right, recognizable by his headdress and a mitered elephant, and a Cham leader

who is executing a great leap and holding his adversary by the leg. The tableau must now be read from left to right. The Cham army is seen parading in no. 21. The scenes show an elephant that has lost its rider and its companion carrying a warrior bending a bow. In scene no. 22, there is a palace surrounded by coconut trees with a peasant climbing them to gather their fruit. In the foreground, the army is marching, while on the left in a tableau with an ascending orientation, three wild geese are taking flight. The lower section of no. 23 displays coarse sculptures; it shows a *garuda* surrounded by fish; the mythical beast with outspread wings may be sustaining Mount Kailasha, on which are dotted hermits and animals hidden in the forest.

It is probable that the figure on top of the mountain is the god Shiva. In nos. 24 to 27, the army is in procession, passing in nos. 26 and 27, in the lower section of the panel, in front of a palace with an empty throne. Only a few belongings of the absent prince remain; the wings of the palace shelter his concubines. At the end of this long bas-relief, no. 28 presents a fight between a man and a lion. The man, whose three-peaked miter may signify that he is the king, has his right leg wrapped around the lion, while behind these figures in combat warriors appear to be waiting for the outcome. In a lower register, there are other soldiers helmeted with animal heads. The small vestibule in no. 29 is decorated with the large image of a prince wearing a conical miter and a protective sheet of armor on his chest; he is felling an elephant. Behind him his servants and standard-bearers crouch down as if awaiting an order from their lord. In the foreground, an orchestra plays music to inspire the men; further to the left, in panel no. 30, there is a scene drawn from an Indian legend. In a

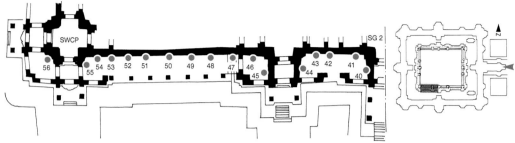

palace by a river, the king receives the gift from two fishermen of a fish that has swallowed a child. The fish is cut open and the babe is given to the queen, who sees at once, thanks to her magical powers, that the child is Dvaipana, the son of Krishna. She raises him in secret as her own child and later reveals to him the story of his birth. The fish with the child in its stomach is distinctly visible in the lower register, where a humble fisherman presenting the child to the king can also be seen. Beside him, another standing fisherman offers the child to the queen, who leans over to gather him into her arms. After going through the intermediary pavilion, we reach panel no. 31, which is a lake or a river scene. It represents a palace floating on a boat with a *garuda* figurehead surrounded by parasols and six heavenly dancers wearing long neckpieces. The boat is carrying a female figure that may be a princess with her servants. In the register below, there are fishermen in a small pirogue circled by water animals. A net is cast by one of the fishermen, possibly the one who will give the gluttonous fish to the king. Both images relate to the legends connected with the son of the god Krishna.

Tableau no. 32, inspired by a legend from the *Mahabharata*, completes the story of the Dvaipana leg-

end. Krishna Dvaipayana was the son of the great sage Parajana and Satyavati, the daughter of a simple fisherman. The upper register shows a palace with an empty throne, and below it a noble lady and her maids are putting a child into a trunk. The scene continues on the left (33), with a view of the palace and another empty throne (34). The panel is in poor condition and obscured on its left by the image of a great goddess beneath an arch. There is the faint outline of a procession of people carrying ill-defined objects on their shoulders. Nos. 35 to 39 are rather deteriorated, although combat scenes are discernible beside another palace with an empty throne.

South Gallery, West Wing

A palace scene animates the upper and lower sections of the walls of the small gallery that follows the south *gopura* (nos. 40 to 44). These tableaux include a seated figure placed next to a reclining man in the upper reaches and a woman who seems to be watching over him. The lower register contains a number of images representing, first, a high member of society surrounded by his family and, at a short distance from this group, on the right, a particularly tall and upright figure who is carrying

a sword on his shoulder and who seems to be joining the praying group at the foot of the stairs. Farther on, to the left, another devotee lies on his stomach with his face against the earth in the act of worshipping a god on a pedestal. At the same level, another group is drawing a cart with an object in a great box whose liturgical nature is signified by the parasols grouped about it. Several other worshippers pay homage to another god who is holding prayer beads and standing on a pedestal shaped as a gigantic lotus in flower. Near the corner can be seen Shiva under an arch with a trident on his right shoulder; he is encircled by worshippers. Directly below this tableau, in a pagoda, there is a harpist performing for a dancer, while under the porch of a temple, Vishnu with his four arms greets Shiva as a dignitary. *Apsaras* fly in the upper sections of the tableau, while birds strut on the finials.

Avoiding the intermediary passage, you will come to a small vestibule where a longer gallery displays interesting scenes of Shiva and Vishnu (nos. 45 to 49). This long expanse of imagery including tableau no. 50 begins at the edge of a body of water where fish swim and rabbits hop. In a nearby forest, there is a hermit in apparent difficulty with a tiger, while, on high, a wild goose wings across the sky. No. 51 presents another scene of adoration

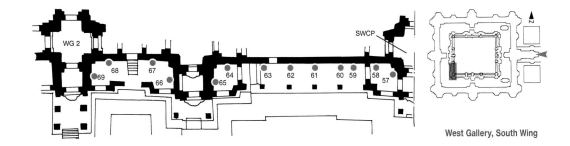

West Gallery, South Wing

of Vishnu with his four sacred objects under a triangular pediment. The god, wearing a long skirt, is receiving the respects of a prince who lies face down on the ground with an offering in his hands; the prince has feet that are bizarrely twisted. Other scenes (52) of a sacerdotal nature unfold in the lower register. Riderless horses are held by their halters, while above them cart pushers are sitting unceremoniously on the shafts of their vehicle. No. 54 presents a décor of wavy lines punctuated by two subjects with arms raised to the sky directing the eye of the viewer up to the image of two women embracing in the upper section. In the lower part, the tableau presents the image of a small skiff with a woman gathering lotus flowers; in no. 55, two seated figures are gazing at a vaguely outlined elephant.

In the small vestibule south of the corner pavilion, there is an image of two women in a garden (56).

West Gallery, South Wing

The images in nos. 57 to 59 recount the episode from the *Ramayana* in which Vishnu takes the defense of the benevolent *deva* against the demons (*rakshasas*). In no. 60, Vishnu on a *garuda* leads his army to the sounds of the gongs in no. 62. The scene comes to an abrupt halt near the door

with the appearance of a large goddess beneath an arch. In no. 63 following another goddess image, there are further palace scenes, although these are poorly carved and badly eroded. Nos. 64 and 65 show graceful and elegant female bathers arranging lotus bouquets. Above them is a beautiful, rhythmic dance scene. In the upper left corner above, a richly dressed couple holds hands while two figures on their left have been fighting; one of the combatants has had his head chopped off. The scene near the corner (65) is interesting even though it is damaged because it shows workers of various kinds building an edifice (possibly a temple dedicated to Vishnu, who can be seen at the center of the panel).

After the intermediary pavilion, we come to a shorter gallery whose walls in tableau no. 66 are decorated with representations of the four-armed Vishnu and his entourage of praying devotees, together with servants bringing in plates of food on their heads. This panel may portray the inauguration of the temple, a follow-up to the scene with the laborers. The succeeding panel (67) is in a very poor state and scarcely legible, but the lower part contains a water scene (68) with small boats navigating among the fish and the crocodiles. No. 69 shows, in the lower part, hermits meditating in grot-

tos in the middle of the forest. Above this group, other ascetics joyfully walk through the leafage while a goddess takes wing to join the four-armed Vishnu rising in the air, watched by people seated in a pagoda.

West Gallery, North Wing

Entering the long vestibule, the visitor reaches the west gallery. The tableaux on the corner wall (70) and on the wall extending as far as the passage (71) are not very legible. However, the outlines of knights and chariots can be made out. On the other side of the door, tableau no. 72, although eroded in its lower section, occupies several tiers with the images of spear-bearing knights and infantrymen. It is difficult to analyze the sculpture on the corner wall in no. 73, as both its condition and workmanship are very poor. After going around the intermediary passage, the visitor will enter a small vestibule where, on panel no. 74, the two debating courtiers reappear under a portico. In the lower half of the tableau, there are scenes of the women's quarters and images of litter-bearers waiting near their empty chaises. The next panels are thought to be connected with the legend involving an Indian princess's choice of a spouse following the outcome of a contest held by her father; there is some debate

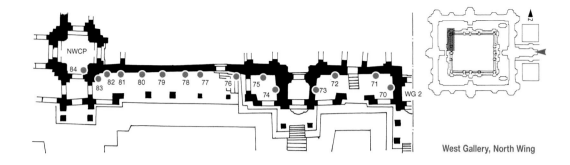

about this panel as the representation of the protagonists is far from clear. In no. 75, the Brahmans and ascetics who occupy three tiers are walking or offering objects to the gods while others assemble around a fire. Further on, in no. 76, there are two archers stretching their bows in front of two people underneath a shelter. A large goddess below an arch terminates the scene near the door.

There follows a long bas-relief that reiterates a favorite theme at Angkor, "The Churning of the Ocean of Milk." Although these panels have deteriorated and several upper wall sections are missing, the vestiges are of superior quality to the carvings on most of the other interior bas-reliefs. An assembly of Brahmans appears in no. 77, continuing as far as no. 83; at the left, the *devas* graced with their characteristic diadems and beatific smiles appear carrying the *naga* to the mountain-pivot that the god on the tortoise-Vishnu attempts to rotate. The mean-looking *asuras* in the vicinity all wear a strange helmet resembling an inverted flower that is reminiscent of Cham helmets. The whole scene rests on the ocean symbolized by the fish, the crocodiles and the sea monsters.

North Gallery, West Wing

Although the corner panel no. 84 is practically illegible, the outlines of cavalry or infantry marching through

a forest are faintly visible. The images of the superposed palaces that compose this long bas-relief starting at the corner (85) cover several tiers. In the upper part, a court dignitary is seen in discussion with his advisers. It is at this point that a long column of servants bearing offerings to the gods (86, 87 and 88) begins. The retinue stops at a mountain where savage beasts dwell, including two snakes that share one body; the monstrous serpent may be a symbol of the meeting of this cortege with the one on its left. In the vicinity of the mountain, people have gathered next to a temple with closed doors guarded by *dvarapalas*. In no. 89, beyond the shrine, there are two dignitaries under parasols carrying tridents (90), which indicate they are followers of Shiva; they lead the procession that arrives from the left and progresses to the temple with the closed doors. In tableaux nos. 91 and 92 we witness the landing of junks with *makara* figureheads and sterns and large figures with tridents on their right shoulders standing beneath their pavilions. Another junk transports people who dance while the sailors eat. On the water, the boats navigate midst a host of sea animals, while in the sky a flock of birds is in full flight. It is not impossible that the boats pictured on the bas-relief participated in the inaugural ceremonies of the temple at the foot of the mountain. In no. 93, the

visitor will see a forest scene that shows praying hermits facing Shiva with his ten arms and fine beard; the god is performing the *tandava*, the dance of the destruction and creation of the world. The gods Vishnu with his four attributes, Brahma with three faces and four arms and the elephant-headed Ganesha are respectively placed at his right, left and back; the subject with the open shirt below the platform where the *tandava* is being danced may be the saintly follower of Shiva known as Karaikkalamaiyar. At the corner of the wall (95) is a representation of Shiva with a halo in the center of the panel surrounded by Brahma and Vishnu. The forest, which is inhabited by animals and ascetics, includes a very fine likeness of a wild boar sculpted at the lower edge of the tableau.

Walking around the intermediary pavilion, the visitor will see Shiva and his consort Uma in panel no. 96; they are sitting under a pavilion, waited on by an entourage of Brahmans and young women. Tableau no. 97 with its imagery of a young girl under a pavilion appearing between a hermit and a god identified as Kama, the god of love, on her left evokes the legend of the incestuous attraction that Brahma felt for one of his daughters. The following panels (98 and 99), to be read in reverse order, recount how the gods asked Kama to distract Shiva from his meditations. No. 99 shows Kama in

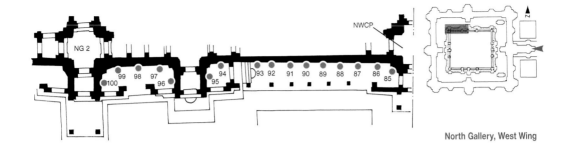

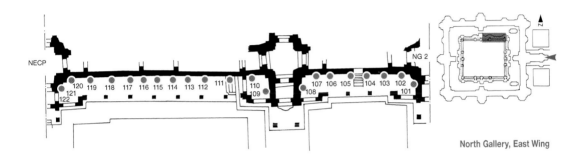

his palace, while in no. 98 the god of love is directing an arrow toward Shiva. The poor condition of the lower tableau hampers the reading of the legend, but it is probable that the theme is the anger of Shiva towards Kama taking the form of a burning ray shot from his third eye. Tableau no. 100 shows Shiva triumphantly riding the bull Nandi.

North Gallery, East Wing

In no. 101 near the corner, in the center of the tableau, the image of Shiva holding a trident and riding on Nandi can be seen, his wife, Uma, by his side. Beneath the couple there is a dance scene. The tableau no. 102 is divided into two registers: the lower one shows a group of servants ascending a stairway with trays of offerings they are about to deliver to the higher level, where, beneath a

pavilion, there is a small stepped pyramid with an urn that may serve in a crematory ritual. The urn is placed beside a vague figure of a man sitting with a folded parasol in his hands. At a certain distance from that point, a group of kneeling women appears while the servants with empty trays descend another staircase (103).

Tableau no. 104 is a reference to the *Mahabarata*. Shiva disguised as a hunter claims a wild boar that Prince Arjuna affirms he has slain. The god and the hero are about to fight over the trophy; however, in the upper tier, Arjuna pays homage to Shiva, who pardons his rival by giving him a magical weapon. The series of panels nos. 105, 106 and 107 near the door display the scene in which the ogre Ravana using his many arms and heads tries to destroy Mount Kailasha, the home of Shiva and his wife Parvati. To the right of the god,

the vague contours of a flying palace borne by *hamsas* appear.

In no. 108, the palace in the foreground is occupied by several people showing their respect with the appropriate hand gesture, while at the next level, beneath a portico, there is a nobleman with a sword on his shoulder being fanned by his servants.

After the intermediary passage, the visit will enter a small vestibule to look at tableaux nos. 109 and 110, in which a parade covers several registers; here we see a medley of servants carrying whips and round palanquins, as well as oxen pulling carts. On the upper tier, there are people carrying a huge coffer on their shoulders. In no. 111, beyond the door, we return to the first procession marching in honor of Shiva, who appears continuously from nos. 112 to 120 running the entire length of the panel. The god is seen under a pavilion boarded up with wood logs; then, on

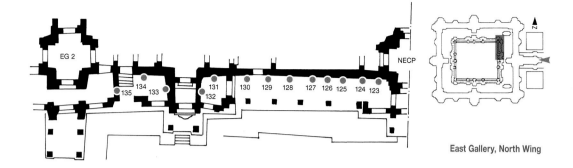

East Gallery, North Wing

another tableau, he is encircled by his worshippers while he distributes favors to a crowd of people moving in his direction; the crowd is followed by banners, an orchestra, soldiers and elephants. In no. 117, the mood of the sculptors seems to have changed. Moving away from the glorious processions with trains of gods, heroes and elephants, they now introduce simple figures like the one seated on a folding chair with its back turned to the processional scenes and its gaze turned to a moveable highly decorated pavilion carried on a simple horseless chariot with six wheels. Behind this vehicle appears a kneeling lord; this svelte, elegant figure is crowned by a miter with three peaks (118).

In nos. 119 and 120, images of the palace reappear with a figure seated beneath a pavilion, possibly the driver of the preceding chariot, pointing his drawn sword to the earth. On his right, two female dancers are dancing beside a harpist. The bas-relief ends at no. 121 with forest scenes featuring a hermit meditating on a mountain and a woman, visible full face, carrying a sack on her head; in a pond, there is a fish swimming among the water lilies.

East Gallery, North Wing

Panel no. 122 in the corner pavilion is virtually illegible, except for the figures of foot soldiers, cavalrymen and palanquin bearers appearing in three registers.

Opposite this pavilion, tableau no. 123 presents an armed king speaking with Brahmans in his palace. A cortege proceeds from tableaux nos. 124 to 129. In a richly decorated chariot sits a figure holding a sword and wearing the same three-peaked headdress as the individual in the preceding gallery. Despite its six wheels, the chariot looks as though it is being carried by the men; wild geese peep between the wheels, suggesting that it is in fact no ordinary vehicle but a flying palace. The parade of armed troops keeps on marching across two tiers, but the end of the panel terminates in the large figure of a goddess beneath an arch. There is a sculpture of Shiva in no. 130 seated on a throne in "the Javanese position," with one leg folded beneath his body. He is instantly recognizable by the trident in his hand, but in this tableau there is a buoyant ripple of energy radiating about the god, who floats on the waters alive with fish and fantastic animals. Shiva receives the respects of a king who lays his large frame upon the earth in adoration. In the lower register, the litter-bearers lay down their load. In tableau no. 131, directly following the scene with Shiva, we proceed to a water scene where two pirogues face each other in front of the image of a man who has jumped into the sea to catch fish. Each fish appears to be hanging from the boat by a long gaff. At the corner in no. 132, the panel illustrates a legend that has received a number of interpretations. According to an old Khmer tale, a king passing through mountain territory hears a voice coming from a rock. He discovers that the rock was a prison for a princess (or her statue), whom he succeeds in only partially liberating. In the bas-relief, the king's men are busy at work, exerting pressure on levers, striking the rock with sledgehammers or pulling on cables assisted by teams of elephants hauling under the direction of their drivers. A fire to blast the rock has been lit immediately below the statue.

Continuing beyond the intermediary passageway, we now enter a small vestibule whose adornments illustrate the celebrated legend of the mysterious Leper King of unknown or disputed identity; mysterious as well are the circumstances in which he contracted his terrible disease. Tableau no. 133 shows the king in his palace; no. 134 tells of the king battling a gigantic snake, which he eventually masters although he has been bitten; his disease has neutralized the lethalness of the venom. No. 135 presents the king in his palace where he has his scaly hands examined. In the lower tiers, there are Brahmans meditating in caves and people everywhere in the forest perhaps in search of a medicine that would cure their sovereign.

Banteay Samre

It is in the temple of Banteay Samre that the most extensive and complete series of wall carvings are to be found. These are unique examples of religious art. They were initially inspired by Indian themes, but Khmer sculptors added their own interpretations that grew bolder over time. The interpretation of Indian religious concepts remained a perennial element in various artistic disciplines down the centuries, from literature to sculpture, the latter remaining one of the most difficult areas of investigation for the specialists of the École Française d'Extrême-Orient. The meaning of many scenes remains a mystery to us.

This uncertainty makes it impossible to assign a precise religious aim to Banteay Samre. No inscription relating to this temple has been discovered, which means that we are lacking a precious source of information.

A comparison of photographs taken today with those taken sixty years ago reveals that many carvings have deteriorated since their restoration in 1942.

The following circuit is intended to give the visitor both a general overview of the bas-reliefs and a more detailed view. Starting at the east side of the temple, the visitor will proceed according to the tracking numbers on the map. Those bas-reliefs that have been damaged or eroded beyond recognition are not included in this description.

Gopuras of the Second Enclosure
East Gopura (EG 2)
1. Pediment above the entrance: the upper part no longer exists. The lower part: praying figures circle about a tall animal with a raised withers, possibly a horse.

South Gopura (SG 2)
2. Half-pediment of the east wing, north face (partially destroyed): this section is dominated by a figure coifed with a flared mukuta flying over a recipient and a small apparently reclining individual who is followed by another person in a floral jacket. In the upper part of the tympanum, there are two tiny figures in a decent condition looking at the scene.

3. Pediment above the entrance to the central porch, north façade: scene of the Ramayana. Monkeys are transporting stone blocks to build the bridge for Rama to reach Ravana on the isle of Lanka. The lower angle of the tympanum is ornamented with carvings of fish swimming between the continent and the isle.

4. Pediment in the central porch, north façade: a tree wrapped in a vine stands in the center. The limbs of the tree spread onto the upper part. A rock pile appears to the left of the tree, and on the right there is a mysterious animal with either a scaly or a furry hide.

5. Half-pediment of the west wing, north face: Vishnu with sacred objects in his four arms fells a demon by grabbing the monster's hair. Apsaras and praying figures circle about.

6. Pediment above the entrance to the central porch, south façade: the tympanum is very eroded. Scene from the Ramayana, dominated by monkeys. A headless figure is seated nearby; another person is lying on the ground suffering. A group of squatting monkeys aligned in a frieze pattern appears to be holding up the scene. Several experts believe this to be Hanuman bringing the top of Mount Kailasha with its magical healing plants to the wounded heroes, Rama and Laksmana.

7. Interior pediment of the central porch, south façade: despite the poor state of the tympanum, it is possible to identify Shiva on a pedestal performing the tandava, his dance, between two kalpas, or periods of creation and destruction.

West Gopura (WG 2)
8. Half-pediment, east façade: the figure is unclear but might represent a hunter amid foliage; the hunter is creating a leaf that becomes a trap for a wild boar.

9. Southern half-pediment of the entrance to the central porch, east façade: unusual likeness of Shiva dancing on a platform. The god of ten arms is adorned with heavy earrings and a mukuta headdress; there are two people holding both his legs. On his right side, two deer, frightened by his dance, take flight. The lower half of the panel shows people sustaining the "platform" on which a kind of ogee arch, possibly symbolizing Mount Meru, stands. The lower part of the tympanum is occupied by worshippers.

10. Pediment within the central porch, east façade: Although the tympanum in its central area is in poor condition, Shiva engaged in his cosmic dance in a circle of heavenly female dancers is still visible.

11. Half-pediment of the north wing, east façade: the three divinities portrayed are Vishnu, on the left with his four objects, riding on a lion, the six-headed war god, Skanda, who wields swords with his twelve arms and mounts a peacock, and below, to the right, Yama, the god of death on his buffalo holding a rod.

12. Pediment above the entrance to the central porch, west façade: a fierce struggle between the monkeys and the rakshasas. The tableau is worth examining in its minutest details. Although the scene has not yet been precisely identified, it is believed to illustrate a section of the local Ramayana.

13. Pediment in the central porch, west façade: a large figure, possibly representing Vishnu, crowned with a *mukuta* is sitting on a low stool. At his sides, there are two other people who seem to be on the back of mysterious animals. The presence of tree limbs may indicate that the scene is taking place in a forest. Above the tableau, the blurred contours of other subjects show hands joined in prayer.

North *Gopura* (NG 2)

14. Upper pediment of the entrance to the central porch, south façade: the Battle of Lanka from the *Ramayana*. Although the main figure's head cannot be seen, photographs previously taken have identified it as Rama riding on the monkey Hanuman; Rama's brother, Laksmana is on his right and mounts the monkey Angada; a simian throng has gathered about them.

15. Pediment inside the central porch, south façade: scene from the *Ramayana*. The headless Rama (the complete image appears on reproductions dating back to 1940) is in the midst of a monkey crowd; at his side someone seems to be consoling a seated monkey. The lower part is eroded, but the wheels of a chariot and the hind quarters of a horse are discernible. The horse seems to be stampeding over a prostrate figure.

16. Left pillar of the entry porch: the carvings at the base of the pillar are of particular interest.

17. Pediment above the entrance to the central porch, north façade: scene from the *Ramayana*. As the monkeys and the *rakshasas* swarm in mortal combat, Rama on a chariot and the ogre Ravana of the many heads (some of them missing) and arms are in combat. Ravana's chariot is drawn by a team of beasts with lions' heads. The lower part of the tableau has been smashed.

18. Pediment in the central porch, north façade, eroded tympanum: Indra rides his three-headed elephant and on his right, a large figure, perhaps a *garuda*, supports a platform.

Gopuras of the First Enclosure

East *Gopura* (EG 1)

19. Pediment above the entrance to the central porch, east façade, eroded tympanum: the upper part is in poor condition and only the bust of a subject can be seen.

20. Interior pediment of the central porch, east façade: a frieze shows a column of worshippers and an elephant transporting an unclear figure with parasols overhead.

21. Pediment above the entrance of the north wing, east façade, eroded tympanum: the vague form of Vishnu appears with four arms riding on a mitered *garuda* bearing a faint human resemblance.

22. Pediment above the entrance to the north wing, west façade: on a frieze of worshippers, there is a representation of Krishna lifting Mount Govardhana to provide refuge for the shepherds from the storm created by Indra. Krishna is the excessively large figure holding a curved shape (probably the edge of the mountain) in which animals and hunters are going about their different activities. At Krishna's side, a smaller figure carries a shepherd's crook on his shoulder and both sides are filled with animals resting and their keepers.

23. Pediment above the entrance to the central porch, west façade: the attack from the sky by the *rakshasas* on Indra. Several demons are mounted on horses and elephants, and on chariots pulled by lions. The foot soldiers send a volley of arrows in Indra's direction. The Sun riding his chariot with its team driven by the coachman Aruna and the Moon sitting on a pedestal in the shape of a lotus appear as two discuses on high, over Indra. Above the Sun and the Moon is a figure (damaged) in a round niche. In the upper part of the tympanum, the indistinct silhouettes of two *apsaras* in flight can be seen.

24. Pediment above the entrance to the south wing, west façade: image occupying two tiers. In the lower one, a group of visitors including a monkey are paying their respects to a mitered subject placed in the left corner. In the upper row, Vishnu assuming the form of a dwarf who has suddenly become a giant conquers the world in three steps. An *apsara* hovers above.

25. Pediment above the entrance to the south wing, east façade: the "Churning of the Ocean of Milk," with the *asuras* and the *devas* taking it in turns to rotate the *naga*-cable. Vishnu in his tortoise form pivots Mount Mandara, which becomes a leafy tree ending in a flowering lotus where Brahma sits. Brahma is surrounded on both sides by the discus shapes of the Sun and the Moon. Lower down, a mitered subject seems to be hanging from a tree trunk.

South *Gopura* (SG 1)

26. Upper pediment of the entrance to the east wing, north façade: the tympanum here is divided into three tiers. In the partially ruined lower tier, figures that may be servants carrying trays arrive from the right. In the middle section, a mitered person is receiving the visit of three women. In the upper part, there is an elephant in armor passing through with its driver.

27. Pediment in the central porch, north façade: the lower register shows several subjects—bearded hermits (*risi*), and men and women bringing presents to a mounted princely figure holding a lotus flower as a scepter. A column of marchers follows him and

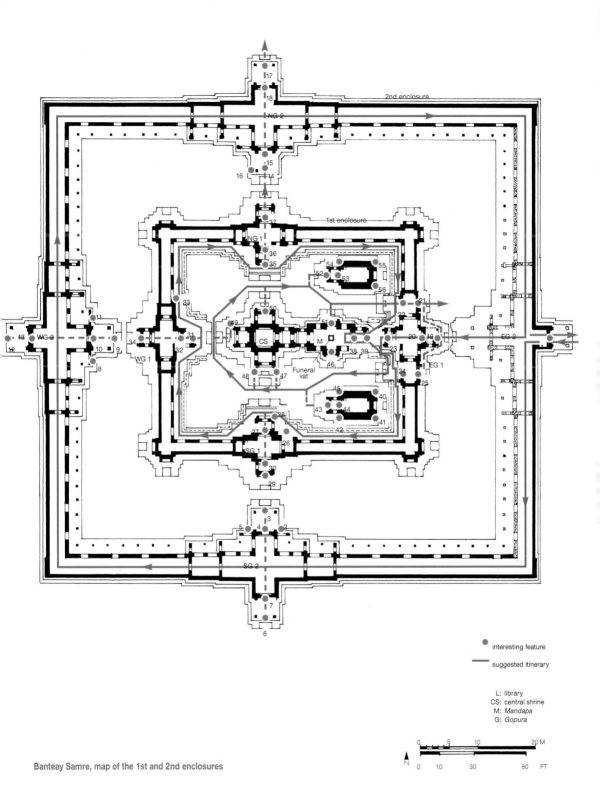

2nd enclosure

1st enclosure

NG 2

NG 1

WG 2

WG 1

SG 1

SG 2

EG 2

EG 1

CS

M

Funeral
vat

● interesting feature

━━ suggested itinerary

L: library
CS: central shrine
M: *Mandapa*
G: *Gopura*

Banteay Samre, map of the 1st and 2nd enclosures

0 5 10 20 M

N

0 10 30 60 FT

The Tale of the Peasant Who Cultivated Sweet Cucumbers

The Samres are an offshoot of a primitive Mon-Khmer tribe from northern Cambodia. The name, Samre, pronounced "samrai," is a corruption of the Khmer word for rice field, *srae*, which later became S-am-re, meaning "men of the rice field." The Samre race comprised a considerable number of tribes and peoples of Indonesian and Vedic origin who were forced to flee from the Dravidian Aryan invasions and who were then confined by the Khmers to the inhospitable lands in the Siem Reap and Kampot regions that their present-day descendants still occupy. Although the Khmers tend to look down upon these darker people, one ancient tale tells how a poor Samre peasant became king.

A young girl named Ren lived in the region. One day while working in the paddy next to her humble dwelling, a hermit passing by stopped by her side in amazement at her marvelous beauty. He immediately became infatuated and Ren felt strange and new powerful emotions grip her, but the hermit continued on his way. Soon after their apparently innocent meeting, the virginal Ren began to feel pains in her lower abdomen and gave birth a few months later to a child who she named Pou.

Pou became a strong boy with such remarkable skill in games that other children jealousy teased him for being fatherless. The young boy, very upset, asked his mother if it were true that he had no father and she, no husband. Ren answered that his father was indeed alive, living as a hermit at the foot of the eight-sided Mount Kulen.

The years passed and Pou became a handsome and strong young man. He spent his days searching through forests and clearings for his father. One day, by a hermitage, he stopped to look at an old man whose wild appearance caught his eye, and who seemed strangely to be waiting for him. After delivering the customary greeting of respect, Pou said to the old man, "Oh Master, I have come from the west in search of the man called Old Anakoret; I am his son and I want to bring him back to his wife, my mother, who lives alone in the village." The old hermit immediately understood the nature of Pou's quest but did not show emotion. He offered Pou shelter and hospitality. When Pou was ready to leave, the hermit—after swearing Pou to secrecy—taught him a magical incantation. The magical verse was to be used to subjugate all forest animals, from the largest elephant to the smallest mouse. He also gave Pou a bamboo tube filled with the seeds of sweet cucumbers, and told Pou to plant them and offer the first crop to the king.

In the course of his voyage, Pou met a young girl named Rik and they fell in love. He told to his mother that he wanted to marry, which made her very happy as she had grown old and could not help him prepare a garden. A few weeks later, Pou and Rik were married and went about clearing a field, cutting down trees and tearing out weeds to make their garden. The couple were skillful gardeners; the cucumber seeds planted with care grew fast and sturdy on their vines and the magical incantation kept away wild beasts. One morning, when the cucumbers were ripe and fat on their vines, Pou and Rik picked them. They departed for the capital to bring the sweet fruit to the king on his throne at Angkor, which was not an easy task as they had to get past the guards. They persevered, however, and the king, amused at their canniness and audacity, accepted their gift. He was pleased with the sweet cucumbers and declared that he had never tasted anything so delicious. The king asked Pou to continue bringing

above him there are two women sitting in the "Javanese position" on either side of a temple that appears to be immured. The meaning of this scene has not been elucidated.

28. North porch, base of the east pilaster: Agni, the god of fire, holds a flower in his left hand and rides a rhinoceros shaded by a parasol. His two spouses, Svaha and Svadha, are fanning him. The symbol of Agni, a brazier spitting flames, appears behind the rhinoceros.

29. Pediment above the entrance to the central porch, south façade: this scene is rather difficult to identify since all the figures are headless. Nevertheless, it may evoke a god who once had several arms and heads and who is standing in the central position, with Vishnu on his right in a chariot, and on his left Ravana transported by lions. Above the decapitated deity there is a dais on which another subject is seated, flanked on his left by a hand holding a stick.

30. Interior pediment of the central porch, south façade: the tympanum is in poor condition and incomprehensible. It represents a subject with many heads and several weapon-bearing arms with flying figures who seem to be carrying other figures now partially erased.

West *Gopura* (WG 1)
31. Pediment above the entrance to the central porch, east façade: on a frieze, praying figures occupy the

his sweet cucumbers to the palace and became obsessed with the marvelous flavor. Soon, he ordered Pou to reserve his entire crop for the royal table and gave Pou a spear with a blade as sharp as a pineapple leaf and a hilt made from areca wood.

Unfortunately, with the first rains, the crop—and Pou's palace visits—dwindled. Impatient for more cucumbers, the king set out for Pou's village with only a few men as escorts. It was nightfall by the time they arrived at Pou's garden. Pou's hut was silent and the pungent odor of the cucumber field enticed the king to climb the fence. His movements awakened the denizens of the small hut; Rik gave the alert and Pou grabbed his weapon and chased the thieves, who got away. However, the king was so besotted by the cucumbers that he did not want to leave the spoils and decided to hide in the nearest pile of leaves. Pou was furious at not catching the thieves and angrily thrust the spear down into the very leaves where the king was hiding.

The king was brought back to Angkor, but the wound on his side proved mortal and he soon died. As the monarch had no heir, the Great Council of ministers, generals, Brahmans and astrologers convened to designate the next ruler but, unable to agree on a candidate, the members decided to ask the gods. The heralds went forth from the palace to order the population to gather in the streets of Angkor Thom. At a specific time determined by the astrologers, a sacred white elephant, wearing jewels and crowned with a miter, was released among the crowd. Princes and nobles hurried to confront the animal hoping to be chosen, but to no avail. Then the elephant ventured into a street where the common people were assembled. It stopped in its tracks, sniffed the air and rapidly trumpeted as it rushed to a man who was none other than Pou. The beast sensed Pou's power to appease wild animals, and it stopped. The elephant knelt down and with its trunk hoisted Pou onto its back. The gesture was taken as a sign that the gods had chosen Pou to rule; the simple peasant was carried in triumph to the palace, while the people, both high and humble, knelt in respect.

Pou's troubles were not over, however. His remarkable and inexplicable rise to power annoyed the dignitaries of the realm. Pou built a new palace where he could escape the petty hostilities of his courtiers. Thus Bantaey Samre, the Citadel of the Samre, was built. But snide comments continued and King Pou, furious, ordered all the dignitaries to gather in his new residence, where they paid him false respects. Pou was not fooled and ordered his guardsmen, almost all of whom were of the Samre race, to cut off their heads.

From the top of his mountain, the old hermit who had a mystical knowledge of everything that had been happening, was grieved that his son's enemies had forced him out of his palace. He begged the gods to move the capital and the royal abode from Angkor and the gods heard him. This is why all subsequent kings left Angkor to found capitals elsewhere in the land of the Khmers.

This tale is still told in the villages of the descendants of the Samre tribe.

(This abridged version of the tale is based on a study by Mr. R. Baradat: "Les Samré ou Pear, population primitive de l'ouest du Cambodge," in *Bulletin de l'École Française d'Extrême-Orient*, volume XLI-1941.)

lower section of the tympanum; just below, a discussion seems to be taking place. The upper part shows two discs surrounding human figures representing the Sun and the Moon, both with lotus flowers in their hands.

32. Interior pediment of the central porch, east façade: representations distributed in three registers. In the lower section, there is the traditional line of worshippers, and in the middle section, bearded hermits present gifts to Skanda, the god of war riding his peacock. The whole group is covered by parasols held up by several figures; to the right, there is another subject wearing what appears to be a long scarf.

33. Pediment above the entrance to the north wing, east façade: above a frieze of worshippers, a giant, possibly Ravana, struggles with a crowd of monkeys. Ravana has gripped onto the feet of one of the monkeys, whose comrade-in-arms is retaliating by biting the giant's right heel.

34. Pediment above the entrance to the central porch, west façade: this is a strange tympanum. In its lower section, a god with several goddesses who are scarcely identifiable appear in "vehicles." Following the tableau from left to right, we can see a female figure holding a lotus flower, a larger figure wearing a miter and riding a *garuda*, and a masculine figure in the center. This last figure dominates the whole scene; he is crowned with a miter and carries a club over his right shoulder,

and his mount is an animal with three human heads. Following this strange character, we meet someone on a *garuda* or a lion. The next female image shows a four-armed goddess without any carriage; she is supporting someone whose body is not complete and who appears to be looking out of a window. Both goddesses are riding erect on *nagas*. In the upper register, four *apsaras* are in flight around a god comfortably installed on a cushion held by a figure with raised arms represented only to the waist.

North *Gopura* (NG 1)

35. Pediment above the entrance to the central porch, south façade: the pediment is badly eroded and the whole upper part has been destroyed. The bottom register shows a scene in the women's quarters and on the right, there is a female harp player. Another musician beside her is playing an unknown instrument, while in the center, two women dance. The female servants follow with arms folded in the traditional gesture of respect. The lintel above the door is of remarkable beauty. In the center is an image of the victorious Vishnu; the god stands on a monster's head and holds one of his two adversaries by the hair while he threatens him with his spear.

36. Interior pediment of the central porch, south façade: in the lower part, there are two tiers of praying figures supporting Shiva and his wife, Uma, who are both in a chariot drawn by the bull Nandi; the god and goddess are covered by parasols while *apsaras* fly overhead.

37. Interior pediment of the central porch, north façade: in the lower two tiers, certain subjects are sitting and holding fly swatters. Indra riding his three-headed elephant is placed

under an arch; a driver leads the elephant by its trunk. *Apsaras* are in flight above.

Antechamber to the Central Shrine

38. Pediment above the central porch, east façade: this pediment shows the Brahmanic triad of Shiva, seated in the center, Brahma with four heads and arms to the right, and Vishnu on the left. Nothing is left of Vishnu apart from one hand raising a club.

39. Interior lintel of the east porch: Indra on his three-headed elephant.

South Library (SL)

40. North half-pediment, east façade: two bizarrely coifed women figures walking in a forest; they seem to want to stroke an animal tied to an image resembling a tree. A flying person watches over the scene.

41. South half-pediment of the east façade: someone of small stature is flying or running in a wood; above him, another figure, head lowered, seems to want to join him.

42. South half-pediment, west façade: two people are seated in worship; above, there is another figure who cannot be identified since it has been decapitated.

43. Pediment above the entrance porch, west façade: two tiers of sitting monkeys and humans. Certain protagonists in this scene are pointing to the upper level, where a central figure is kneeling on a high pedestal and a worshipper is bowing in front of him. The scene continues on both sides to show other subjects sitting on pedestals placed slightly lower. The meaning of this tableau remains unexplained.

44. Pediment above the central porch, west façade: scene on three tiers showing figures sitting beneath arches of vegetation; the people form supports for a central god, who

was once placed in the upper part of the tympanum; this deity has unfortunately been obliterated.

45. North half-pediment, west façade: two monkeys pass through a forest.

Exterior of the *Mandapa* (M)

46. Pediment above the south side entrance: this pediment is mostly in poor condition. Its lower section shows a dance scene; the dancers appear to be holding each other's shoulders as they move. The upper part is limited to a line of heads, the only remains of a frieze of worshippers. The outline of a figure that may be an *apsara* can also be made out.

Exterior of the Central Shrine (CS)

47. South porch, base of the pilaster at the southeast corner: scene from the *Ramayana* in which Sita is abducted by the giant, many-headed Ravana. The stone on the east wall of the same porch shows the outlines of a god.

48. South porch, base of the southwest corner pilaster: another representation of Vishnu with four arms holding a club and a conch while reclining on the *naga*-snake above the cosmic waters; the god's feet are resting on his wife Sri's lap.

49. West porch, base of the northwest corner pilaster: the decoration between the colonette at the corner of the door and the base of the pilaster is particularly fine. The pilaster displays two warriors locked in combat beneath a person who seems to be holding them by the legs. This image is the starting point for a foliated scroll.

50. Pediment above the entrance to the north porch: a musical scene.

Exterior of the *Mandapa* (M)

51. Pediment above the northern side axis: fishing scene.

North Library (NL)

52. Pediment above the entry porch, west façade: another scene of Vishnu on the Ananta snake, this time with a dragon head, afloat over the cosmic waters. The god is carrying a partially broken club in his left hand; his right hand is gripped around the stem growing out of his navel. The stem flowers into a lotus and becomes the seat for a four-headed, four-armed Brahma fingering a string of praying beads. There are two people "sprouting" from the stem with the leaves and the flowers, on either side. Sri, the *shakti* of Vishnu, is holding the god's feet.

53. Pediment above the central porch, west façade: this pediment is in poor condition. The lower part is occupied by a line of worshippers. Above them are flying figures who no longer have heads; the upper section has been totally obliterated.

54. North half-pediment, west façade: forest scene. A hunter is bending his bow, while another figure is kneeling close to a tree. A staircase after this pediment leads to the side walkway from which the east bas-reliefs of the north library can be seen (55 and 56).

55. North half-pediment, east façade: a standing figure with a damaged head carries an instrument on his left shoulder. A seated figure places his right hand over his heart while clutching a weapon, possibly a bow, in his left hand.

56. South half-pediment, east façade: possibly a performance by acrobats; one of the subjects is doing splits under a tree, arm raised, while a mitered figure looks on in amusement.

Banteay Srei

The following description follows the tour suggested in the guide section, from east to west. Consult the two plans on the left-hand pages.

Supposed Fourth Enclosure

East *Gopura* (EG 4)
• East façade (1)
Lintel: missing
Trefoil pediment: the upper part has five notches that held the wooden beams supporting the tile roof.
— Tympanum: Indra is represented on his three-headed elephant midst a pyramid of leaves. Below, a monster spews a garland that it is holding with its claws.
— Rake: decorated with floral motifs and topped by vegetal "flame" motifs. At either end, a lion's head in profile spews an upright *naga*.

• West façade (2)
Lintel: missing
Trefoil pediment
— Tympanum: the decoration is identical to the one on the east façade, with the addition of the image of Varuna, the guardian of the west.

North Annex (NA 1)
• South façade (3)
Upper multifoil pediment: on the rake, preliminary holes; the lower part is missing.
— Tympanum: in the foliage, where several small figures mingle, the bust of Vishnu in his human form with lion's head (Narasimha) digs his claws into the entrails of the *asura* Hiranyakasipu, who had dared to challenge him. The demon has been felled by his conqueror, who is pinning him down at the waist.
— Rake: the end of the rake is adorned with lions' heads spewing strange monsters (*makaras*) that are part reptile and part elephant. Leafy wreaths fall from the *makaras*' raised trunks.

South Annex (SA 1)
• North façade (4)
Upper trefoil pediment below the porch: the upper part of the pediment has notches for the wooden beams that supported the tile roof.
— Tympanum: surrounded by volutes and foliated scrolls in which small figures mingle (busts only), Shiva and his wife, Uma, are mounted on the bull Nandi. Below them is a monster spewing a plant stem.
— Rake: not very clear; it terminates in an upright *naga*.

The south annexes (SA 2 and SA 3) are ruins, and neither the lintel nor the pediment have survived.

Third Enclosure
East *Gopura* (EG 3)
• Outer east side (5)
The superstructure of the *gopura* no longer exists. However, it is thought that the fine pediment lying alongside the *gopura* used to belong to it. The rake is marked with the usual notches for wooden beams.
Multifoil pediment
— Tympanum: a scene from the *Ramayana* appears within the twists and tangles of the stems and volutes; the demon Viradha (center) carries Sita off to the isle of Lanka; on either side, Rama and his brother Laksmana wave their swords, while beneath

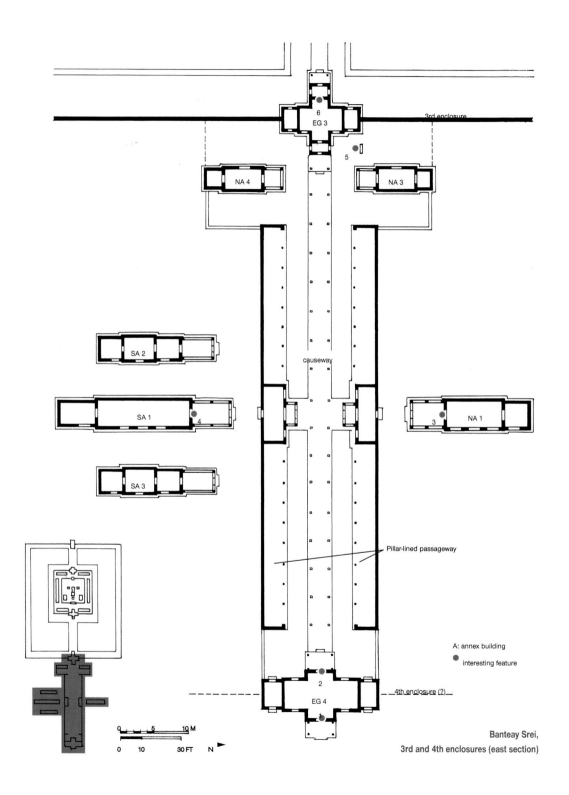

3rd enclosure

6

EG 3

5

NA 4

NA 3

SA 2

causeway

SA 1

4

3

NA 1

SA 3

Pillar-lined passageway

A: annex building

● interesting feature

2

EG 4

4th enclosure (?)

1

0 5 10 M

0 10 30 FT N ►

Banteay Srei,
3rd and 4th enclosures (east section)

them, a small figure appears at the start of the volutes.

• West façade (6)

Lintel (now placed near the enclosure on the west side): in the center of the lintel, atop two diverging stems, is a representation of Varuna, god of the wind, on the sacred goose (*hamsa*). On either side of the god, lions hold up the arch of foliage that shelters him. At the quarter and three quarter sections of the lintel, standing lions interrupt the composition as they peer outward; the figures are caught up in leafy crosiers and are spewing stems at the ends of the lintel.

Multifoil pediment beneath the porch (currently in the Musée Guimet in Paris): this shows two *asuras*, Sunda and Upasunda, fighting over the possession of the *apsara* Tilottama.

Second Enclosure

(see map page 370)

East *Gopura* (EG 2)

• East side

Lintel: missing.

Triangular pediment on pillars (7)

— Tympanum: a divine guard in the center midst the curls of the volutes is resting on a pedestal and sits in the "Javanese style" with his right knee in the air; he seems to be holding a sacred object in his right hand. A monster below the divinity inundates the scene with the vine it is disgorging.

— Rake: it consists of a large stone band course divided into three parts; the central section is adorned with lozenges and is framed by two profiled, pearly bands with flowery motifs. The rakes are joined at the top by a large lozenge that is ornamented with foliated scroll motifs encircling a budding flower; above the flower is a vegetal "flame" motif, on the vertical axis of which is a small praying figure beneath an arch.

Multifoil pediment beneath the porch (8)

— Tympanum: this pediment has an unusual structure in that the tympanum is combined with a sort of false lintel at the base that presents all the decorative characteristics of a real lintel. At the center of the tympanum, dissimulated among the leaves, sits the mitered figure of Laksmi, the wife of Vishnu. Two elephants carved in profile are pouring a magical liquid over the goddess that is supposed to bring abundance and happiness. The lower part of the tympanum is sculpted as if it were a lintel and it displays a waist-length image of a mitered *garuda* in its center; the mythical bird is shown holding foliage that curls back at the ends to form a crozier, in the midst of which a tiny figure, representing a lion, faces the center, spewing a leafy volute.

— Rake: a *makara* head at both ends disgorges a lion which, in its turn, spews a vine falling to the earth.

• West façade (9)

Triangular pediment on pillars: this architectural element is identical to its companion on the east side.

Southeast small building (SESB)

• North façade (10)

Lintel: in the center is a monster's head borne on two volutes that become a stem and crozier at the side to form the support for the divine guardian of the cardinal points. A figure seated in the "Javanese position" is wreathed in foliage. In the upper part, the lintel is separated from the tympanum by a pearly band.

Trefoil pediment

— Tympanum: the floral decoration has remarkable large volutes arranged as a pyramid. The style is the same as that of the east and west tympanums of the east *gopura* of the second enclosure.

— Rake: the ends are in poor condition and many parts are missing. The outlines of what may be a lion spewing another animal are visible.

Northeast small building (NESB)

• South façade (11)

Lintel: The right side is partly obliterated, but a few croziers are still visible on the left.

Trefoil pediment

— Tympanum: the decoration, made up of volutes arranged in pyramidal form, is identical to that of the tympanum on the south façade.

— Rake: at each end, there is a lion spewing a three-hooded *naga*.

North small building (NSB)

• East façade (12)

Trefoil pediment: the rake is in fair condition, but the carvings on the tympanum have been obliterated.

South small building (SSB), northwest small building (NWSB), southwest small building (SWSB)

Little remains of these structures. A few pediments are still standing, but these are of minor decorative and iconographic value.

First Enclosure

East *Gopura* (EG 1)

• East façade (13)

Lintel: the central figure, Vishnu-Krishna, is mounted on a floral arrangement below a small arch; the figure's head is missing. Attacked by the animal henchmen of the cruel king Kamsa, he responds by clutching the elephant's trunk in his left hand while his right repels a lion. A tortuous stem motif starts and coils toward the ends, where it curls around an elephant head beneath a lion spewing a foliated scroll.

Trefoil pediment

— Tympanum: Shiva, standing on two volutes, performs his dance, waving his many arms. He is haloed by a light, airy, canopy of foliage that is supported by four lions. In the left corner of the tympanum, the god's Indian disciple, Karaikkalamaiyar, keeps time for his master. Shiva's lithe body is marked by the god's self-imposed austerities. In the right corner, a musician seated on a stand beats a drum to punctuate the dancer's movements.

— Rake: terminates in the image of lions disgorging a three-headed *naga*.

• West façade (14)

Lintel: the center is occupied by Hayagriva, a four-armed avatar of Vishnu, endowed with a man's body and a horse's head. The scene illustrates the struggle of Hayagriva against the demons Madhu and Kaitabha; the horse figure striding a leaf is gripping the demons by their heads but they are retaliating by holding onto his thigh, out of which spouts a leafy decoration.

Trefoil pediment

— Tympanum: this tympanum is the counterpart of the one on the east façade. Durga, the *shakti* of Shiva, is portrayed in her terrifying persona. She is also larger than usual and is set against a simpler backdrop than was customary. Durga's feet rest on tangles of foliage in the lower section of the tympanum. She is striking the demon-buffalo on her right with one of her many arms while two small lions support the frame of foliage around her. A monster's head is outlined above the goddess and a praying figure appears in each corner.

— Rake: at the end of each rake, there is a lion spewing a multi-headed *naga*.

North Library (NL)

• East façade (15)

Lintel (above the false door): this very fine lintel depicts the god Indra mounted in his chariot drawn by the elephant Airavata, resting on a flowering lotus ornamented by a long pendant. The seated god holds one of his sacred objects, the *vajra*, in his right hand. The vegetal matter disgorged by the *gajasimhas* (lions with elephant trunks) snakes across the lintel to end in other *gajasimhas* with raised trunks holding small figures whose heads have been removed. The upper section of the lintel is decorated with a vegetal stem backdrop dotted with tiny knights who appear to be escaping from the lintel.

Multifoil pediment

— Tympanum: like the lintel, this tympanum is a marvelous, brilliantly executed composition. In the upper part, Indra, as the master of storms and lightning with a *vajra* in his hand, is seated on his three-headed elephant beneath a fiery arch; the elephant "stands" on four wavy lines, possibly clouds or an aquatic motif. Tiny figures speckle the background, peeping forth from the clouds and swarming about the mounted god who is the object of their adoration. The two horizontal bands notched with thousands of darts, separating the Heaven of Indra from the earthly world of mankind, has given rise to different interpretations. Some experts see them as a curtain of rain coming down from the "clouds," reinforced by the presence of two three-headed *nagas*, a water symbol; these snakes appear one above the other and are positioned at the level at which the shower begins, hence the name "the rain of Indra" given to this pediment. The shafts of rain have what look like feathers and tails, however, so others have seen them as arrows converg-

ing on the god. Just below these bands, frightened birds flee toward the edge of the tympanum.

The leafy growth of the forest of Vrindavana where, in each tree, a bird nests or a monkey sports, sets the scene in the lower tier. On the ground, wild beasts, gazelles, lions, deer and elephants surround Krishna and his brother Balarama. At each corner, a generously drawn figure stands on a chariot with a horse and driver; the figure on the right is Vishnu crowned with a miter and holding his objects, the discus, globe, club and conch. The figure armed with a bow and holding a bundle of arrows appearing in the left corner may be Rama or Arjuna. This last figure may be related to the "rain of arrows" pouring down on Indra.

— Rake: the ends of the rake, like those of the pediments higher up, are very original. They end in *gajasimha* heads in profile with a rearing lion in their mouths, covered as if by a sort of cap, by the crest of vegetal "flames" that line the extrados of the ramp. On the pediment immediately above, *garudas* replace the lions.

• West façade (16)

Lintel: the lintel on the west façade is of the same style as that of the east façade.

Multifoil pediment

— Tympanum: this tympanum features another superb carving, in this case of the cruel king, Kamsa, the ruler of Mathura. As a wise man once predicted that he would perish at the hands of one of his nephews, he had his sister's children put to death. The only ones to escape the slaughter were the seventh and eighth sons, the brothers Balarama and Krishna, who was none other than Vishnu, who had become Krishna to slay the cruel king. The king's fatal gesture is enacted in

this palace scene. The carvings representing Krishna-Vishnu and the king beneath a portico with a pyramidal roof are among the most beautiful of the temple; Krishna is given imposing proportions as he smites his immobilized enemy with his sword. The women of the gynaeceum appear to be casually discussing the scene, although people on the lower floor, possibly the king's domestics, look less calm. In the higher sections of the side galleries, curious by-standers watch the murder. The corners of the tympanum are filled with unidentifiable archers riding chariots.

— Rake: identical to those on the east façade.

South Library (SL)
• East façade (17)
Lintel (above the false door): this slightly eroded lintel is fragmented on its right side. Its central motif represents a feminine divinity, perhaps Laksmi, under a flaming arch, with a sacred object in her hands. Seated on a pedestal, she is framed by small figures that seem to sprout from flower corollas. Under the divinity is a monster with an open, tooth-filled mouth disgorging a vegetal stem, which, at the ends of the lintel, becomes an upright crozier surrounded by leafy volutes.
Multifoil pediment
— Tympanum: this scene depicts the angry return of the giant Ravana to his lair on the island of Lanka. The giant passes Mount Kailasha, the residence of Shiva and his wife, Parvati, which is forbidden territory. Ravana, furious at being denied access, insults the monkey guardian of the mountain and then, to make himself known to the god, takes the mountain by its base and shakes it violently, causing a great fright to come over

Parvati and an uproar among the hermits and animals living there. Shiva, imperturbable, dislodges a rock with his heel and the rock hits the giant. Injured, the latter realizes how powerful the god is and starts to sing his praises. Subsequently, Ravana was condemned to suffer, cry, sing and praise the god for the next thousand years, after which Shiva the magnanimous forgave him and presented him with a sword as a token of his pardon.

The scene in this tympanum shows the giant shaking the terraced pyramid representing the mountain. Ravana, bracing himself by kneeling with one leg on the ground, directs all his efforts to lifting the base of the mountain. The commotion is causing the animals to run away. In the upper section, the mitered beasts appear anguished, while above them, the Brahmanic monks with their tall headdresses are wondering what will happen to them. Shiva on top of the mountain, in the company of Parvati, who is kneeling, gracefully extends his right foot to cause the rock fall with which he intends to crush the intruder.

— Rake: identical to those of the north library.

• West façade (18)
Lintel: this lintel shows a divinity with an oblong attribute; it is difficult to determine whether his mount is a horse or a bull, so his identity remains uncertain. The animal's snout may resemble more that of a "horse" than a "bull," in which case it would be Surya.
Multifoil pediment
— Tympanum: Shiva, the greatest of all divinities, renounced the pleasures of living to meditate and fast on Mount Kailasha. The god's daughter is disappointed that Shiva is not pay-

ing her any attention. Consequently, she assumes the form of his spouse, Parvati, with the aid and assistance of the other gods, who have requested the intervention of Kama, the god of love and a son of Shiva; they are aware that only one of Shiva's offspring is capable of arousing his father's destructive anger. Their plan unexpectedly fails. Shiva is more intent on his meditation than in indulging in earthly pleasures and, annoyed with Kama, beams a ray of light from his third eye upon him and he is burned to ashes. Nevertheless, glancing absentmindedly at Parvati, he forgets his promises momentarily and rejoices in her beauty; shortly after, they are married and Shiva, moved by the pleas of Kama's wife, Rati, resuscitates the unfortunate god of love in the form of Pradyumna, the son of Krishna.

On this tympanum, we se once again Mount Kailasha in the form of a terraced pyramid. On the summit sits Shiva with, on his right, slightly lower down, a kneeling Parvati, who is trying to attract his attention by holding up his beads. To the left of the celestial couple is Kama readying his bow to target an arrow at the god. Rati, Kama's wife, standing on a lower level with a fly swatter in her hand, appears to be sad at the outcome of her father-in-law's wrath. On the same level, the sculptors have included a group of *rishi*, or Brahmanic priests, with extravagant headdresses. They are discussing the incident, as are the animals in the level below—the mitered monkeys, horses, elephant, lion and *garuda*. At the lowest stage of the pyramid, representing the human world, people tend to their daily chores in the presence of a large lying bull, Nandi, Shiva's mount.

— Rake: identical to those of the east façade.

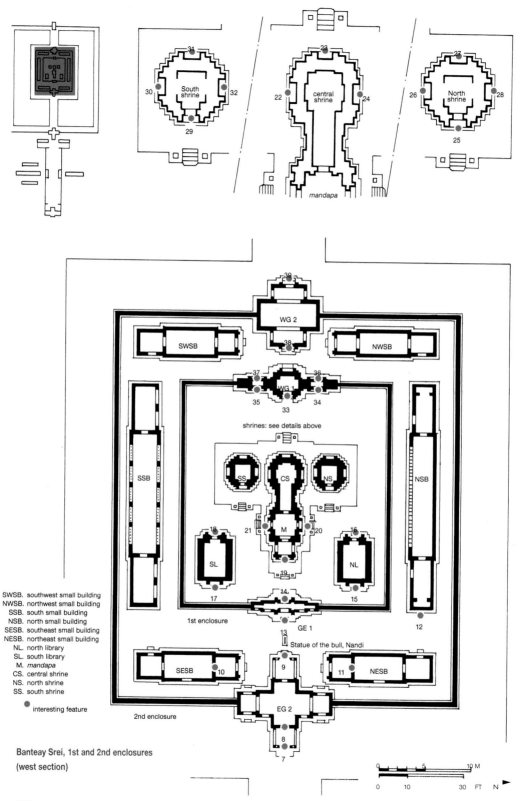

South shrine

central shrine

North shrine

mandapa

WG 2

SWSB

NWSB

WG 1

shrines: see details above

SSB

SS

CS

NS

NSB

M

SL

NL

21

GE 1

1st enclosure

Statue of the bull, Nandi

SESB

EG 2

NESB

2nd enclosure

SWSB. southwest small building
NWSB. northwest small building
SSB. south small building
NSB. north small building
SESB. southeast small building
NESB. northeast small building
NL. north library
SL. south library
M. *mandapa*
CS. central shrine
NS. north shrine
SS. south shrine

● interesting feature

Banteay Srei, 1st and 2nd enclosures

(west section)

0 5 10 M

0 10 30 FT N ▶

Mandapa

• East façade (19)

Lintel (above the east entrance): in the center are three lions under small arches; the middle lion is portrayed full face and its companions in profile. The two lions in profile spew plant stems that terminate in volutes. Multifoil pediment

— Tympanum: beneath small arches, Indra raises his weapon, the *vajra* while other subjects move about midst the foliage. The god is sitting "Javanese style" on the heads of his three-headed elephant. Lower down, a *kala* mask disgorges a ribbon of leaves terminating in volutes.

— Rake: at both ends, the head of a *makara* spews a multi-headed *naga*.

• North façade (20)

Lintel: in the center is the head of a monster accompanied by a plant stem arranged into croziers. Trefoil "basket handle" pediment

— Tympanum: in the center, sitting on a pedestal, a figure seems to be holding a lotus flower. Underneath, is the head of a monster holding an elephant in his teeth, while his sharp claws clutch his victim's ears; the elephant's trunk turns into croziers.

— Rake: at both ends, a multi-headed *naga* emerges from a *makara*'s throat.

• South façade (21)

The lintel and pediment are identical to the ones on the north side.

Shrines

The three shrines are of great iconographic importance, thanks in particular to the representations carved on the door lintels. Indeed, these are among the most inventive and complex carvings of the entire monument. Around the explicit central motif, the sculptors created settings of smaller tableaux featuring secondary scenes.

Central Shrine (CS)

• South façade (22)

Lintel (above the false door): this features an episode from the *Mahabharata* that recounts how Shiva, disguised as a hunter, wrangles over a slain boar with Prince Arjuna. The boar is none other than the demon Muka, delighted to have created strife between the god and the prince. Shiva persuades Arjuna to leave him the animal, but magnanimously gives Arjuna a magical weapon that will appear in the subsequent battle against the demons. In the center of the lintel, under a trefoil arcature, the hero and the god are fighting over the spoils of the hunt. However, the artist has created an air of complicity between them, as if they were engaged in a dance. They are on a base supported by the boar-Muka and by two lions, who have their backs turned to each other and are spewing stems. The lintel, which may be divided into four sections, displays the figures of Shiva and Arjuna (left and right sections respectively) and also the chalice which supports them (center). The god and the prince appear as two rival huntsmen threatening each other, but they are cleverly made to cross the boundaries of their sections as they look toward the center, drawing the viewer's eye to the same place. A figure has been carved at each end of the lintel. The one on the left stands on a pedestal, also turned to the center, with a sword in his hand. His companion on the right is in poor condition and is not very clear. It is likely that these two figures represent hunters who are witnessing the fight between Shiva and Arjuna over the demon-boar.

Trefoil "basket handle" pediment

— Tympanum: Yama, the god of death and guardian of the south, is portrayed mounted on his buffalo, but the latter, possibly in order to make the composition symmetrical, is placed on a base held up by three lions.

• West façade (23)

Lintel (above the false door): in the center, a monster head "drips" a pendant from its mouth. On either side of the monster, two animal heads are stretching upward and the foliage disgorged by one of them becomes the multifoil arcature under which the main theme is set, the abduction of Sita by the demon, Viradha. The demon, armed with a spear, maintains his balance by placing his right leg on the monster's head; he has flung Sita, bravely smiling throughout it all, onto his left shoulder. The sinuous foliage cutting across the scene horizontally is interspersed with four equidistant *garuda* heads; the volutes at the corners swirl over portraits of Rama and his brother Laksmana, whose drawn swords lead our gaze astutely to the central and dominant theme. Trefoil "basket handle" pediment

— Tympanum: in the center is the guardian of the west, the god Varuna, whose head is unfortunately damaged. He is placed beneath an arcature soaring upward like tongues of fire, riding a wild goose. A flower corolla that supports the entire scene produces leafy stems curled into volutes at the ends.

— Rake: identical to those of the other pediments.

• North façade (24)

Lintel (above the false door): this lintel presents a scene from the *Ramayana*, in which the brothers and rivals, Valin and Sugriva, both kings of the monkeys, are engaging in battle. In the

course of the duel, Rama intervenes to ensure the victory of his ally Sugriva by impaling Valin with an arrow. The clash between the monkey kings occupies the center of the lintel beneath a multilfoil arcature; the rivals are standing on their hind paws, their bodies are locked together, they are exchanging blows and biting each other's noses. The whole scene is set on a pedestal held by three *makaras*, two of which disgorge leafy stems. A half-portrait of a figurine appears on each quarter section of the stem; on one side it is Rama, and on the other probably Laksmana, his brother. Both heroes are directing bows and arrows toward the combat occurring in the center. At each end of the lintel, another monkey, whose face is also turned to the center, witnesses the scene. The monkey on the right is given full-length treatment; but its companion on the left appears only waist-length.

Trefoil "basket handle" pediment

— Tympanum: Kubera, guardian of the north, can be made out among the swirling leafy patterns; the god is riding lion atlantes instead of his usual mount, a single lion.

— Rake: identical to the others.

North Shrine (NS)

• East façade (25)

Lintel: the central motif treats a single subject, Indra, the guardian of the east. The god is squatting on his mount, the elephant Airavata. The lintel is divided into four quarters occupied by *garudas* wearing diadems, holding wavy stems and dropping three-headed *nagas*.

Trefoil "basket handle" pediment

— Tympanum: the central motif is Narasimha, the lion-headed avatar of Vishnu. He is framed toward the top by two small flying subjects and is

surrounded by a pyramid of foliage with large volutes. With his claws, he is tearing at the abdomen of the *asura* Hiranyakasipu, lying across his knees, because this demon had dared to provoke him.

— Rake: similar to those of other pediments.

• South façade (26)

Lintel (above the false door): The scene is taken from the Krishna-Vishnu legend. Vishnu is visible in the center felling an *asura* to his right. The scene is placed beneath a multifoil arcature whose lower section sends out a leafy cord. The lintel is quartered by lion heads holding the stem.

Trefoil "basket handle" pediment

— Tympanum: the center of the composition is devoted to Yama, god of death and guardian of the south, who appears on a buffalo. The motif is supported by lions.

— Rake: identical to the others.

• West façade (27)

Lintel (above the false door): in the center, resting on the start of a volute, there is an upright *garuda*, seen frontally and carrying on its shoulders a sitting Vishnu. The whole scene is crowned by an arcature. The hind legs of the *garuda* form the start of a leafy stem.

Trefoil "basket handle" pediment

— Tympanum: Varuna is the central figure here. As god of the waters and guardian of the west, he rides his wild goose, resting on a pedestal supported by two *makaras* looking in opposite directions; their presence may be a reminder that the god is linked to the element of water.

— Rake: identical to those in place.

• North façade (28)

Lintel (above the false door): the central motif is inspired by the legend of

Vishnu-Krishna. On a platform resting on a corolla, Krishna, who wears heavy earrings that stretch his ear lobes, is standing astride the fallen body of an *asura*, which he has just dismembered; a faint smile of satisfaction curls his lips. The scene takes place beneath a multifoil arcature rising like tongues of fire. Each quarter section of the lintel has a monster with the usual leafy cord in its mouth.

Trefoil "basket handle" pediment

— Tympanum: at the center, midst the pyramid of foliage, Kubera, the god of wealth and guardian of the north, is seated in the "Javanese position" on a pedestal supported by three small lions; the figures caught in the tangle of foliage beside him serve to enhance his divine presence; in the upper section, there are flying figures armed with bows.

— Rake: resembles those of the other shrines.

South Shrine (SS)

• East façade (29)

Lintel: the sculptures here portray a triple elephant and its divine rider, Indra, both decked out in necklaces of bells. The god is sitting in the "Javanese position." A multifoil arcature rises flame-like above him. A flower in bloom forms a stage for the entire scene. Just below is a leafy garland that is supported by the trunks of the two outer elephants. A band of praying figures extends the length of the lintel and in the upper part.

Trefoil "basket handle" pediment

— Tympanum: the divine couple Shiva and Uma are mounted on Nandi, the sacred bull. They are encircled by curling vegetation. The upper section features two flying subjects.

• South façade (30)

Lintel (above the false door): this is a magnificent and highly inventive lintel.

In the center, two small upright lions each place a paw on the head of a monster seen in profile, placed a little lower down; with the other raised paw they hold up a kind of shield, which serves as a kind of throne for Yama, the god of death, riding a buffalo. Yama, whose head is missing, has a stick in his hand. The two monster heads are the starting point for a leafy stem that extends to the ends of the lintel and is interrupted at four points first by monsters in profile and then by *kala* heads surmounted by the bust of a worshipper and holding in their mouths an elephant's skull. The plant stem ends in a volute containing a tiny lion.
Trefoil "basket handle" pediment
— Tympanum: this is another version of the theme featured on the lintel; Yama and his buffalo stand on a pedestal maintained by three small upright lions.
— Rake: the rake is flanked by bands and topped by leaves resembling flames. At the ends, there are *makaras* spewing five-headed *nagas*.

• West façade (31)
Lintel (above the false door): Varuna, guardian of the west, is depicted under a multifoil arch with a lasso in his right hand, mounted on a *hamsa*. The scene rests on a small platform maintained by a corolla. The plant stem extends uninterrupted to the ends of the lintel.
Multifoil "basket handle" pediment
— Tympanum: another image of Varuna, guardian of the west, adorns this tympanum. The god is still holding his lasso, but drives a team of three *hamsas*. The whole scene is presented on a chalice that is placed on the raised tails of two *makaras* facing opposite directions. The monsters spew the plant stem that terminates at the ends of the

lintel. The head of the god has been destroyed.
— Rake: in the same style as the previous ones.

• North façade (32)
Lintel (above the false door): the decoration here is similar to that of the lintels on the south façade. The central figure, Kubera, the god of wealth, is sitting in the "Javanese position" on a chalice that is held up by two tiny lions. The plant stem is interrupted by a monster topped with a figure and an elephant head.
Multifoil "basket handle" pediment
— Tympanum: this tympanum also features Kubera in the "Javanese position" placed on a tiny platform held up by three lions. The whole scene is bordered by swirls of leafy volutes. The lion was one of Kubera's mounts, and here a triad of lions serves as the god's vehicle.
— Rake: identical to the one before.

First Enclosure

West *Gopura*
• East façade
33. Lintel above the central passage: in the center, the head of a monster spews a string of leaves, which, at the ends of the lintel, becomes a *makara* disgorging an erect lion facing outward.
34. Lintel above the north passage: in the upper section is a central image of a *garuda* wearing a diadem and dripping a pendant from its beak. A plant stem turns into a vertical multi-headed *naga* at the ends. Underneath the stem, a backdrop of tear-shaped leaves fills most of the upper section of the lintel.
35. Lintel above the south passage: in the center of the lintel is the head of a monster, above which there is a waist-length portrait of a mitered

divinity under an arcature holding a sacred object in his right hand. The monster is flanked by two lions in profile. The latter are spewing a leafy stem that curls into a full-face *naga* replacing the customary volute. As in the lintel of the north passage, high placed "tears" of foliage appear under the leafy stem.

• West façade
36. Lintel above the north passage: features a divine guardian.
37. Lintel above the south passage: notable for the head of a monster in the center.

Second Enclosure

West *Gopura* (WG 2)
• East façade
38. Lintel: A divine guardian is resting on the head of a monster.
Multifoil pediment
— Tympanum: this tympanum is decorated with the battle of the monkey kings inspired by the *Ramayana*. The monkey brothers, Valin and Sugriva, both crowned with miters, are locked in mortal combat, but Rama, the hero, placed on the right, is about to help Sugriva win the fight as he prepares to shoot the arrow that will kill Valin. The figure behind the hero may be Laksmana who is squatting and pointing to the simian brothers. In the left corner, an assembly of monkeys wearing miters is debating the outcome of the contest and the respective chances of the rivals in the center, where a duo of flying figures appears.
— Rake: ends in a *makara* head spewing an erect multi-headed *naga*.

• West façade (39)
Multifoil pediment: currently on loan to the National Museum at Phnom Penh. It represents an episode from the *Mahabharata*: the fight between the Kaurava and Pandava clans.

The Malraux Affair

On November 23, 1996, during an official ceremony, the body of Georges André Malraux was transferred to the Panthéon in Paris, where it was laid to rest beside the men and women who had contributed to the glory of France. Malraux had served under President Charles de Gaulle as Minister of Cultural Affairs. He had died twenty years earlier.

In 1923, Malraux was twenty-two. He had recently married Clara Goldsmith. Thanks to his investments, they led an easy life as wandering esthetes when, following the collapse in Mexican stocks into which they had put all their money, they found themselves penniless. Malraux had no diplomas and was not yet a celebrated writer. Self-taught, he was a gifted talker who had an astounding memory. However, he was lazy by nature and had an almost pathological need to impress others that occasionally led him to lie and exaggerate. Clever and curious about everything, he used to spend hours looking at Khmer sculptures in the Trocadero and the Musée Guimet. After reading about the subject, he rapidly came to the conclusion that in Cambodia, outside the great temples, there were a number of more modest monuments that nevertheless had interesting bas-reliefs. During his trips to the library, Malraux had come across a study of a small temple, Banteay Srei, that was described as being a ruin, yet possessing particularly refined and beautiful stone images. He realized that he might be able to extricate himself from his financial difficulties by traveling to Cambodia and dismantling, removing and then selling several bas-reliefs from the temple.

On October 13, 1923, Malraux, his wife and a childhood friend set sail on a ship that was ironically called the *Angkor*. They landed in Saigon one month after their departure, but did not prolong their stay as the director of the École Française d'Extrême-Orient was waiting for him in Hanoi; the director was an important official who was in charge of all the archeological sites of Indochina. Malraux learned from this illustrious scholar and administrator that all discoveries were to be reported immediately and left in position on the site. Nevertheless, before leaving France, Malraux had got hold of a mysterious *ordre de mission* from the Colonial Administration that authorized him to carry out his own archeological surveys in Cambodia!

Soon after their return to Saigon, Malraux and his party left for Phnom Penh, from where they made their way by boat up the Great Lake to Angkor. There, another official informed them that the king had published a decree in October 1923 protecting all the monuments of the realm. This new decree did not deter the three young adventurers from pursuing their original and legally dubious plan of relieving the temple of some of its artworks. So they set off into the jungle with the most rudimentary equipment, four ox-drawn carts and a dozen coolies. After days of exhausting walking through the forest, they came within reach of their prize: there was the monument, in front of them, ruined for sure, but revealing, partially hidden by foliage, magnificent bas-reliefs. The group immediately swung into action; axes, saws, hammers, shears, levers and cords were used to dislodge seven sculpted stones, which were hoisted onto the carts, transported to the Great Lake and transferred by boat to Phnom Penh.

Not surprisingly, this archeological "excursion" did not go unnoticed by the authorities. On Christmas Eve, the police boarded their boat to confiscate the crates containing the bas-reliefs and the Frenchmen were arrested. Although they avoided imprisonment, they were forbidden from leaving the city and were told to remain in their hotel until the trial. Clara was not charged, but Malraux and his friend were accused of "trafficking in antiquities." The inquiry was to last more than six months and sentence was handed down after three hearings. On July 21, the court delivered its verdict: Malraux was given a three-year prison sentence and a court order forbidding him entry into Cambodia for another five years; his friend was sentenced to eighteen months. Obviously, all the bas-reliefs had to be returned.

Shocked by the verdict, Malraux appealed to the colonial court in Saigon. On October 8, 1924, the two prisoners were again brought before the judges. Malraux's attorney pleaded that the Banteay Srei temple was in such a ruined condition that it was not catalogued as a monument, so his client could not be guilty of theft—which was, in a way, true. But the attorney had a more potent weapon. He produced a petition signed by Malraux's Parisian friends, alerted by Clara who had returned to Paris, among whom were some of the most illustrious names in French literature. The petition attested to the morality of the young Monsieur Malraux and it was effective. On October 28, 1924, the original sentence was annulled and punishment was reduced to a one-year suspended sentence for Malraux and eight months for his friend. The sentence forbidding them re-entry into Cambodia for five years was also annulled.

The two men were bitter and humiliated as they departed for France. However, in 1925 Malraux returned to Indochina with the intention of denouncing the corrupt practices of the colonial administration, but perhaps also with the aim of seeking some sort of revenge over his compatriots who had condemned and rejected him. As soon as he arrived in Saigon, Malraux started a newspaper called *L'Indochine*. He used it as a platform for criticizing the governor general of Indochina and his assistants. he also condemned the terrible treatment meted out to the native Annamites by the colonials. His protests were, however, too strident. When the printer began receiving mysterious threats, the newspaper was obliged to stop publication. Undeterred, Malraux obtained the equipment to set up his own printing press and started another periodical bearing the provocative title *L'Indochine enchaînée*, twenty-three issues of which were printed before it too closed down, a victim of harassment by the colonial administration.

Rejected by the colonials, separated from his friends and with all his hopes in tatters, Malraux returned to France. Five years later, he published his own version of events in his autobiographical book, *La Voie Royale*. Later, in 1933, he received the country's highest literary award, the Prix Goncourt, for his novel, *La Condition humaine*. Although his knowledge of Asia in general and China in particular was limited, his immense intelligence and imagination largely compensated for his inexperience.

Although Malraux's venture in Cambodia can be regarded as suspect, it has to be admitted that it did force those in charge of the conservation of the archeological sites of Cambodia to face up to their responsibilities, leading to the reconstruction of Banteay Srei from 1931 to 1936. All in all, then, the consequences of André Malraux's extraordinary expedition to Angkor were not totally negative, for it permitted the reconstruction of a temple that is now regarded as one of the jewels of Khmer art.

Religions and Civilization in Angkor

Vedism

Approximately two thousand years ago, Aryan tribes riding forth from Iran invaded India to discover a civilization that was in many respects both primitive and sophisticated. The newcomers mingled with their subjects and thus contributed to creating a new race of people endowed with both different physical traits and spiritual beliefs. This new civilization was to produce the first literature of India in the form of sacred texts called the *Vedas*, or the sacred books of the Aryans.

This belief system, which emerged around the 12th or the 10th century B.C., was transmitted orally from generation to generation and only gradually found its way into writing. Its elaborate mythology involved the exploits of the Vedic gods, hardworking demiurges who intervene wholeheartedly in human affairs. Easily amenable through prayer and offerings, these gods smile upon those they favor and help them to obtain wealth and privileges in this life and the other. On the other hand, those

unfortunate enough to anger the capricious double-faced divinities have to bear the brunt of their wrath.

The Vedic system included thirty-three gods of the earth, atmosphere and heavens. The *Rigveda*, the oldest and most important text, recounts the marvelous feats of the king of the gods, Indra, a war divinity attended upon by the Maruts, a group of jovial young male gods who cause rainstorms by riding on clouds. The Maruts are also known as the sons of Rudra, a most singular divinity who, in the form of Shiva, can be particularly fearsome. A divine couple called the Asvin, linked to Indra, usher in the dawn and the nightfall as their chariot journeys across the heavens. The god Vishnu conquers the universe in three gigantic strides. Natural elements represented by Surya, the sun, and Vayu, the wind, are also godly. Other things that are close to humans also receive divine status, such as Soma, the liqueur of immortality, or natural phenomena like fire, associated with Agni.

The second *Veda*, the *Yajurveda*, is a catalogue of texts explaining the

reasons behind the practices of different cult ceremonies. The third *Veda*, the *Samaveda*, is excerpted from the *Rig Veda*; it includes a musical notation. The fourth and last *Veda*, the *Atharvaveda*, contains magical prayers, ceremonial incantations and poetic explanations of how the universe came into existence.

Brahmanism

Brahmanism, descending directly from Vedism, appeared in India during the 6th century B.C. and was practiced at the same time as Buddhism. It absorbed the Vedic universe with all its multiple and varied gods and genies into its own religious structure. The founding texts of the new religion, the *Brahmanas*, represent India's second major body of literature. The *Brahmanas* interpret the Vedic mythological system through commentaries and grant an extended role to the concept of sacrifice, a particularly fundamental act of the religion. Other texts, the *Upanishads*, elaborating on the *Brahmanas*, relate

its writings to the microcosm and the macrocosm. The principle notion is the identification of the universal soul, *brahman*, with the individual soul, *atman*. Like the Vedic religion, Brahmanism is situated outside the realm of faith and evolves independently from the gods representing the powers of the universe.

The Brahmanic religion centered on the all-important sacrifice of the ritual fire ceremony, during which worshippers, hoping for favors, paid homage to the divinity. A guide was needed to orchestrate the performances of the ritualistic gestures (*mudras*); the recitation of the texts in celebration of the sacrifice (*sutra*) enables the devotees to complete the ceremony successfully.

The writings of the *Upanishads* and Buddhism both express the belief in the *samsara*, or the wandering of the individual soul submitted to perpetual reincarnations, and the *karma*, or *karman*, which is the final reckoning setting the circumstances of the individual's reincarnations based on acts from his previous existences. The holy texts in both religions explore the means to arrest the inexorable cycle of birth and rebirths; Brahmanism is the final deliverance from the *karma* through knowledge.

The supremely important concept of the universal soul (*brahma*) is the quintessence of all things and the key to comprehending the world. When it organized this world, the *brahma* was personified by the creator god Brahma, whose power and omniscience was expressed in his four arms and four faces looking out over the four cardinal directions. He reigned in that hidden world that would become the future dwelling of the Wise. However, Brahma was to play a secondary role as the sovereign god.

The Brahmanic religion incorporated the thirty-three Vedic deities, and like the older Vedic system, turned to one supreme god, Indra, who controlled the atmosphere and the storms and presided over a section of paradise, the "Eden," for a population of half-gods.

However, a triad of divinities (the Trimurti) appeared particularly favored: Brahma and two other gods of Vedic origin: Vishnu, the slayer of demons, and the two-faced Shiva, who was intermittently benevolent and terrifying.

The universe is structured in the Brahmanic conception as a succession of appearances and disappearances subdivided into four periods, or *kalpas*, of gradually decreasing duration, force and energy that are metaphorically like a boiling river whose buoyant course is lost in the sands; it ends in a period of dissolution that, in its turn, will precipitate a great upheaval before the arrival of a time of peace brought by the original waters. Millions of years later the world will reappear with new gods identical to the old ones, who are also subject to the process of *samsara*.

The notions of purity and impurity became increasingly important in Brahmanism, engendering taboos and establishing categories for things, individuals and acts; this trend eventually produced the caste system. The ancient Indian social fabric was dominated by a theocratic caste in the person of the Brahman, who was obliged to keep apart from all impure contacts. Then came the warrior caste (Kshatriya), the merchants and farmers (Vaisya) and finally artisans and laborers (Sudra). The lowest caste, the "untouchables," toiled at the most menial jobs.

Hinduism

Hinduism was essentially a form of Brahmanism that evolved in India during the era that coincided with the advent of Christianity in the West. Although it was respectful of all the traditional teachings of Brahmanism, Hinduism was selective in its adoption of some of its principle creeds: the presence of a transcendent figure; the adherence to the caste system; the belief that existence is a cycle of birth and rebirths with rewards and punishments for acts committed during one's lifetime. The highest aspiration is to escape this seemingly never-ending cycle of reincarnation.

The verses of the epics *Mahabarata* and *Ramayana* contain the seeds of Hindu beliefs. The splendid philosophical poem called the *Bhagavadgita* that forms part of these texts, reveals the three means of deliverance from *samsara*: the observance of strict discipline, knowledge and, above all, devotion to the foremost divinity—the surest way of escaping it.

The idea of sacrifice, so important to the Vedic religion, was abandoned because the new creed emphasized non-violence (*aimsa*), even to the point of renouncing the desire to live.

Hinduism did not, in theory, reject the Brahmanic pantheon of the thirty-three deities where the Brahma-Vishnu-Shiva trio reigned supreme. Brahma assumed a secondary role, received no particular devotional attention and was invoked only by worshippers on a personal basis.

Vishnu was a complex and prominent god figure. The Vedic Vishnu was associated with the sun. The most fascinating role he played—and his most truly captivating portrait—is the one in which he appears asleep on the serpent Ananta that floats aloft the primeval waters during the

disappearance of the cosmos while waiting for Brahma to recreate the world. To re-establish the universal order in a demon-tormented world, Vishnu comes down to earth as different forms, known as avatars. These avatars were at first few in number, but eventually there were ten. He can appear in human form, as Krishna, the warrior god of the *Baghavadgita*, associated with an infant-god or a shepherd-god who delighted in panicking the shepherd lads. Other avatars are Rama, the hero of the *Ramayana*, Vamana, a dwarf who, after his transformation into a giant, takes the world in three strides. He can also be half-man and half-beast, like Kalkin, who has a man's body and a horse's head, or Narasimha, the man-lion. The purely animal-shaped avatar are the fish that saves humanity from the flood, the tortoise which upholds Mount Mandara during the Churning of the Ocean of Milk and the wild boar that carried the goddess of earth back up to the surface of the waters. For cult ceremonies, Vishnu often appears in human form on the back of the mythical bird Garuda. The Hindus readily bestowed on the god Vishnu a consort, Laksmi or Sri.

Like Vishnu, Shiva, the Hindu deity, has mixed origins. As Rudra, he leads the gods of the atmosphere and he is also a great ascetic. In subsequent periods he was associated with the destruction wrought by the passage of time. His name means the "favorable" or the "benevolent," but he is capable of awesome acts, as when he destroys the world in his cosmic dance, the *tandava*. A frequent representation of Shiva is the phallic form known as the *linga*. His wife is Parvati, also called Uma or Durga, and the white bull, Nandi, is his mount and attendant.

The Life of the Buddha

The doctrine of metempsychosis, or the transmigration of souls, describes the advent of exceptional beings able to attain the state of enlightenment, the Bodhisattva, literally the "enlightened one." The legendary writings of Pali cite the twenty-four Buddhas who preceded Siddhartha and announce the arrival of Maitreya, the Buddha of the Future.

When the time comes for a Bodhisattva to appear, all the gods of the cosmos gather to ask him to descend to earth, where he will live his last existence. The Bodhisattva is empowered to choose the moment of his appearance, the region on earth that will receive him, the place of his birth, his ancestry, and the woman who will carry him.

In the 6th century B.C., King Suddhodana of the Sakya tribe ruled the small kingdom of Kapilavastu at the foot of the Himalayas in northern India. The father of the future Buddha belonged to the warrior caste. He was married to Princess Mayadevi who, like her husband, traced her lineage to the Brahman Gautama. When the future Bodhisattva with the supernatural gift of knowledge of the past, present and future perceived that his time had come to descend among men, he chose Suddhodana and his wife, whose souls were pure.

Indian literature grants a miraculous character to the birth of the Enlightened One, which occurred in 563 B.C. Queen Mayadevi dreamed that the Bodhisattva entered her womb in the shape of a lovely snow white elephant. The dream was interpreted by prophets as evidence that the queen was pregnant and out of the royal union would come a male child who was to be either the universal sovereign or a Buddha if he renounced the pleasures of earthly existence. Ten months after the prophets had spoken, Queen Mayadevi retired to the garden and there, beneath a tree, she gave birth to the Bodhisattva, who came forth painlessly from her right side. As soon as the birth had taken place, the child began to walk; a lotus miraculously appeared as his foot touched the earth. He took seven steps in the direction of the four cardinal points while proclaiming he would vanquish illness and death.

Shortly after his birth, in the temple, the prince received the name of Siddhartha ("he who obtains success") from his father. There, on that holy ground, the prophets who composed his horoscope recognized the thirty-two stigmata and eighty signs which distinguished the young prince from the rest of mankind, destined to become either the sovereign of the universe, a prospect which delighted his father, or a Buddha, an ascetic, who would benefit humanity. The wise man known as Asita foresaw that the young Siddhartha would become a Buddha. On the seventh day after his birth, Queen Mayadevi died, leaving her sister, the prince's aunt, to take care of him until his seventh birthday. When he had become an adult at the age of thirteen, a family council decided it was time to arrange his marriage. The king and his ministers chose Gopa, a young princess of the Sakya clan, but before Siddhartha had the right to court his future wife, he had to prove his valor in tournaments by affronting other rivals to the princess's hand. He did so very successfully and was accepted by the family of his fiancée.

Fearful that the prediction that the prince would become a holy hermit might prove true, King Suddhodana

made every effort to prepare his son for his future secular existence as a Sakya ruler by providing every indulgence his fertile imagination could devise—sumptuous gardens of delight, games and amusements; he also attempted to keep Siddhartha far from the real world with all its misery, pain and illness. Fate, however, cannot be opposed; Siddhartha became suddenly aware of the existence of pain. One day, as he rode joyfully through the gardens that his father, the king, had built especially for him, he beheld an old man stooped and bent with the burdens of age; soon after, he encountered a poor beggar with an incurable disease who lay dying and stretched out in the street like a dog. Then, on another day, a funeral procession presented to his innocent eyes the grief and helplessness of a family confronted with death. Troubled by what he had seen, Siddhartha began to question the beautiful frivolity and isolation of his own existence, and he realized that youth was but a passing stage that would end in illness, old age and the ultimate severance from the delights of this world, death. A fourth encounter with a wandering monk living on alms, serene and unperturbed by the cares of the material world, convinced him to leave his secluded life and go into the world to seek the truth about mankind, the pain it suffers and the deliverance from that pain.

The birth of his son Rahula weighed heavily upon him. It shackled him to his pleasurable existence by adding the joys but also the responsibilities of fatherhood to the torments that had beset him; these new experiences and his meditations on what he had seen, indicated to him that his path lay outside the ideal kingdom that his father had contrived. One night, as he gazed at the harem with its slumbering concubines and observed their limp bodies in positions of lascivious abandonment, his entire being was infused with a feeling of horror and disgust.

He was twenty-nine when he secretly rode from the palace one night after obtaining his father's blessing; his faithful equerry Channa followed him as his horse, Kanthaka, galloped noiselessly down the streets; the gods lifted the horse's hooves to soften the noise of the iron shoes beating down on the stone pavement. They headed southeast, crossing the Anoma River. A little later, after meeting a hunter, Siddhartha exchanged his fine garments for the man's rags, abandoned all his jewels and, with a sweep of his sword, cut off his long hair. He gave his horse to Channa and departed; the horse died of grief at the loss of its master.

Far from the world he had known and had come of age in, Siddhartha assumed the name of Gautama and became a wandering monk begging for his daily bread. Soon, in his search for wisdom, he became a disciple of a Brahmanic sage, but the doctrine he was taught failed to satisfy his spiritual longings. Still pursuing the truth, he found a new master to direct his studies, but to no avail. Still frustrated, he took to wandering again, but this time in the company of five fellow disciples who were the first men to hear his preachings. The tiny community of holy men settled at last at Uruvela on the bank of a river. Still looking in vain for the teacher or guru, Gautama, or Sakyamuni (the Sage of Sakya, his other name), took upon himself an intense spiritual investigation to find the path toward liberation from the cycle of birth and rebirth. During that period, he practiced incredibly harsh acts of self-denial and austerity in which he renounced all food and sustenance and thus reduced his body to virtual nothingness. Mara, the demon and tempter, the lord of evil and death, decided to take advantage of his feeble state to persuade or coerce him into giving up his spiritual search. Indra who was troubled and concerned, appeared before Gautama to preach that extreme self-inflicted sufferings are sterile acts. Sakyamuni took the god's preaching to heart and put an end to his excessive fasting; his five companions greatly shaken by his behavior, abandoned him. A hermit now, he retired to sit under the "goatherd's tree" and it was there that he encountered a peasant girl, Sujata, who had come to pray at this sacred spot and, mistaking him for the god living in the tree, offered him a "a bowl of succulent rice porridge." During the night preceding this encounter, the Sakyamuni had dreamed five dreams that foretold the advent of his imminent Enlightenment. He directed his steps in consequence toward the unique and immutable region considered the center of the earth, where all the preceding Buddhas had reached this divine state of being. Making a rough throne of some newly cut grass, he sat down and faced the east. As his whole being entered into deep meditation, the demon Mara, jealous and fearful of the liberation that the Sakyamuni would bring to mankind through his teachings and his example, intervened once more, but in vain; the virtue of Siddhartha had erected an impregnable barrier against diabolical temptations and assaults; Mara and his minions had to desist. Sakyamuni could proceed on his journey to supreme Enlightenment. He was thirty-five years of age.

He chose to spend a night beneath the tree of Enlightenment (*Ficus*

religiosa). During the first night, he passed through the four stages of meditation to arrive at a stage of absolute purity. The second night brought him the vision of events that had marked his own preceding existences and those of others. It was during the third night that in profound meditation he discovered the means to liberate mankind from the never-ending fatal chains of cause and effect.

He now possessed the Four Noble Truths: the evidence of pain, the evidence of the origin of pain, the evidence of the cessation of pain and, at last, the evidence of the road of eight paths symbolizing the eight perfections leading to the state of Buddha, the supreme and complete state of Enlightenment.

Siddhartha, now the Buddha, remained for seven weeks on the site of his illumination. He meditated during the first week on the law of cause and effect that had subjugated mankind. During the second week, he announced to the gods that he had achieved the state of Enlightenment. During the third week, he wandered around the site of his illumination. In the course of the fourth week, he turned his thoughts to the doctrine to be preached. The fifth week was spent in meditation beneath the "goatherd's tree," to which he finally returned and where he had to confront once again the wrath of Mara. The king of the demons sent his three daughters to tempt him, but the Buddha cooled their perfidious attempts to seduce him by revealing their future aged and decrepit state. The sixth week following his Enlightenment brought him to the Lake Mulilinda, where he meditated beneath a tree; Mara, this time, sent cold weather and rainstorms as a deterrent. Then the *naga*, the godlike

serpent of the lake, seeking to acquire some of the Buddha's virtues, slithered from its watery dwelling and coiled itself about the Buddha's body, raising its hood as a canopy against the stinging arrows of rain. A multitude of free statues represents this legend. During the seventh week, the Blessed One went to live beneath a tree called the "royal site," where he began to preach and make his first converts, two caravan leaders who were also brothers. He gave them handfuls of his hair and nail peelings, which were to become the first sacred relics of the new religion.

Then he returned to the "goatherd's tree" to meditate on the best way to teach his doctrine; he recognized its obscure nature, but also the precious help it offered to men on different spiritual levels. Some men were unaware of the road they had to take and others were already engaged on their journey. The majority, however, were still searching for the right path and needed his help to be free. It was toward the latter that the Buddha directed his efforts. Who would be the first to hear his preaching? He turned to the five disciples who had left him. He went to them and after persuading them to join him, he announced that they would be his first audience. The Buddha preached his first sermon, the Four Noble Virtues known as the Sermon of Benares. The sermon set in motion the Wheel of the Law, an extremely symbolic name, for just as the solar disc lights and illuminates the world, the wheel, which represents the doctrine and teaching of the Buddha, through its radiant spokes disseminates the "Good Law," the light of the world that shines on all creatures. Miraculous events occurred as he preached. The five disciples that had strayed from their master returned to

him to form the first community of believers. From that moment on, the Buddha's teachings would be addressed to all men.

The Buddha then began a tireless journey through the middle basin of the Ganges River, stopping only when the rainy season hindered his progress. He was thirty-six years of age. He began to preach endlessly and he made numerous converts from all castes.

Thanks to the many gifts that he received, he built the first retreat and monastery of Jetavana in the city of Sravasti (the woods of the Prince Jeta) considered the most important institution of learning and an eminent temple of knowledge. It was in Sravasti that he produced the "twin miracles." Meditating deeply, he caused water to gush forth from his feet and flames to envelop his shoulders and then, in reverse, he made his feet disappear in tongues of fire while drops of rain fell from his shoulders. Then he caused a mango tree to grow spontaneously and sprout images within its foliage. After these magical feats, the Buddha, following the tradition of his predecessors, sojourned with Indra, the divinity reigning over thirty-three gods of the sky, during the rainy season. When the time of his visit drew to a close, and as he descended to earth by a triple stairway of divine making, another great miracle occurred. As his feet touched the ground, the immense crowd that had gathered to observe him was suddenly awed by the clarity of the spectacle unfolding before it, representing all the "visible worlds" from the seat of the god Brahma on the very highest to the nether regions of hell far below the crust of the earth.

The sermons and conversions continued, always addressed to all men regardless of birth or caste origin. Even an ogre who was terrorizing a

whole city and a bandit known as the "garland of cut-off fingers" abandoned their evil ways to join the ranks of the faithful.

At the time of the tenth anniversary of his Enlightenment, he retreated alone into the forest of Parileyyaka, where he found contentment in the company of a solitary elephant and a monkey offering him their disinterested assistance (several Khmer bas-reliefs were inspired by this scene). Time passed. Thirty-seven years after his Enlightenment, Devadatta, an ambitious cousin, tried to usurp his place at the head of the community. The Buddha survived an attempt on his life when a boulder that was loosened from the mountain to crush him produced a few merely superficial injuries. Devadatta then made a war elephant, Nalagiri, drink liqueur until it was drunk and then unleashed it in the streets while the Buddha was passing by. At the sight of the Buddha, the besotted beast suddenly became appeased and knelt at the feet of the Blessed One. (Both scenes of Devadatta's treachery appear in Khmer art.)

The Buddha, despite his declining forces and advancing age, pursued his commitments to teaching and converting, traveling until he felt the coolness of the shadow of death overtake him. With the end of the rainy season, the Master, accompanied by several monks, set off for a town called Pava, where he feasted on a succulent pork dish that worsened his feeble condition. Bravely, nevertheless, he tried to reach the city of Kusinara, but was obliged to stop in the middle of his journey to rest and take a bath. Reaching his destination, he had his disciples prepare a bed between two trees and he lay down on his right side facing the west, his head oriented north. He

exhorted his weeping disciples not to mourn. He spent his last night on earth in deep mediation and ecstasy, attaining in successive stages the "domain of the cessation of consciousness and feeling" and expired having reached Nirvana. He was eighty. The earth shook, the gods revealed themselves and all the trees became instantly laden with flowers.

His funeral was majestic and royal, like the grandiose ceremonies reserved for universal sovereigns. His body was placed on the funeral pyre that lighted itself and, just as spontaneously, extinguished its flames. Legend tells us that his ashes were given to mankind, the divinities and the nagas.

The Doctrine of the Buddha

The Buddhist creed was born and elaborated in an environment impregnated with the Brahmanic religion. The Blessed One was a reformer who moved within the traditions of Indian civilization whose fundamental precepts and divinities he never questioned. His life work was not directed at contesting and revolutionizing but reformulating the very ancient teaching of the individual soul's deliverance by its complete and definitive union with the soul of the universe. The Buddha did not actually preach a religion in the usual sense of the term, but rather taught from his own experience. He believed that all the beings and objects of this world were in continuous mutation and unaware of previous existences. His work was intended to bring about the discovery of the reality that lay behind the appearances; he established a line of conduct for the soul desiring to free itself

from the illusions and passions that bring on the onslaughts of pain that were a part of existence. Birth, torments, frustrations, separations, grief, illness, old age and death are nothing more than the pain that afflicts all creatures, even divine beings. Nothing is eternal, everything changes, alters, and inevitably disappears one day. However, each death is followed by a rebirth whose place in the system of values depends on the quality of acts accomplished in former lifetimes. These consecutive transmigrations of the soul or samsaras, will determine the form in which the deceased will be reincarnated—as a god, a human being, an animal, a ghost or a denizen of hell. This principle of soul journeying was not an innovation, for it was a belief already held by Indians before the advent of the Buddha. The Enlightened One emphasized the importance of liberating the soul from the infernal cycle of births and deaths; arresting the cycle meant putting an end to pain not by self-annihilation but by plunging the spiritual entity into the great absence, or Nirvana.

Pain, he taught, originated from the desire to attach oneself to pleasure, which, in turn, led the individual to be reborn to savor other delights. The Buddha believed that desire is produced by a chain of causes, the first of which is ignorance. Ignorance is the basis of all evil and takes three forms: greed, hatred and error. The three evils are fertile ground for other passions, vices and false opinions. In the Buddha's teaching, the way to deliver the soul was to seek the state of non-desire, meaning as well, non-pain; to achieve this state, the individual had to adopt eight correct attitudes in his opinions, his intentions, his words, his bodily activity, his means of existence, his efforts, his attention and his mental concentration. These attitudes are

favored by practicing physical exercises to aid meditation. Nevertheless, it was clear from the beginning that these various disciplines required a strict observance and a freedom to dispose of one's own time that was rarely available to believers who led secular lives.

The Buddhist communities constituted by monks were completely free to practice the methods but, since the doctrine was also taught to secular laymen, regardless of their origin or social rank, it had to be simplified and shortened for their requirements. A lay brother was required only to pronounce before an assembly of monks his promise to adhere to the three concepts of Buddhism, called the "Three Jewels": submission to the Buddha, obedience to the Law and to the Community, and observance of five principles associated with a moral conduct, which are not to kill, not to steal, not to commit adultery, not to lie and not to consume intoxicating substances. In exchange, the road to acquiring the eight perfections leading to the total dissipation of pain and suffering would be open to him. These rules, which were minor in comparison to the discipline the monks had to observe, were further lightened by the fact that Buddhism does not impose any rites or ceremonies except in its Tantric version, practiced notably in Tibet.

Ancient Navigation and Trade in the Indian Ocean

In the 7th century B.C., Phoenician navigators were the first to circumnavigate the African continent for the Egyptian pharaoh Necho I of the 26th dynasty. Following the voyage of the Greek navigator Scylax of Caryanada serving the Persian King Darius, during which he explored the Indus River, commercial relations between that area of India and the Red Sea along the southern coast of Arabia began to develop. Egypt and the Gulf of Suez became a crossroads for trade during the Acheamenian dynasty of Assyria. Alexander the Great during his conquest of Asia from 334 to 321 B.C. left his mark on the sea routes of the Persian Gulf and the Indian Ocean with his founding of coastal cities. He sent his chief admiral Nearchos to explore the Persian Gulf with an armada of ships built in India. After conquering Egypt in 332 B.C., Alexander established trading posts along the Red Sea. The direct links between Egypt and India became permanent ways of communications when Rome occupied Egypt in 30 B.C. The sea routes were navigated to further trade between the east and Rome, whose inhabitants delighted in acquiring luxurious products and were willing to pay gold for them. Evidence of the importance of this intercontinental trade surfaced when certain archeological sites that were uncovered in India on the Coromandel coast were found to contain objects not made in India. Furthermore, sites excavated in the Mekong delta in Indochina revealed Indian artifacts. At the close of the 1st century B.C., the Periplus Maris Erythraei, which completed the treatises on classical geography compiled during Roman times, enumerated the coastal cities of India, their resources and their needs. The navigators of the time learned how to use the monsoon winds, permitting an intensification of trade. Stabon, the geographer, cites the annual departure of one hundred twenty ships for India. The Mediterraneans, Arabs and Indians were not the only great navigators. For many years, Chinese junks had been stopping at different ports of the sub-continent, while Indian ships often sailed into Chinese ports after laying anchor to trade at the ports of other Southeast Asian lands that were on their sea routes.

Indian Expansion into Southeast Asia

(see map on page 26-27)

Although India and Southeast Asian lands were trading partners before the 2nd century B.C., the Vo Canh stela written in Sanskrit and discovered in South Annam was the first document to record their exchanges.

India needed Southeast Asia. Perfume and rare wood, commodities highly valued in imperial Rome, had become scarce in India, so Indian merchants went looking for new sources. Southeast Asia was probably a less expensive and more accessible supplier.

Through trade and the inevitable religious and cultural exchanges that follow in its wake, Indian sailors were able to acquaint the Southeast Asian populations with the doctrines of the Brahmans, who acquired a prestigious reputation and were solicited by native rulers to help them affirm the power and influence they hoped to exercise over their subjects.

The long periods waiting for favorable monsoon winds in the ports of Southeast Asian lands encouraged the Indian sailors to enjoy the life of ease that, according to Zhou Daguan, could be led in their host ports. Many sailors married native women, creating family ties. Although settled in other lands, the Indians continued to worship the Hindu deities, who were readily adopted by the native cultures. The presence of

these multi-ethnic families diffused a higher culture, and the Khmers assimilated its knowledge, practices and techniques.

The Indians reached the harbors of Southeast Asia by two sea routes. They could sail directly into the Strait of Malacca and from there to the South China Sea, or they could reach that strait by skirting the coasts of Burma and Malaysia. At the start of the 5th century, they all but abandoned the direct Malacca passage, which was overrun with pirates. Consequently, the trading posts of Java and Sumatra declined rapidly while those of the west coast of Malaysia prospered.

There was another half-sea, half-land route they could take as well. The ships could have docked at the tenth parallel on the Isthmus of Kra, the time to unload their cargoes onto other ships anchored in a port in the Gulf of Siam. The cargoes would have been transported east by road to the Indochinese Peninsula and, beyond that, to China. The journey by this means was shorter and safer.

Finally, there was another, older trans-peninsular road that started in northeastern India, cut across Burma and reached Tenasserim in the region of the present-day city of Moulmein. From that point, the merchandise would have traveled southeast down to southern Siam (Thailand) and the Indochinese Peninsula. This journey would also have been quicker and safer than attempting the Malacca Strait.

Indian Epics

The *Mahabarata*

The *Mahabarata*, with its eighteen chapters and hundred thousand stanzas of verse, was written over a period of six or seven hundred years. It dates back roughly to the pre-Christian era and overlaps into the 1st century A.D. It is the most important religious text of Hinduism and has exerted an enormous influence.

Popular tradition ascribes the authorship of this unique epic to Vyasa. Structured as a suite of extremely intricate themes, it has only the remotest link to the glorious feats of the Bharata clan that occurred over a period of two centuries. The epic is largely devoted to an account of the war between two tribes around the 10th century B.C. In the second millennium B.C., Aryan tribes left Iran for the northwest of India. One of the tribes, the Bharata, was grouped in eternally warring clans that ruled small kingdoms. The origin of the conflict stemmed from the rivalry of two of those clans for the control of Hastinapura, an ancient city located near present-day Delhi.

You have to go back several generations to understand the conflict, however. From the union of King Santanu, one of the great grandsons of the ancestor Kuru, who later gave his name to the Kaurava clan, and Ganga, a nymph, was born a male child, Bhisma, graced with virtue and reason. When it came time for Santanu to marry his son, he chose Princess Satyavati, who had already given birth to a son, Krishna, whom she had abandoned on an island; at the time of his mother's marriage, Krishna had attained adulthood and was living as a hermit in the forest. The father of Satyavati, who wished his grandson to become lord of Hastinapura, consented to wed his daughter to Bhisma on the condition that there would be no issue from their union. Respectful of the older man, Bhisma acquiesced. The union of Bhisma and Satyavati produced two sons. The elder was slain in combat and his younger brother died childless. In Indian tradition, having no sons to accomplish the ritual of sacrifice to one's ancestors is a great tragedy and one that would permit the brother of the deceased to marry his widow. Satyavati, suddenly remembering her abandoned child Krishna, sent for him and when he appeared as a miserable hermit before the two daughter-in-laws, one shut her eyes and the other, aghast, fell into a swoon; these were premonitory events, since one girl would give birth to a blind child, Dhrtarastra, and the other would bear a son called Pandu, or "the Pale One." Though Dhrtarastra was the elder, he was denied the throne by his brother, Pandu, who argued that a blind man could not be king. Although he was aware of a curse that said he would die if he had intercourse with a woman, Pandu took two wives. In the legend, his first wife, Kunti, had once taken in an old sage who, in return for her hospitality, bestowed on her the gift of conceiving a son by merely pronouncing the name of the god of her choice. In the face of her husband's great distress, she obtained from the gods several sons whose paternity was not to be questioned. The sons were named Yudhidtira, from the invocation of Dharma's name, who personified justice; Bhima, the son of the god of wind, Vayu; and Arjuna, the archer and the handsomest of the three, born of Indra, king of the gods. The wife of the blind king, Dhrtarastra, also produced many sons, including Duryodhana, whose violence, jealousy and hatred was to start the war between the clans.

At Pandu's untimely death, his young children—the Pandavas—and their mother found refuge in the house of their blind uncle and their

brother-in-law, Dhrtarastra. Together, the Pandavas and their cousins, the Kauravas, were raised under the protection of their tutor and relative, Bhisma. Harmony between the two families was soon disrupted by the jealousy of Duryodhana, who could not bear the sight of Arjuna's wondrous beauty and his dexterity at wielding the bow. The virtues and the great wisdom of Yudhidtira convinced his uncle Dhrtarastra to offer him the throne in preference to his own eldest son, Duryodhana, who, in a gesture of fury, obliged his father to exile the Pandavas and their mother into the forest.

During their period of banishment, the Pandavas learn that Draupada, a ruler of a neighboring kingdom wishing to find a husband for his daughter, Draupadi, organized a contest in which the three Pandavas appeared in disguise. Arjuna, proving himself to be the best archer, won the hand of the princess. He brought his wife home and announced triumphantly to his mother that he had "won a treasure." Unfortunately, his mother did not know what he actually meant by "treasure" and decided that if "treasure" it was, then it had to be shared by the rest of the family! In India, the power of the spoken word was as binding as law; thus, Draupadi became the wife to the three brothers.

As the time of their exile was drawing to a close, they reappeared before their uncle, the blind king, to claim their due. Dhrtarastra consented to share his lands, keeping for himself the city of Hastinapura and giving Yudhidtira the city of Indraprastha. Although a paragon of virtue in other respects, Yudhidtira had a weakness: he loved to gamble. Duryodhana, aware of his cousin's shortcoming, persuaded him to engage in a game of dice, which the evil man had

loaded. As a settlement for Yudhidtira's losses, he demanded the city of Indraprastha and he made slaves of his brothers and their common wife, Draupadi. The young woman was so continually humiliated that Dhrtarastra, overwhelmed by the malevolent conduct of his eldest son, intervened to reinstate Yudhidtira in his former position. Unluckily, his passion for gambling got the better of him and Yudhidtira again lost everything to his cousin. The heartbroken blind king had no other choice but to banish the Pandavas, this time for the longer term of thirteen years, a period that was rich in new adventures. At the end of their time of exile, they returned and demanded the return of their estates, but their cousins, the Kauravas, were unwilling. The conflict gathered force and finally became a war between the two families, who immediately started brandishing arms and concluding alliances. Krishna, who was distantly related to both rivals, intervened with a more subtle offer: he would put either his army or his own person at their disposition in the conflict. Immediately, Duryodhana thoughtlessly chose the army. This angered Krishna, who allied himself with the other side, the Pandavas. Krishna, personified by Vishnu, drove the chariot of Arjuna and the victory of the Pandava family was assured.

The clash between the armies was terrible. The battle unfolded with a series of successes and defeats on both sides, but in the course of one of the encounters, Duryodhana, the emblematic leader of the Kauravas, was mortally wounded. Three of his comrades-in-arms, seeking vengeance, made off into the night, slipped into the Pandava camp and slaughtered the five sons of Draupadi. Bhisma, who was also seriously injured,

mourned the futile deaths of so many cousins; he was to succumb to arrow wounds after fifty-eight days of fighting. All the heroes of the combat who escaped injury perished later in a forest fire or disappeared during a pilgrimage in the Himalayas, but they were later all reunited in the Heaven of Indra.

The Ramayana

The *Ramayana*, or the "feats of Rama," was written around the beginning of the Christian era. It is the second greatest epic of Indian tradition and it shares certain episodes with the *Mahabarata*, such as the one recounting how Arjuna obtained the hand of Draupadi, or how Rama, with the help of his bow, conquered Sita.

In India itself and in other lands, the *Ramayana* became so popular that its tales crossed the boundaries of the spoken or sung verse to animate the bas-relief carvings of the temples. Like the *Mahabarata*, the *Ramayana* was said to have been the work of one single author inspired by vague historical occurrences mixed with folklore. According to legend, its author, of humble birth but gifted with many talents, retreated to the forest to live as a hermit when he had concluded his work. As a holy man, he was so endowed with the power of concentration that one day, he sat inadvertently on an anthill to meditate and was soon covered by the tiny insects; this incident gave him the name of Valmiki, or "Son of the Anthill."

The text of the *Ramayana* was written in Sanskrit and was destined to be either recited or sung. It is composed of seven books, divided into 645 songs celebrating in twenty-four thousand verses the exploits of Rama. The first book of the *Ramayana*, called the "Childhood Section" or "The Beginning," recounts the supernatural

birth of Rama, his childhood and his marriage. King Dasaratha believes himself punished by the gods because he has no son; to regain their favor, he celebrates the sacrifice of a horse, a ritual that only sovereigns could perform. Finally, he enters into their good graces and his three wives produce four sons. The first is called Rama, who is actually an avatar of Vishnu sent by the gods to remove the evil ogre, Ravana. The virtuous Rama is a model for all humanity, and he enjoys superhuman strength. Defeating his rivals at a particularly difficult archery tournament, he is rewarded by King Janaka with the hand of his daughter, the Princess Sita. Other great myths such as the "Churning of the Ocean of Milk" appear in the first book.

In the second book, called the "Book of Ayodhia," King Dasartha feeling his great age, chooses Rama his eldest son as a successor and arouses the wrath of one of the queens who coveted the throne for her own son. She successfully intrigues and persuades the sovereign to banish Rama for a period of fourteen years.

In the third book, Rama, followed by his wife and his brother Laksmana, enter the forest of Dandara that the henchmen of Ravana have turned into their own private lawless domain. The hermits who live and meditate in the woods plead with him to deliver them from the demons. He hears their supplications and engages in a fierce combat with Ravana, the chief of the *rakshasas*, an inferior rank of demons who sprout from their hideous bodies a multitude of heads and arms.

Ravana's sister, also a demon, outraged at Rama and Laksmana's rejection of her advances, asks her brother to abduct Sita. At first unsuccessful, Ravana finally achieves his end when a demon in the shape of a golden gazelle distracts Rama, who leaves his spouse to Ravana disguised as a beggar monk. The king of the demons carries off Sita in his aerial chariot to keep her captive in his island of Lanka (Sri Lanka). The vulture Jatayu witnesses the abduction and warns Rama, who departs in search of his wife.

In the fourth book, Rama, looking for Sita, encounters Hanuman, the chief of the monkeys, who leads him to Sugriva, his ruler. Sugriva has been dispossessed of his throne by his brother Valin; when Rama helps him retrieve it, he puts his monkey army at the service of the hero.

The fifth book relates how Hanuman is sent as a secret messenger to Sita. The monkey scout tells her that help and deliverance are on the way. In one fantastic leap, Hanuman crosses the ocean to Lanka and, assuming human shape, enters the palace to discover Sita guarded night and day by demon women in a small wood of *asoka* trees. Hanuman tells her of her husband's message of hope and in return she entrusts him with one of her rings to show her husband that the monkey general's mission was successful. Then, Hanuman miraculously jumps back across the ocean.

The sixth book is devoted to the heated battle between the hero and the villain. The monkeys build a pontoon of stones and felled tree trunks; then, the strange army starts to cross the sea. Unfortunately, Ravana spots them and ventures out from his island fortress and a terrible skirmish takes place; magical as well as conventional weapons enter into the fray. The high point of the combat is the duel between Rama, mounted on his chariot or on Hanuman's shoulders, and Ravana, in a chariot drawn by human-faced horses. One of Ravana's sorcerer sons shoots a volley of enchanted arrows at Rama and Laksmana; the arrows change into snakes as they touch the heroes' bodies and are about to suffocate them when Garuda, plunging from the sky, attacks the hideous beasts and frees Rama and his brother. Finally, in an implacable duel, Rama, with one fell swoop of a spear prepared for him by Brahma, kills the king of the demons and frees Sita. It was with pain, however, that Rama beholds Sita, whom he fears sullied by Ravana. Consumed by jealousy, he repudiates his wife. In despair, Sita prepares to immolate herself, but, as she steps onto the pyre, the flames miraculously do not touch her; the god of fire, Agni, proclaims her innocence and gives her to her husband. Rama then returns to the city of Ayodhya, where he takes the throne.

The seventh book contains a succession of tales about the origin of demons, the childhood of Hanuman and other combats and anecdotes with no particular connection with the end of the story of the *Ramayana*. In fact, the heroic exploits of Rama are mostly contained in the second book, with a fuller development in books three and four; the first and the seventh books were added to glorify the protagonists and emphasize the divine nature of the hero.

Chronology of Ancient Cambodia

Name of king	Dates	CAPITAL and monuments

PRE-ANGKOR PERIOD (Indian influence and start of the Christian era)

DYNASTIES OF FUNAN

Name of king	Dates	CAPITAL and monuments
FAN CHE MAN	c. 220	
KAUDINYA-JAYAVARMAN	c. 480–514	(Vyadhapura) BA PHNOM
RUDRAVARMAN	c. 515	ANGKOR BOREI

THE CHENLA DYNASTIES AND THE WAR BETWEEN FUNAN AND CHENLA

Name of king	Dates	CAPITAL and monuments
SRESTHAVARMAN		WAT PHU
BHAVAVARMAN I	?–c. 598	(Bhavapura) SAMBOR PREI KUK
MAHENDRAVRMAN		Temple of Wat Phu
ISANAVARMAN I	c. 611–635	(Isanapura) South Group SAMBOR PREI KUK
BHAVAVARMAN II		

DIVISION OF CHENLA: LAND CHENLA AND WATER CHENLA

Name of king	Dates	CAPITAL and monuments
JAYAVARMAN I	c. 659	

ANGKOR PERIOD

Name of king	Dates	CAPITAL and monuments
JAYAVARMAN II	802–c. 835	Ph. Kulen, Hariharalaya (ROLUOS)
JAYAVARMAN III	c. 842–877	
INDRAVARMAN I	877–889	Indratataka, Preah Ko, Bakong
YASOVARMAN I	889–910	Yasodharapura (FIRST ANGKOR CITY), Bakheng, East Baray, Lolei, Ph. Bok, Ph. Krom
HARSHAVARMAN I	910–c. 922	
ISANAVARMAN II	c. 922–928	
JAYAVARMAN IV	c. 921–940	Preah Kravan
HARSHAVARMAN II	940–944	CHOK GARGYAR (Koh Ker)
RAJENDRAVARMAN	944–968	Return to ANGKOR East Mebon, Pre Rup, Srah Srang, Bat Chum, Bant. Srei, Baksei Chamkrong
JAYAVARMAN V	968–c. 1000	Ta Keo, North Khleang
UDAYADITYAVARMAN I	1000–1001	
JAYAVIRAVARMAN	1002–1010	
SURYAVARMAN I	1002–c. 1049	Royal Palace of Angkor Thom, West Baray, Preah Vihear
UDAYADITYAVARMAN II	1050–1066	Baphuon, West Mebon
HARSHAVARMAN III	1066–1080	
JAYAVARMAN VI	1080–1107	Temple of Phimai (THAILAND)
DHARANINDRAVARMAN I	1107–1113	Thommanon (?)
SURYAVARMAN II	1113–1150	Angkor Wat, Chau Say Tevoda, Bant. Samre, Beng Mealea
YASOVARMAN II	c.1150–1165	
TRIBHUVANADITYAVARMAN	1165–1177	1177 the Chams enter and plunder Angkor

CHAM OCCUPATION OF CAMBODIA FROM 1177 TO 1181

Name of king	Dates	CAPITAL and monuments
JAYAVARMAN VII	1181–c. 1210	Angkor Thom, Ta Prohm, P. Khan, Neak Pean, Bayon B. Kdei, Royal Ter., Ta Som, Ta Nei, B. Chmar
INDRAVARMAN II	1210–1243	Continues work begun in the Jayavarman VII era
JAYAVARMAN VIII	1243–c. 1295	Brahmanic reaction: destruction of Bhudda images, transformation and restoration of earlier period temples
SRINDRAVARMAN	1295–1307	Construction of Bhuddist terraces
SRINDRAYAVARMAN	1307–1327	

1431 SUPPOSED DATE OF THE FALL OF ANGKOR TO THE THAI ARMY,
ABANDONMENT OF ANGKOR IN THE 15TH CENTURY

Extent of Khmer cvilization in 20th century

Extent of Khmer civilization at the beginning of
18th century, during the reign of Jayavarman VII

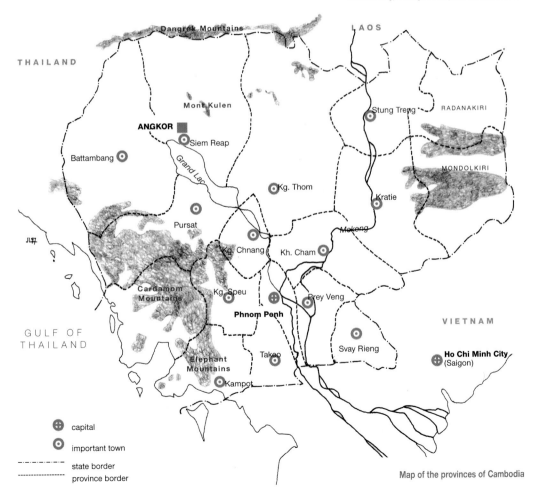

Map of the provinces of Cambodia

Glossary

accolade. Shaped like the musical mark known as a brace.

anastylosis. A method of restoring a monument that entails dismantling and rebuilding the structure using the original materials.

ancon. A projecting bracket used to support a cornice, a console.

apsara. A female divinity and celestial dancer.

arcature. A small arch or arcade.

asura. A demon representing the forces of evil.

avatar. The incarnation of a divinity in human or animal form.

baluster. A short pillar supporting a balustrade.

band course. Molded horizontal strip on a façade.

baray. A large man-made body of water.

bas-relief. A sculpture in relief in which the figures project less than half their true depth from the background.

causeway. A raised road across a body of water.

cella. Enclosed inner area of a temple incorporating the sacred chamber.

colonette. Small column.

coping. Top course, usually sloping, of a wall.

corbeled vault. Vault made up of successive courses of corbels (cantilevers).

crozier. Curled motif.

deva (*devata* = Sanskrit). A deity that is often a guardian. Feminine: *devi*.

dvarapala. Guardian placed at the entrance to a temple or sanctuary.

extrados. Outer curve of an arch.

finial. Ornament at the apex of a roof.

gopura. An entrance pavilion in enclosure walls around a temple.

hamsa. A sacred goose; Brahma's mount.

intrados. Inner curve of an arch.

kala. Monster with a grinning face and bulbous eyes.

laterite. Porous, reddish soil that hardens on exposure to the air. Widely used for the foundations of Khmer temples.

linga. A stylized phallus, a symbol of Shiva as cosmic creator.

lintel. A horizontal support across the top of a door or window.

makara. A mythical sea monster that has a reptilian body and a trunk.

mandapa. A hall or porch connected to the sanctuary by a vestibule.

naga. A mythical water creature and deity, usually seven- or nine-headed, with a scaly body.

ogive. An arch made up of two arcs meeting at a point.

palmette. An ornamental stylized palm leaf.

pediment. A triangular feature above a doorway, sometimes richly decorated.

phnom (Kh). "Hill, mountain."

prasat (Kh). "Tower," a sanctuary in the form of a tower.

preah (Kh). "Sacred, holy."

rake. Inclination or slope of a pediment or roof.

rakshasa. A demon with fierce fangs who lives in Lanka with Ravana.

stela. A vertical stone carved with reliefs, inscriptions.

srah (Kh). "Pond."

srei (Kh). "Woman."

string course. A horizontal band or molding.

ta (Kh). "Ancestor."

trefoil. Decorative element consisting of three foils (arcs or curves); sometimes used in Khmer pediments.

tympanum. Triangular face of a pediment.

wat (Thai). "Shrine or temple."

yaksha. A male nature spirit and deity often serving as a guardian.

Index

The numbers in italics indicate pages
with illustrations.

The numbers in bold indicate pages
of primary relevance.

Production: CPE Conseil
Color separation: SNO, Ivry-sur-Seine

FA0723-02-V
Dépôt légal : 05/2002

—